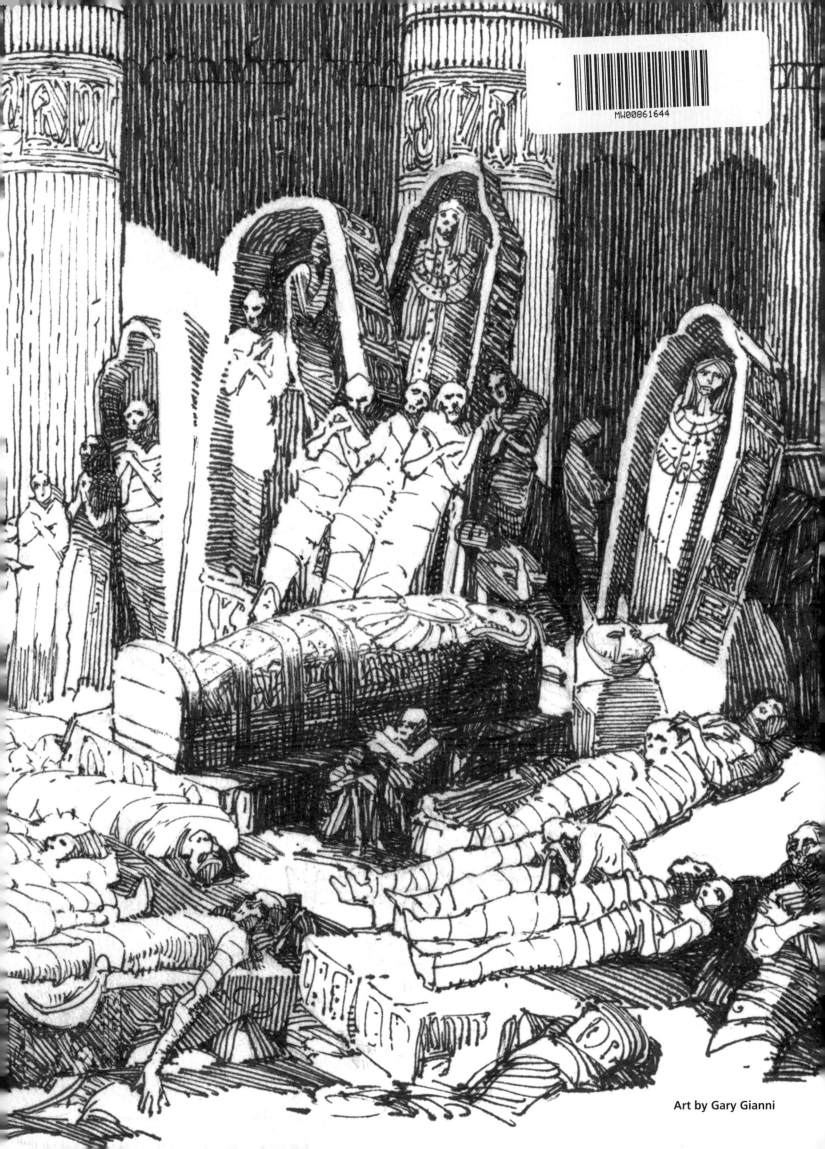

Art by Gary Gianni

Alexandra Manukyan [see page 213]

E.M. Gist [see page 100]

Ana Bagayan [see page 184]

Edward Howard [see page 233]

SPECTRUM 20

The Best in Contemporary Fantastic Art

EDITED BY CATHY FENNER & ARNIE FENNER

UNDERWOOD BOOKS

Fairfax, CA

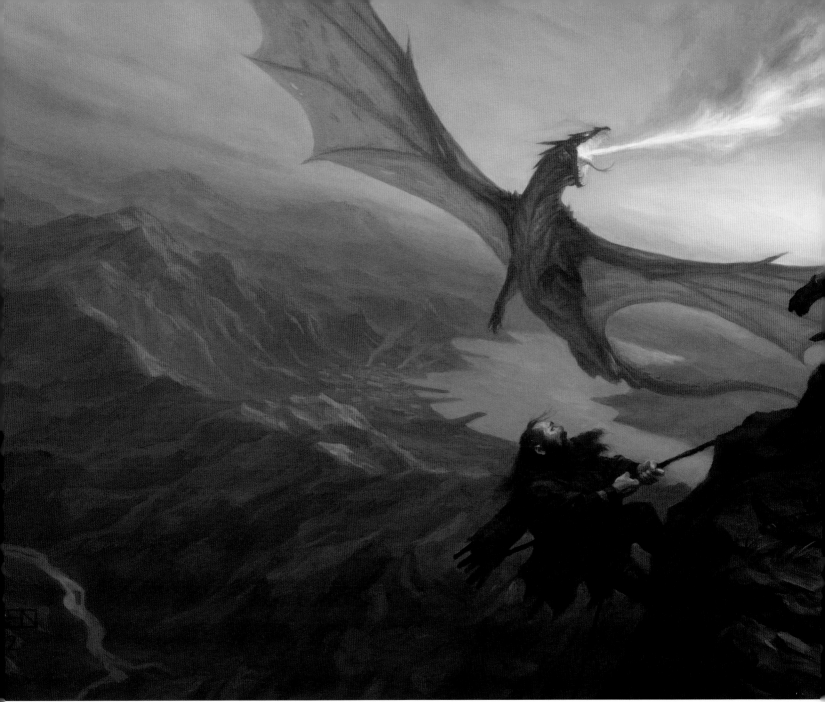

Chris Rahn [see page 26]

Trade Softcover Edition ISBN 1-59929-067-7 ISBN-13: 978-1599290676
Hardcover Edition ISBN 1-59929-068-3 ISBN-13: 978-1599290683
10 9 8 7 6 5 4 3 2 1

Artists, art directors, and publishers interested in receiving entry information for the next *Spectrum* competition should send their name and address to:
Flesk Publications, P.O. Box 54044, San Jose, CA 95154
Or visit the official website for information & printable PDF entry forms: **www.spectrumfantasticart.com**
Call For Entries posters (which contain complete rules, list of fees, and forms for participation) are mailed out in October each year.

Spectrum Fantastic Art Live 2 was sponsored by:

PUBLISHED BY
UNDERWOOD BOOKS, P.O. Box 459, Fairfax, CA 94978 www.underwoodbooks.com **Tim Underwood**/Publisher

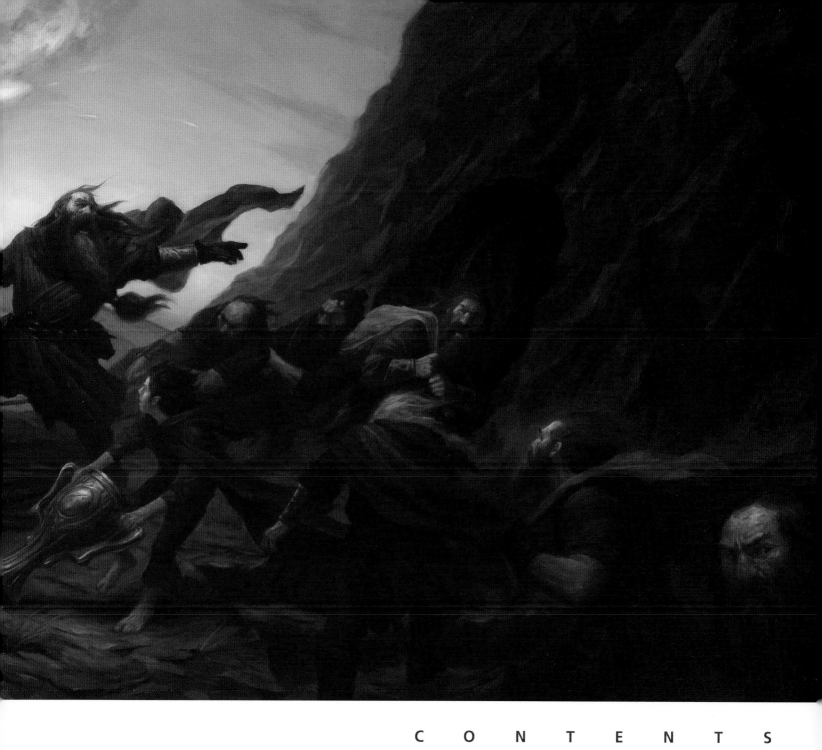

C O N T E N T S

T H E S H O W

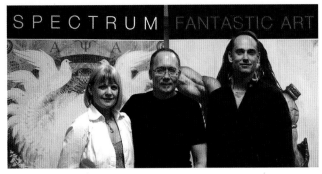

Above: *Cathy and Arnie Fenner with John Fleskes at the judging for* Spectrum 20.

Once upon a time, many years ago, Arnie and I were having lunch in the courtyard near the fountains on the Crown Center Square in Kansas City. The topic of conversation that day was one that we had discussed many times in the past: the increasing number of exceptional artists creating fantasy and science fiction art and the lack of recognition they were receiving from either their peers or the public. Arnie had been talking about the need for a fantastic-centric art annual since the early 1980s, had kicked ideas back and forth with Michael Whelan, and had even pitched a book proposal to various publishers and agents, but had never been able to get beyond the "it's a nice idea, but..." phase. Figuring out how to turn it from dream into reality—to get a publisher on board and get the support of artists—was the conundrum that kept the project from reaching fruition.

So we talked. And we talked. And we talked some more. Until finally I threw up my hands and said, "If we can't get anyone to back it, let's just do it ourselves!" Instead of telling me I was crazy, Arnie thought for a minute and said, "Why not?" I knew that Arnie had been working in publishing since he was a teenager and had published books and magazines himself besides being an award-winning artist and art director. I was also working as a graphic designer and knew my way around a drawing table; I figured that with our combined experience all we had to do to bring this idea to life was to...try.

So we did.

We pooled our money and opened a bank account and P.O. box. Rick Berry, who was one of the earliest and most enthusiastic advocates for the project, suggested "Spectrum" as a title and we were off. Rather than go out and pick what we thought was "the best" art of the year from what was readily viewable (much like the editors of the fiction annuals choose the contents of their books), we didn't want to limit the content to our own tastes and elected to follow the "competition model" that had been successfully pioneered by the respected *Illustrators* annual. We organized a jury, printed a Call For Entries poster, purchased mailing lists, and traveled to conventions to talk about a best of the year book for artists. More often than not people looked at us like we had potatoes growing out of our ears when we tried to explain both the need and our goals, but there were also many who "got it," who understood what we were trying to accomplish, and joined in. Tim Underwood (whom Arnie was friends with and had been designing book covers for) stepped in and offered to act as publisher of the first annual and when the initial entries began to arrive (including a large package from Playboy magazine), we knew that *Spectrum* was actually going to happen. At least once.

Twenty years later—twenty annuals, twenty juries, two-soon-to-be-three museum shows, and two conventions later—*Spectrum* has become something of a tradition of the fantastic art world. Even as the publishing industry has changed, even as the art community has morphed and expanded and been impacted by all things digital, even as the marketplace takes on a roller coaster appearance and creates challenges and raises questions for artists of all sensibilities, *Spectrum* has grown as something of a "safe harbor," one that welcomes all artists from around the globe without prejudice or pretension. As Arnie has said elsewhere on numerous occasions, *Spectrum* is a celebration of the imagination and the artists who help expand our sense of wonder. We aren't the ones who made it that way: it was all of *you*.

We never have had any votes for what was selected for inclusion in the annual or what received awards: that has always been determined by the judges. We have never had any control over the amount or types of art entered in the competition. We have never had any say regarding which stores or outlets the books have appeared in; we've never been able to predict sales. When we have needed help or guidance we've been able to turn to our bright group of advisors for advice. We have been along for this ride with everyone else, constantly surprised, constantly excited.

But our journey is coming to an end, at least when it comes to *Spectrum*. This volume will be our last as editors for the series and it will be the final published by our close friends at Underwood Books.

Beginning with *Spectrum* 21, John Fleskes will assume the role of director of the competition and editor/publisher of the annuals. We're sure the announcement may come as a surprise to many, but we see it as a natural progression. We have never viewed *Spectrum* as something we owned, it was never anything that was about us: *Spectrum* has always been about the artists, the art, and the community. As such, we have thought about how best to position it for the future, to try to make sure it would not only last beyond our tenure, but continue to be vibrant and vital and to serve the creative field.

We had met John Fleskes at the San Diego Comic Con; our admiration for his books and thoughtful approach to publishing led to a friendship. Though we didn't approach him with the idea of taking over *Spectrum* immediately, Arnie and I both knew that he shared our outlooks, our ethics, and our love of the art. We knew that if anyone could carry on and, in the process, also build and improve upon everything that has come before, it was John.

For the past five years we have met and talked and planned for this transition. At Spectrum Fantastic Art Live in Kansas City in May we made the formal announcement and introduced John as the new face of *Spectrum*. It was gratifying that the audience immediately—and happily—recognized that rather than being the end of the story, the transition marks the beginning of an exciting new chapter.

We encourage everyone to give John the same support that you all have so graciously given to us through the years. He has many ambitious plans that we know you will want to experience and be a part of. There will be a new website (with the same address) that you will enjoy visiting often.

And us? We'll still be around. There are a few more books in the planning stages with Tim Underwood, a *Spectrum* exhibit curated by Irene Gallo and

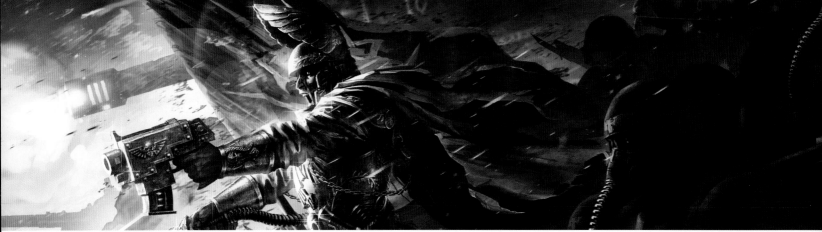

Raymond Swanland [see page 61]

The *Spectrum* 20 Jury

Tim Bruckner *Sculptor*

Irene Gallo *Art Director*

Tim Kirk *Artist/Designer*

Mark A. Nelson *Artist*

Michael R. Whelan *Artist*

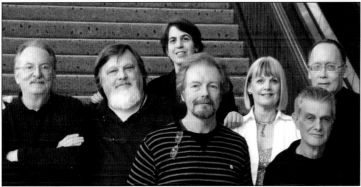

Images from Spectrum Fantastic Art Live 2

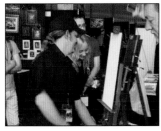

Ron & Vanessa Lemen

Commemorative book

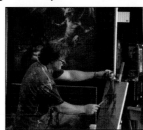

Justin Sweet

Guests' group book signing

Special Guest Jon Foster

Greg Manchess at the Museum of American Illustration in New York scheduled for September, 2014, and several other projects (like Spectrum Fantastic Art Live) that we hope everyone will enjoy.

It's been something of a tradition for me to thank everyone at the end of these messages and I'm not about to change after two decades. So...thank you. Thank you to Tim Underwood for being a partner in this adventure. Thank you to John Fleskes for jumping into the trenches. Thank you to all of our jurors through the years, many of whom have become close and valued friends. Thank you to our Advisory Board: Rick Berry, Brom, Mark Chiarello, Diane Dillon, Harlan Ellison, John Fleskes, Irene Gallo, Bud Plant, Tim Underwood, and Michael R. Whelan—and our thoughts are with the advisors who have sadly passed away, Leo Dillon and Don Ivan Punchatz. Thank you to all our helpers for the competitions and for SFAL. Thank you to the artists that have taken part in the competitions and to the readers who have bought the annuals. Thank you for supporting *Spectrum* and for allowing us to be a part of this community. The best is yet to come! •

Grand Master Award
B R O M
Born March 9, 1965

Occasionally people have asked what the criteria is to be designated a "Grand Master" and it always seems easy enough to explain. Artists must have a career exceeding at least twenty years, must have maintained a consistently high level of quality throughout the body of their work, and they must have been an influence on their fellow artists through both their art and their attitude toward the fantastic art field and the arts community as a whole.

Craft alone is not sufficient to receive the honor: there are many skilled painters and illustrators who produce solid, professional work. But (and this is the key) it fails to resonate. It is admired in the moment and immediately forgotten. A Grand Master's art, on the other hand, gets stuck in the viewer's heart and memory and is irresistibly revisited—reevaluated, appreciated—regularly.

Perhaps "attitude" and "influence" seem subjective and open to debate, but I don't believe they are. As attributes, I believe they're always obvious. Who do other artists talk about? Who do they gravitate to? Whose works and stylistic solutions have an effect and begin to be reflected in the art of students and peers? A Grand Master casts a long shadow.

And no one casts a longer shadow than Brom.

Tall and thin with a shaggy head of hair and a steady, sometimes piercing gaze, Gerald Brom stands out in a crowd. He speaks softly but directly, with a rapid cadence and the slightest hint of a residual Southern accent. As I explained to Frank Frazetta once (who was fascinated with both Brom and Jon Foster as his "competition"), he goes by his last name not out of pretense but as a personal preference. Brom tends to stoop when he talks to people, not because he has bad posture, but because he's interested and doesn't want to miss the details—and nuances—of a conversation. He observes and absorbs; he files away details for drawings, paintings, and now, novels. He is quick to smile, quick to laugh, and has a dryly mischievous sense of humor. Brom delights in the macabre and cheerfully cultivates a "prince of darkness" persona, but is neither morbid nor mordent. When the indignant call his work "evil" he responds cheerfully and returns to the easel or keyboard, reinvigorated by the validation for a job well done.

Born in Albany, Georgia, Brom is the son of an Army pilot of both helicopters and fixed-wing aircraft. As a "Military brat" he spent his school-age years on the move and grew up in Japan, Alabama, and Hawaii. Influenced by monster movies, comics and Tarzan and Conan paperback books, Brom began drawing all manner of fantasy characters in childhood; rather than outgrowing the interest, it grew with each passing year.

While attending a two-week summer "art camp" in Atlanta at age 17 he met his muse and future wife, Laurie, and brazenly informed her parents when they came to pick her up that he planned to marry their daughter. Fortunately they didn't shoot him on the spot and, as it turned out a few years later, Brom proved that even at an early age he was unquestionably a man of his word.

He graduated from high school in Frankfurt, Germany, and, following a brief stint at a commercial art school in Georgia (where he found he had to teach himself how to paint), Brom started working full-time as an illustrator. By age 21, he had two national art representatives and was producing work for such clients as Coke, IBM, Columbia Pictures, and CNN. Three years later, he entered the fantasy field he had loved all his life when TSR hired Brom as a staff artist. He would spend the next three years creating the dramatic look of the best-selling *Dark Sun* world: it was on that project that his European/Asian/Fetish-inspired style fully emerged, became his trademark, and inspired both his contemporaries and a generation of emerging artists. His work increasingly became intriguing explorations of twilight realms and emotional (and physical) strife, providing viewers with something more than a cathartic thrill.

In 1993 Brom returned to the freelance market and, over the last twenty years, has created hundreds of paintings for novels, roleplaying and computer games, comics, and films. He licensed his art for statues and toys and also turned his hand to writing illustrated novels, including *The Plucker, The Child Thief,* and *Krampus: The Yule Lord.* His art has been collected in three books: *Darkwerks, Offerings,* and the definitive 2013 release, *The Art of Brom.* He is the only artist whose work has been selected by twenty separate juries for inclusion in every volume of *Spectrum.*

Let me say that again: Brom is the *only* artist represented in *every* volume.

As an advisor, Cathy and I have called upon his wisdom on numerous occasions: Brom's love for our field is second to none.

Though I've written about him often through the years, I've never truly felt that anything I've said has added even the slightest to understanding who Brom is as an artist or why his work matters. He is, in his own way, enigmatic. He *is* mysterious.

Every generation has their own heroes; creators who both inspire and influence, whose works inexplicably encapsulate the zeitgiest of an era, whose oeuvre transcends original intent to become symbolic of their time. Every generation produces artists of note, artists of significance, artists that matter.

Brom is one of those icons.

There is no way to predict who will leave a lasting impression and who will not, especially in the arts—and it is fruitless for anyone to believe they have control over how others will perceive their work or that they can somehow determine their own import in history. The only thing an artist can do is apply their skills to the best of their abilities and express themselves sincerely in the hope that what results will resonate with their peers and an audience.

I don't believe Brom has ever given much thought to his position in the art world; I don't believe he ever cared about his stature or awards or what his place in history might be. I don't believe he's ever felt compelled to make career comparisons.

Brom's focus has always been on the *work*; his passion has always been to tell stories and to engage and enthrall an audience.

That is what makes a Grand Master. That is *Brom.* •

Grand Master Honorees

Frank Frazetta Don Ivan Punchatz Leo & Diane Dillon James E. Bama John Berkey Alan Lee Jean Giraud Kinuko Y. Craft Michael Wm Kaluta

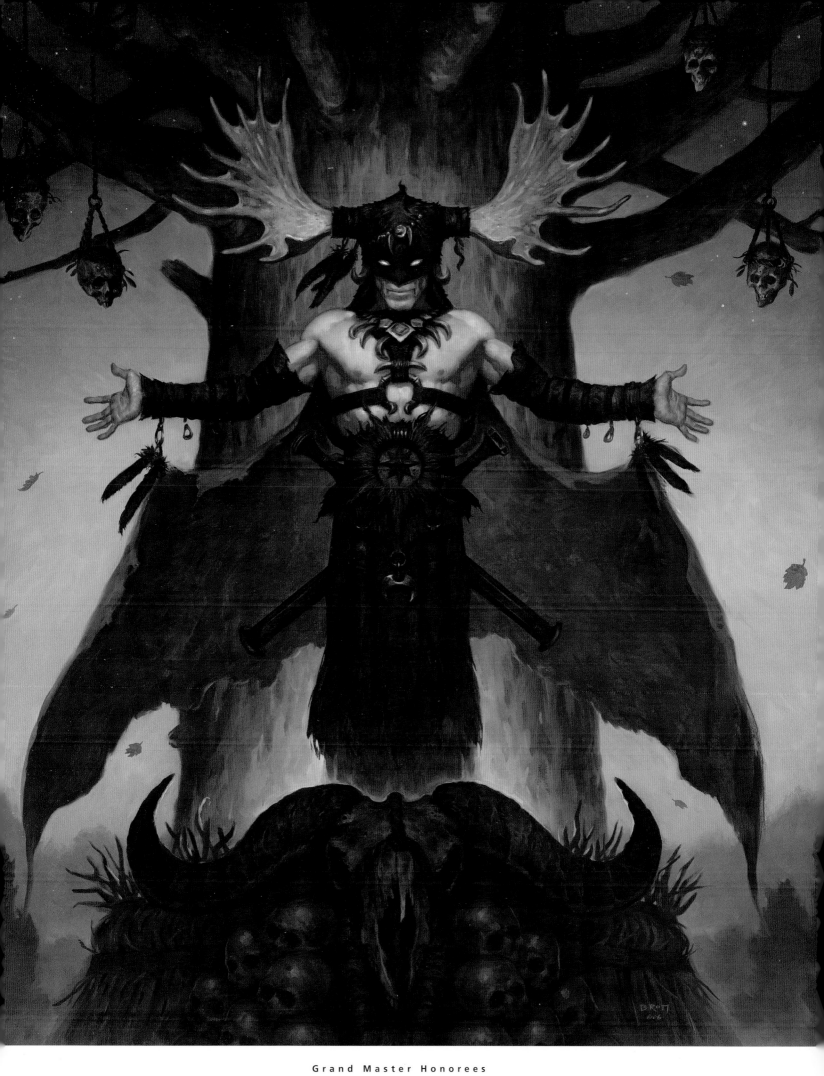

Grand Master Honorees

Michael Whelan H.R. Giger Jeffrey Jones Syd Mead John Jude Palencar Richard V. Corben Al Williamson Ralph McQuarrie James Gurney Brom

Hello, I Must Be Going

by Arnie Fenner

"(I) saw a conversation on [Facebook] that was fascinating. There were 2 people arguing over which 'art' was more valid. They both seemed really impressed with themselves. It was over a piece on NPR about a post modern artist, . . . this art world we live in is so big and so small all at once. As their argument over whose 'art' was more valid seemed to boil over into a series of personal attacks it became laughable, . . . it started to feel like Pee Wee Herman saying 'I know you are, but what am I ?'"
 —Travis Louie

"You may think it's unfair and/or foolish [that publishers] turn you down because you're so talented but the sheer arithmetic tells us that a lot of talented people are going to be turned down. There's no way to avoid it. In some ways, saying 'That guy got to draw Superman…why can't I draw Superman?' is like saying 'That guy won the lottery…why can't I win the lottery?'"
 — Mark Evanier

"The big lie is that the people who make a lot of money were the only ones that worked hard."
 — Chris Matthews

"There are always a lot of bad books and bad art and bad movies and bad ideas and bad people. It is true that 'the bad' never lasts, but there's also one other truth that can't be ignored: The bad drives out the good."
 — Tim Underwood

"Those are brave men knocking at our door. Let's go kill them!"
 — Tyrion Lannister [Peter Dinklage] in *Game of Thrones*

"Why do art museums present vanity exhibitions? Packing up paintings and sculptures from a private collector's living room and hauling them over to the museum's public galleries for a temporary display is about as low-grade a curatorial enterprise as can be imagined. The vision required is limited, if not nonexistent."
 — Christopher Knight, *Los Angeles Times* Art Critic

Let me warn you from the outset: I'm going to ramble and wander all over the place in this essay, worse than Billy in the old *Family Circus* cartoons. If you're impatient for "the point," all you have to do is skip my gabbing and turn to page 19. If you decide to stick with me, I'll try not to make it too painful. But…you've been warned.

In the early days of science fiction conventions—from which all of today's fantasy, steampunk, comics, and pop culture conventions evolved—it was a common practice for publishers to contribute art from their files to the cons' "sketch tables" or auctions. Originals by Virgil Finlay, Ed Cartier, Frank R. Paul, Hannes Bok and others were routinely sold to eager fans for tiny amounts (anywhere from a dollar or two for drawings to $10 or $20 for paintings) with proceeds going to help pay for the events' expenses. There was even one convention at which there were so few buyers present that the auctioneer threw art into the audience and allowed whomever caught the work to keep it (Harlan Ellison says that was how, as a teen, he acquired his first Bok original). Of course, all of this was done without the permission of the artists or additional compensation to them: it was a common practice for publishers to consider all commissioned art as their property to do with as they pleased. And they did. On extremely rare occasions they would return it. Sometimes they would give it away or sell it, but generally they would store the art (never in a facility that was climate controlled or particularly secure) or eventually, when they needed the space, toss everything in the dumpster.

That slowly started to change in the late 1960s when Frank Frazetta

Above: *In 2012 we lost a number of important members of the fantastic art family, including* Spectrum *advisor and Grand Master Leo Dillon, who passed away May 26.* **Opposite:** *Leo & Diane Dillon's cover for* The Abhorsen Trilogy *by Garth Nix.*

(who was angry that Ace Books kept his early book covers) began to insist on the return of his art as a condition of taking a job. But it really did not become a standard practice until the field was infused with a new generation of artists (led by Michael Whelan, Don Maitz, Carl Lundgren, among others) and the revision of the copyright laws in 1976/77.

In the decades since, conditions for artists have improved…and declined…and improved again, almost cyclically: for every good thing that has happened, there inevitably seems to be something less good to counterbalance it. We've watched as the culture has shifted in its methodology and preferences of delivering entertainment and content; we've witnessed changes in the way artists create, for whom, and how they reach an audience. Science fiction, fantasy, and comics art went from being easily dismissed "kid stuff" to being the basis—the life blood—of the entertainment world. The most popular films of all time are based on science fiction, fantasy, and comics; the most profitable video games are genre-based. Entire advertising campaigns and corporate identities are fantastic art-inspired and driven. A few dozen illustrators of merit have grown into a legion, skilled with all manner of traditional and digital tools.

As Cathy mentions in her Chairman's Message, *Spectrum* began as a response to what we perceived as a need to recognize excellent "fantastic art" and the people who created it. It was a simple idea, really, one that could have easily started before 1993. Ten years earlier Michael Whelan and I were chatting about a fantasy art annual while he

changed his daughter Alexis' diaper in a hotel room in Kansas during a break from Fool-Con. (Michael remembers the conversation as taking place in an airport bar—which would have been nicely arty, but, trust me, we talked over a dirty Pampers. And Alexis? Now a doctor!) But everything had to align; everything had to be just right. And, frankly, it would not have happened without Cathy. The idea—admittedly a good one—needed a kick in the seat of the pants to get it started and, fortunately, Cathy was there with very pointy shoes to provide the proper impetus.

And that's how we got...here.

I started writing the "Year in Review" (under various titles) with *Spectrum* 3 and I have been very surprised through the years both at how popular it has been and at how often it (or aspects of it) has pissed people off. Some folks got upset if I said I didn't like their book or comic or statue very much (which is understandable, I guess) or if I *didn't* say anything at all about their book (or comic or statue). But it was my mentioning what was going on in the world (with the thought that art is never created in a vacuum and that events affect the tone and content of the work created in a given year) that got some people royally ticked. A sentence about Iraq or Afghanistan or the state of the economy were viewed as some sort of political commentary despite my saying little more than "this happened." One writer was so incensed by my mention of world events that she began using her reviews of our *other* unrelated books as a way to lambast me for something I supposedly had written in *Spectrum*. I was never able to find out whether I was supposed to be a left wing socialist or a right wing fascist: I suppose a little bit of both, just to keep everyone happy (or equally dissatisfied).

For my last essay ("and a cheer went up") I'm going to eschew yammering about what went on hither and yon in '12 (for the most part), but instead give a little background on how we managed to stick around for as long as we have.

So I'll start with the beginning. We've often been asked: How is the cover chosen?

It's pretty simple really: we pick about a half dozen pieces that for one reason or another seem to stand out, use them to design comps, send them to the publisher who sends them to the distributor who presents them to the buyers of the largest accounts. The one that everybody likes best...is the cover. Tim Underwood, our publisher of long-standing and one of the most intuitive people I've ever known, has always told us "pretty sells" and he's usually been proven right. We've never been able to predict what will connect with book buyers and what won't, but I will say that *Spectrum* 5, 12, 14, 15, and 19 (with cover art in order by Donato Giancola, David Bowers, Android Jones, Michael Whelan, and Brom) were particularly popular.

Then there's a matter of jurors: How have they been chosen?

Basically, it was a matter of inviting people whose work we respected. For many that's all we knew about them (with a few exceptions) before we asked if they might be interested in taking a plane ride to Missouri. Unlike most competitions, *Spectrum* has always covered the expenses for the jurors to fly into Kansas City for the judging: Cathy and I believed that since they were giving up their time it was the least we could do. Even after technology had advanced to the point that we could have done the competition via downloads and remote judging,

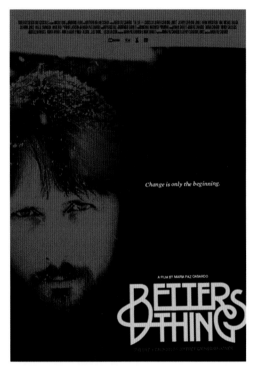

Above: *One of the posters for Maria Paz Cabardo's touching documentary about Jeffrey Jones.*

we've always believed that it was important to bring people together in one place at the same time to work toward a common goal. We've also always believed that viewing art on the computer creates a distracting barrier between the viewer—in this case, the judge—and the art. As Tor's Irene Gallo once said, "*Anything* can look good on a screen in RGB at 72dpi." Which was why we've stuck to a model of taking only print entries for the competition through the years. It is almost inevitable that will change in the future, but for us...it worked.

There were a number of people we approached to be judges that turned us down for one reason or another—and for a time after 9/11 there quite a few who were afraid to fly *anywhere*. If we had lived in New York or spent every weekend at illustration conferences or at comics or SF conventions our paths might have crossed with everyone...but for the most part we were flying blind and hoping we were putting together a group that could treat each other with respect and work together in the course of a very long day (the judging—viewing and voting on thousands of artworks—has always

been done in *one* day). For the most part, we made good choices and it turned out well. Not always, admittedly, but mostly. (Remind me sometime if our paths cross to tell the story of how one jury completely *disappeared* while we were resetting the room for the next round of voting. It's funny now, but with the clock ticking on the time remaining for our room rental we were panicked for a bit.)

Every jury came together with pure intentions and did their best to not only be conscientious and fair, but also advance the field with their choices. Over the years many judges became not only good friends, but trusted advisors.

One of the things I've heard that made me laugh is that some folks believe *Spectrum* is a type of "private club" and that only "club members" have art selected for the annual (we have a secret handshake and wear fezzes at meetings you know—which, as soon as I start to think it over, kinda sounds like a fun idea). The fact is that the voting takes place anonymously: the judges don't know who created what (unless their name is emblazoned across the art in some way and even then we would routinely go over each piece and mark out signatures or identifiers with a Sharpie before the jury saw anything, just to even the playing field). As bitter a pill as it is for some to swallow, the jury has always voted on the merits of the entry, not on who created it. Don't believe me? Ask any judge. They've often been completely surprised by the identity of an artist they not only voted for, but presented an award to.

The smallest number of entries have traditionally been submitted in the Advertising and Comics categories; the Unpublished category has unquestionably received the most entries each year (which also means the competition in that section is pretty stiff) and has the most pages devoted to it in the annual. The majority of submissions have come from individual artists, but we have had tremendous support, participation, and cooperation from Wizards of the Coast, DC Comics, Lucasfilm Ltd., and Playboy Enterprises, Inc. to name but a few. And who has received the most awards in the past two decades?

Phil Hale, with ten.

I've been told so many myths and conspiracy-theory silliness through the years about how the competition works that it's a wonder I don't drink more than I do. One Facebook poster recently insisted *Spectrum* was too expensive for students to enter and actually called me a liar when I pointed out that there were a number of students in the books each year and that several had actually won awards. The more transparent we tried to make the procedure (via our website and videos from the judging), the more wacky the stories from others became.

I've also heard that people believe *Spectrum* is some sort of big business operation. I wish. It's

always been Cathy and I addressing and mailing out Call For Entries posters, organizing the judging, putting the books together, creating advertising and promotions, and mailing copies of the annual (which we purchased) to the artists. We've always taken an altruistic attitude toward *Spectrum*: it was never about money, but about an idea we believed in.

Arlo Burnett has run the website, helped us with clerical work, and manned the booth at Comic Con. Our friend Jackie Miles has helped answer e-mail when we've been swamped. And Tim Underwood, of course, has been our stalwart publisher through thick and thin. On judging day we would hire helpers (always family and friends) to help set the hotel ballroom we had rented for the occasion and tabulate votes. It would have been easier on our old bones if we could have grown to the point of hiring some staff to help out, but there never seemed to be the opportunity. Something *always* came out of the blue to throw a monkey wrench into the works, whether it was a dockworkers strike on the West Coast that delayed getting books to the stores and the artists or the bankruptcy of the distributor (which resulted in Underwood Books receiving only a portion of the amounts they were owed for books that had already been sold) or bookchains being paid for promotions that they didn't implement (oh the stories I could tell) or, most recently, the bankruptcy of Borders Books, which went under without paying for *thousands* of copies of *Spectrum* and other Underwood titles they'd ordered. The recession that began in 2008—and which we're all still recovering from—didn't help matters.

Twenty years ago readers could find *Spectrum* in B. Dalton's, Waldenbooks, Brentano's, the above-mentioned Borders, Best Buy, Virgin Superstores, Tower Records, Suncoast, and any number of other retailers...who are either no longer in business or (in the case of Best Buy)have stopped selling books. Anyone who believes the book business is an easy road to riches should remember *Locus* founder Charles Brown's old joke: **Q:** Want to know how to make a small fortune in publishing? **A:** Start with a large one.

That still makes me smile, bless Charlie's soul.

Cathy and I always worked at our 9-to-5 jobs and put on our *Spectrum* caps in the evenings (and on the weekends). Most vacations and holidays were spent working on it or worrying about it in some way; when one book was completed it was time to start thinking about the next competition. And we did it happily: there were many evenings spent opening entries (puffs of smoke always floated out of John Palencar's mailers) and logging them in, usually with a martini at hand. It was always tremendous fun: there were discoveries to be made, new artists to be encountered, more creators for us to become fans of.

One of my regrets is that I didn't start noting the passing of artists in the "Year In Review" until *Spectrum* 6. I wish I had been smart enough to give a final acknowledgement to the people that have influenced us and enriched our lives much sooner than I did. It's a matter of showing respect. Some called the listing of artists who had died as a "necrology," which I suppose is okay, but I preferred to think of it as a memoriam. I felt good that we were able to take it a step further with the video memorials that we ran during the awards ceremonies at Spectrum Live 1 and 2.

I'm proud that *Spectrum* was the first art

Above: *The internationally renowned dance troupe Quixotic Fusion performed at the* Spectrum *20 awards ceremony at SFAL 2.*

annual to have categories for Comics and Concept Art; I feel both good and a little disappointed that it's still the only annual with a distinct category for Dimensional art (I wish others would follow suit). I am thrilled that *Spectrum* recognized Frank Frazetta, James Bama, John Berkey, the Dillons, Syd Mead, and Kinuko Craft as Grand Masters before others conferred the same honors on them (everybody will catch up in recognizing Don Punchatz, Mike Kaluta, Moebius, H.R. Giger, and the rest of the GM's sooner or later).

I've also been proud of some of the things that we've been a part of simply because it seemed right. We became executive producers of *Better Things: The Live & Choices of Jeffrey Catherine Jone*s, a documentary directed by Maria Paz Cabardo (premiered at the convention we helped put together and which is currently available for download at www. alivemindcinema.com/betterthings/)—a wonderful film about one of the true masters and, yes, tragic figures of modern fantastic art.

Spectrum has sponsored a number of student scholarships through the years (to the Columbus School of Art & Design and to multiple kids via the Society of Illustrators Student Scholarship Program) as well as arranged for museum shows

in New York. In 2012 we sponsored a student to Rebecca Guay's Illustration Master Class (a week-long intensive summer art seminar at Amherst University) and arranged for an exhibit of Greg Manchess' paintings at the Museum of American Illustration (scheduled for Fall, 2013). And, of course, we joined with Baby Tattoo and the Lazarus Group to host a convention in Kansas City: Spectrum Fantastic Art Live. To give credit where it's due, it was all Bob Self's idea—obviously, we thought it was a good one—and we could not have pulled it off without the tireless efforts of our committee: Arlo Burnett, Amanda Butler, Jim Fallone, John Fleskes, Bunny Muchmore, Lazarus Potter, and Shena Wolf. As the largest and, really, only fantastic art convention in the U.S. that welcomed *all* creators without artificial restrictions, it was so successful that we did it again in 2013 to mark *Spectrum*'s 20th anniversary.

I sat having coffee recently with one of the summer college interns the company I'm an art director for—Andrews McMeel—brings in each year for publishing experience and college credit (yes, they get paid; we've always been way ahead of any Supreme Court rulings). And it struck me that this youngster was, in the words of Myrna Loy in *The Thin Man*, "a gleam in [her] father's eye" when *Spectrum* was born. (Her father is eighteen years younger than I am.) It sort of makes you think about things, you know?

When *Spectrum* began twenty years ago, virtually everything that was entered had been created with traditional media (paint, pencil, collage, clay) and was delivered to us for reproduction in the book in the form of a transparency, print, or slide. Now there is a large percentage of digital art that is both entered in the competition and which is selected by the jury for inclusion in the annual. Literally everything is delivered to us (regardless of how it's created) via our FTP site. We've never cared about what was used to create art, only about the results. Not everyone, unfortunately, has felt the same way; instead of accepting digital art as simply a new method for expressing ideas some collectors (supported by a few traditional illustrators who felt threatened by the increasing numbers of tech-savvy competitors) began to actively diminish the skills and value of CG creators for no other reason than there wasn't an "original" to be purchased or coveted. More than once we received letters or e-mails suggesting that we divide *Spectrum* into two volumes, one devoted to traditional mediums with the second for the "other (i.e. digital) stuff"—to make shopping easier, one writer blatantly admitted. Some of those disappointed collectors had looked at *Spectrum* in the early years as a catalog and were alarmed at the growing number of artists that were doing their best work with a Wacom and not a sable brush.

We ignored that line of thinking. The whole

argument of "pixels vs. paint" (as friend and art dealer Jane Frank once described it) is, to be blunt, silly. An artificial issue fomented by those motivated by preference, prejudice, and, when all is said and done, greed.

Many genre art collectors have based their acquisitions on the literary connection a work has (as a cover or story illustration), just as a number of comic art collectors are interested in the characters rather than the artist (or the true quality of the work). As the publishing industry—like all entertainment businesses— "went digital," increasingly fewer hand-drawn or painted pieces have been created and available for purchase. Which meant there were "fewer" popular works to be traded or resold, usually at a wonderful mark up, on the secondary market. Some collectors looked at the $1.5 million that was paid for Frazetta's revised painting for the *Conan the Buccaneer* paperback and thought their dreams of similar scores were being dashed by Photoshop practitioners. I once pointed out that there were *thousands* of traditional artworks already in existence for collectors to pursue—and even more being produced by young artists wanting to make a splash—more than *anyone* could ever hope to get their hands on much less afford. It all fell on deaf ears.

Of course, serving as a collector's wish book had never been the purpose of *Spectrum*: all that we wanted to do was chronicle the best of what had been created in a given year, regardless of how it was done. That's the model that we've followed from day one until now.

We're collectors of all manner of original art ourselves, but we fully agree with Android Jones when he said, "2D art is nothing more than pigment that an artist applies to a surface. Whether one uses oils or an ink jet printer is irrelevant. The craft is there, the vision is there, and the value is determined by the price an artist wants to ask and what a patron agrees to pay."

Technology will always continue to evolve; new tools and new methods are introduced every year. I think this volume of *Spectrum* marks another first for us: look at Andrew Baker's "Demon Girl" on page 142. A dimensional piece digitally sculpted on the computer and out-put on a 3D Printer. It is simply another—what? approach? preference?—not one that replaces or invalidates clay or sculpey, but which suggests new opportunities (just as it raises questions).

Times change. Materials and methodology change. But it is also true that no technique, no procedure, no art form, *ever* disappears. *Nothing* is ever abandoned: every addition merely expands our "art vocabulary" without replacing any form that already exists. It is the *intellect* that both creates and responds to art: the tool employed doesn't matter at all.

Our view for the last twenty years has been consistent: art is art. *Period.* Anyone who says otherwise, anyone who tries to create some

sort of hierarchy or class system based upon the methodology an artist uses (which, sadly, has been going on in public forums and behind the scenes), anyone who attempts to diminish what any creator does with the intent of advancing their own narrow agenda...

Is an enemy of art and *all* artists everywhere, not a friend.

Creatives, whether they're introverted and insecure or alpha-dog egotists, have always suffered from the anxiety of "place." Will their work be taken seriously? Will they be respected by the public *and* their peers, by the artists *they* respect? Will they be *remembered*? It is so easy for an artist to be hurt, so incredibly easy

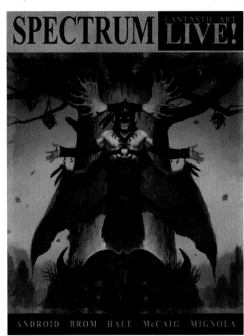

Above: *Flesk Publications produced this beautiful commemmorative book for the first Spectrum Fantastic Art Live in 2012.*

for them to be made to doubt their choices and abilities, to doubt themselves. Tom Leher could probably have written a song about the wholly manufactured and entirely specious pecking order in the art world that far too many have swallowed hook, line, and sinker: comic artists are lower on the totem pole than gag cartoonists who in turn are lower than newspaper strip artists who are a step below editorial cartoonists who are a tad lower than illustrators (who have all sorts of contradictory levels amongst themselves) who are beneath the gallery painters and sculptors (even if the majority of gallery artists are much less financially secure and not as widely known as their "lower caste" sisters and brethren).

Spectrum (happily, if inadvertently) became something of a melting pot over the decades. Illustrations for books and pages from comics appeared beside works by sculptors and painters. However a participant wanted to classify themselves—illustrator, fine artist, lowbrow creator, or outsider; realist, narrative artist, surrealist, or "imaginative realist" (Jim Gurney should demand a fee from the opportunists

who recently misappropriated the title of his excellent book without asking); professional, student, or hobbyist—didn't matter to us. If the jury said it fit in *Spectrum*...it fit. We never had a desire to define fantastic art; I think early on we realized that it was an impossible task. People are always coming up with something new, something mysterious, which is precisely the way it should be for *any* vibrant art form. Once everything can be neatly explained it becomes... predictable. Safe. Boring.

Fantastic art should *never* be boring.

And no one should ever be ashamed of having a love of—or connection to—genre.

I know that a number of things have had a negative impact on artists since the turn of the century. The recession and the painfully slow recovery, of course, dried up a lot of accounts and made those that remained stingy with their budgets. Companies laid off creative staff and embraced a new model of doing more with less (and reaped the profits for stockholders). The rapid growth of e-books (at the expense of their ink-on-paper equivalents) and the disappearance of multiple bookstore chains, as I noted earlier, forced publishers to rethink their plans (which usually resulted in flat or reduced fees for cover artists). Film and game studios were able to commission creative work from emerging studios in Asia and India at rates that were lower than they'd have to pay in the U.S. or Europe (so, naturally, the bean counters were all over the prospect of outsourcing to improve the bottom line)—which in turn forced domestic companies to underbid jobs in an attempt to keep their heads above water (it didn't work for Rhythm & Hues—the SFX studio that had brought *Life of Pi* to life—which filed for Chapter 11 shortly before winning the Oscar® for Best Visual Effects). Anger became misdirected, with xenophobic reactions aimed at overseas artists rather than at the companies who were putting the bank accounts of a stockholders and executives above the livelihoods of the many. Less work and stagnant fees means more struggle for artists; more struggle almost always translates into unhappiness and discontent.

The internet—that insidious, seductive devil—continues to nurture a culture that not only wants instant gratification, but wants it for *free*. Even as the public clamors for visual stimulation there is a simultaneous and subconscious devaluation of the work itself. Images flood the internet and social media sites (many loaded and shared illegally by enthusiastic "fans" who never asked for permission from the copyright holders), making what was once special...common. And if something is "common"...where is the incentive to pay for it to help support the artist who created it?

The internet is the double-edged sword of the culture, doing good when swung in one direction and causing destruction on the back

swing. Twitter and Facebook have had all sorts of positive effects, but also is the tool of choice to express discontent, disaffection, and, for some, to engage in manipulative meanness. Though I've just mentioned the culpability of corporations in making things "not nice" for artists, they have also unfairly been on the receiving end from literally armies of malcontents with no knowledge of facts, history, or contract law—who nevertheless are positively cheerful to launch attacks on businesses and schools (attacks that tended to go viral as friends shared the poison with friends). Too many times the attacks are launched for the originator's amusement and without a moment's thought for the *people* working for those "faceless entities" who get caught in the crossfire and are forced to contend with the mess created for "fun." Civil discourse has been replaced by rants and rambling nonsensical manifestos, without consideration for the toxic residue left behind: none of that mattered when compared to the adrenaline rush of instant gratification the internet and social media grants, augmented by subsequent validation from sycophants.

It is that "I don't care" attitude which has hurt...*everyone*. It is also the strident call to retreat into like-minded hives—at the expense of the *community*—and to attack others that is ultimately destructive. I hate to use Glenn Beck or Rush Limbaugh as examples, but the shoe fits: the outlook of "fuck everyone who doesn't think the same way I do" began to creep into the illustration and fantastic art community about six years ago and has only gotten more virulent with time. As Spencer Tracy said in *Inherit the Wind*, "... fanaticism and ignorance is forever busy, and needs feeding." Feed it has.

I've mentioned that in recent years people have complained via multiple platforms about the *tool* an artist uses to create their work (pixels vs. paint, if you'll recall). We've read complaints about *styles* of art that have grown in popularity. We've seen people complaining because some artists are simply *better* at their craft than others, that some are able to communicate their ideas more effectively and as such get more attention than some of their compatriots.

An entrant to one of the competitions told us flatly, "You need to kick all those *old guys* out of *Spectrum* and make room for us young guys that *need* the exposure." The "old guys" cited were all younger than I was—and *all* were regularly producing art that was infinitely more compelling than the person pitching a fit.

We've received complaints about the quantity of "dark art"—i.e. horror—that has appeared in the annual (remember, the judges can only cast votes for the art that's entered). We've received complaints from people unhappy (and *shame* on them) about the presence of creators from overseas in the annual. And yes, we've received complaints from people who are mad

that the jury didn't select their art for inclusion in the book (I've lost track of the times we've been called "cheats" of one sort or another). There have been people who were angry that *more* of their entries weren't accepted and others that were angry because they didn't like the work that *did* receive a majority of votes as much as another that *didn't*. We've had people who were ticked off because *this* piece of art was given a full page while *that* piece of art got "only" a quarter or half page. Even though the book has grown to more than double the size it was when we started, we're limited in just how many pages we can have and maintain a price that readers are willing to pay. If we could afford

Above: *Grand Master Jean "Moebius" Giraud.*

to give every piece accepted for the annual a full page, we would. Fold-outs, too. But publishing always is a matter of compromises based on overhead. We've always done the best we could and tried to be fair while also trying to highlight exemplary works. And, yes, there have been complaints about *that*, too.

I was once talking to Diane Dillon about how perplexed we were at some of the complaints we had received and wondered what we could do better. Diane said simply and directly, "No matter *what* you do, *somebody* will always be mad. Take satisfaction in doing your best and don't worry about trying to make everyone happy. You can't." It was great advice.

I mention this fussing not to take anyone to task but merely to provide some background and perhaps help everyone understand that *Spectrum* has *always* faced challenges: it's never been a concept that has been universally embraced. It's not something everyone has always understood. Not everyone "gets it." And that's always been okay. Not everyone thinks the same way; not everyone likes or believes in or supports the same things. And that's also *precisely* the reason we have always been so appreciative of all of the artists, art directors, companies, and readers who *have* supported *Spectrum* for the past two decades.

But I have to admit that the disaffection I've seen in recent years worries me. I see the cynicism—when combined with a false sense of entitlement, disrespect, impatience, and dissatisfaction—as dangerous to our community and makes artists the easy prey of those seeking to profit from their unhappiness. I worry that the unwary will fall for the "them vs. us" rhetoric of those who try to promote themselves

or their ideas or their businesses by deliberately attacking the accomplishments of those they wish to sublimate. I worry about the reticence of good people to speak up (partly out of fear of getting lambasted on-line); I worry that cupidity allows—to paraphrase Tim Underwood—the bad to drive out the good. All of these elements conspire to splinter our community into warring camps: traditional artists to the south, digital artists to the north, sculptors to the west, and everybody else to...Siberia!

The creatives are not the ones who will profit from division. Trust me.

We *have* to stick together; we have to support each other. The artists, the designers, the art directors, the clients, the companies all *need* each other. And if we'll work together, if we can ignore the nay-sayers and profiteers and shun the smarmy dividers...we can *all* grow.

What gives me solace, what makes me optimistic and gives me hope for the future, regardless of challenges or circumstances, is... *Spectrum*.

There is strength in our diversity, not weakness. And when all of our disparate voices come together to advance a common purpose, we have a chorus, not a raucous cacophony.

I don't say that wrapped in a flag of delusion or pretension. I say it because I believe (to be painfully repetitive) in our *community*. I believe in the artists. I believe in the fans. I believe in the patrons. I believe in the businesses that are fueled by the creatives. Yes, certainly, there will *always* be barriers and hurdles to contend with. But we can overcome any obstacle and continue to grow and succeed *if* we continue to have a place that welcomes us all with open arms.

With John Fleskes as director—truly one of the sharpest people I've ever met (and I've met a *lot*)—*Spectrum* has the potential to be...any number of things for *every* creator willing to join in. As Cathy concluded: the best is yet to come.

Yes indeed.

Jean "Moebius" Giraud [1938-2012]
by Dan Dos Santos

If you asked me what my favorite movie is, I would likely have to give you a "top three."

If you asked me who my favorite musician is, I would again have to give you a "top three."

But if you asked me who my favorite artist is, I would say without a moment's hesitation that it is Jean "Moebius" Giraud.

I heard about Jean's death the day after it happened, and the whole experience honestly took me by surprise. Obviously, I considered writing a blog post about it immediately, but then decided otherwise. I just wasn't in the mood to simply 'report' his death solely for the sake of promptness. It seemed inadequate. His work means so much more to me than that.

I confess, I've always thought it was kind of lame when I'd see teenagers sobbing over the

death of some musician. I just didn't understand how they could be so upset about the death of someone they didn't even know. Yet, here I found myself, in the middle of some mundane conversation, unusually upset at the loss of a man. A man with whom my only worldly connection are the books on my shelf.

Now don't get me wrong, I wasn't some blubbering mess crying in my cereal bowl or anything like that. But hearing the news was enough to keep me awake that night, with a rotten pang in my stomach. Perhaps it is because I admired his work so much. Or maybe it is because we share the same job, and the same passions, and with that similarity, one can't help

my patience would be rewarded, usually every year or two, with a new book, and the promise of more things to come.

But that's done.

There is no more to come.

Every Moebius drawing that will ever exist, has been drawn.

As boundless, and prolific, as his imagination was... Moebius' body of work in now finite. You can go back, and look at every illustration he ever produced. It's there. It's done. It's not going anywhere, and there won't be any more of it. It is now a quantifiable thing, which can be seen as a whole.

No more potential... just achievements.

who professed their admiration. "They said that I changed their life," Giraud was quoted as saying at the time with more than a little amazement. "'You changed my life.' 'Your work is why I became an artist.' Oh, it makes me happy. But you know at the same time I have an internal broom to clean it all up. It can be dangerous to believe it. Someone wrote, 'Moebius is a legendary artist.' I put a frame around me. A legend — now I am like a unicorn."

Jean Moebius Giraud: Legend. Yes, despite Jean's skepticism, the title actually fits. May he rest in peace.

REQUIEM

In 2012 we also sadly note the passing of these valued members of our community:
Ken Alexander [b. 1924] Cartoonist
Jan Berenstain [b. 1923] Cartoonist
Pierre-Alain Bertoca [b. 1956] Artist
Ernie Chan [b. 1940] Comic Artist
Randy W. Clark [b. 1963] Artist
Sid Couchey [b. 1919] Artist
Arthur E. Cumings [b. 1922] Artist
Tony DeZuniga [b. 1932] Comic Artist
Leo Dillon [b. 1933] Grand Master Artist
Michael Embden [b. 1948] Artist
Arnoldo Franchioni [b. 1928] Cartoonist
Jean Giraud [b. 1938] Grand Master Artist
David Grove [b. 1940] Artist
Harry Harrison [b. 1925] Writer/Comic Artist
Scott Hensen [b. 1960] Cartoonist
Alan Hunter [b. 1923] Artist
Noboru Ishioka [b. 1938] Animation Artist
Eiko Ishioka [b. 1939] Costume Designer
Thomas Kinkade [b. 1958] Artist
Joe Kubert [b. 1926] Educator/Comic Artist
Bruno Le Floc'h [b. 1957] Artist
John B. Lindstrom [b. 1935] Artist
Pat Mallet [b. 1941] Cartoonist
Robby McMurtry [b. 1950] Artist
Ralph McQuarrie [b. 1929] Grand Master Artist
Josh Medors [b. 1976] Comic Artist
Sheldon Moldoff [b.1920] Comic Artist
Eileen Moran [b. 1952] Visual Effects Producer
Keiji Nakazawa [b. 1939] Manga Artist
Leroy Nieman [b. 1921] Artist
Eddy Paape [b. 1920] Comic Artist
Carlo Rambaldi [b. 1925] SFX Artist
Al Rio [b. 1962] Comic Artist
Manuel "Spain" Rodriguez [b. 1940] Artist
Al Ross [b. 1911] Cartoonist
T. Samuvai [b. 1925] Cartoonist
Maurice Sendak [b. 1928] Artist
John P. Severin [b. 1921] Comic Artist
Marcus Swayze [b. 1913] Comic Artist
Gene Szafran [b. 1941] Artist
Sergio Toppi [b. 1932] Artist
Jim Unger [b. 1937] Cartoonist
Bill White [b. 1961] Artist
Mike White [b. ?] Comic Artist
Bert Witte [b. 1943] Cartoonist
Lebbus Woods [b. 1940] Architect/Artist •

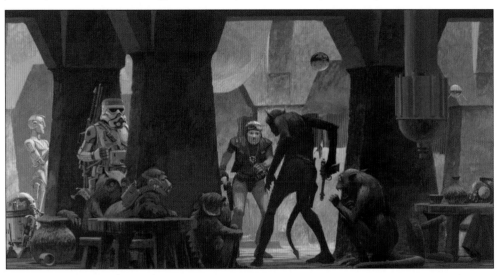

Above: *Early concept art for* Star Wars *by Grand Master Ralph McQuarrie.* ™ & © Lucasfilm Ltd.™

but to compare their own self to the departed.

Whatever it is, his death has left me a little bit empty.

As I've mentioned many times in various places through the years, I am a bit of an art-book junkie, and Moebius is a particular weakness of mine. There is a even a dedicated section on my shelf just for his work. The first book I ever bought of his was 'Fusion'. After pouring through the book repeatedly, and falling absolutely in love with his work, I proceeded to spend the next few years digging up every old, out-of-print Moebius book that I could find. Whenever I got a new Moebius book, I would open it the way a Diabetic would open a Twinkie; with a wolf-like fervor that can only be sated by sweaty, panicked over-indulgenced, and lots of heavy breathing.

After a while, about 20 or 30 books into it, I felt like I had most of the ones I really wanted. Well, the ones I could afford anyway. After that, all I needed to do was 'keep up', so to speak. When a new book of his work would come out, I would buy it immediately. It didn't matter if it was in French, or if it was written by someone else, or if it was shrink-wrapped and I couldn't even see inside of it. All that mattered, was that inside that book, pressed between the two covers, would be some gem of a drawing that I knew would inspire me. And as time passed on,

That startles me.

Now, I'm willing to bet the reason this bothers me so much is because inside of me is some deep-rooted, existential anxiety, fighting the notion of my own mortality. But... I'm going to choose to ignore that. Instead, I'm going to say that this whole thing upsets me so much, because I love Moebius.

I mean, I seriously love Moebius.

For me, Moebius' work is in a class by itself, and merits very few comparisons...or contenders.

When I look at his art, I sometimes imagine him actually drawing it. I follow his strokes, as they flow across the page, as if each one brings the white of the paper that much closer to fulfilling some unspoken potential. With just a few black lines, he manages to create an amazing sense of depth, a menagerie of characters, and a backstory a hundred years long. To me, Moebius' work epitomizes what good art/ design is all about... Simplicity. Someone once said that "good design is achieved only when you've removed everything from the picture that you can remove." I think Moebius' work in general is a great example of this notion

In November, 2011 Jean made a rare visit to the U.S. to speak at the Creative Talent Network Animation Expo and again and again he was approached by fans and younger professionals

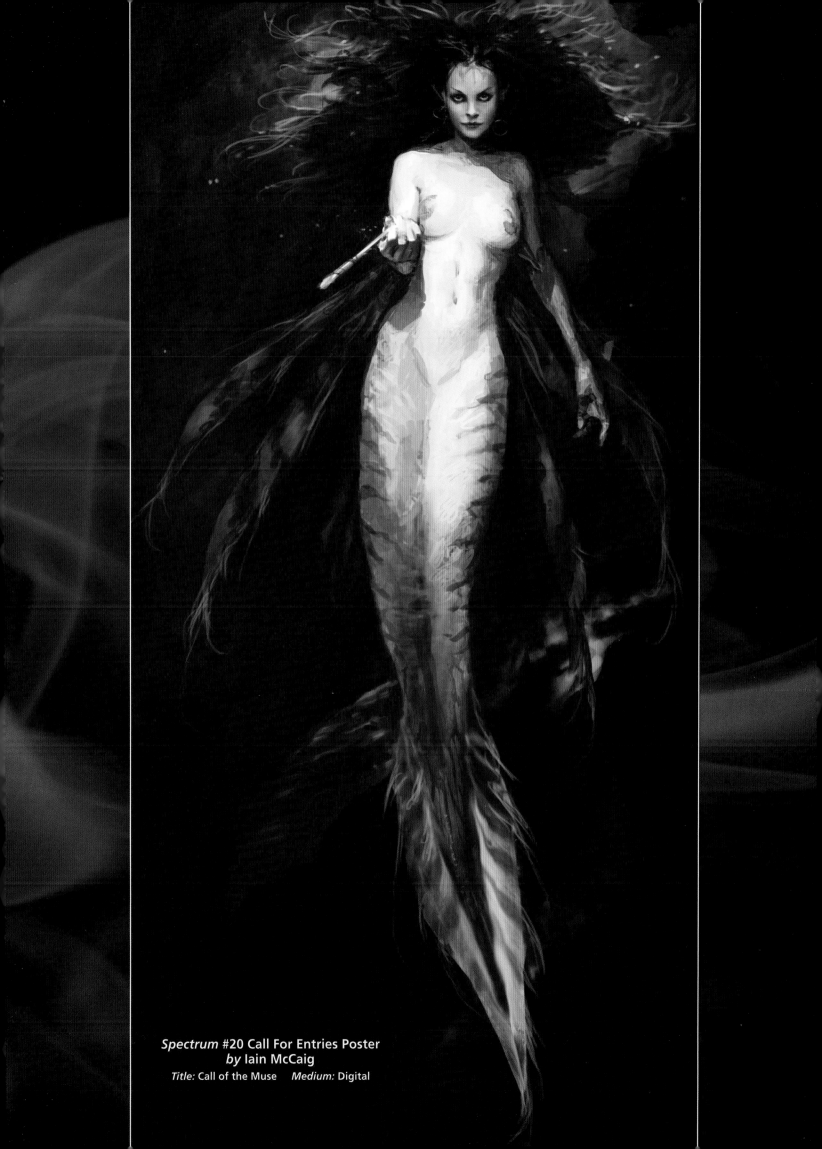

Spectrum #20 Call For Entries Poster
by Iain McCaig
Title: Call of the Muse *Medium:* Digital

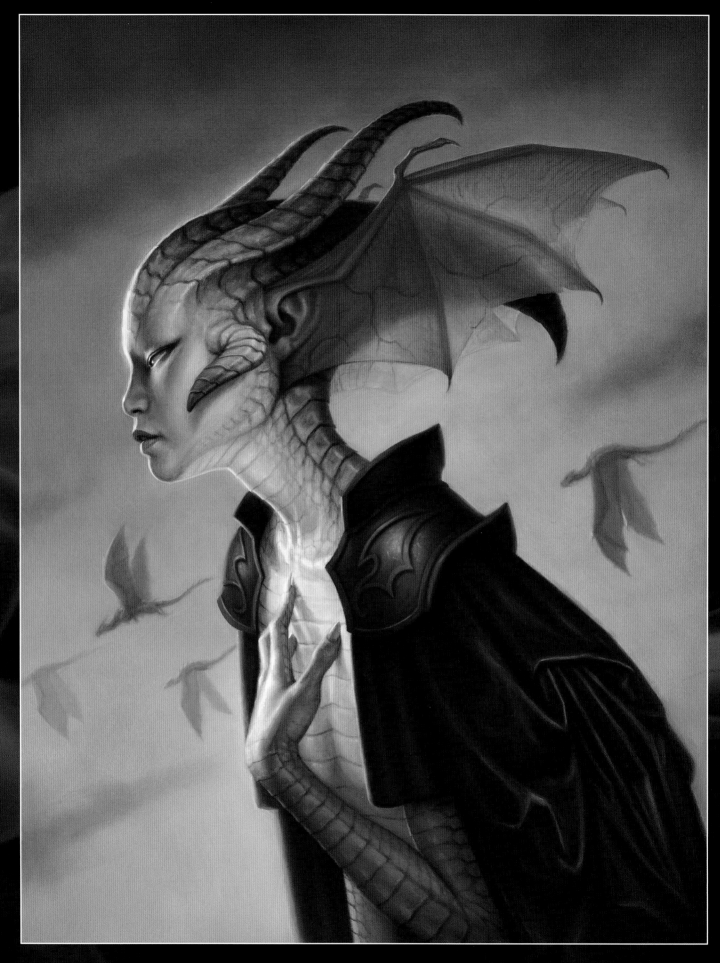

Dan Dos Santos
Client: Dragon Con *Title:* Dragon Empress *Medium:* Oil

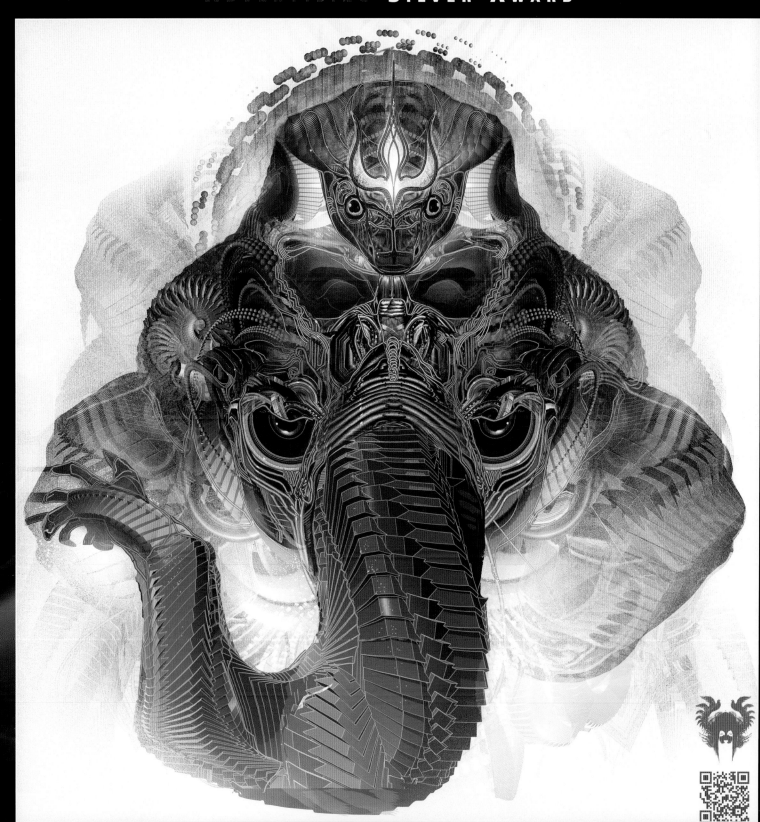

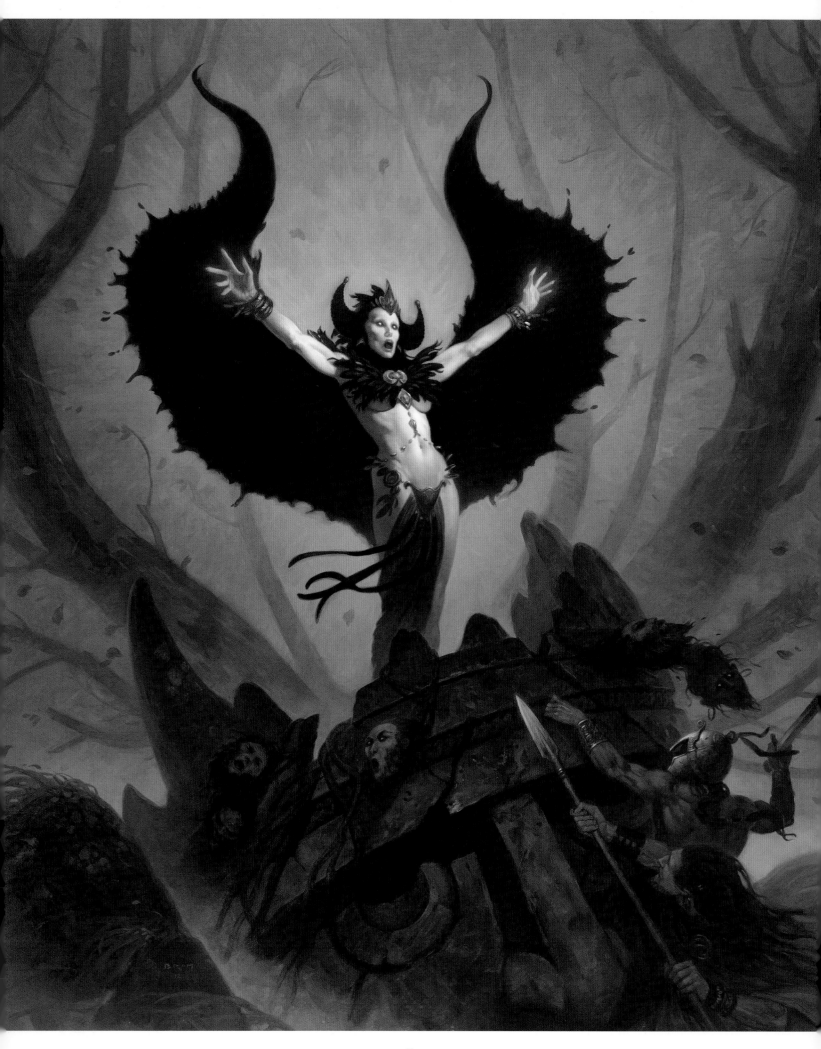

Brom
Title: Witchwood *Medium:* Oil

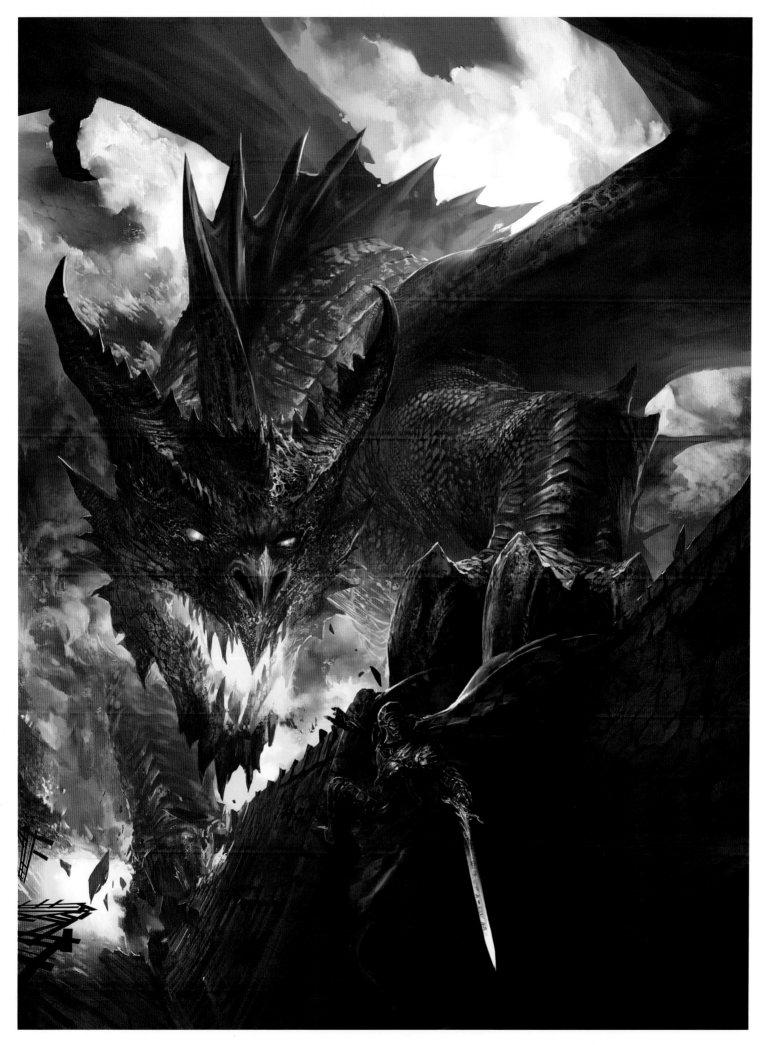

Kekai Kotaki

Art Director: Jon Schindehette & Melissa Rapier *Client:* Wizards of the Coast *Title:* Dungeons & Dragons *Size:* 20"x30" *Medium:* Digital

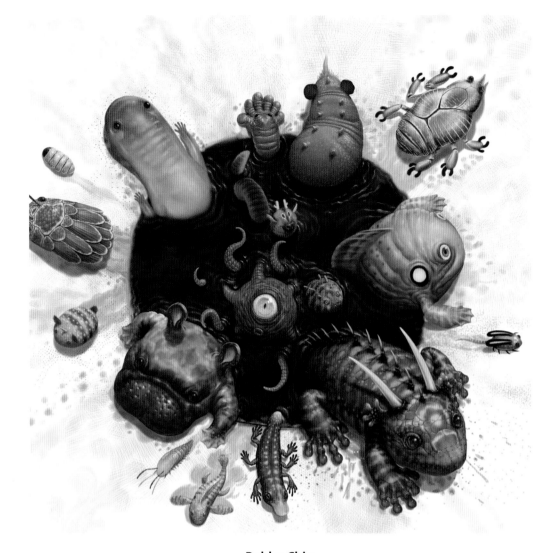

Bobby Chiu
Art Director: Anne Edwards *Client:* Autodesk Sketchbook Pro *Title:* Invasion *Size:* 12"x12" *Medium:* Digital

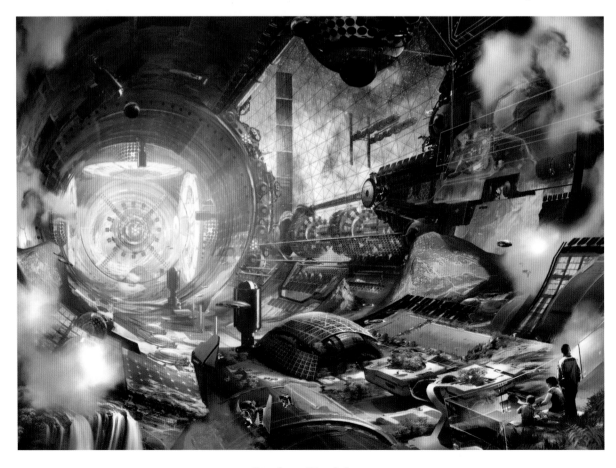

Stephan Martiniere
Art Director: Charles Floyd *Client:* National Geographic *Title:* Mayflower *Medium:* Digital

Chris B. Murray

Art Director: Jon Gibson *Client:* iam8bit/Sony *Title:* Buds: Clank & I *Size:* 14"x21" *Medium:* Pen & ink with digital color

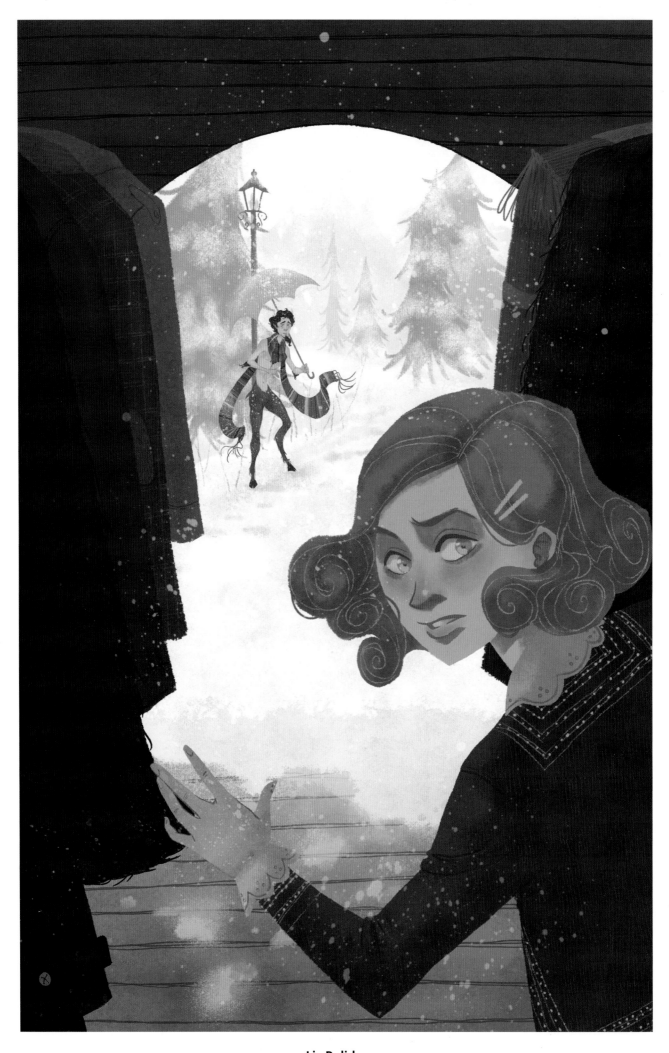

Liz Pulido
Client: Zion Theater Company *Title:* The Lion, The Witch, and the Wardrobe *Size:* 22"x34"

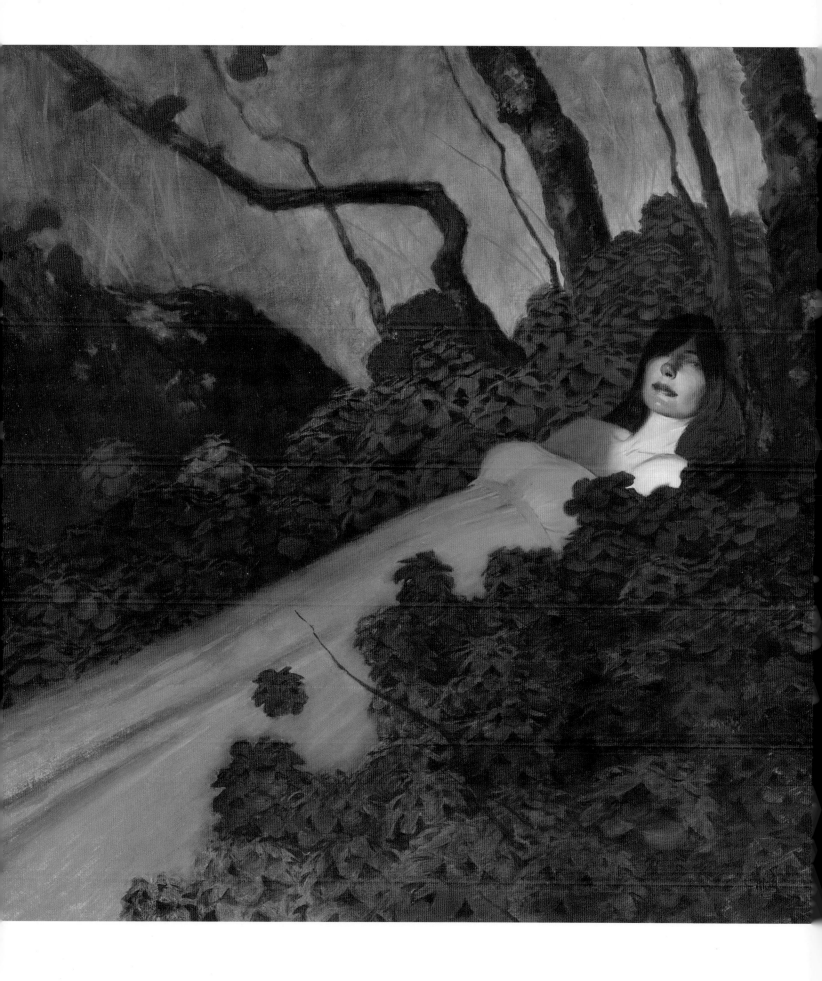

Craig Elliott

Client: Arcadia Fine Art *Title:* Forest Awakening *Size:* 48"x48" *Medium:* Oil

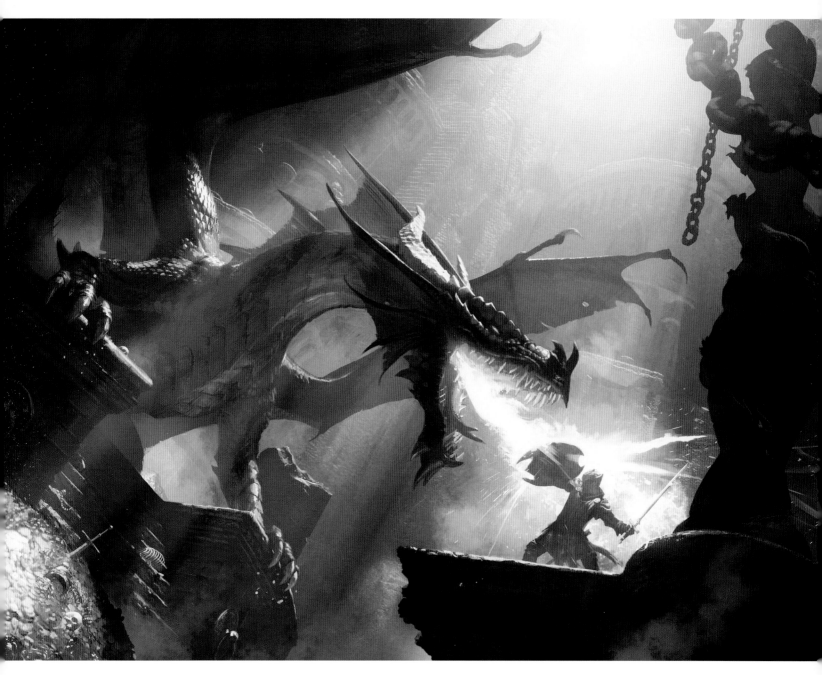

Michael Komarck
Art director: Daniel Gelon *Client:* Wizards of the Coast *Title:* Dungeon! board game packaging *Size:* 16"x11" *Medium:* Digital

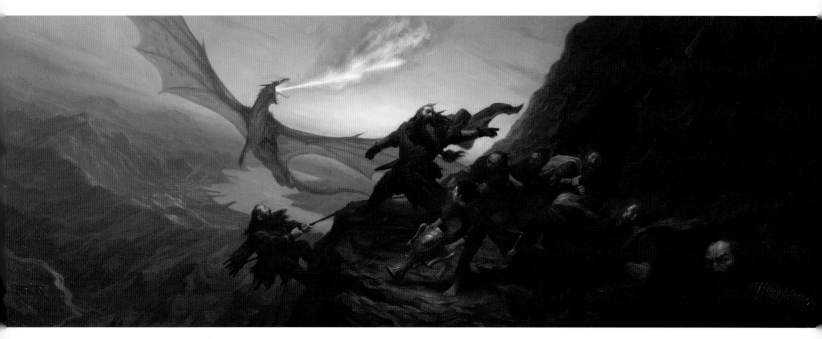

Chris Rahn
Art Director: Zoë Robinson *Client:* Fantasy Flight Games *Title:* The Hobbit: On the Doorstep *Size:* 36"x14" *Medium:* Oil

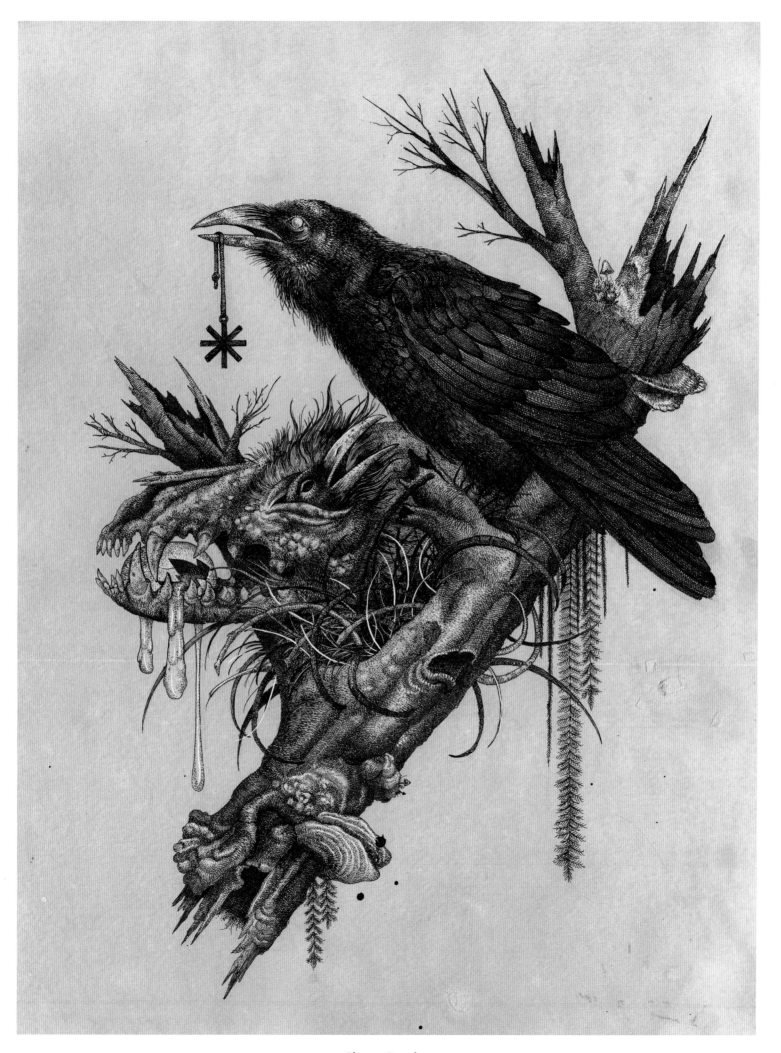

Shaun Beadry

Art Director: Laura Pleasants *Designer:* Casey McKinley *Client:* Kylesa *Title:* Ravens with Wolf Skull *Size:* 10"x13" *Medium:* Pen & ink with coffee stains

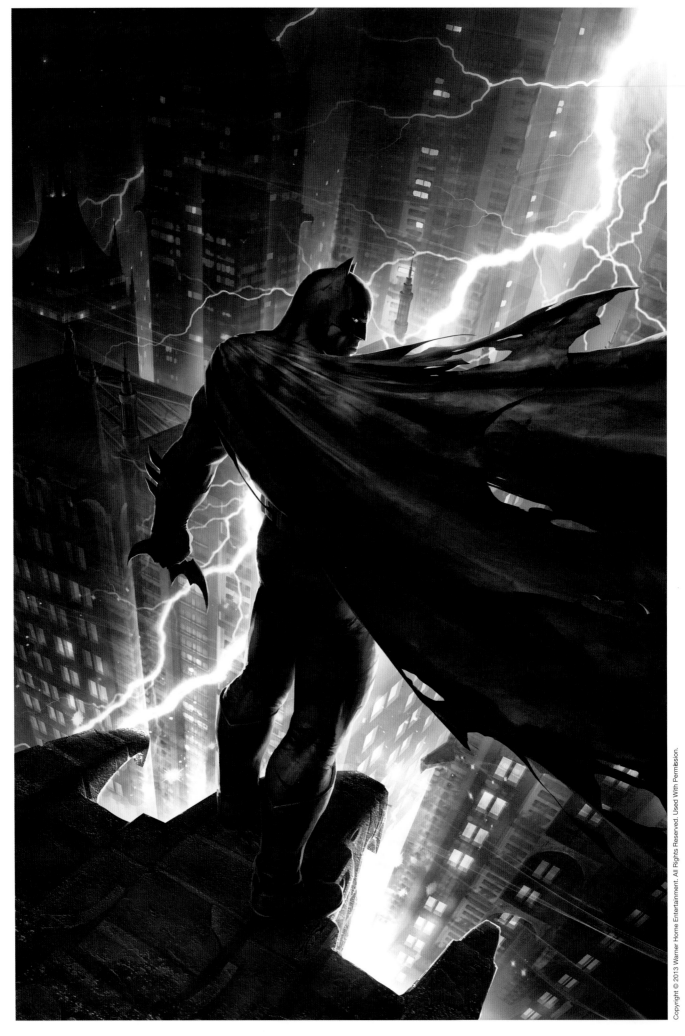

Raymond Swanland

Art Director: Janice Walker *Client:* DC Entertainment/Warner Home Entertainment *Title:* Batman: The Dark Knight Returns Part 1 *Medium:* Digital

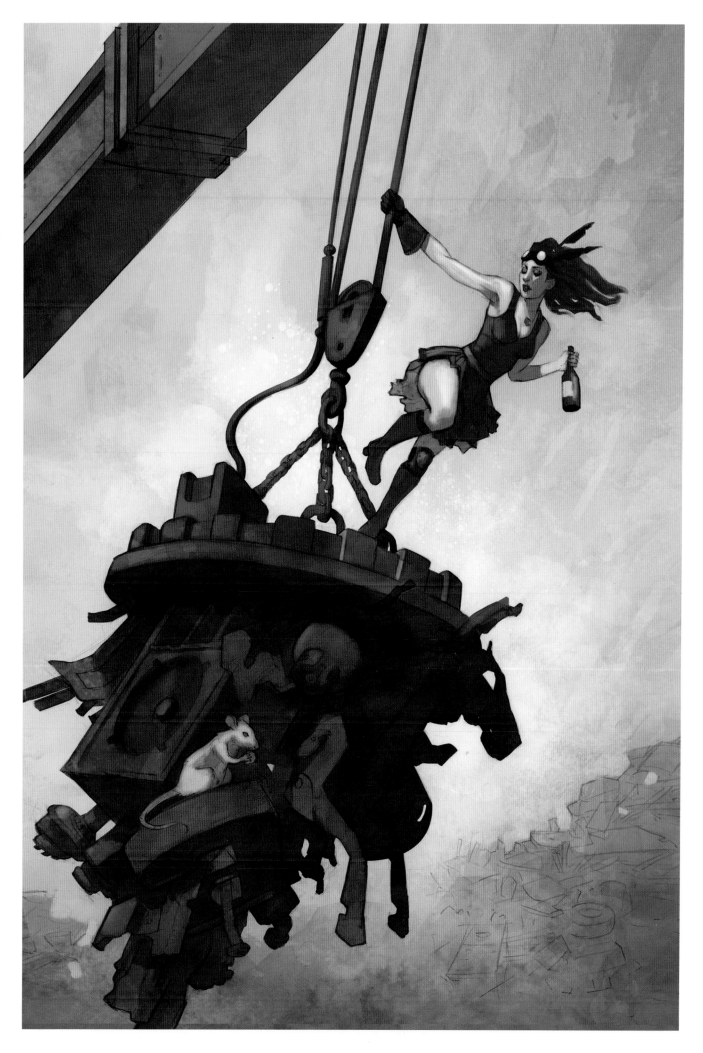

Kurt Huggins & Zelda Devon
Client: Acavallo *Title:* Trash Ball *Medium:* Digital

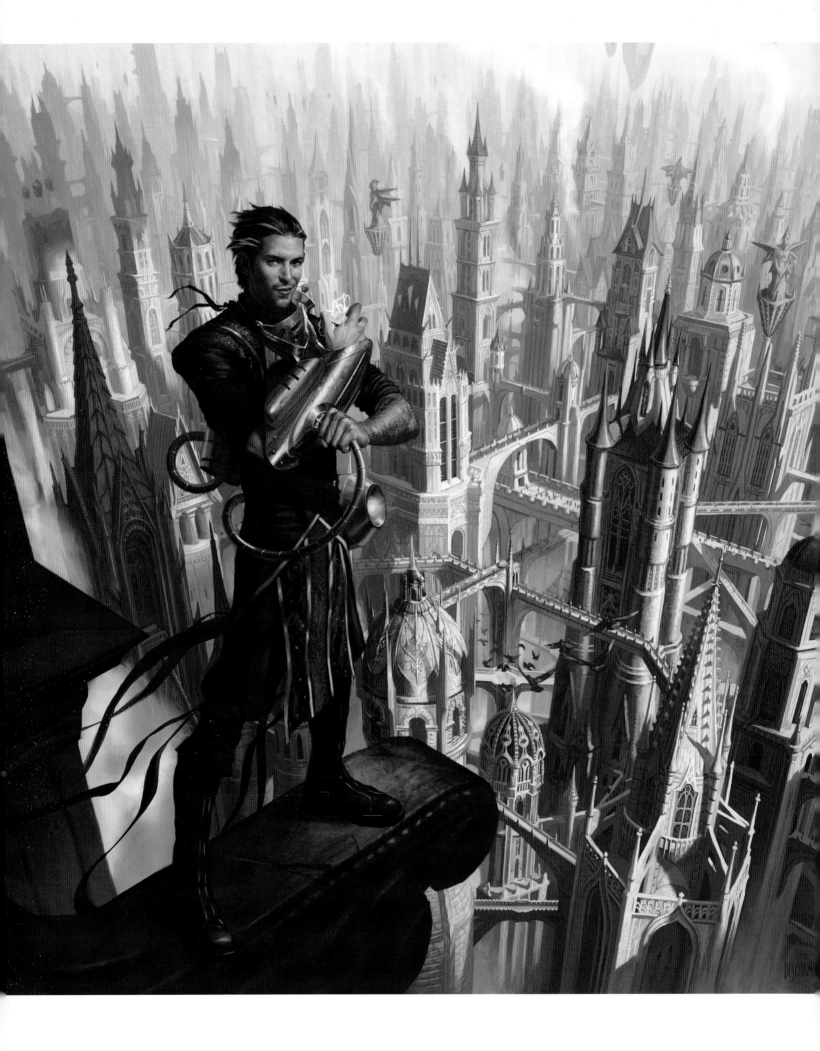

Eric Deschamps

Art Director: Jeremy Jarvis *Client:* Wizards of the Coast *Title:* Ral Zarek, Dragon's Maze *Size:* 16"x17" *Medium:* Digital

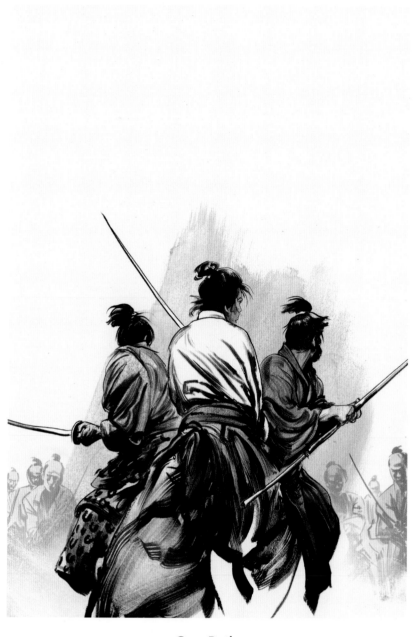

Greg Ruth

Art Director: Eric Skillman *Client:* Criterion Collection *Title:* Three Outlaw Samurai
Size: 12"x20" *Medium:* Sumi ink

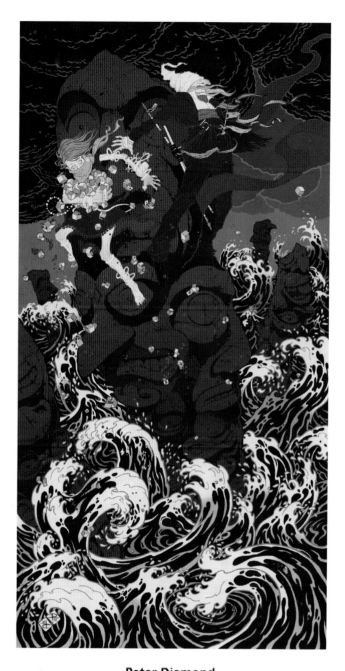

Peter Diamond

Client: Burden *Title:* Aeons *Size:* 15"x30" *Medium:* Ink & digital

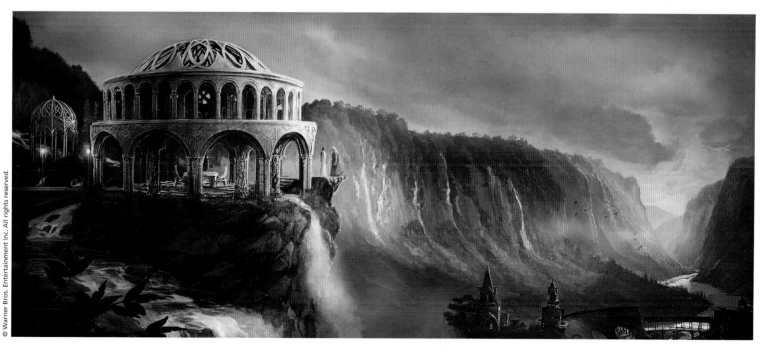

Paul Tobin

Art Director: Richard Taylor *Client:* Weta Limited/Warner Brothers *Title:* Rivendell *Size:* 53cm x 22.05cm *Medium:* Digital

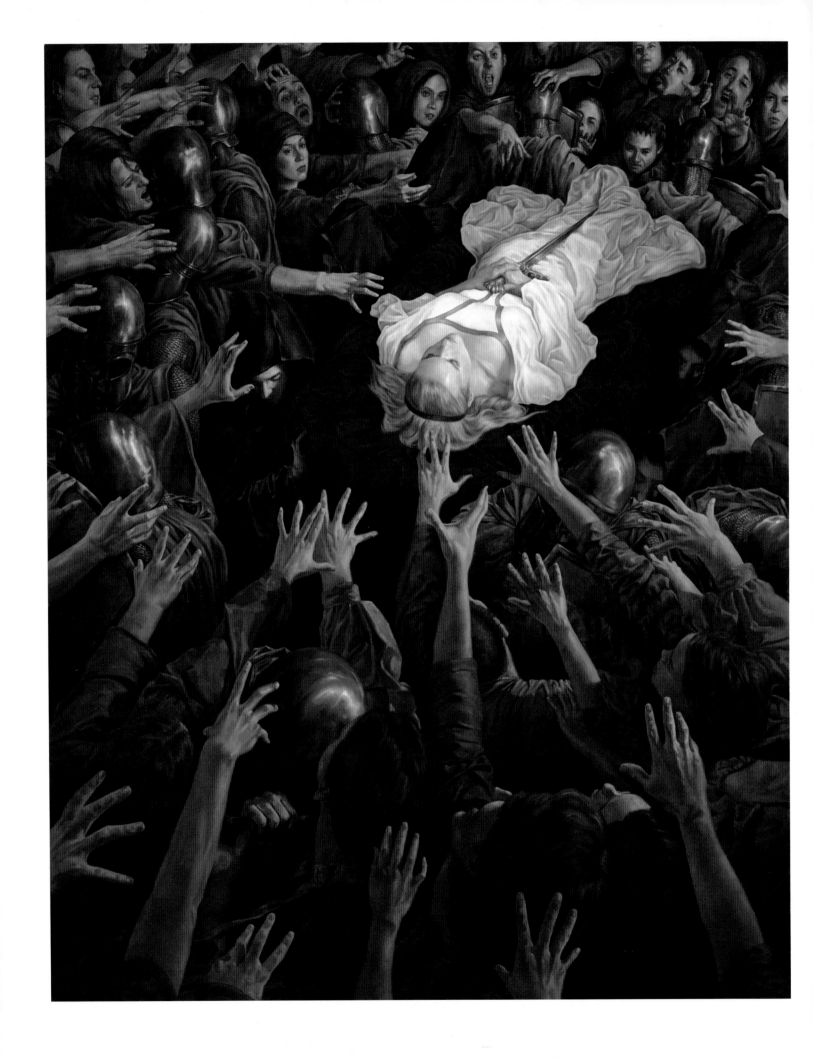

Michael C. Hayes

Art Director: Patrick & Jeannie Wilshire *Client:* Illuxcon *Title:* Procession *Size:* 32"x40" *Medium:* Oil

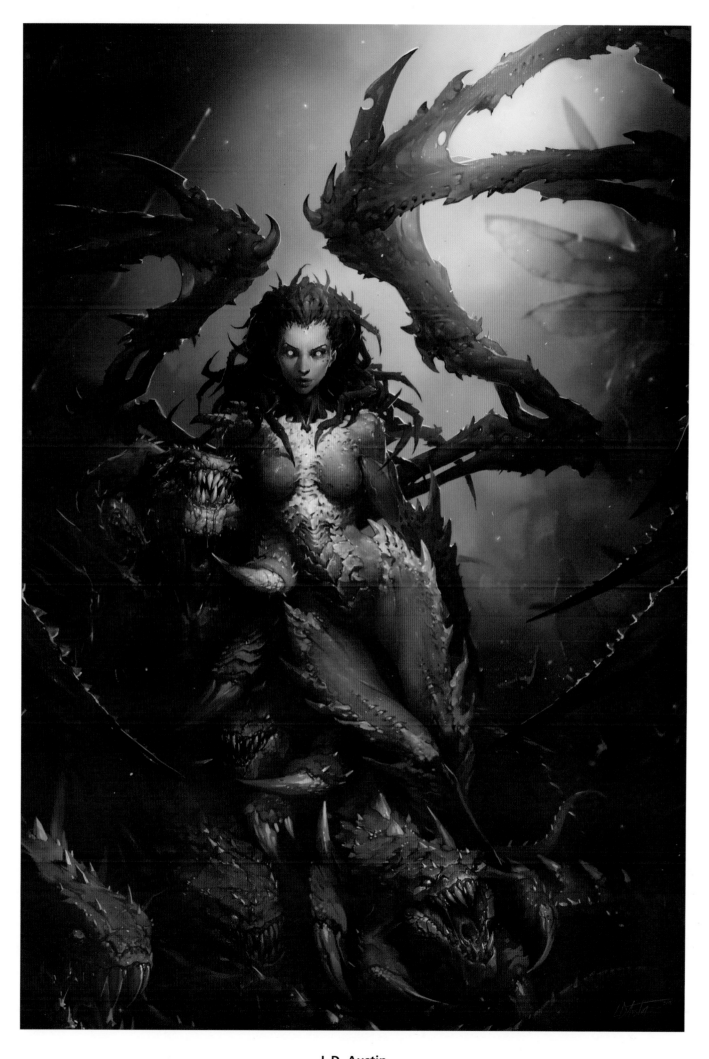

L.D. Austin

Art Director: Samwise Didier *Client:* Blizzard Entertainment *Title:* Kerrigan, Queen of Blades *Size:* 8.5"x11" *Medium:* Mixed

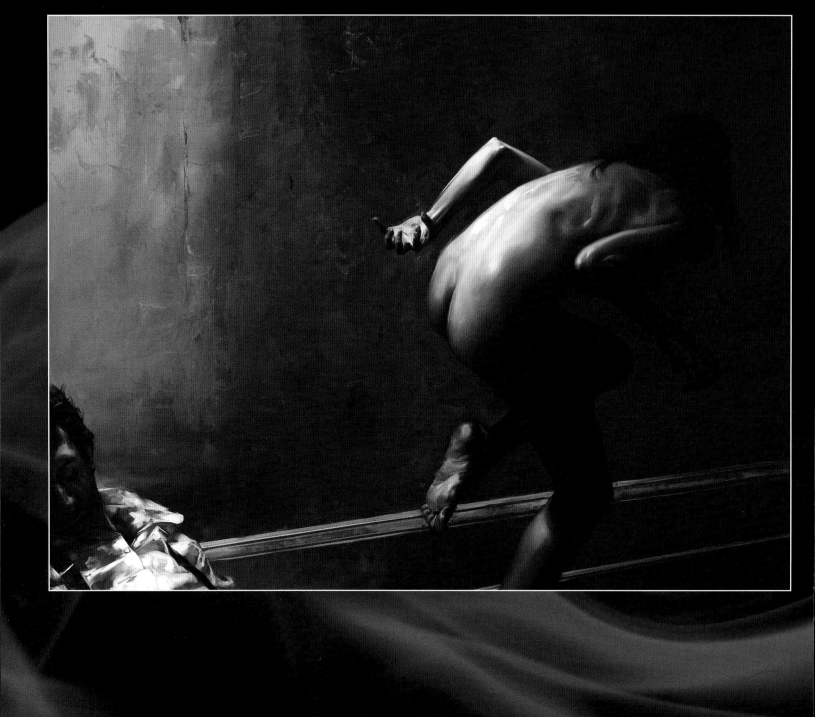

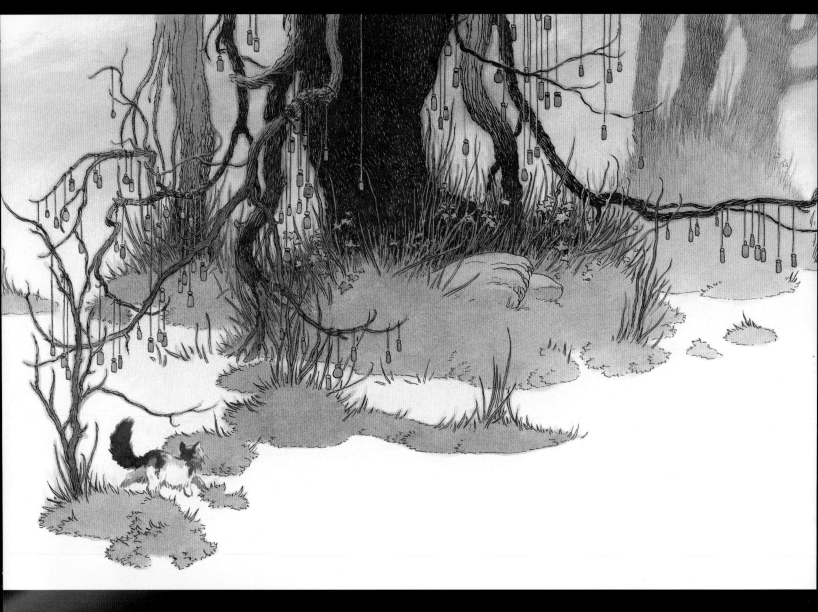

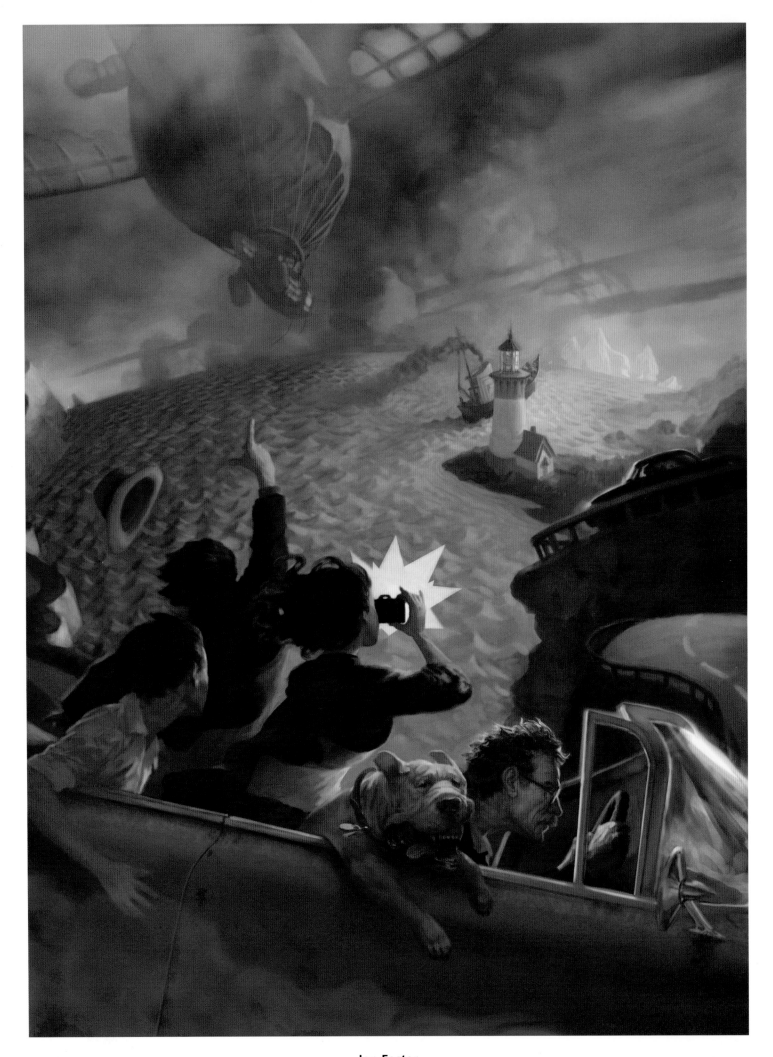

Jon Foster
Art director: Bill Schafer *Client:* Subterranean Press *Title:* Zeuglodon *Medium:* Digital

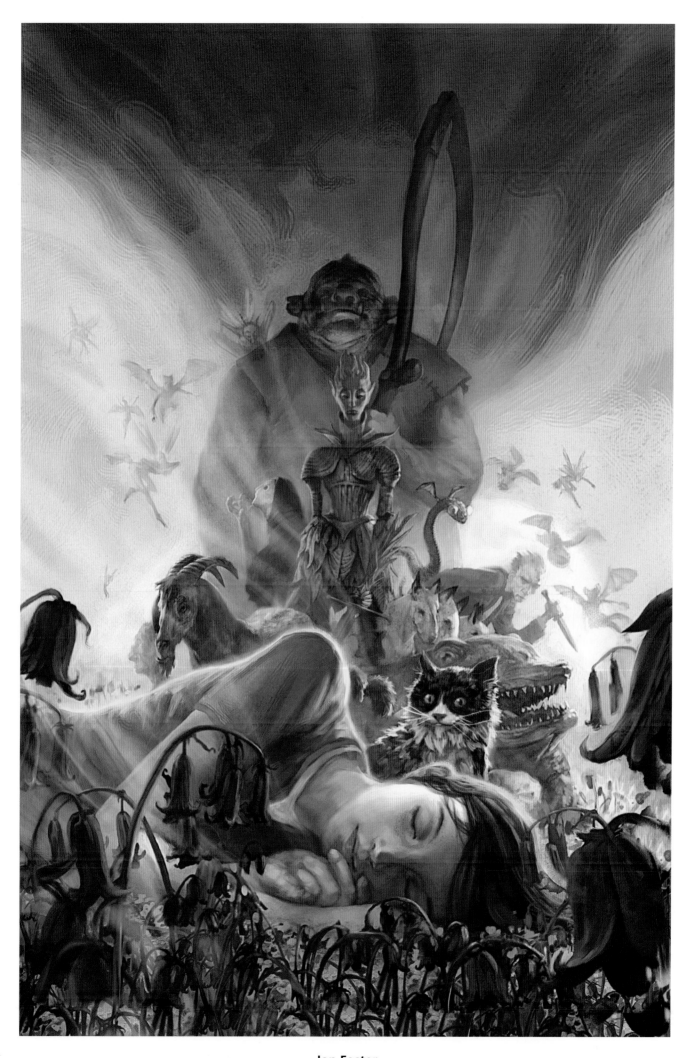

Jon Foster

Art Director: Patrick Collins *Client:* Henry Holt Books *Title:* Guardian of Green Hill *Medium:* Digital

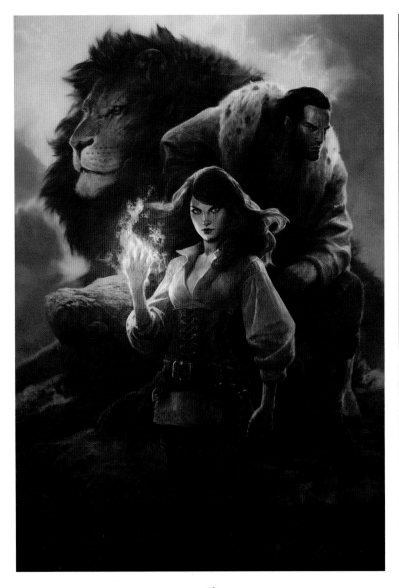

Jason Chan
Art Director: Lesley Worrell *Client:* Penguin Group *Title:* Harbinger
Size: 12"x17.5" *Medium:* Digital

Wayne Reynolds
Art Director: Sarah Robinson *Client:* Paizo Publishing *Title:* Clockwork Reliquary
Size: 10"x11" *Medium:* Acrylic

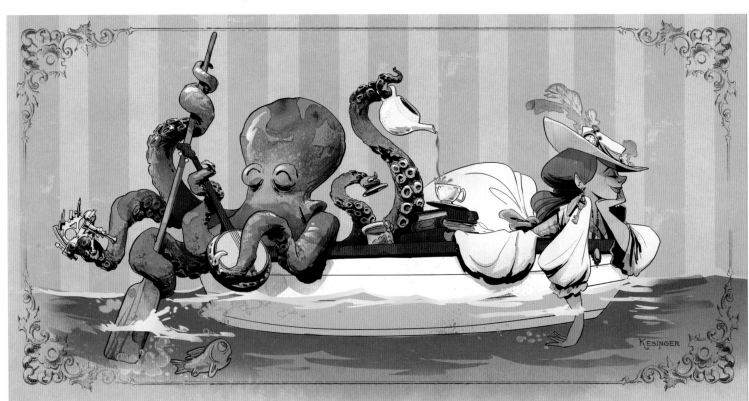

Brian Kesinger
Art Director: Brian Kesinger *Client:* Baby Tattoo Books *Title:* Boating with Otto *Size:* 19"x9.5" *Medium:* Digital

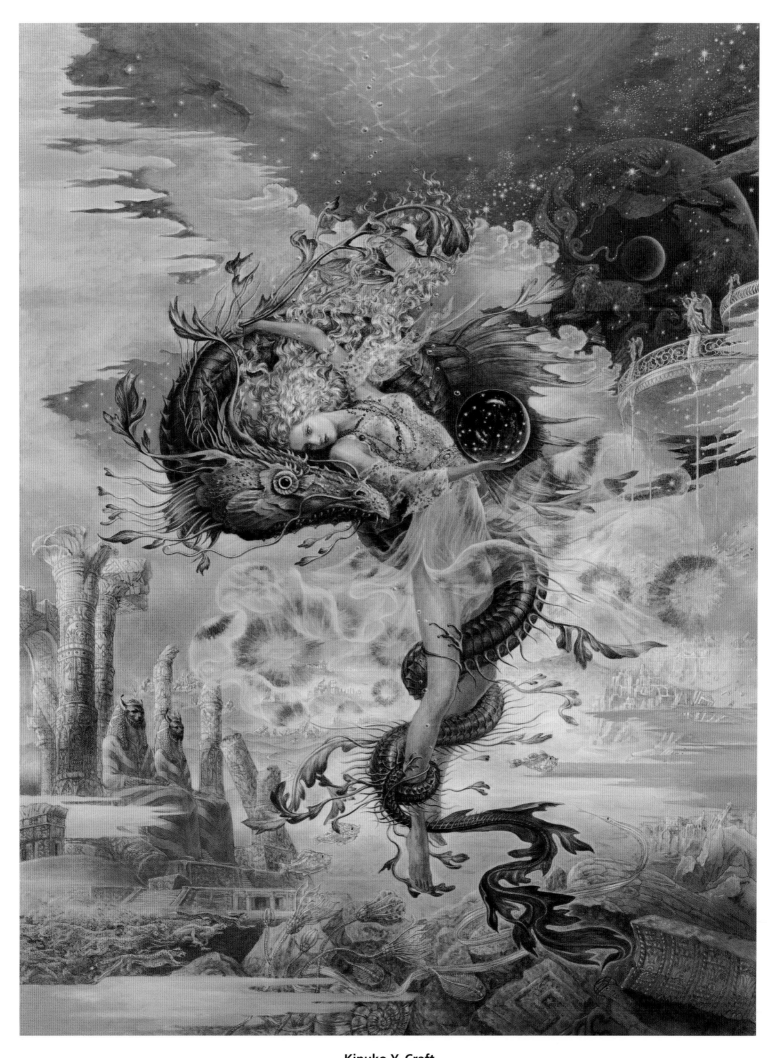

Kinuko Y. Craft
Art Director: Irene Gallo *Client:* Tor Books *Title:* The Grail of the Summer Stars *Size:* 18"x24" *Medium:* Oil

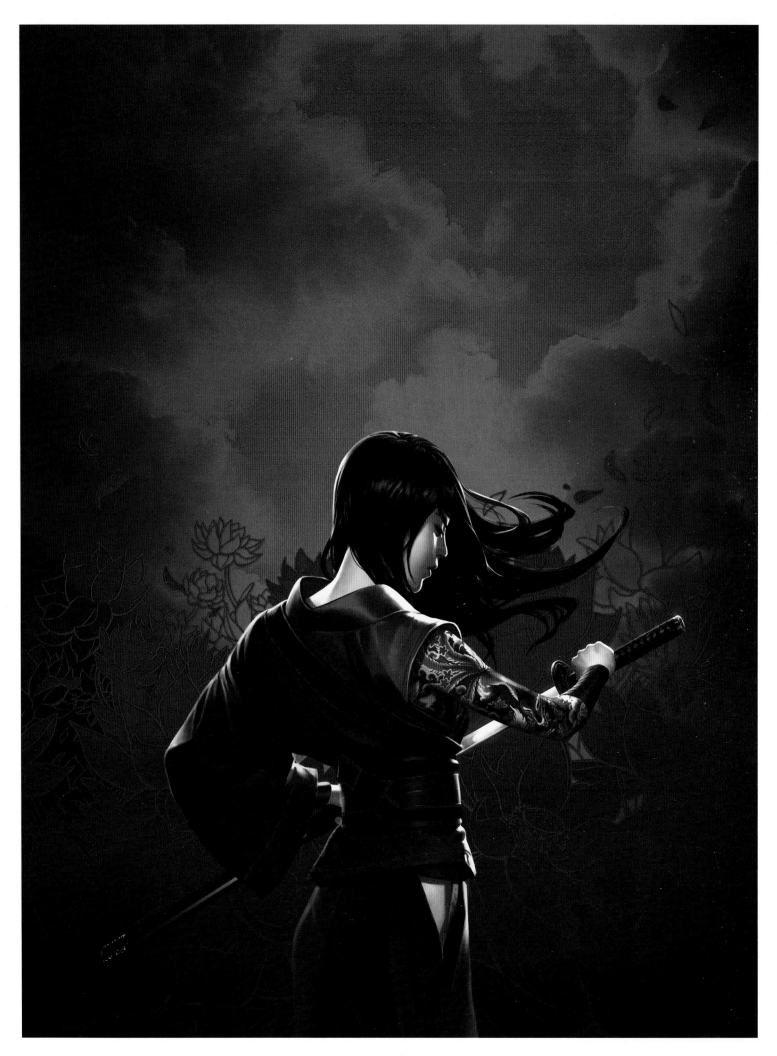

Jason Chan
Art Director: Young Lim *Client:* St. Martin's Press *Title:* Storm Dancer *Size:* 11"x15" *Medium:* Digital

Brom
Title: Wipi *Medium:* Oil

A.M. Sartor
Client: Athena *Title:* Murder of Crows *Size:* 5"x8" *Medium:* Digital

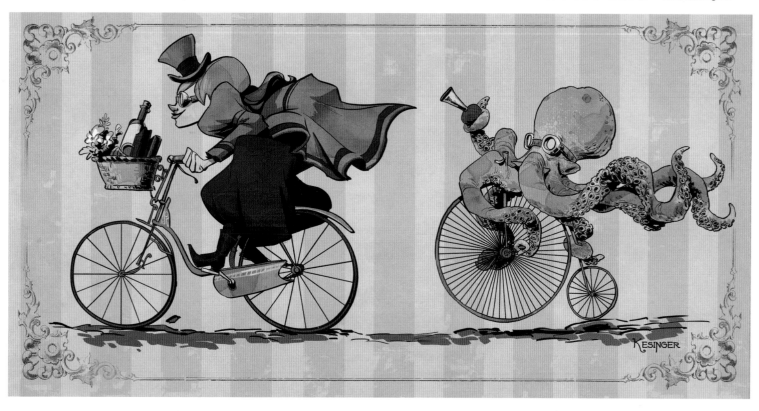

Brian Kesinger
Art Director: Brian Kesinger *Client:* Baby Tattoo Books *Title:* Cycling with Otto *Size:* 19"x9.5" *Medium:* Digital

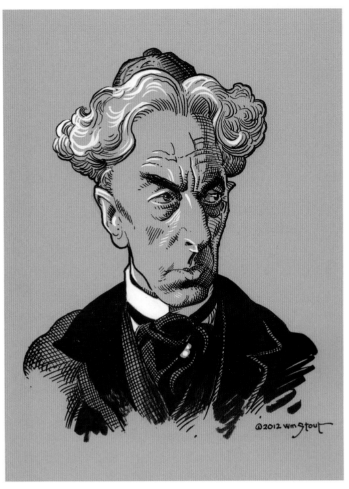

William Stout
Client: Terra Nova Press *Title:* Dr. Pretorius *Size:* 8.5"x11"
Medium: Ink & gouache on paper

Chris Ayers
Client: Design Studio Press *Title:* The Daily Zoo Goes to Paris—Day 2080: *Le Penseur*
Size: 18"24" *Medium:* Colored pencil & watercolor

Gris Grimly
Client: Baby Tattoo Books *Title:* Wicked Nursery Rhymes III *Size:* 8.5"x7" *Medium:* Ink & watercolor

Gris Grimly
Client: Baby Tattoo Books *Title:* Crooked Man's Daughter *Size:* 7"x7" *Medium:* Ink & watercolor

Pascal Blanche
Client: Derelict Planet_CFSL *Title:* Danu *Medium:* Digital

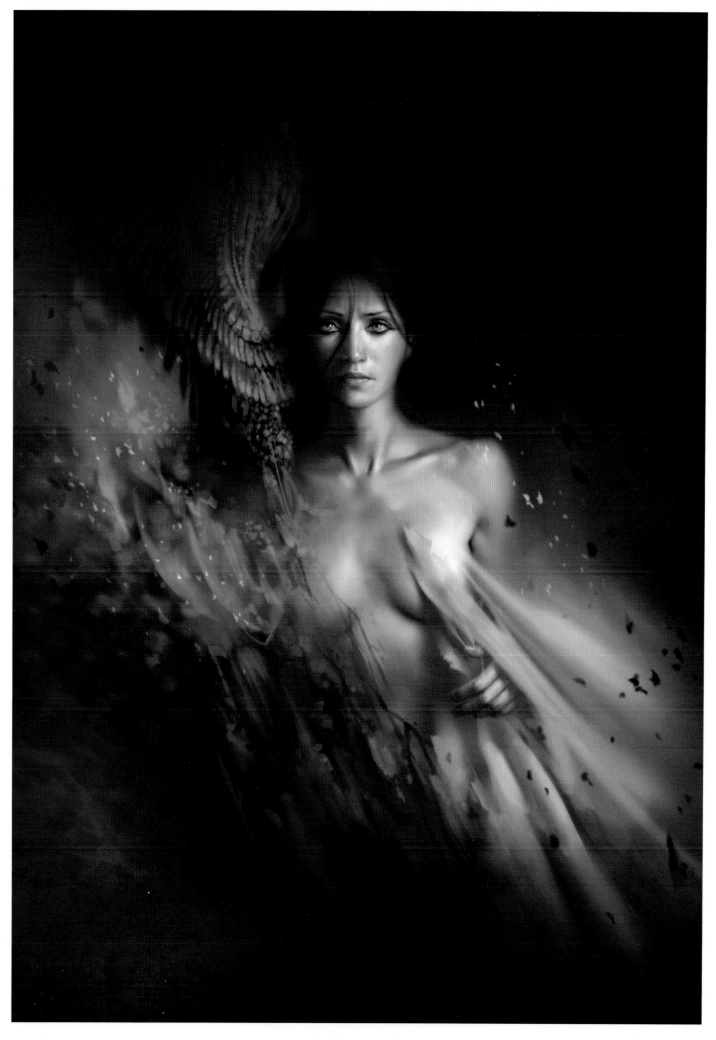

Paolo Barbieri

Client: Arnoldo Mondadori Editorial *Title:* Cleopatra (from *L'inferno di Dante Illustrato da Paolo Barbieri*) *Size:* 34cmx48cm *Medium:* Digital

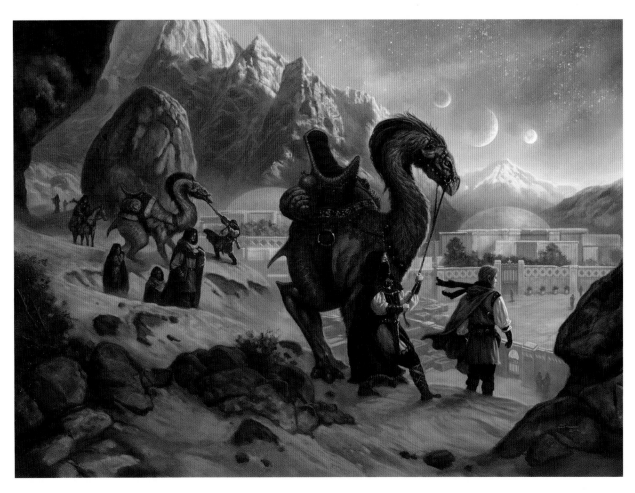

Matt Stawicki
Art Director: Betsy Wollheim *Client:* DAW Books *Title:* Children of Kings *Medium:* Digital

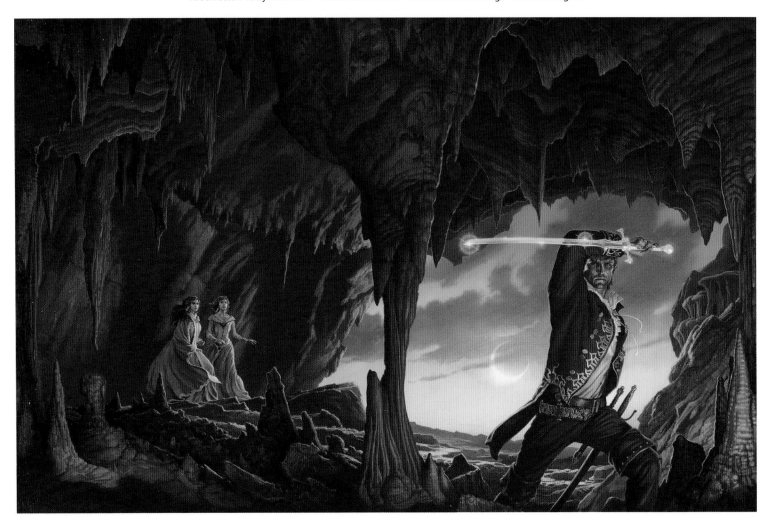

Michael R. Whelan
Art Director: Irene Gallo *Client:* Tor Books *Title:* The Memory of Light *Size:* 36"x27" *Medium:* Acrylic on panel

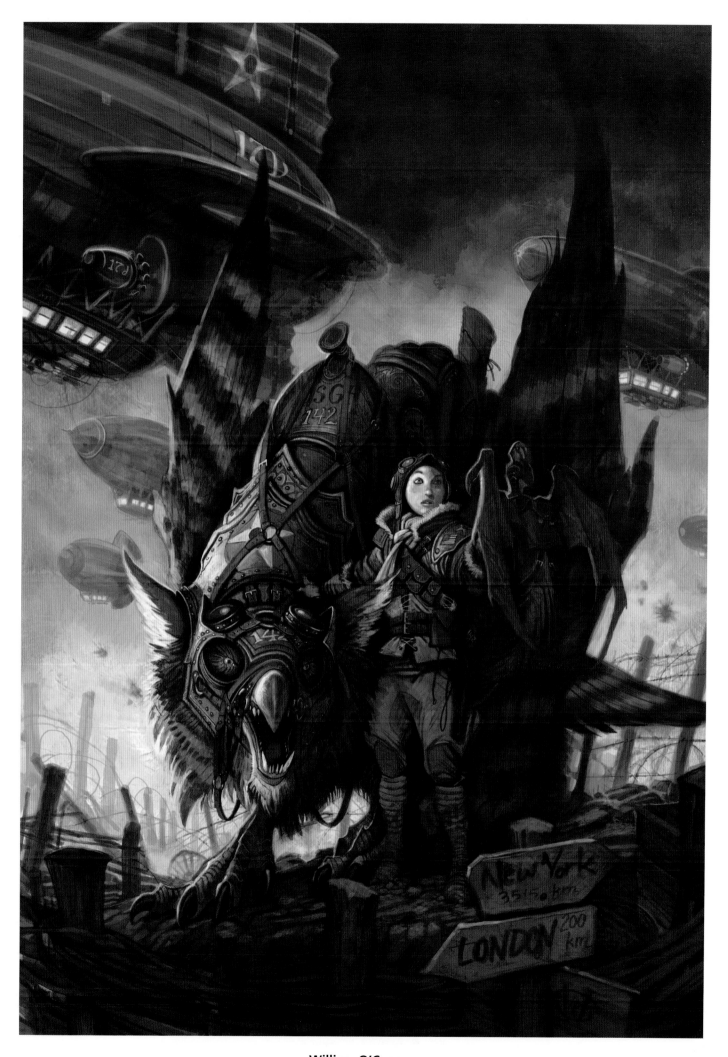

William O'Connor
Designer: Wendy Dunning *Client:* Impact Books *Title:* Wargriffin *Size:* 12"x16" *Medium:* Digital

John Picacio

Art Director: Lou Anders *Client:* Pyr *Title:* The Creative Fire (*AKA* Girl with Microphone—You Say You Want a Revolution) *Size:* 17"x22" *Medium:* Pencil/oil/digital

Dave Seeley
Art Director: Patrick Kang *Client:* Penguin Publishing *Title:* The Burn Zone *Size:* 24"x36" *Medium:* Oil over digital

Stefan Kopinski

Art Director: Rob Lane *Client:* Mierce Miniatures *Title:* Darklands *Size:* 43cmx30cm *Medium:* Digital

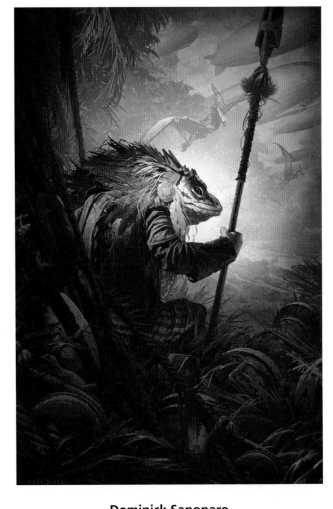

David Seidman

*Client:*Permuted Press *Title:* Lords of Night *Medium:* Digital

Dominick Saponaro

Art Director: Matthew Kalamidas *Client:* The Science Fiction Book Club
Title: Destroyermen: Rising Storm *Size:* 13"x20" *Medium:* Mixed/digital

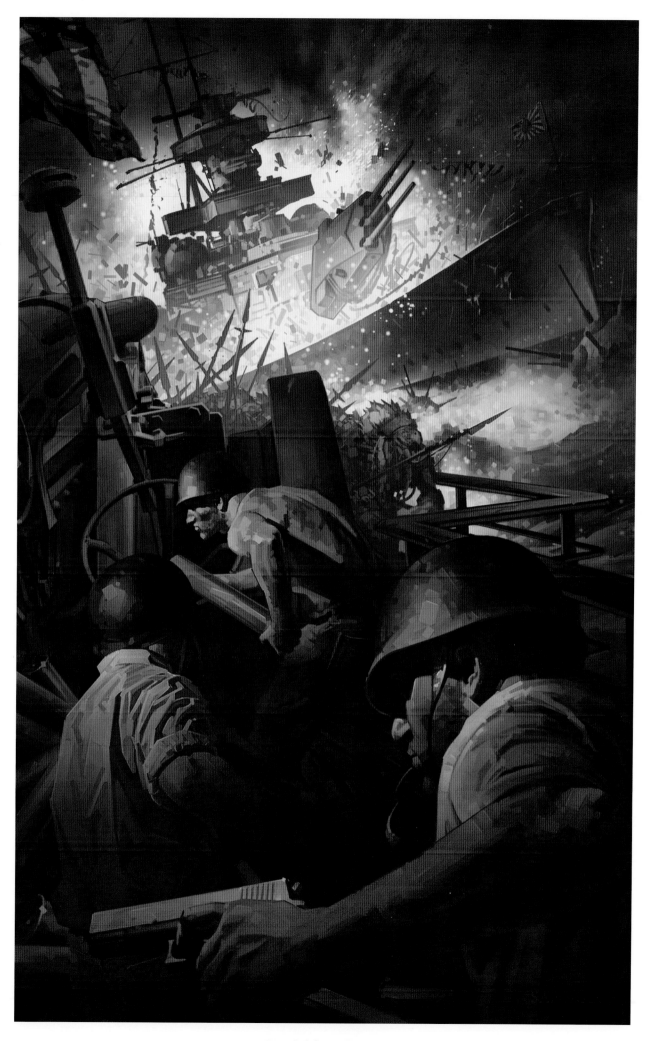

Dominick Saponaro

Art Director: Matthew Kalamidas *Client:* The Science Fiction Book Club *Title:* Destroyermen: Fire on the Water *Size:* 13"x20" *Medium:* Mixed/digital

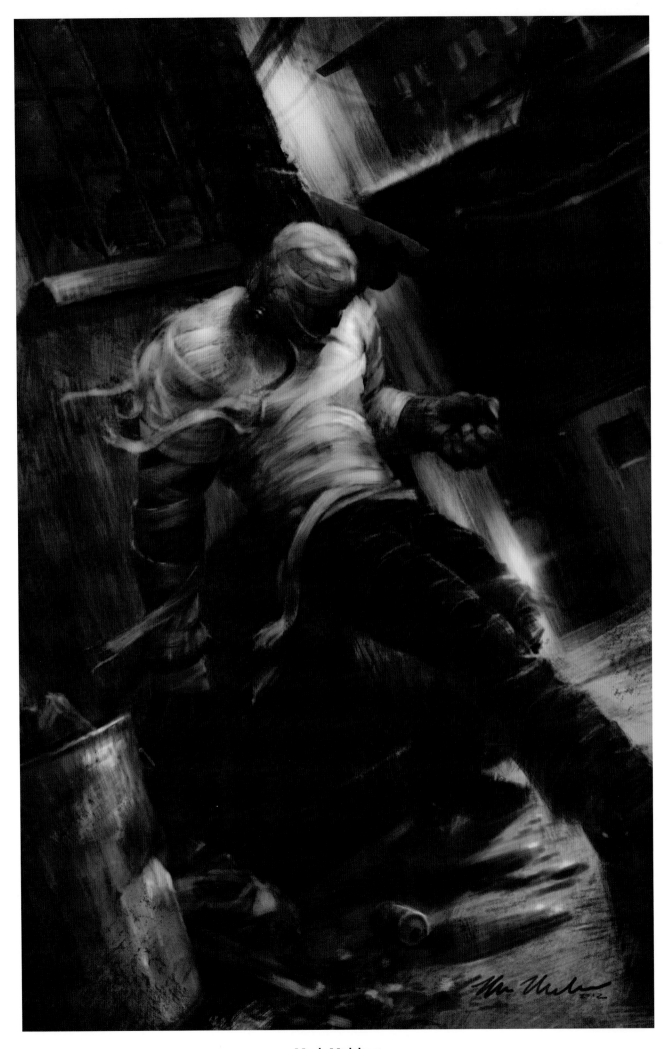

Mark Molchan
Title: M. Frankenstein *Medium:* Digital

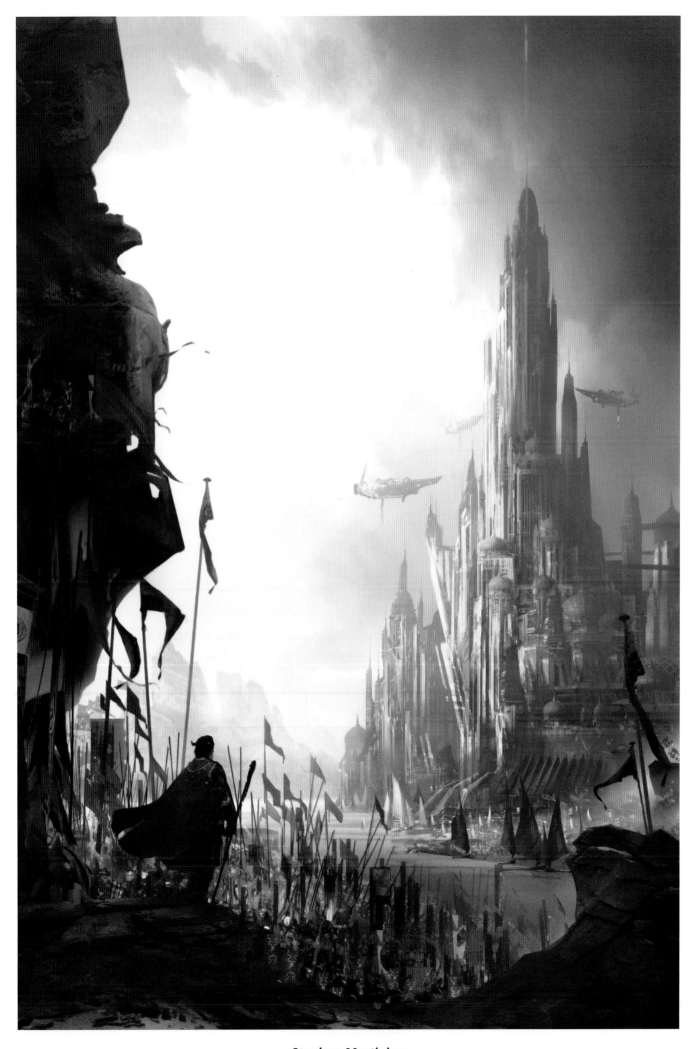

Stephan Martiniere

Art Director: Danna Mathias *Client:* Create Space *Title:* The Garden of Stones *Medium:* Digital

Christina Hess
Client: Exposé 10 *Title:* Grape Spider *Size:* 8.5"x11" *Medium:* Digital

Nekro
Client: Norma Editorial *Title:* Bird of Prey *Size:* 7"x12" *Medium:* Digital

Cliff Nielsen
Art Director: Andy Gavin *Client:* Mascherato Publishing *Title:* Untimed *Size:* 9"x6" *Medium:* Digital

Cliff Nielsen

Art Director: Russell Gordon *Client:* Simon & Schuster *Title:* Eddie: Clockwork Princess *Size:* 6"x9" *Medium:* Digital

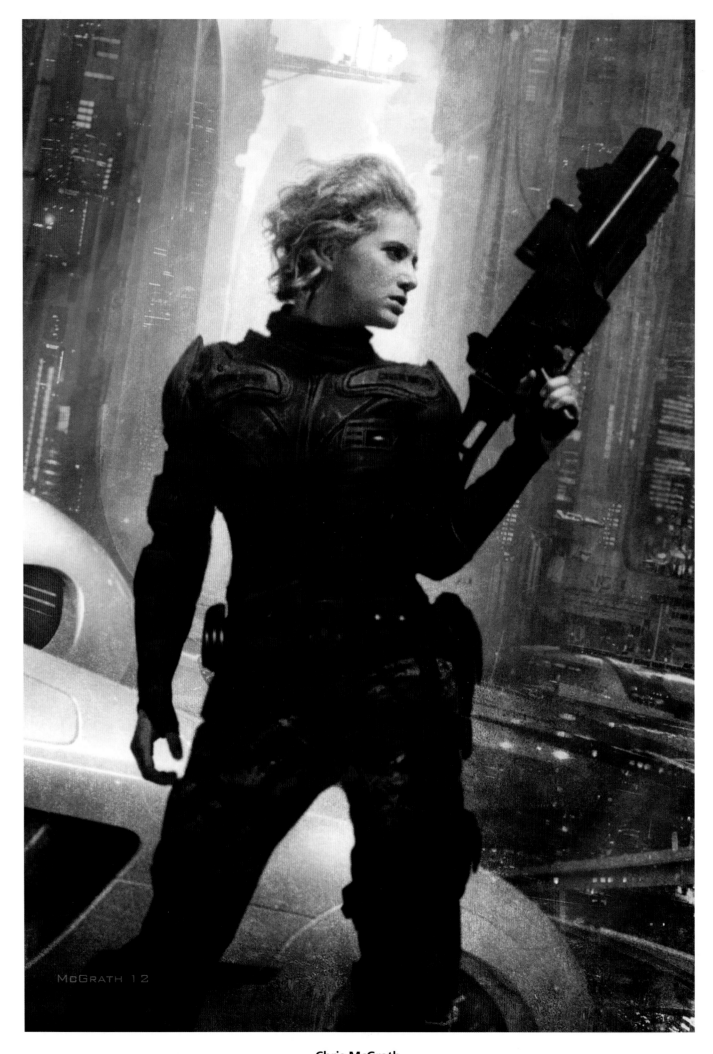

Chris McGrath

Art Director: Judith Murello *Client:* Ace Books *Title:* Andromeda's Fall *Size:* 4.6"x7" *Medium:* Digital

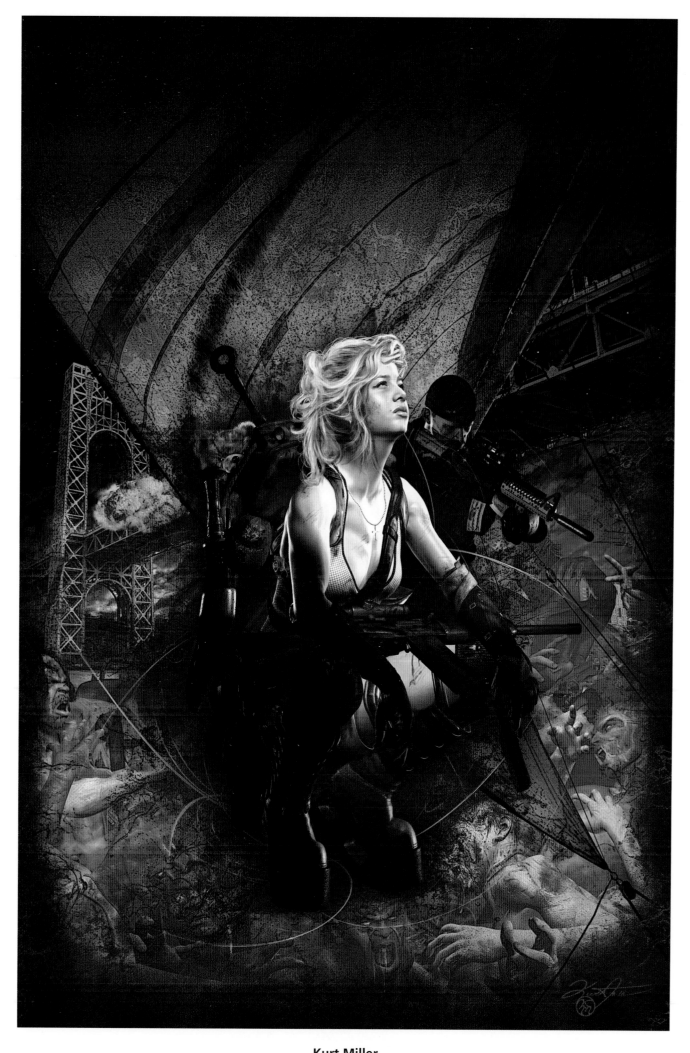

Kurt Miller

Art Director: Toni Weisskopf *Client:* Baen Books *Title:* Under a Graveyard Sky *Size:* 9"x12' *Medium:* Mixed/digital

Gary Gianni
Client: The Ras Press *Title:* Nef-Tut Express *Size:* 11"x8.5" *Medium:* Pen & ink

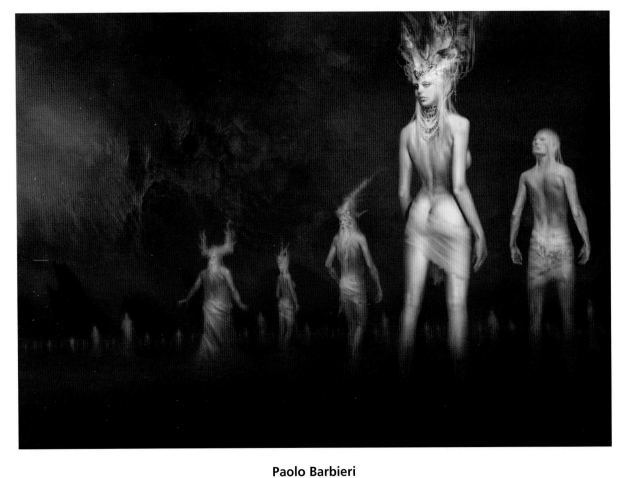

Paolo Barbieri
Client: Arnoldo Mondadori Editorial *Title:* Gli Indovim (from *L'inferno di Dante Illustrato da Paolo Barbieri*) *Size:* 48cm x 34cm *Medium:* Digital

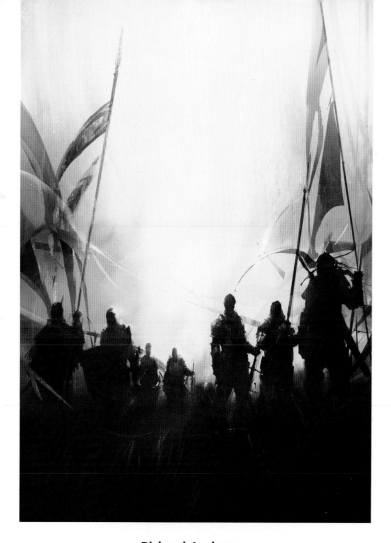

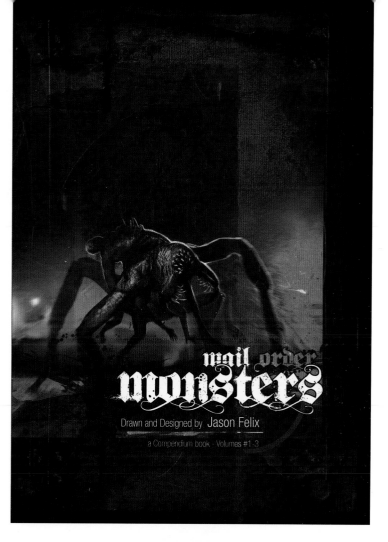

Richard Anderson
Art Director: Lauren Panepinto *Client:* Orbit Books *Title:* Seven Princes
Size: 5.5"x8.25" *Medium:* Digital

Jason Felix
Client: Trinquette Publishing *Title:* Mail Order Monsters
Medium: Mixed

Gary Gianni
Client: The Ras Press *Title:* Nefertiti-Tut Express *Size:* 11"x8.5" *Medium:* Pen & ink

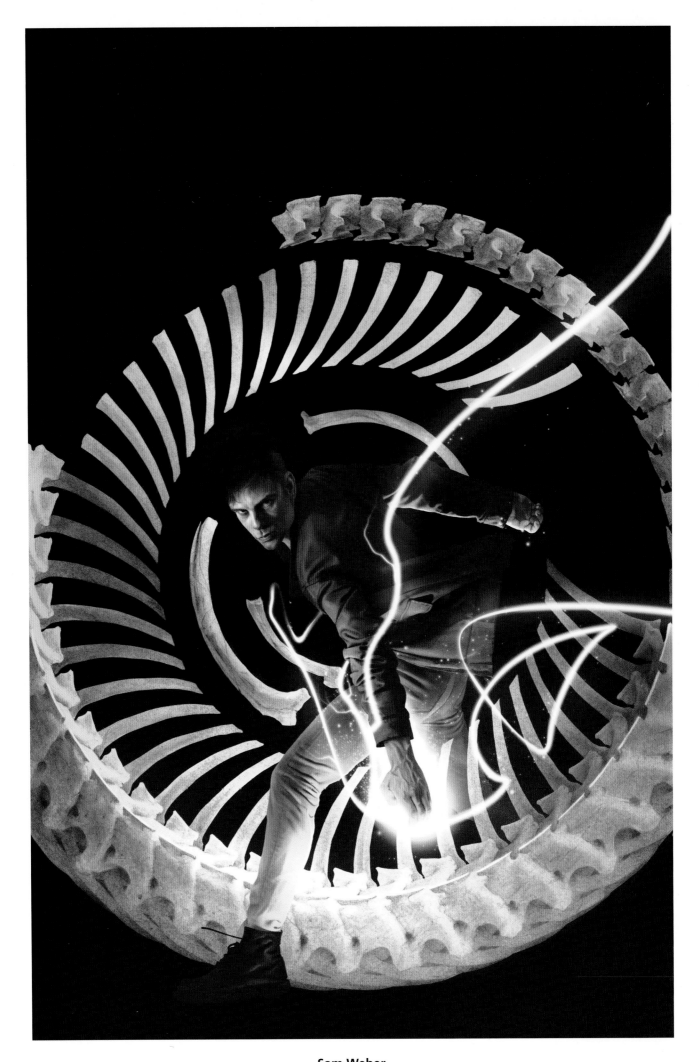

Sam Weber

Art Director: Irene Gallo *Client:* Tor Books *Title:* The Osteomancer's Son *Size:* 5.5"x8.25" *Medium:* Watercolor/digital

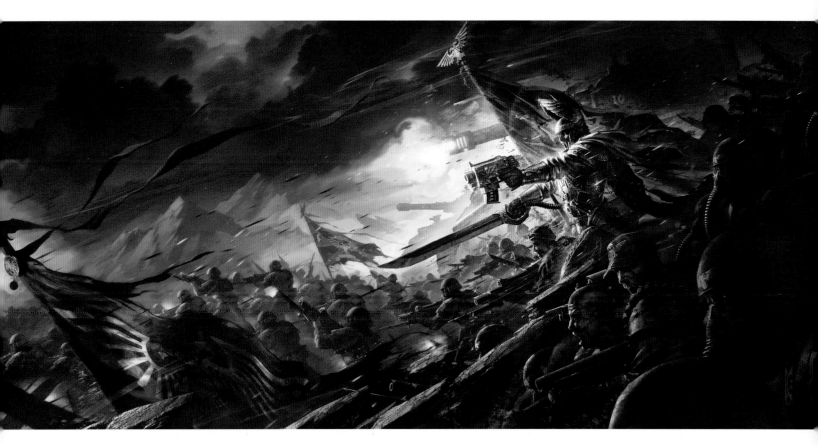

Raymond Swanland
Art Director: Darius Hinks *Client:* The Black Library *Title:* Fist of Demetrius *Medium:* Digital

Greg Manchess
Art Director: Matthew Kalamidas *Client:* The Science Fiction Book Club *Title:* Vampire Earth Vol. 1: Enter the Wolf *Size:* 28"x20" *Medium:* Oil on linen

John Picacio
Art Director: Tom Daly *Client:* Simon & Schuster *Title:* Tars Tarkas
Size: 12"x17" *Medium:* Pencil, acrylic, oil

Eric Deschamps
Art Director: Dorian Danielsen *Client:* Bayard Press *Title:* Blood of the Witch
Size: 16"x22" *Medium:* Digital

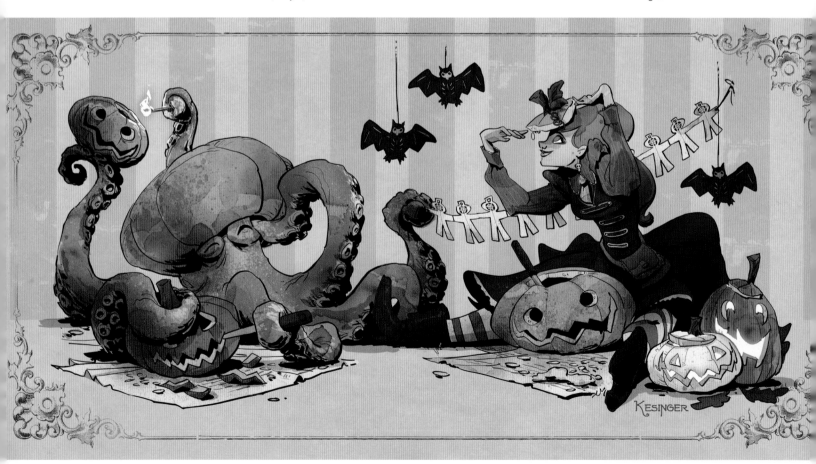

Brian Kesinger
Art Director: Brian Kesinger *Client:* Baby Tattoo Books *Title:* Carving with Otto *Size:* 19"x9.5" *Medium:* Digital

Ben Templesmith
Client: 44 Flood *Title:* Monkeyback *Size:* 12"x18" *Medium:* Watercolor/digital

Allen Williams

Art Director: Irene Gallo *Client:* Tor Books *Title:* Wildmen *Size:* 14"x18" *Medium:* Mixed

Allen Williams
Art Director: Irene Gallo *Client:* Tor Books *Title:* Victoria's Book of Spells *Size:* 14"x18" *Medium:* Mixed

Karla Ortiz
Art Director: Matthew Kalamidas *Client:* Direct Brands, Inc. *Title:* The Order of Deacons *Size:* 8.25"x5.5" *Medium:* Digital

Donato Giancola
Art Director: Irene Gallo *Client:* Tor Books *Title:* Roman Legionnaires *Size:* 48"x20" *Medium:* Oil on panel

Sam Burley
Art Director: Irene Gallo *Client:* Tor.com *Title:* Brother. Prince. Snake *Medium:* Digital

Todd Lockwood
Title: Wind *Size:* 30"x20" *Medium:* Oil on panel

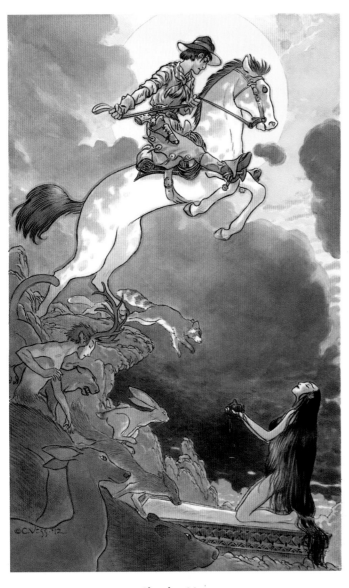

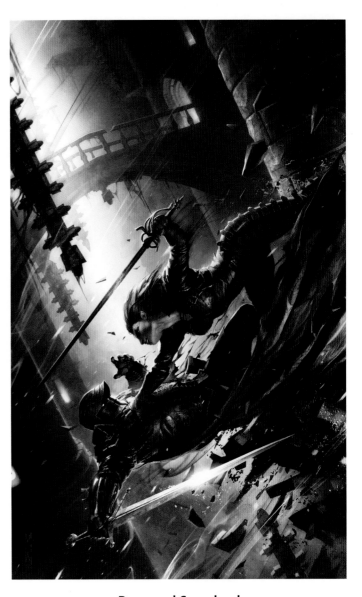

Charles Vess
Art Director: Bill Schafer *Client:* Subterranean Press
Title: Six-Gun Snow White *Size:* 10"x15" *Medium:* Colored inks

Raymond Swanland
Art director: Jon Schindehette *Client:* Wizards of the Coast
Title: Eye of Justice *Size:* 8"x10" *Medium:* Digital

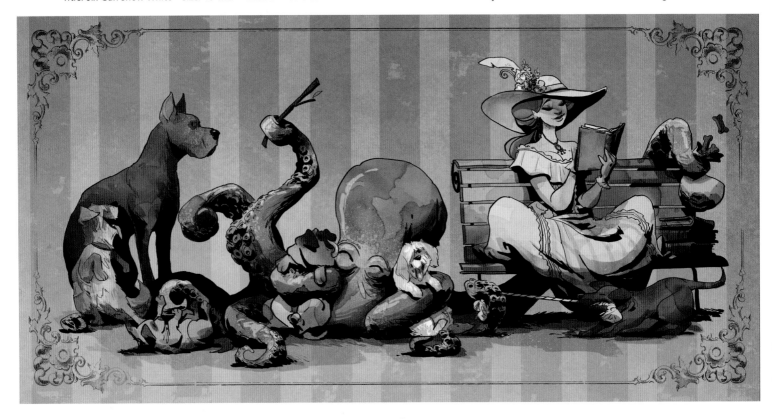

Brian Kesinger
Art Director: Brian Kesinger *Client:* Baby Tattoo Books *Title:* Socializing with Otto *Size:* 19"x9.5" *Medium:* Digital

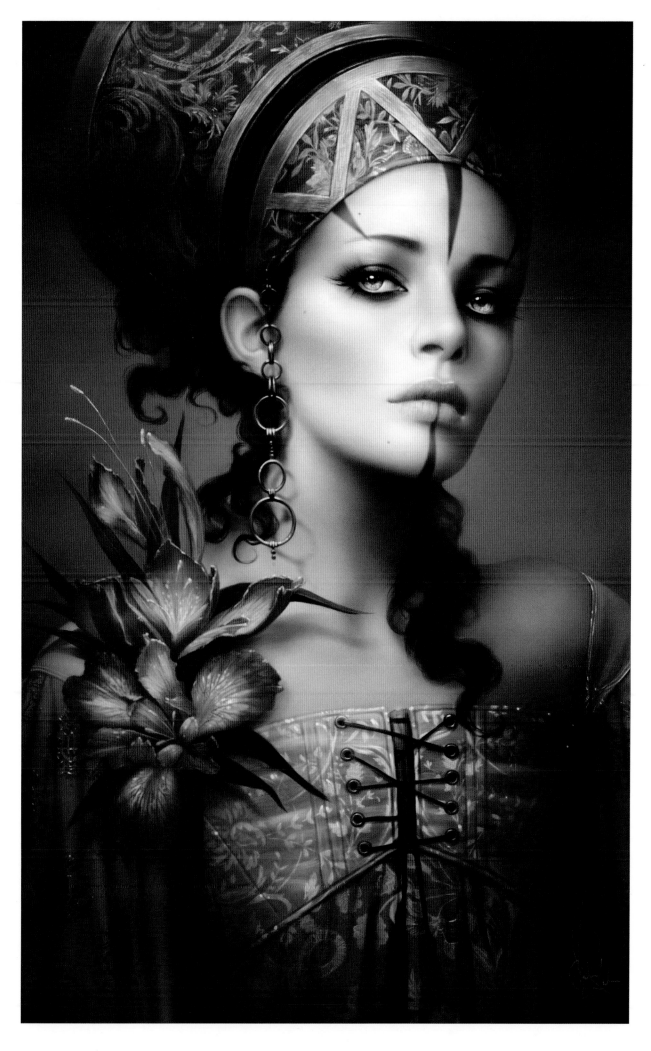

Mélanie Delon
Client: Exuvia *Title:* Glow from Opale *Size:* 10"x15" *Medium:* Digital

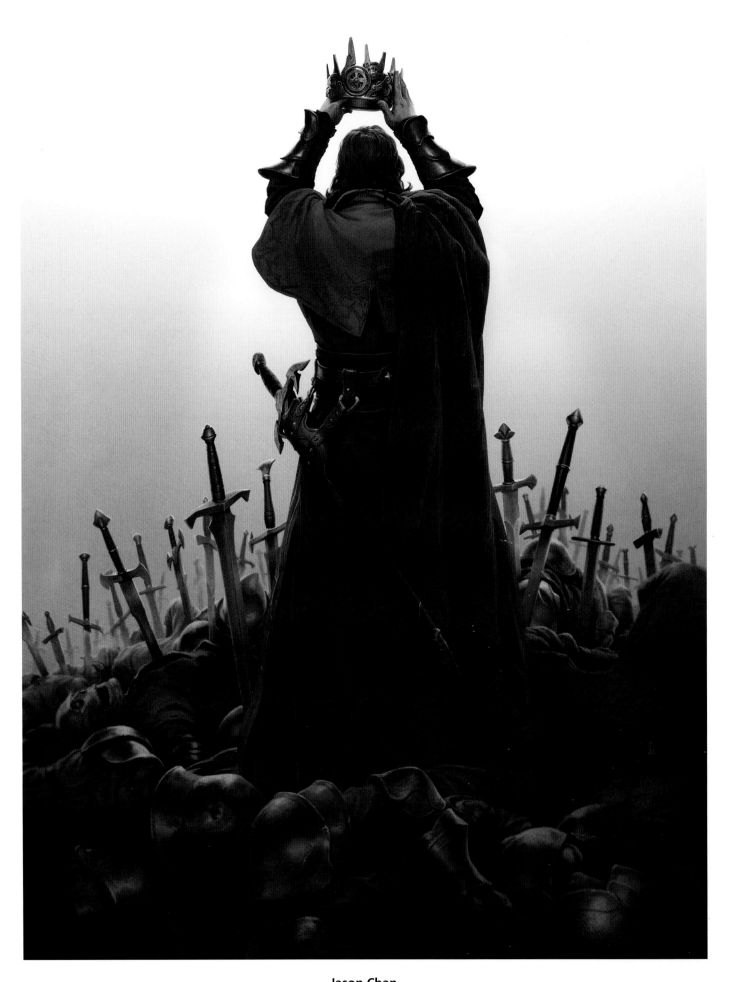

Jason Chan
Art Director: Judith Murello *Client:* Penguin Group *Title:* Emperor of Thorns *Size:* 14"x20" *Medium:* Digital

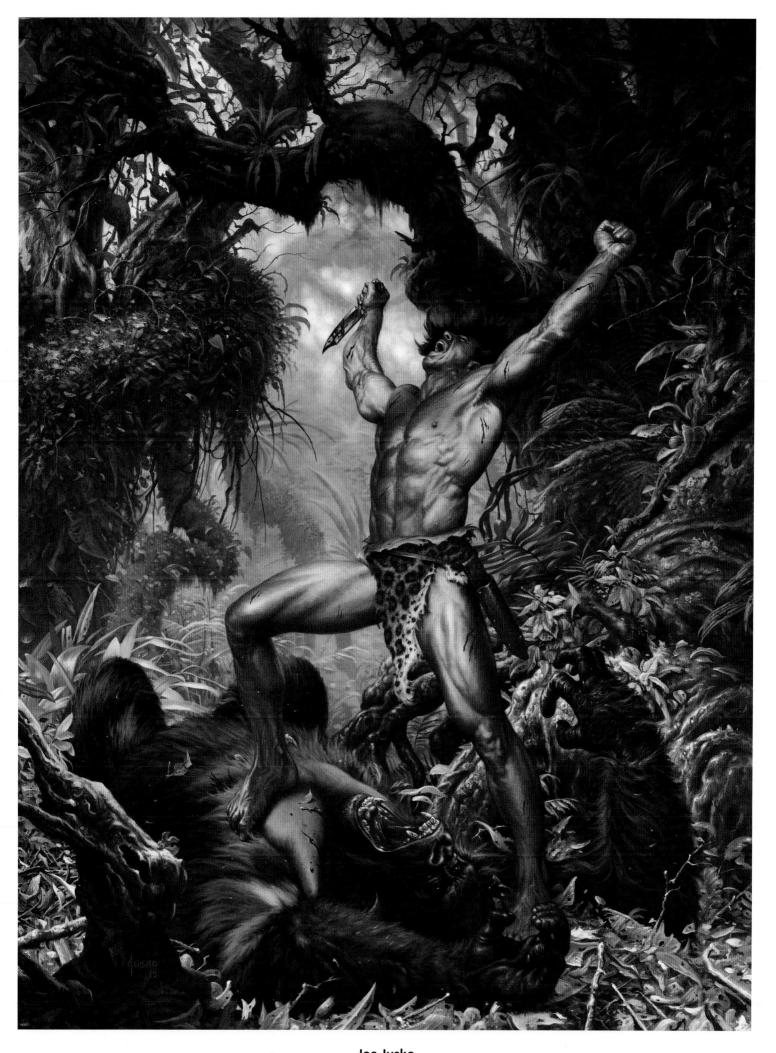

Joe Jusko

Client: ERB, Inc. *Title:* Tarzan of the Apes 100th Anniversary *Size:* 30"x40" *Medium:* Acrylic

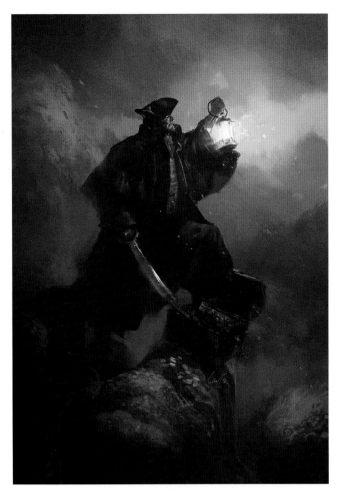

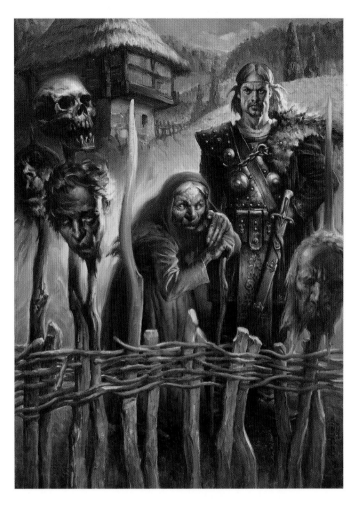

Lauffray
Client: Ankama/CFSL *Title:* Axis Mundi cover *Medium:* Digital

Petar Meseldžija
Client: Carobna Knjiga *Title:* The Golden Apple-Tree 3 *Medium:* Oil

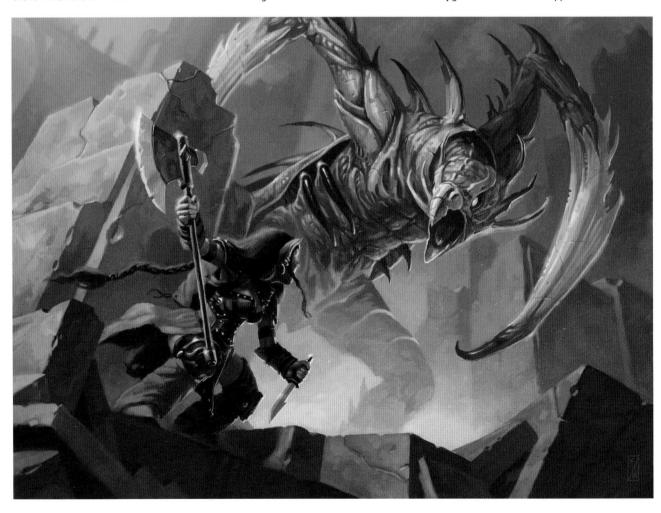

Craig J. Spearing
Art Director: Kate Irwin *Client:* Wizards of the Coast *Title:* Goblin Vs. Hook Horror *Size:* 15"x11" *Medium:* Digital

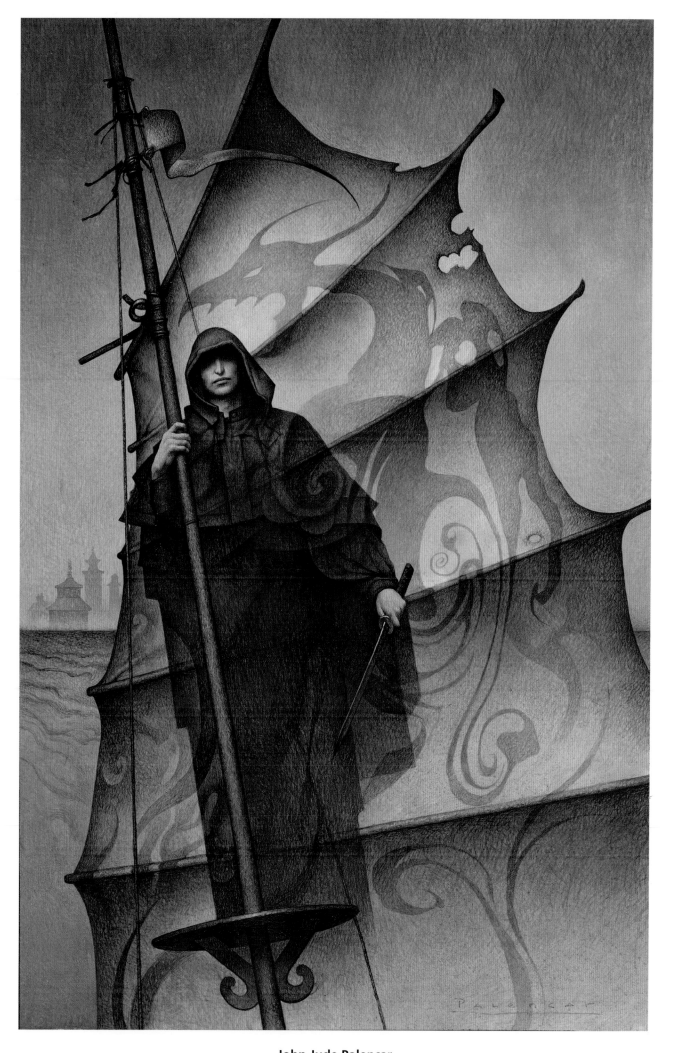

John Jude Palencar
Art Director: Judith Murello *Client:* Ace Books *Title:* Crossed Blades *Size:* 19"x27" *Medium:* Acrylic

Scott Brundage

Art Director: Zoe Soane *Client:* The Story Elves *Title:* The Waking Prince *Medium:* Pencil/digital

William Stout

Art Director: Bill Morrison *Client:* Comic Art Professional Society
Title: Cave Cutie *Size:* 10"x10" *Medium:* Ink, watercolor on board

Shaun Tann

Client: Hachette Australia *Title:* Never Leave a Red Sock on the Clothesline [Redux]
Size: 36"x30" *Medium:* Oil

Jonny Duddle

Art Director: Mike Jolley *Client:* Templar Publishing *Title:* Warbot (Mark 2) *Size:* 22"x32" *Medium:* Digital

Winona Nelson
Art Director: Darius Hinks *Client:* Games Workshop *Title:* Bloodword *Medium:* Digital

Tyler Jacobson
Art Director: Irene Gallo *Client:* Tor Books *Title:* Forerunner *Medium:* Digital

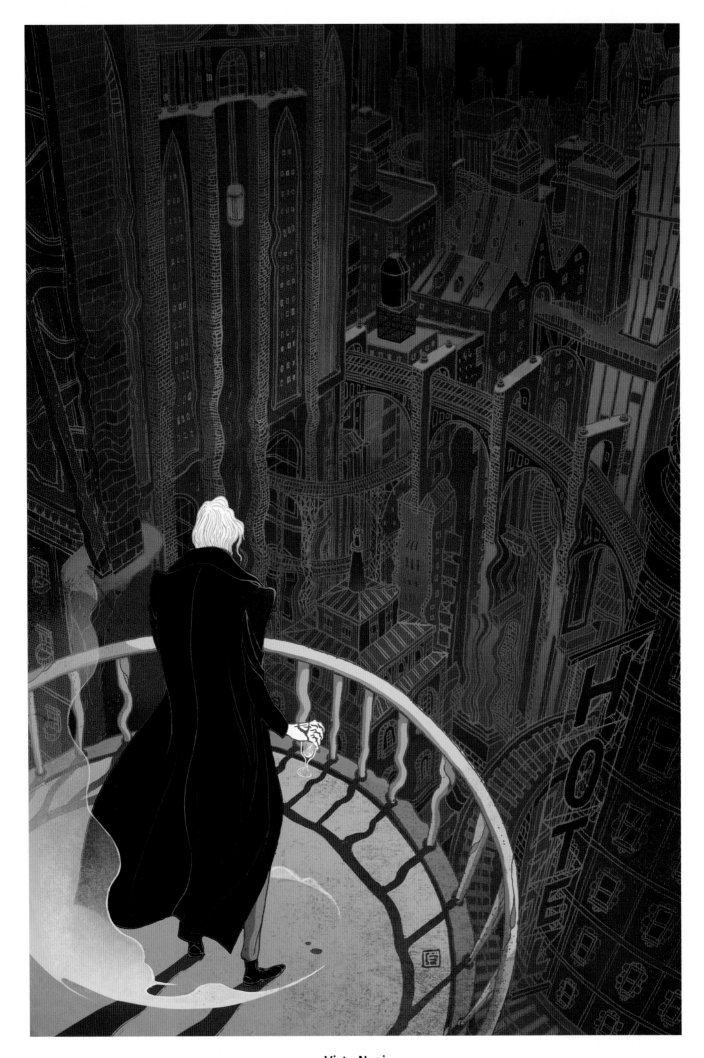

Victo Ngai

Art Director: Irene Gallo *Client:* Tor Books *Title:* Vicious *Size:* 11"x16.5" *Medium:* Mixed

Dany Orizio
Art Director: Alberto Ruiz *Client:* Trinquette Publishing
Title: Pinky-Panky *Medium:* Pencil/digital

Bruce Jensen
Art Director: Judith Murello *Client:* Berkley Publishing Group
Title: A Fighting Chance *Size:* 7"x10" *Medium:* Digital

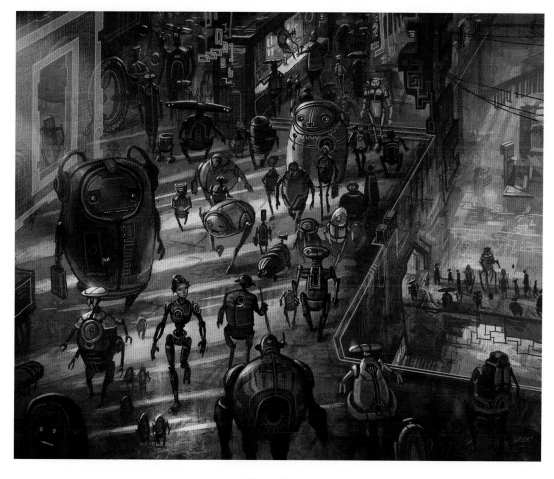

Matt Gaser
Client: Battlemilk 3 *Title:* Through the Crowd *Size:* 11"x9" *Medium:* Digital

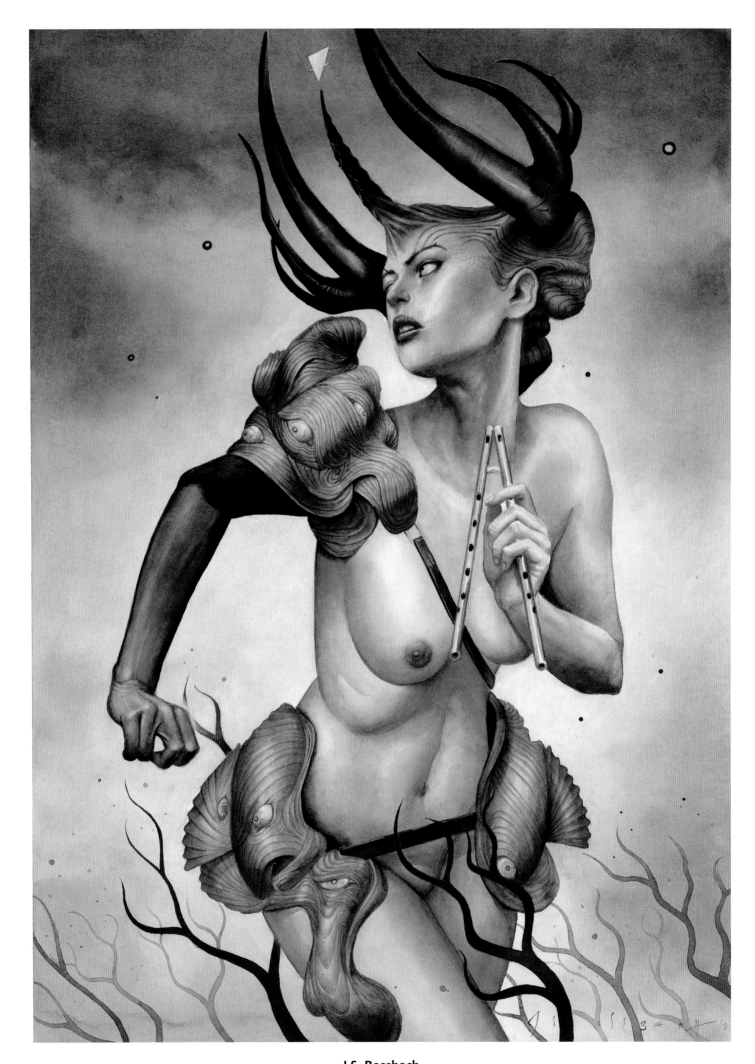

J.S. Rossbach
Client: Daniel Maghen *Title:* Pan! *Size:* 50cm x 70cm *Medium:* Watercolor

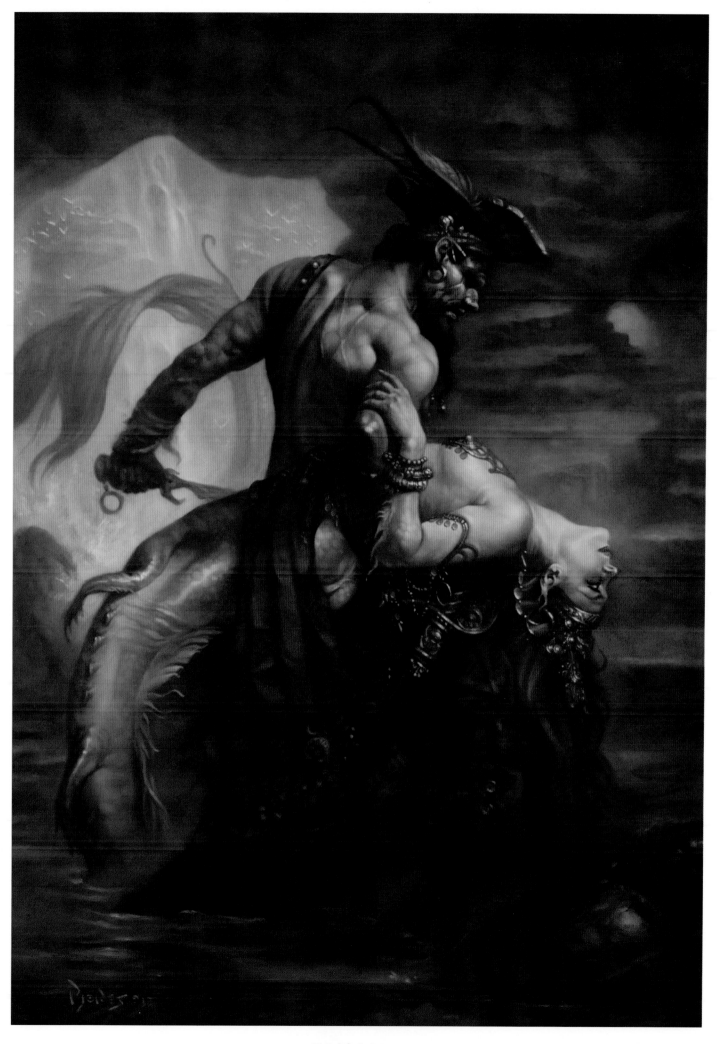

Patrick J. Jones
Title: The Captive *Size:* 19"x28" *Medium:* Oil on board

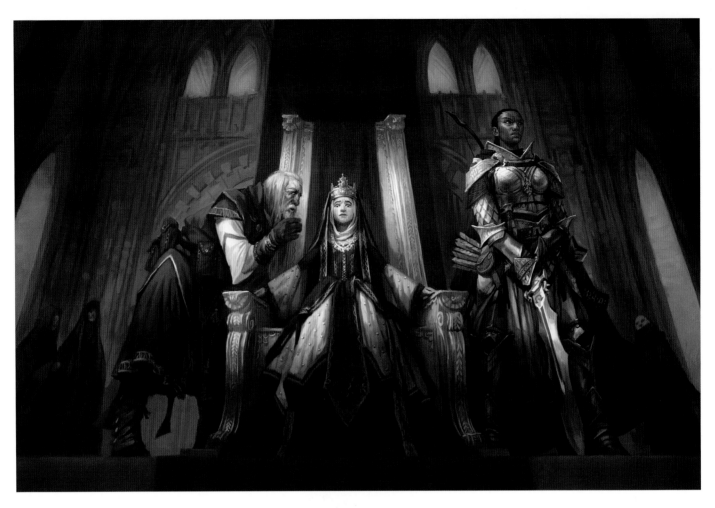

Denman Rooke

Art Director: Sarah Robinson *Client:* Paizo Publishing *Title:* Servants of the Crown *Medium:* Oil on wood

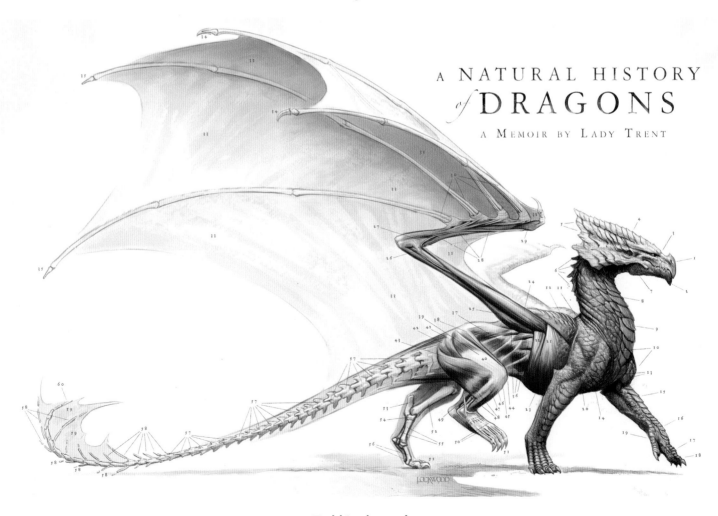

Todd Lockwood

Art Director: Irene Gallo *Client:* Tor Books *Title:* A Natural History of Dragons *Size:* 21"x16" *Medium:* Digital

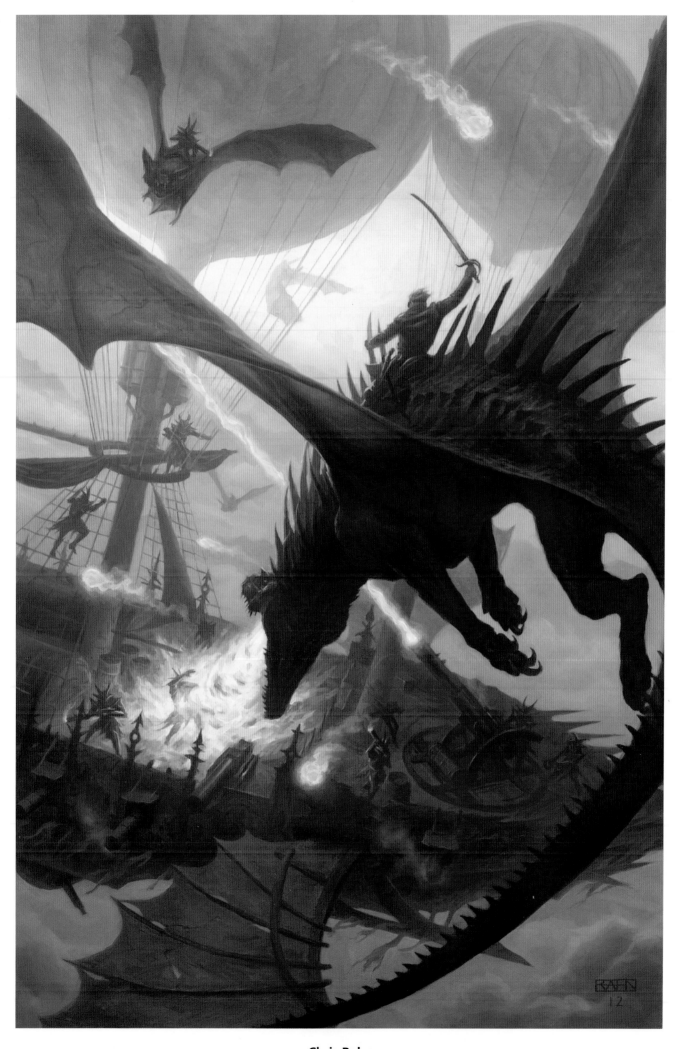

Chris Rahn

Art Director: Irene Gallo *Client:* Tor Books *Title:* Storm Riders *Size:* 14"x22" *Medium:* Oil

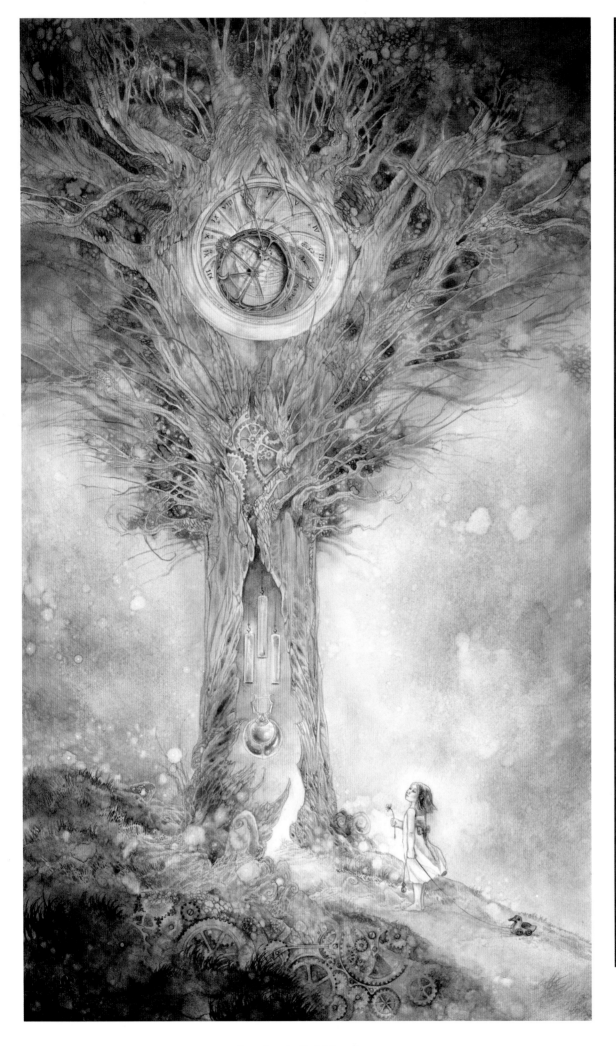

Stephanie Pui-Mun Law

Title: Timepiece *Size:* 12"x21" *Medium:* Watercolor

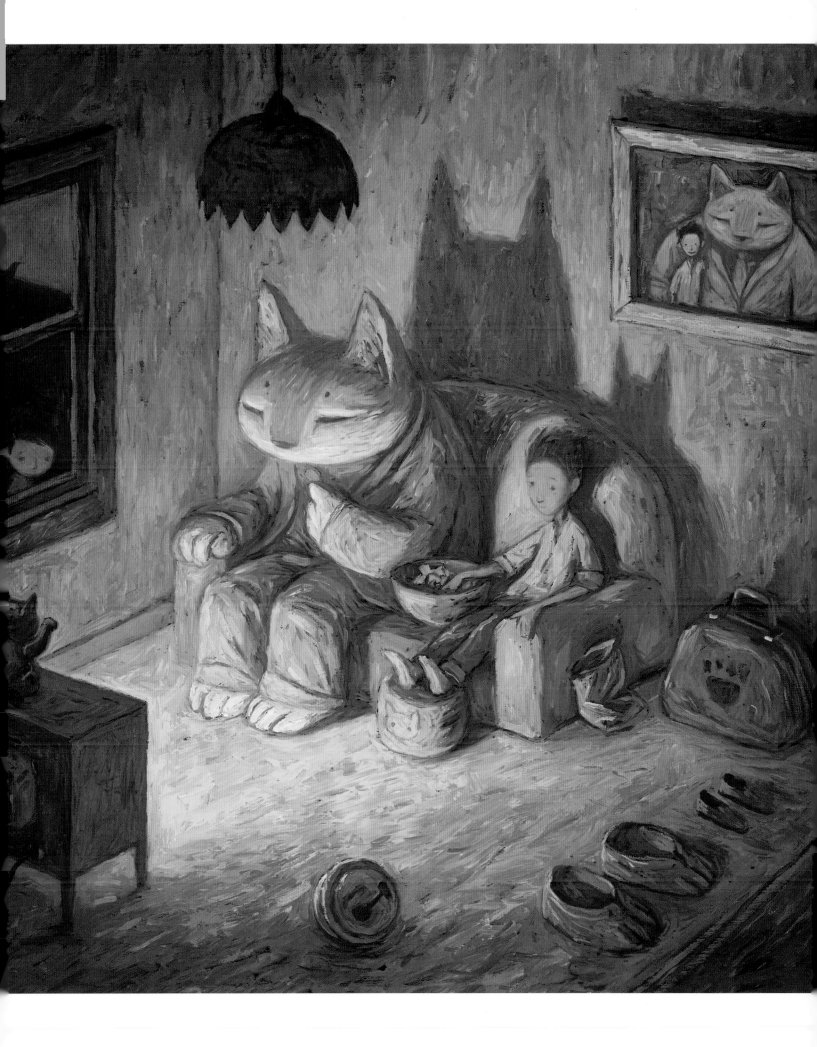

Shaun Tann

Client: Hachette Australia *Title:* Never Give Your Keys to a Stranger *Size:* 34"x30" *Medium:* Oil

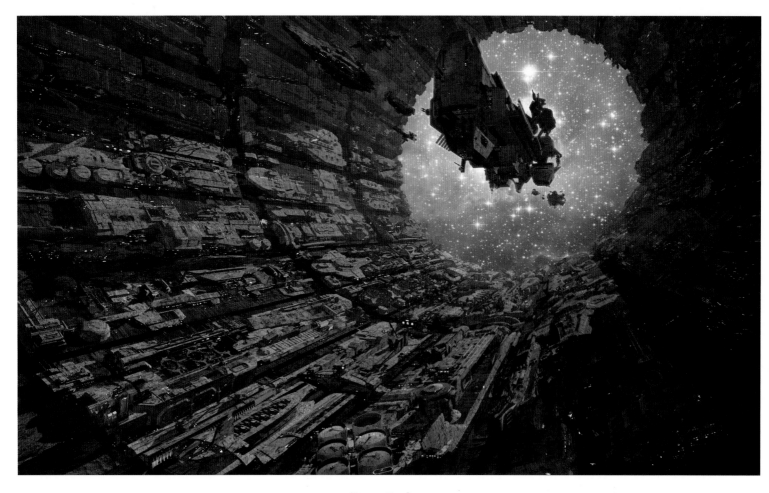

Dave Seeley
Art Director: Irene Gallo *Client:* Tor Books *Title:* The Unincorporated Future *Medium:* Digital

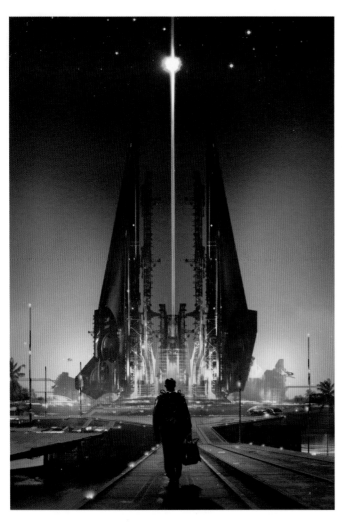

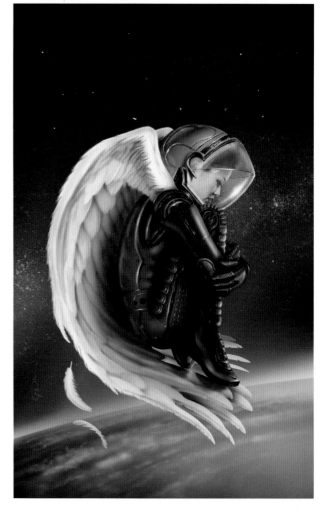

Stephan Martiniere
Art Director: Irene Gallo *Client:* Tor Books *Title:* Transcendental *Medium:* Digital

Maurizio Manzieri
Client: Delos Press *Title:* Paradise Lost *Medium:* Digital

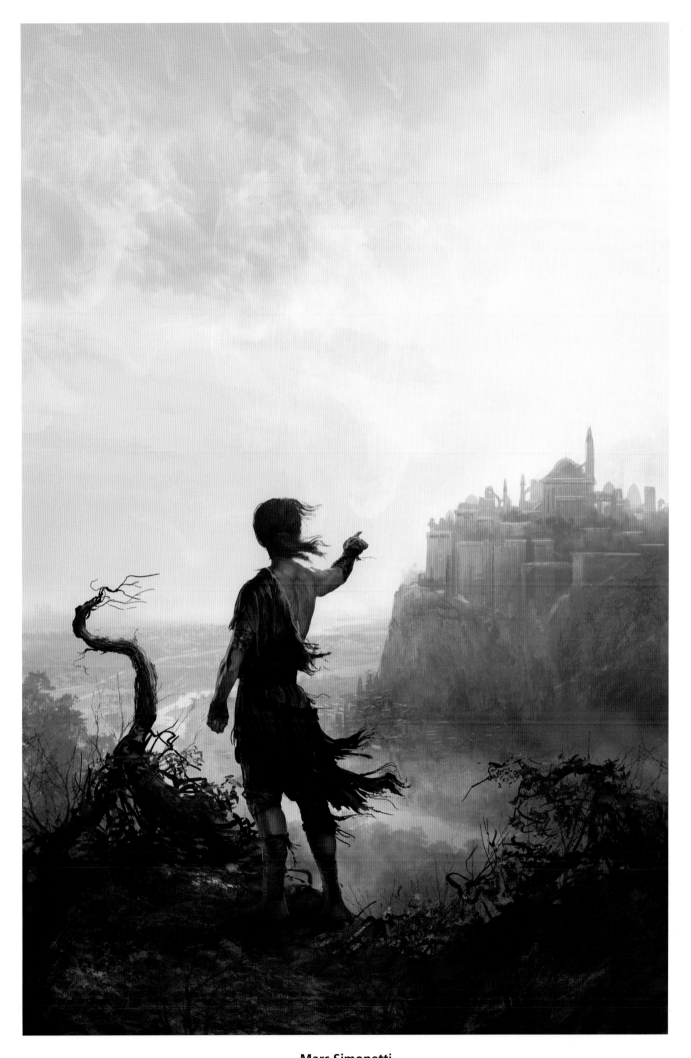

Marc Simonetti
Art Director: Fabrice Borio *Client:* Editions Bragelonne *Title:* The Wise Man Fear *Medium:* Digital

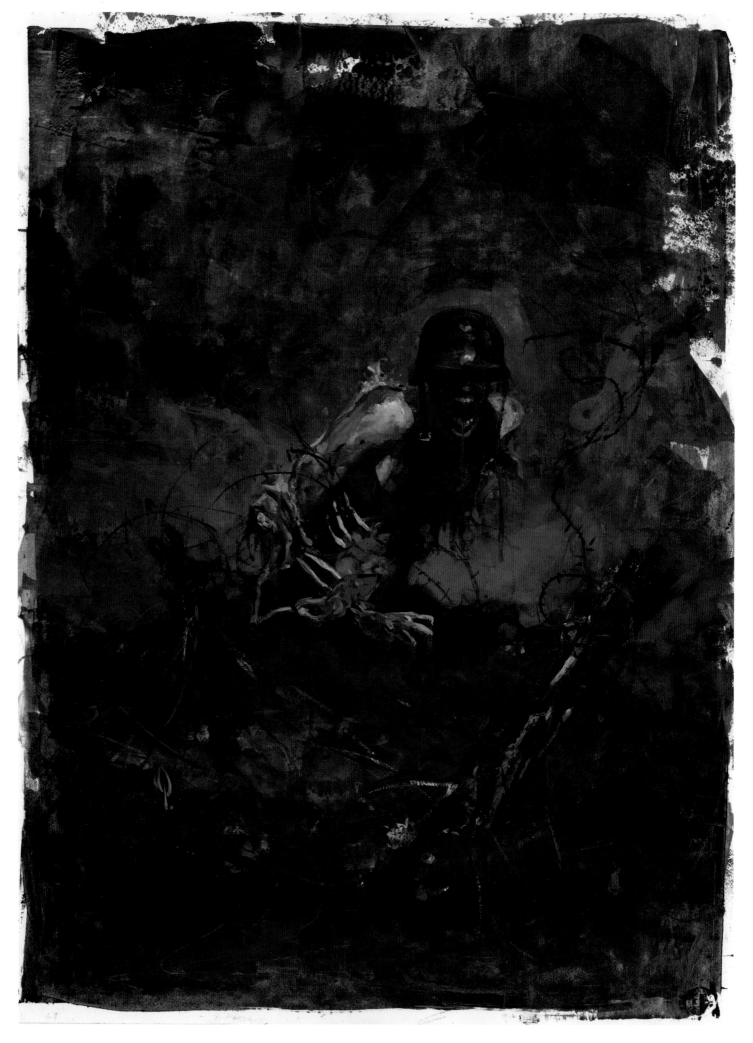

George Pratt
Client: Chris Williams *Title:* Nazi Zombie *Size:* 22"x36" *Medium:* Mixed

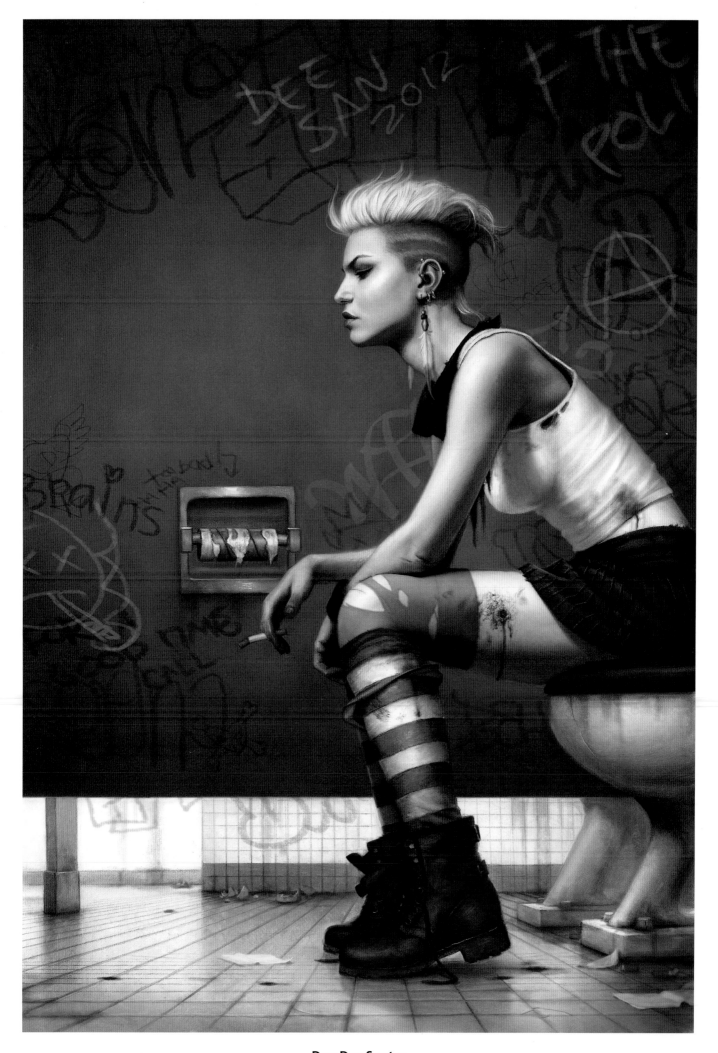

Dan Dos Santos
Art Director: Betsy Wollheim *Client:* DAW Books *Title:* Even White Trash Zombies Get The Blues *Medium:* Oil

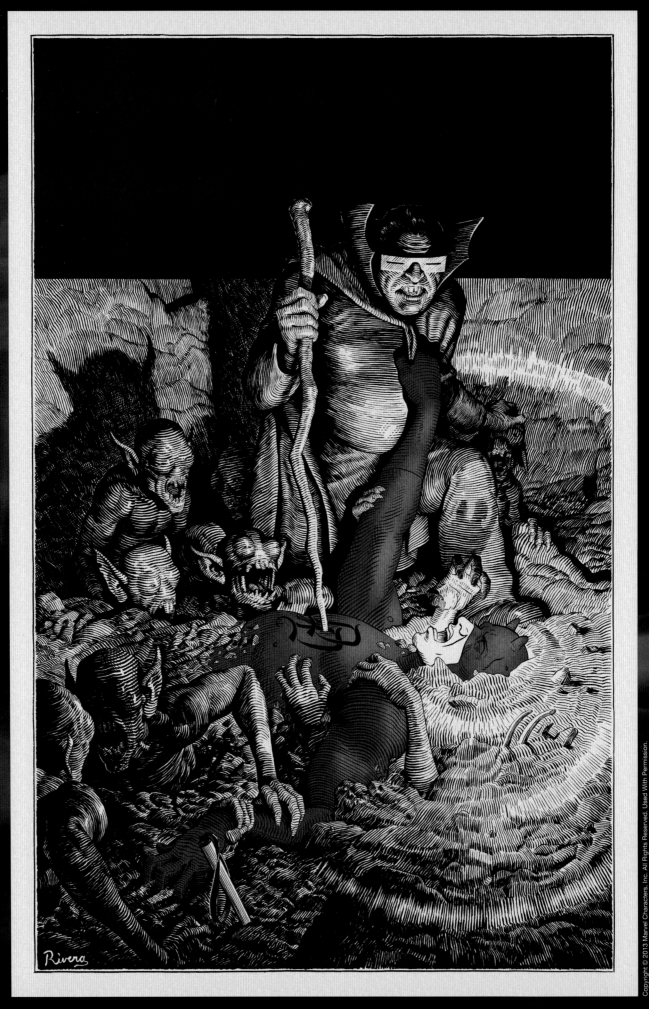

Paolo Rivera

Art Director: Steve Wacker *Client:* Marvel Comics *Title:* Daredevil #10 Cover *Size:* 11"x17.25" *Medium:* Ink with digital color

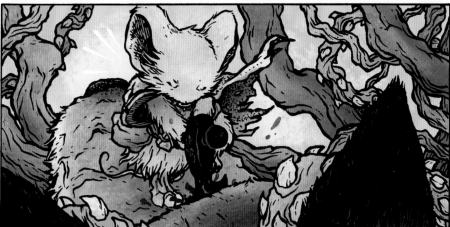

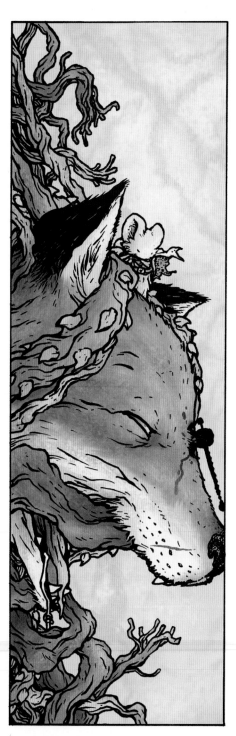

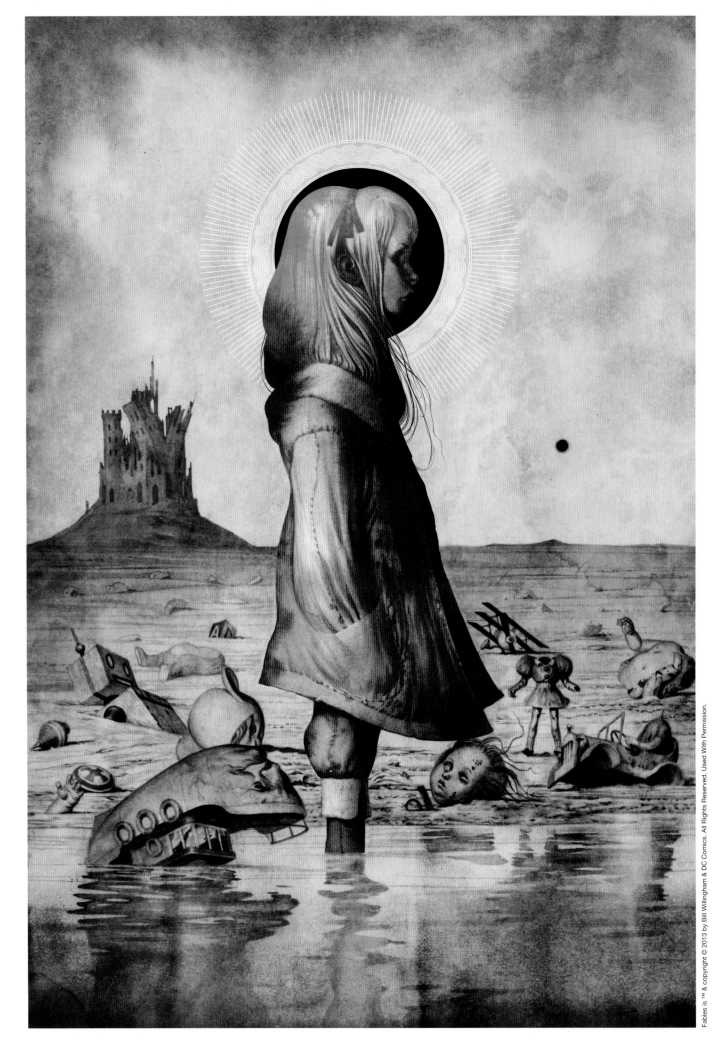

João Ruas

Art Director: Shelly Bond/Bill Willingham *Client:* Vertigo/DC Comics *Title:* Fables #115 *Size:* 8.8"x13" *Medium:* Watercolor/gouache/digital

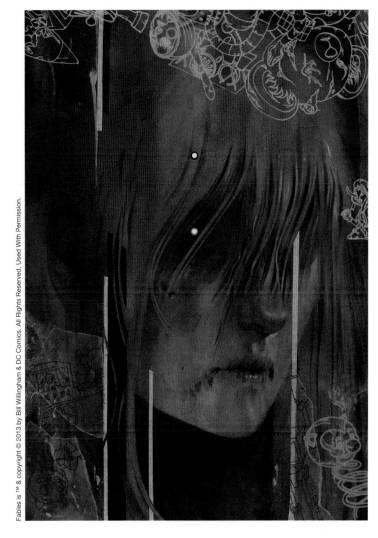

João Ruas
Art Director: Shelly Bond/Bill Willingham *Client:* Vertigo/DC Comics
Title: Fables #121 *Size:* 8.6"x12.5" *Medium:* Watercolor/gouache/digital

João Ruas
Art Director: Shelly Bond/Bill Willingham *Client:* Vertigo/DC Comics
Title: Fables #123 *Size:* 9.6"x13.5" *Medium:* Watercolor/gouache/digital

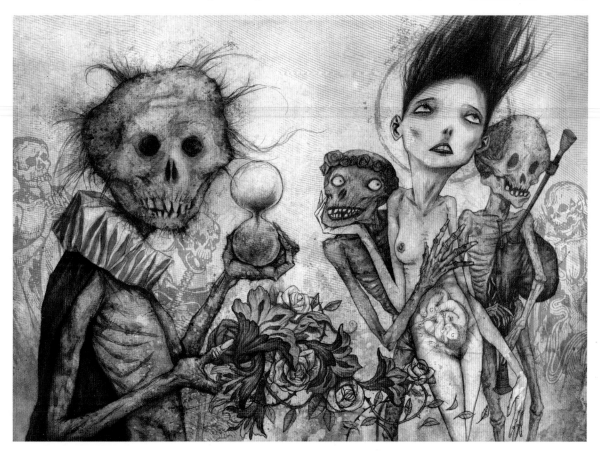

Ivica Stevanović
Client: Komiko *Title:* Kindy Corpses

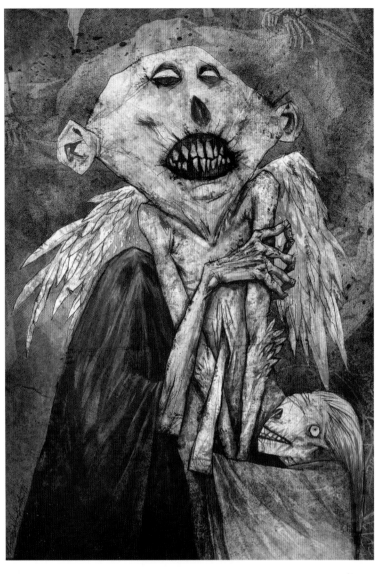

Ivica Stevanović

Client: Komiko *Title:* Kindly Corpses

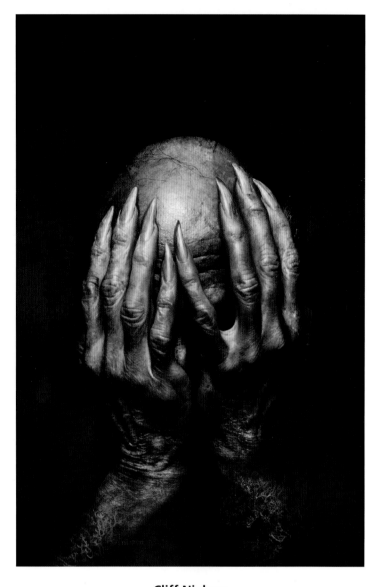

Cliff Nielsen

Client: IDW *Title:* Bram Stoker's Death Ship *Size:* 6.5"x10" *Medium:* Digital

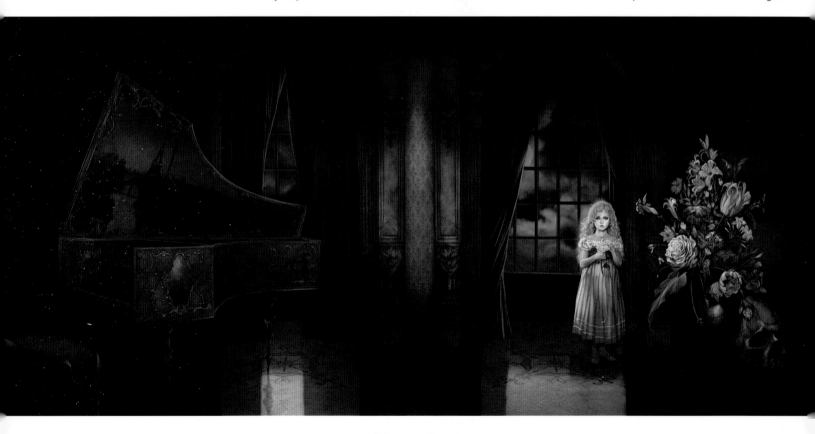

Ashley Marie Witter

Art Director: Juyoun Lee/Lauren Panepinto *Client:* Yen Press *Title:* Interview With the Vampire *Size:* 15"x8.25" *Medium:* Ink/digital

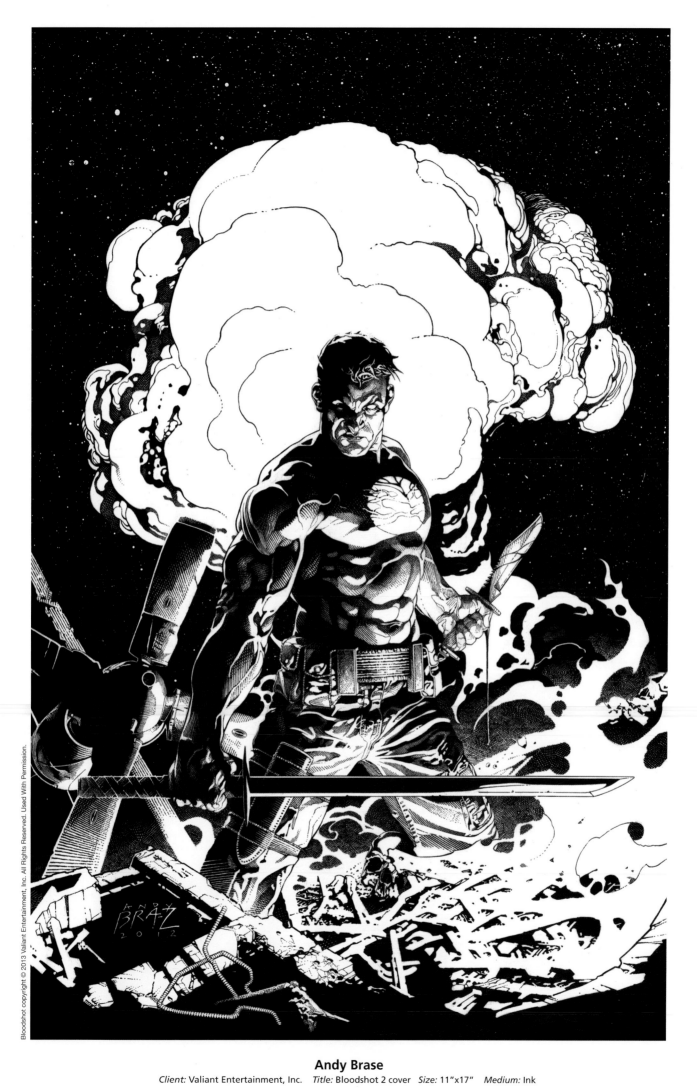

Andy Brase

Client: Valiant Entertainment, Inc. *Title:* Bloodshot 2 cover *Size:* 11"x17" *Medium:* Ink

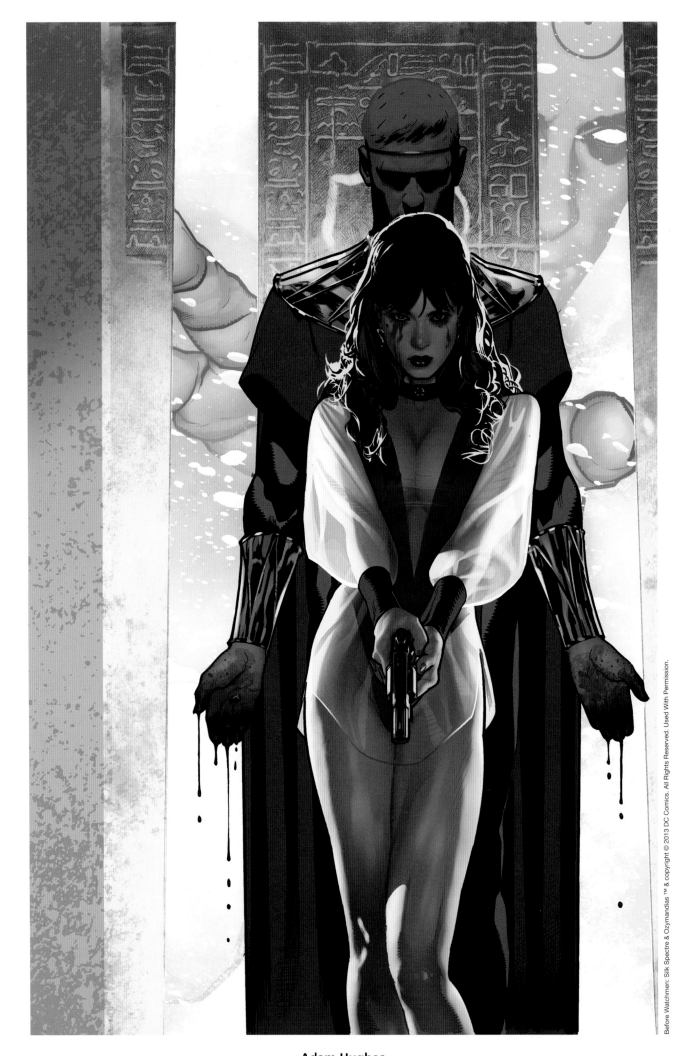

Adam Hughes
Art Director: Mark Chiarello *Client:* DC Comics *Title:* Before Watchmen: Dr. Manhattan #4 *Medium:* Mixed

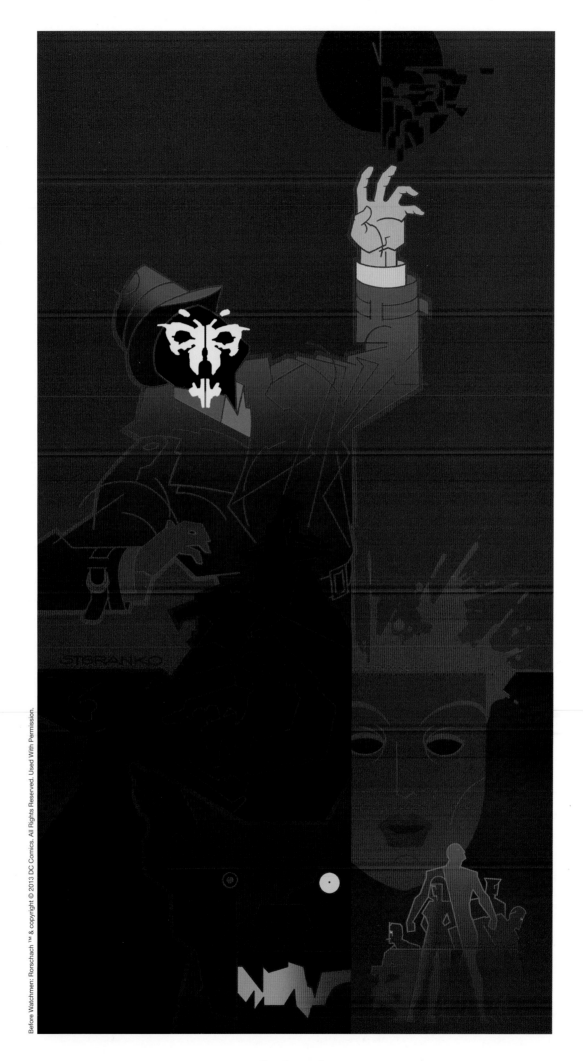

Jim Steranko

Art Director: Mark Chiarello *Client:* DC Comics *Title:* Before Watchmen: Rorschach #1 *Medium:* Mixed

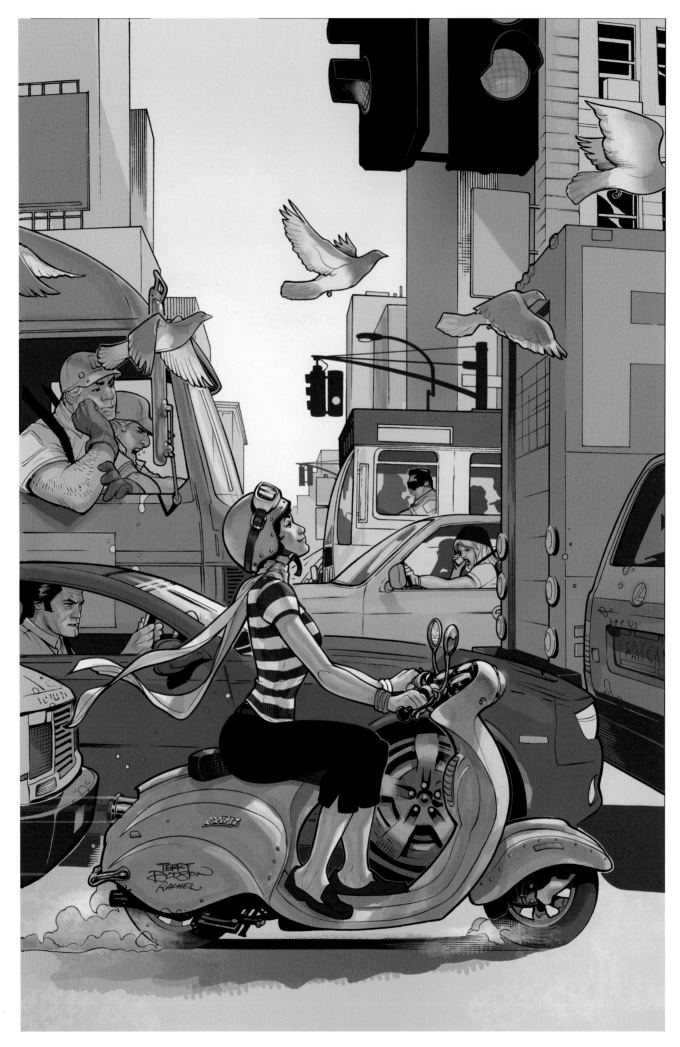

Terry Dodson

Art Director: Eric Stephenson *Inker:* Rachel Dodson *Client:* Image Comics/CBLDF *Title:* Comic Book Legal Defense Fund's Liberty Annual *Size:* 11"x17" *Medium:* Mixed

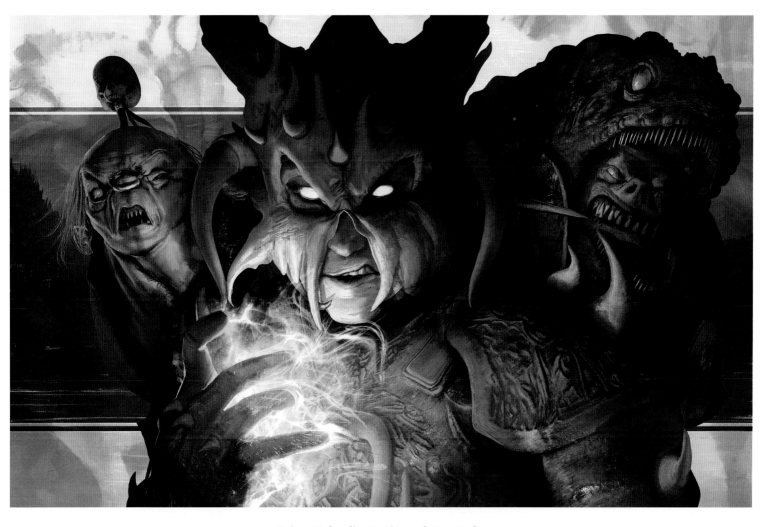

Brian Haberlin & Gierrod Van Dyke
Art Director: Skip Brittenham *Client:* Anomaly Productions *Title:* Anomaly Cover *Size:* 17"x11" *Medium:* Mixed

Winona Nelson
Art Director: Alex Woolfson *Client:* Yaoi911 *Title:* Artifice *Medium:* 40"x30" *Medium:* Oil

Greg Staples

Art Director: Matt Smith *Client:* Rebellion *Title:* Dark Justice *Medium:* Acrylic

Greg Staples

Art Director: Chris Ryall *Client:* IDW *Title:* Dredd Vs Mars Attacks *Medium:* Acrylic

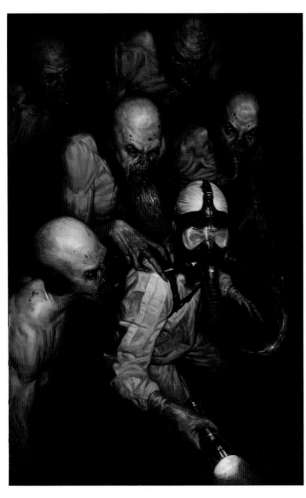

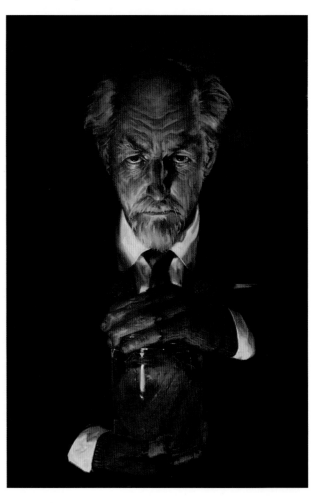

E.M. Gist

Art Director: Jim Gibbons *Client:* Dark Horse *Title:* Strain TPB *Medium:* Oil

E.M. Gist

Art Director: Jim Gibbons *Client:* Dark Horse *Title:* Strain #6 *Medium:* Oil

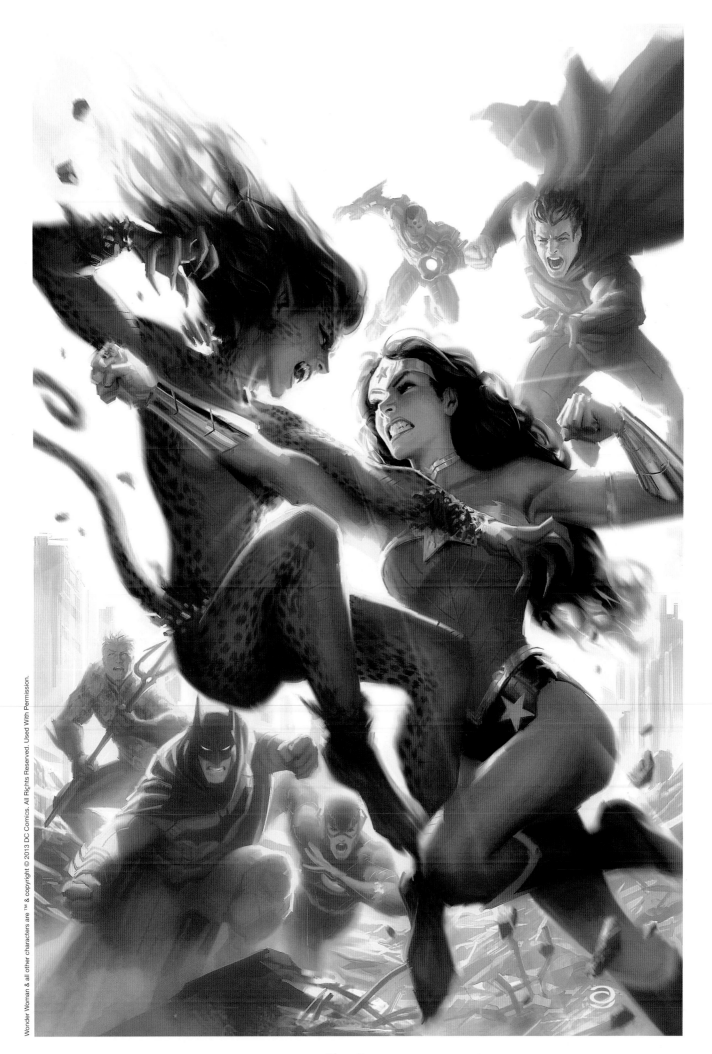

Alex Garner

Art Director: Katie Kubert & Mike Marts *Client:* DC Comics *Title:* Justice League #13 *Size:* 10.5"x15.8" *Medium:* Digital

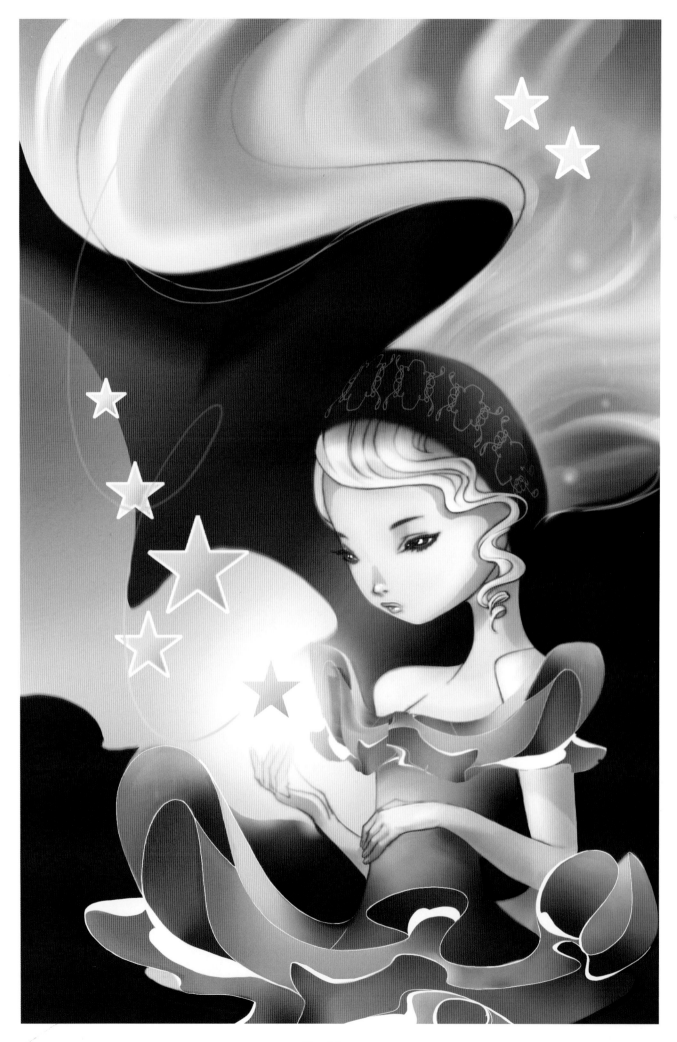

Sho Murase
Client: Womanthology/IDW *Title:* Star *Size:* 13"x19" *Medium:* Pencil/digital color

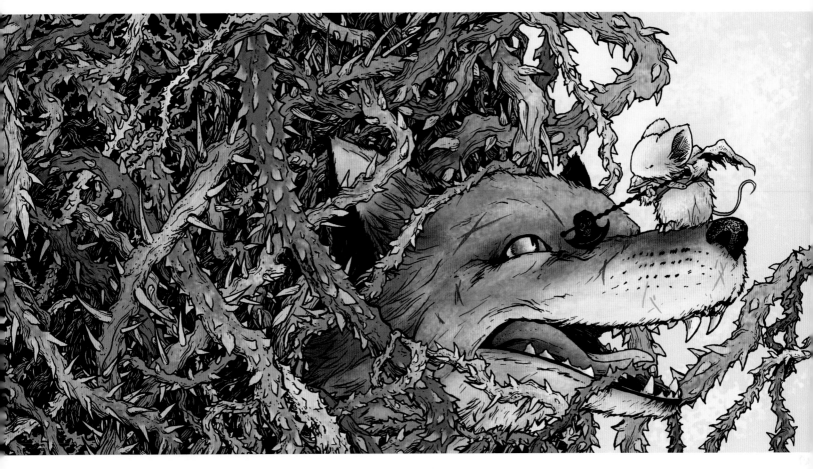

David Petersen
Title: Mouseguard Black Axe #4 Cover *Size:* 17"x11" *Medium:* Ink on Bristol board with digital color

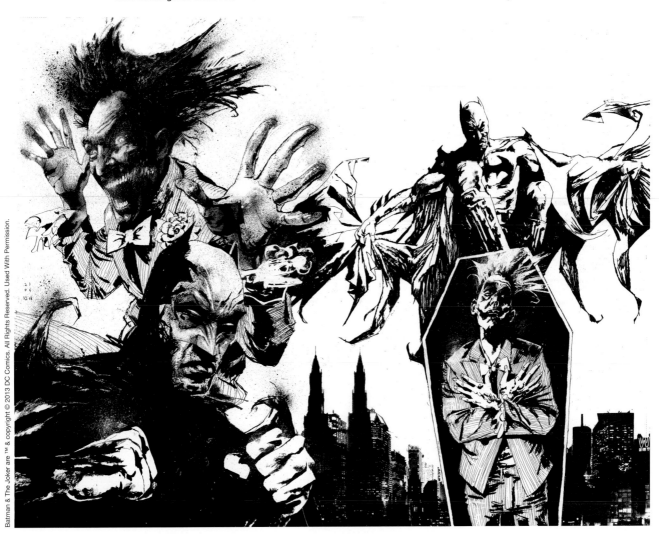

Sean Jason Alexander
Art Director: Jim Chadwick *Client:* DC Comics *Title:* Batman: Arkham City: End Game *Size:* 29.5"x23" *Medium:* Ink

Jennifer L. Meyer
Client: Monkey Brain Comics *Title:* Aesop's Ark Ch.2, P.2 *Medium:* Pencil/digital

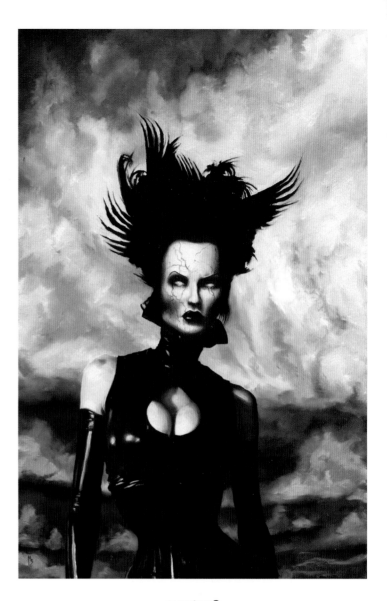

menton3
Client: IDW *Title:* Monocycle #3. P 6 *Size:* 11"x18" *Medium:* Oil on panel

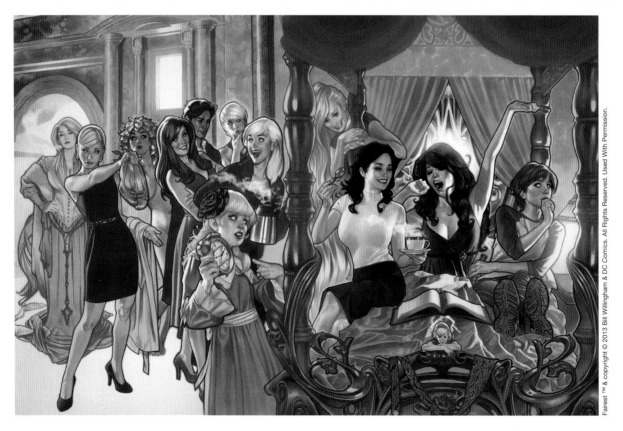

Adam Hughes
Art Director: Shelly Bond *Client:* Vertigo/DC Comics *Title:* Fairest #1 *Medium:* Media: Pencil, ink, marker, digital color

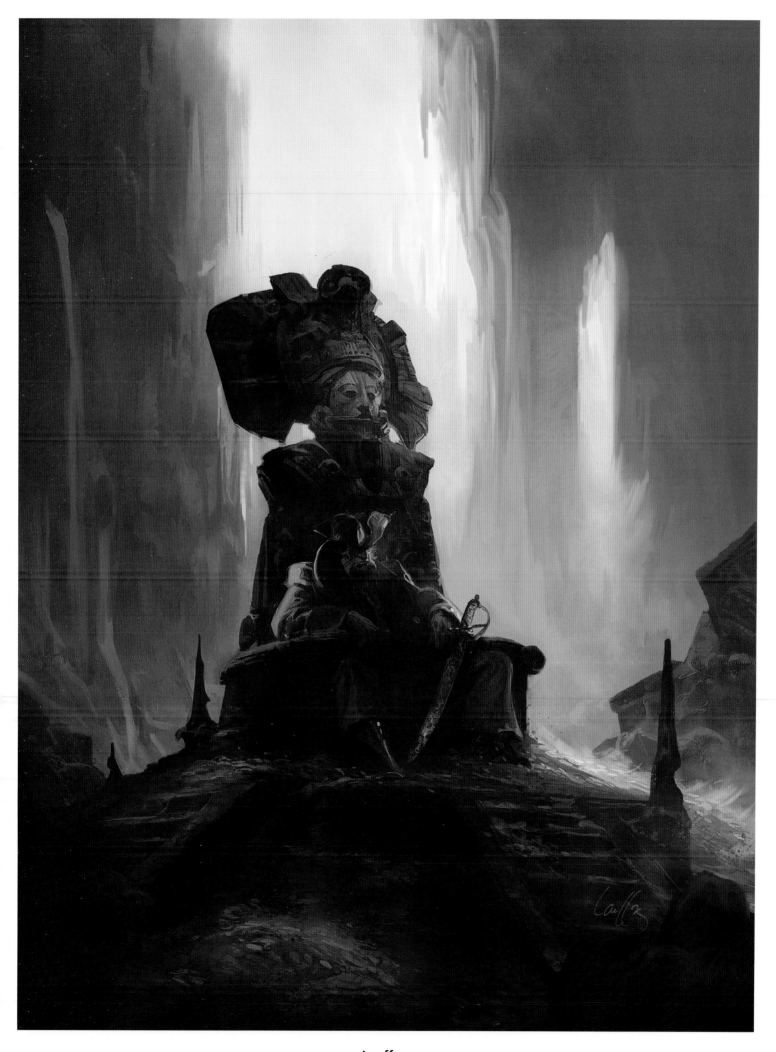

Lauffray
Client: Dargaud *Title:* Long John Silver #4 *Medium:* Digital

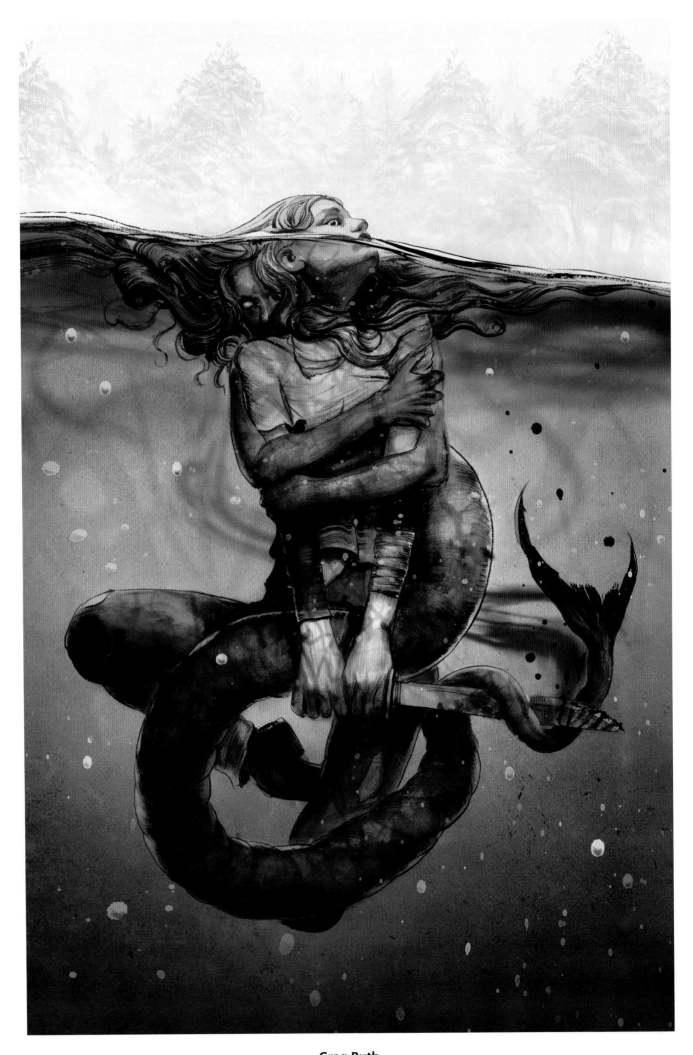

Greg Ruth

Art Director: Rachael Edidin *Client:* Dark Horse Comics *Title:* Alabaster #21 *Size:* 11"x17" *Medium:* Sumi ink/mixed

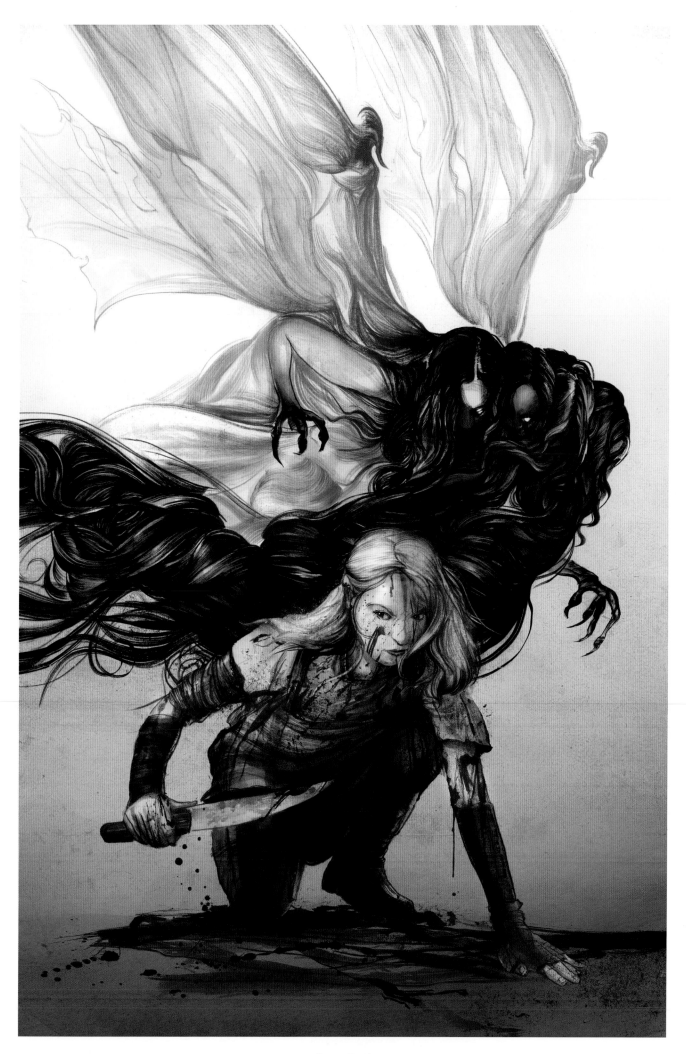

Greg Ruth
Art Director: Rachael Edidin *Client:* Dark Horse Comics *Title:* Alabaster Hardcover Collection *Size:* 11"x17" *Medium:* Sumi ink/mixed

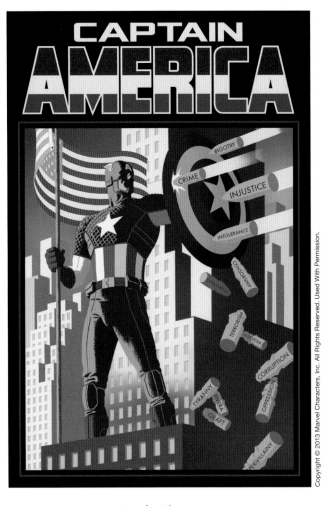

Paolo Rivera
Art Director: Tom Brevoort *Client:* Marvel Comics *Title:* Captain America #1
Size: 11"x17.25" *Medium:* Ink/digital

David Mack
Client: Marvel Comics *Title:* Daredevil: End of Days
Size: 9"x12" *Medium:* Mixed

Fabio Listrani
Client: IDW Publishing *Title:* Illustrated Masques *Medium:* Digital

Gus Storms
Title: Space Creep P.28 *Size:* 10"x13" *Medium:* Mixed/digital

Aleksi Briclot

Art Director: Eric Adams *Client:* Marvel & Subs. / DenA Co., Ltd. *Title:* War of Heroes: Emma Frost *Size:* 22.6cm x 28.2cm *Medium:* Digital

Joe Quinones

Art Director: Sana Amanat *Client:* Marvel Comics *Title:* Captain Marvel #11 *Size:* 10.25"x15.5" *Medium:* Ink/digital color

Joe Quinones
Art Director: Sana Amanat *Client:* Marvel Comics *Title:* Captain Marvel #12 *Size:* 10.25"x15.5" *Medium:* Ink/digital color

Arantza Sestayo

Title: Eleonora *Size:* 16.7"x20.5" *Medium:* Oil

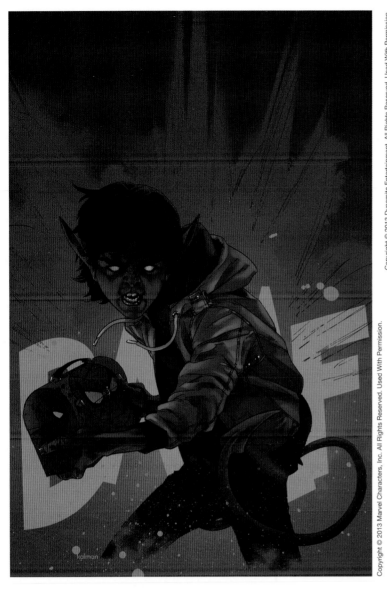

Kalman Andrasofszky

Art Director: Jeanne Schaefer *Client:* Marvel Comics
Title: X-treme X-Men #6 *Size:* 6.88"x12.44" *Medium:* Ink/digital color

Lucio Parrillo

Art Director: Josh Green *Client:* Dynamite Emt. *Title:* Vampirella #26
Size: 50"x70" *Medium:* Oil/digital

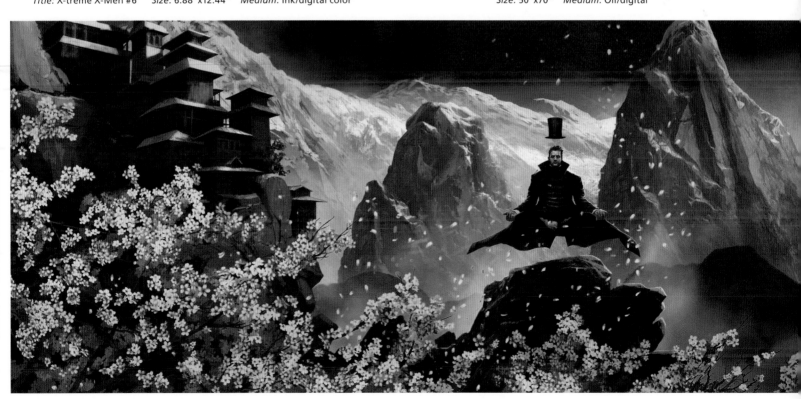

Vincent Proce

Art Director: Frank Beddor *Client:* Automatic Pictures *Title:* Natter M: The Zen of Wonder *Medium:* Digital

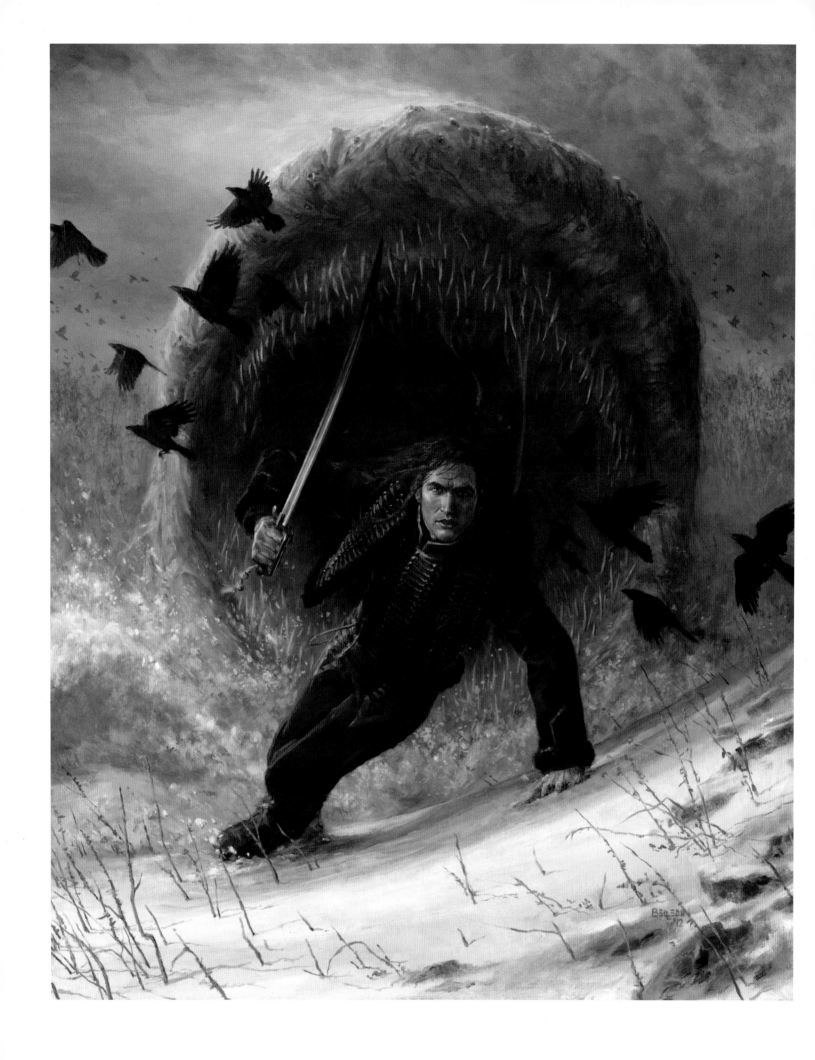

Steven Belledin

Art Director: Alex de Campi *Client:* Alex de Campi *Title:* Valentine *Size:* 16"x20" *Medium:* Oil

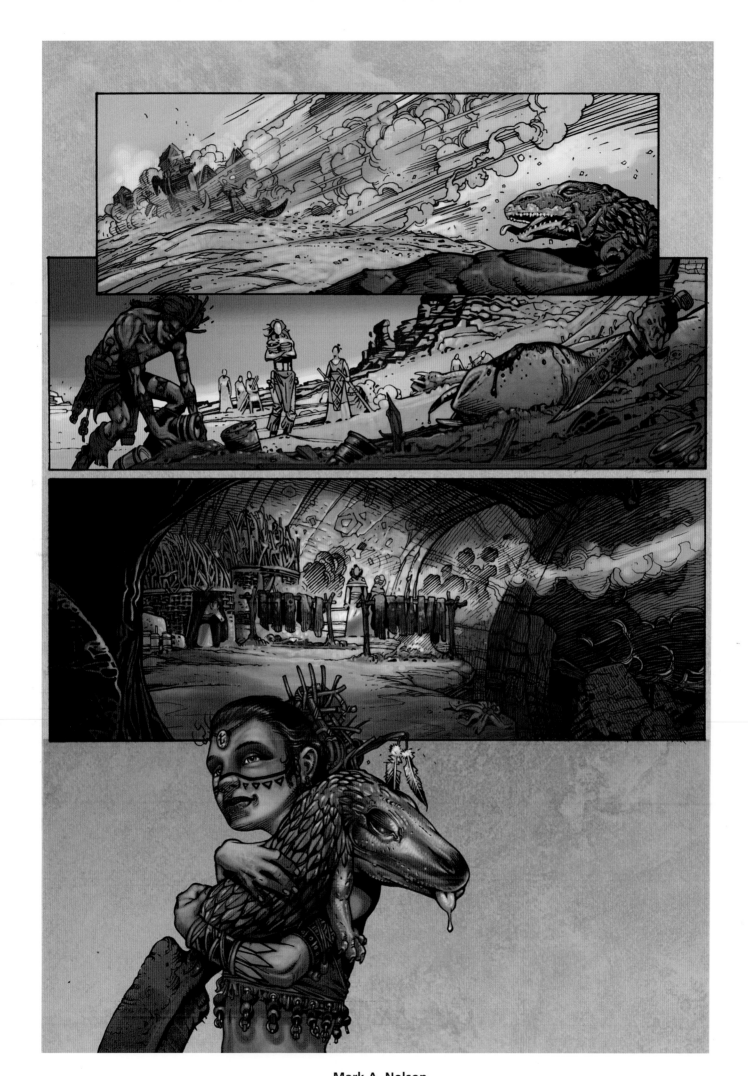

Mark A. Nelson

Art Director: Dave Elliot *Client:* Heavy Metal #259 *Title:* Bandits P.5 *Size:* 10.5"x15.5" *Medium:* Ink/digital

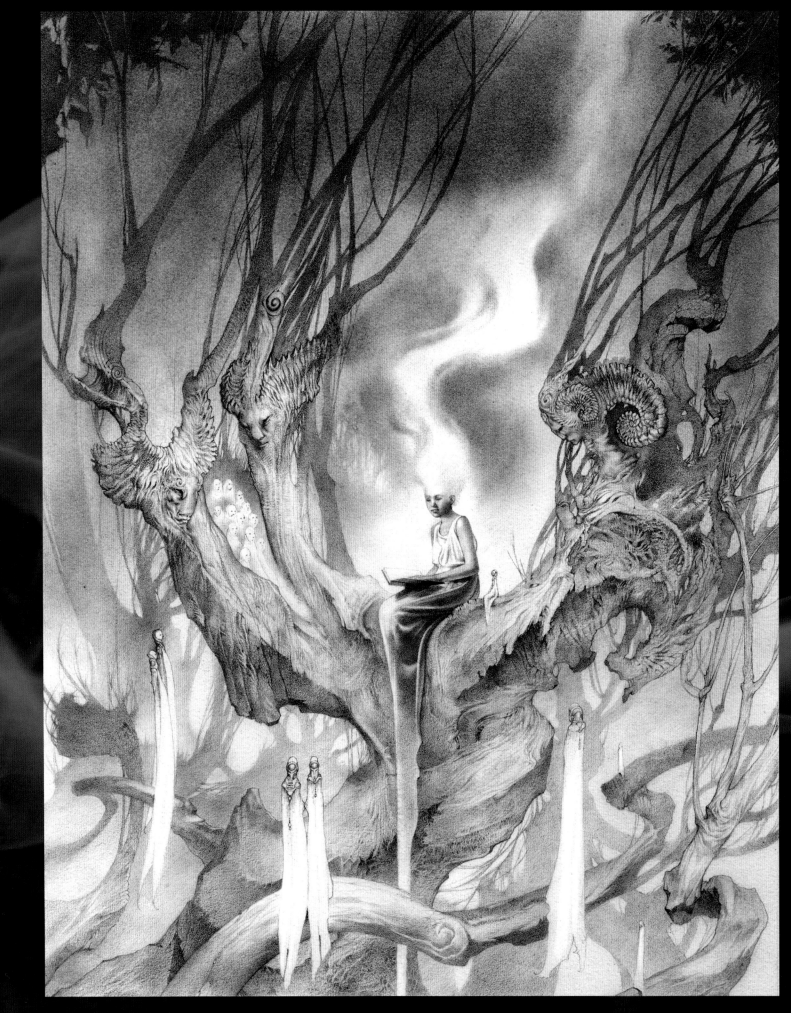

Allen Williams
Title: Tree of Tales *Size:* 14"x18" *Medium:* Graphite

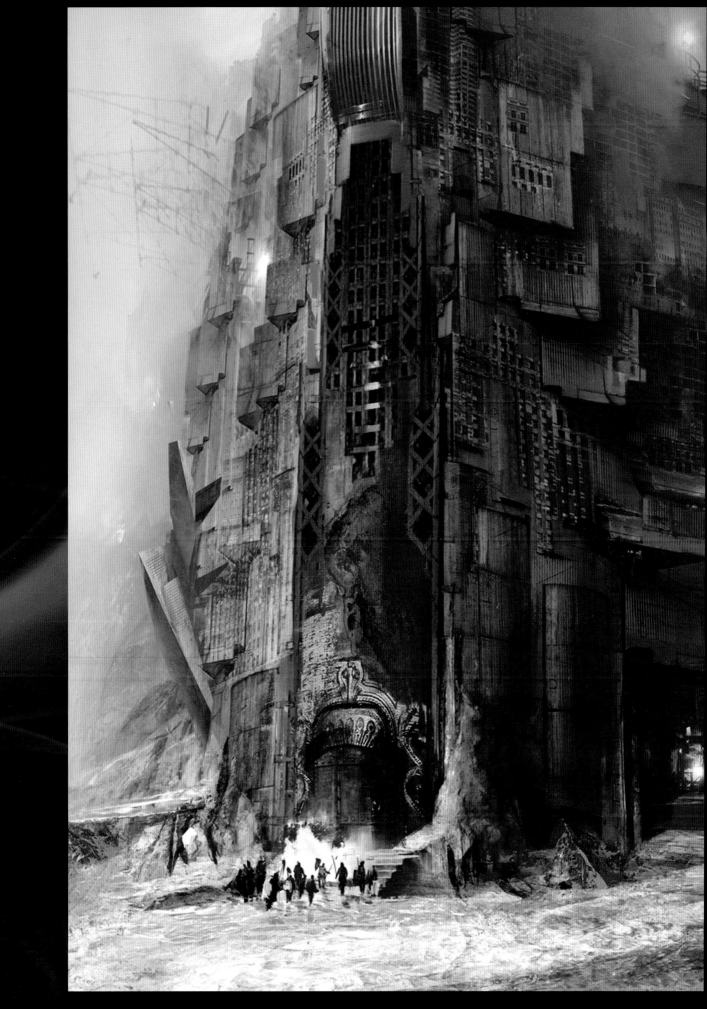

Daniel Dociu
Client: ArenaNet *Title:* Guild Wars 2: Norn Lodge *Medium:* Digital

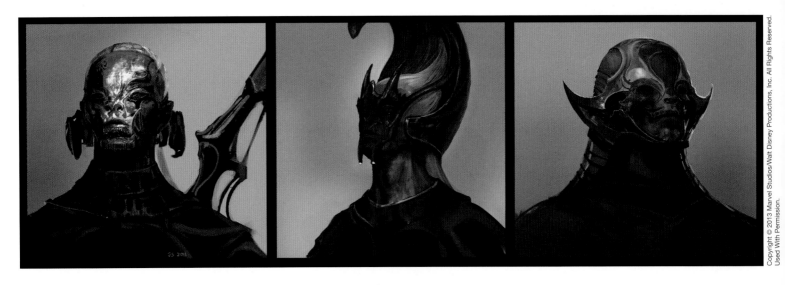

Justin Sweet
Art Director: Charlie Wen *Client:* Marvel Studios *Title:* Darkelves *Medium:* Digital

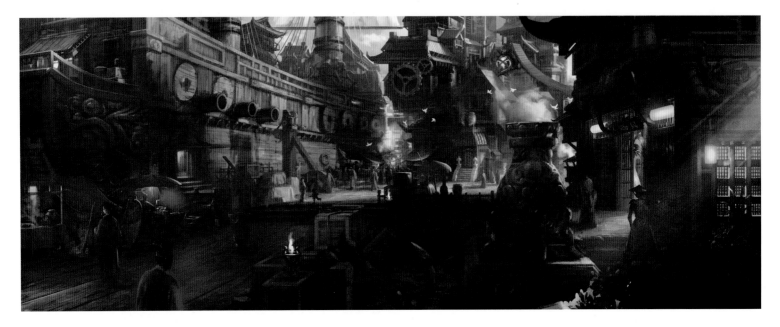

Jianbang Zhang
Title: City Series 02—The Wharf *Medium:* Digital

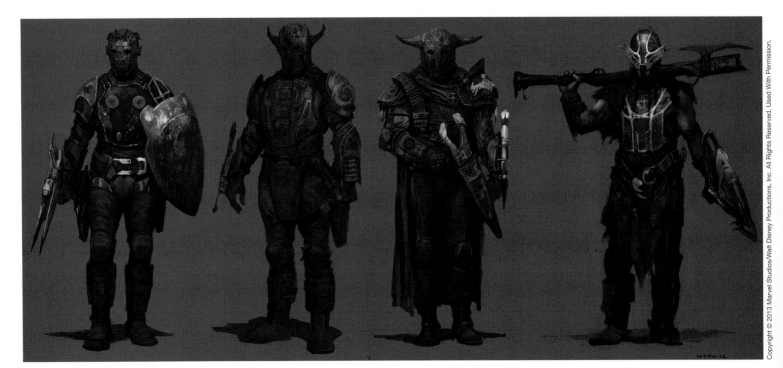

Justin Sweet
Art Director: Charlie Wen *Client:* Marvel Studios *Title:* Marauders *Medium:* Digital

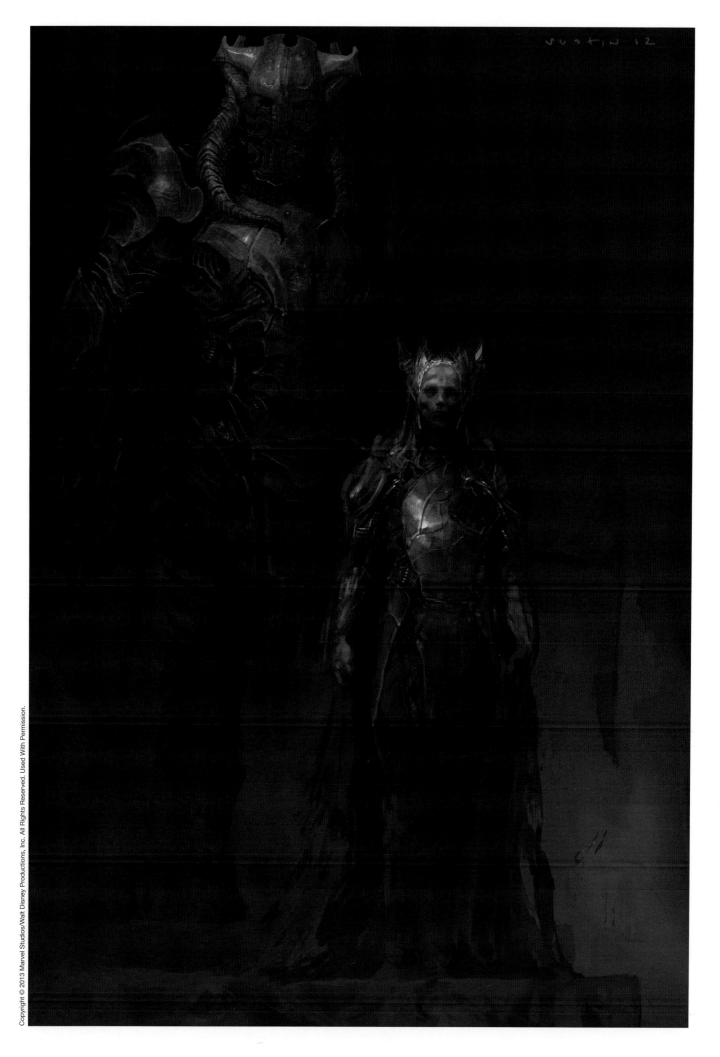

Justin Sweet

Art Director: Charlie Wen *Client:* Marvel Studios *Title:* Malekith & Alerim *Medium:* Digital

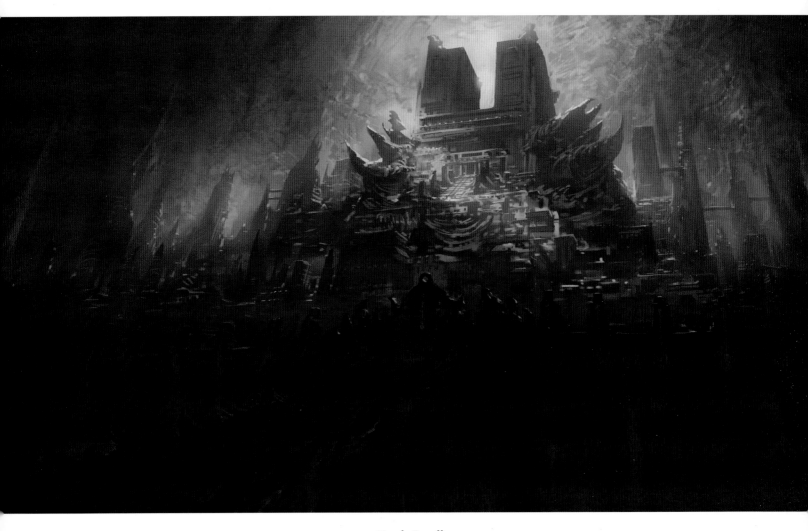

Noah Bradley
Title: The Desperate Lamentations *Size:* 16"x9" *Medium:* Digital

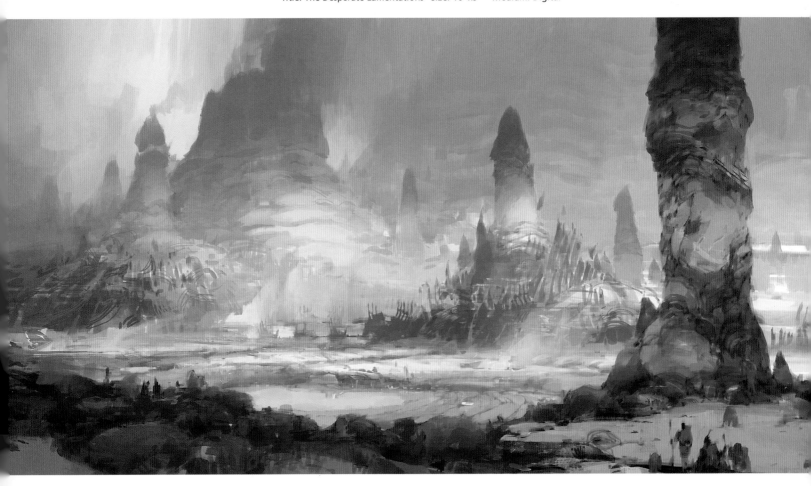

Theo Prins
Art Director: Daniel Dociu *Client:* ArenaNet *Title:* Southsun Cove *Medium:* Digital

Steven Sanders

Title: Falling *Size:* 17"x11" *Medium:* Graphite/digital

Brian Matayas

Art Director: Aron Luben *Client:* Kabam *Title:* Highway Officer *Medium:* Digital

Jean-Baptiste Monge
Art Director: Brian Pimental *Client:* Sony Pictures Animation *Title:* Rock-a-Bye Witches *Size:* 19.6"x14.7" *Medium:* Digital

Xiang Ling
Title: Port *Medium:* Digital

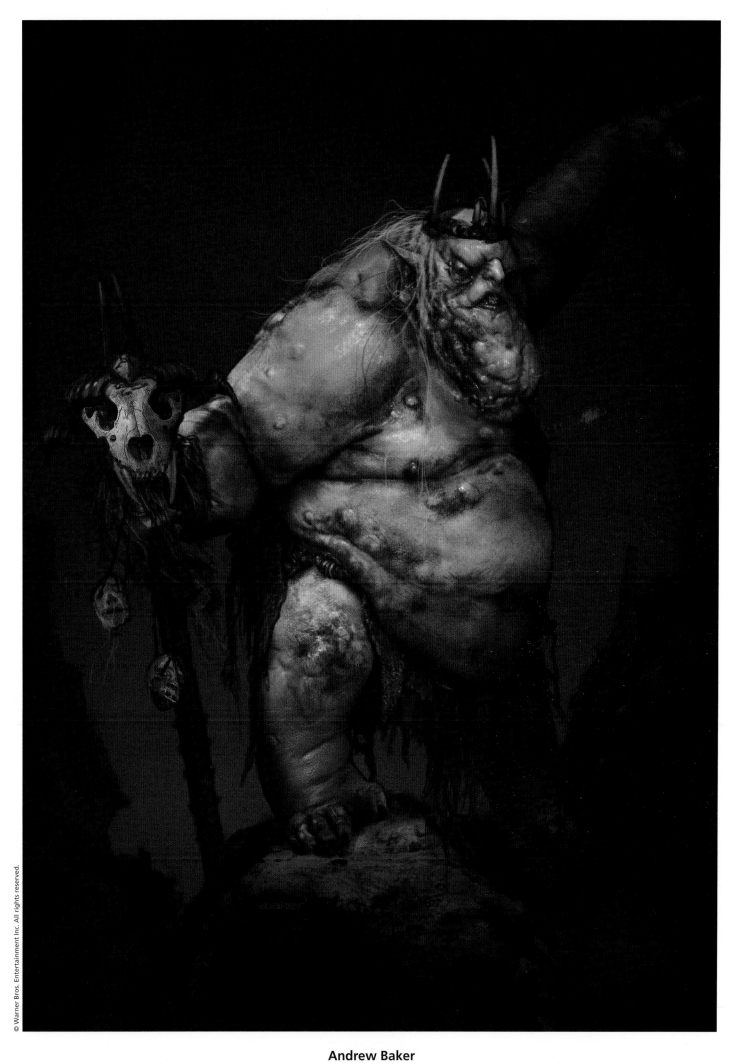

Andrew Baker
Art Director: Richard Taylor *Client:* Weta Workshop/Wingnut Films/Warner Bros. *Title:* Goblin King (Full Body) *Medium:* Digital

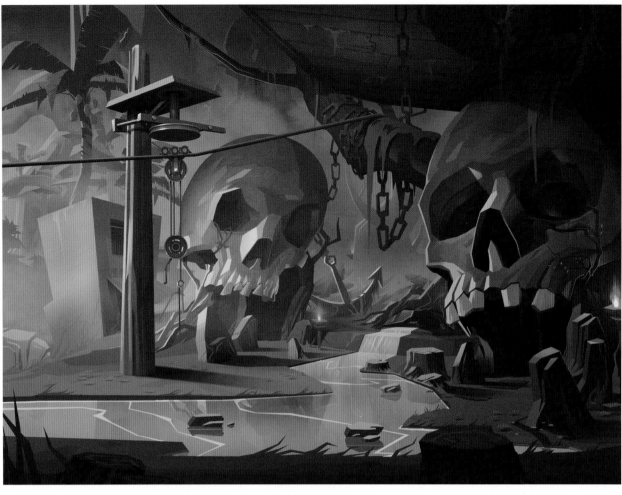

Soi H. Che
Art Director: Brian Thompson *Client:* Big Fish Games *Title:* Skull Island *Medium:* Digital

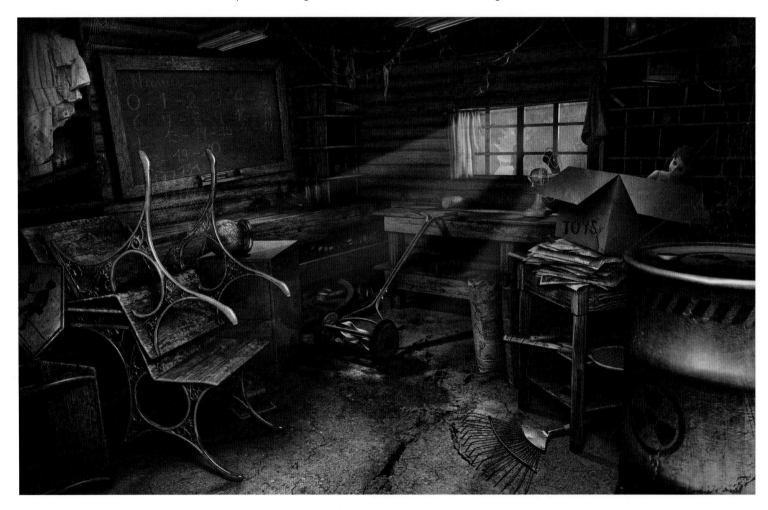

Lara Schneider
Art Director: David Stevenson *Client:* Big Fish Games *Title:* School Shed *Medium:* Digital

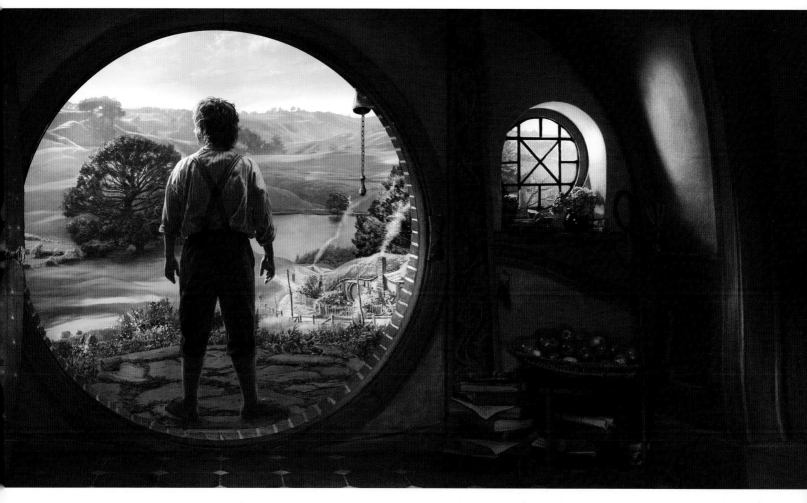

Gus Hunter

Art Director: Richard Taylor *Client:* Weta Workshop/Wingnut Films/Warner Bros. *Title:* Bilbo Baggins *Medium:* Digital

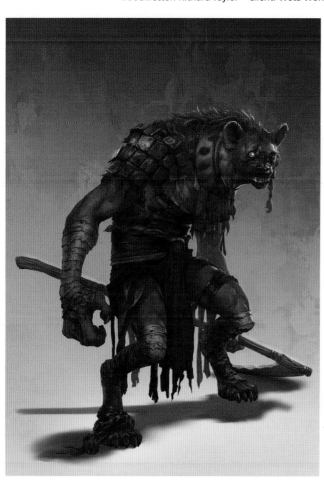

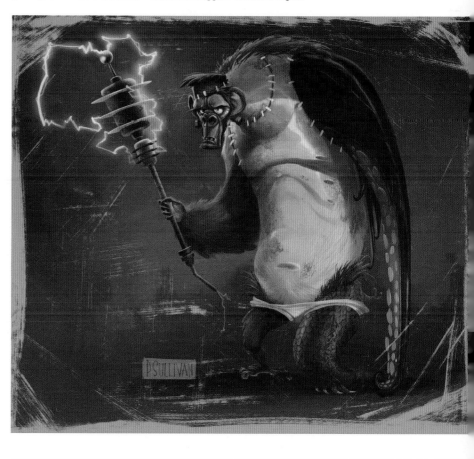

Conceptopolis

Art Director: Jon Schindehette *Client:* Wizards of the Coast
Title: Forgotten Realms Concepting *Size:* 8"x10" *Medium:* Digital

Paul Sullivan

Client: Sanzaru Games *Title:* Franken-animal Digital

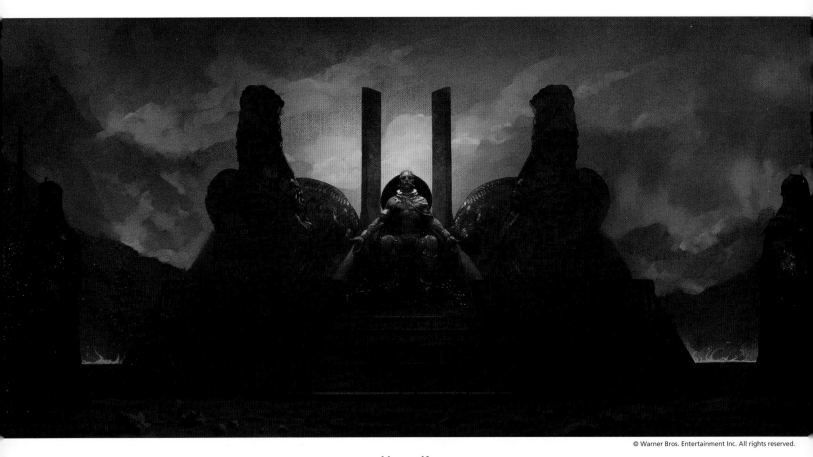

Vance Kovacs
Art Director: Patrick Tatopouios *Client:* Warner Bros. *Title:* Xerxes *Medium:* Digital

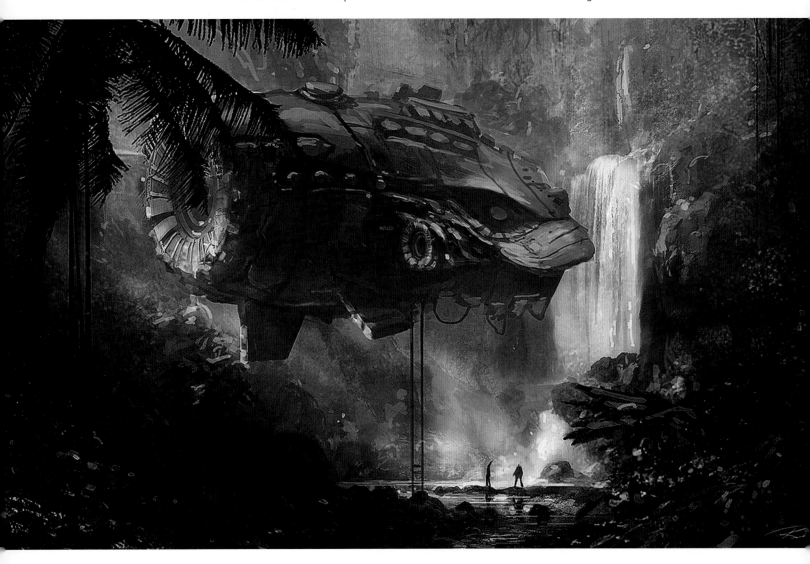

Rasmus Berggreen
Title: Jungle Ship *Medium:* Digital

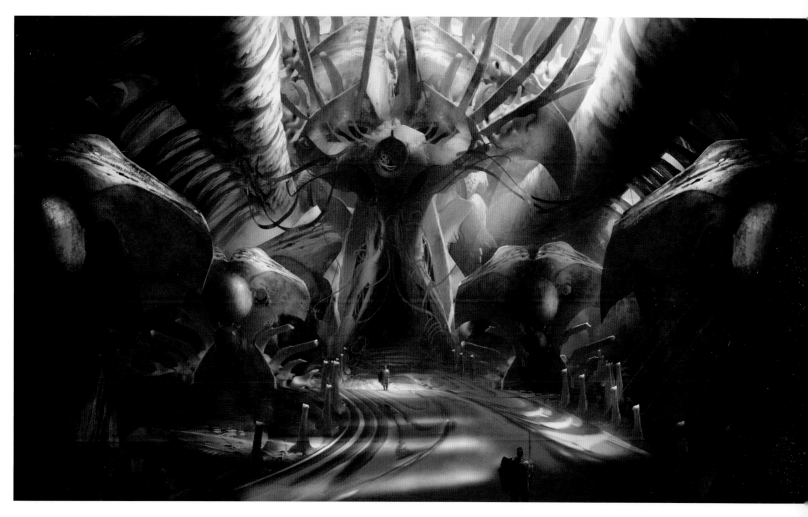

Levi Hopkins

Art Director: Darren Pattenden *Client:* Trion Worlds, Inc. *Title:* Palace Interior *Size:* 16"x9" *Medium:* Digital

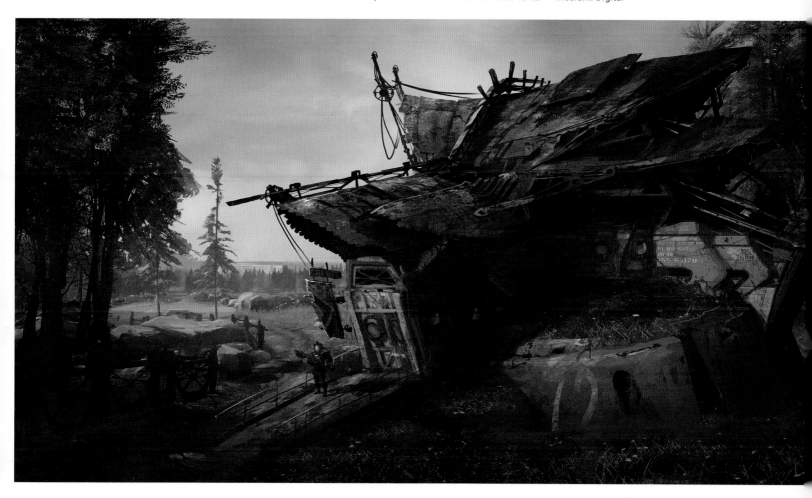

Jason Stokes

Client: FuturePoly *Title:* Mining Structure *Medium:* Digital

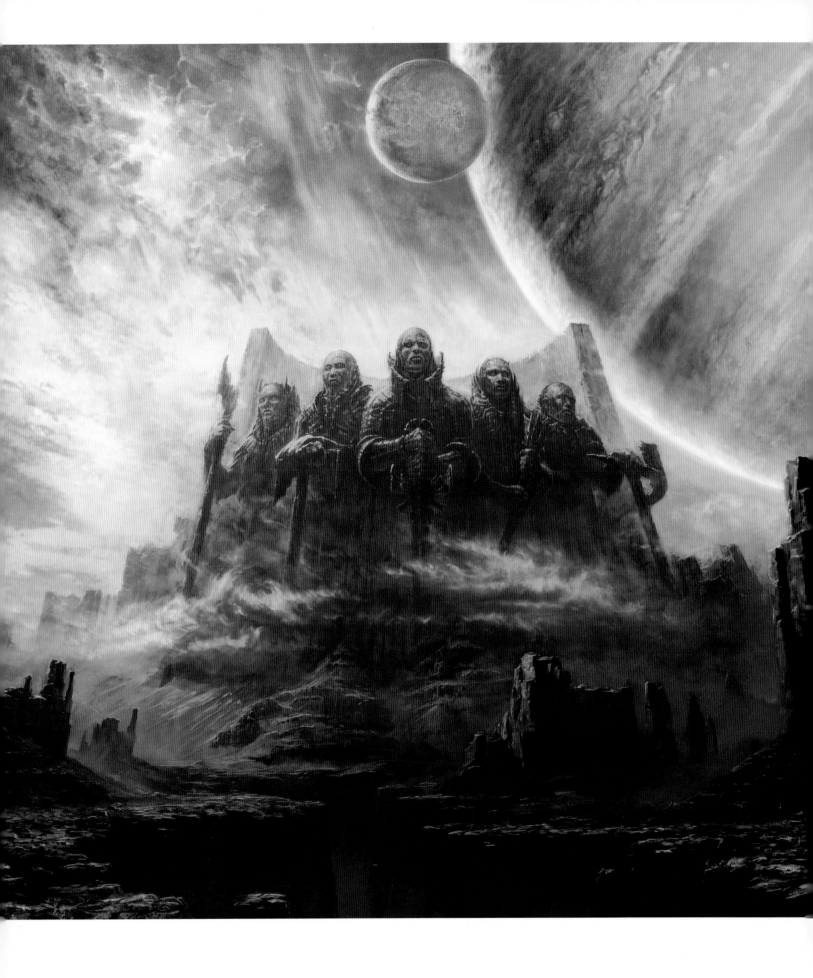

Nick Keller
Client: Kora *Title:* Lora *Medium:* Digital

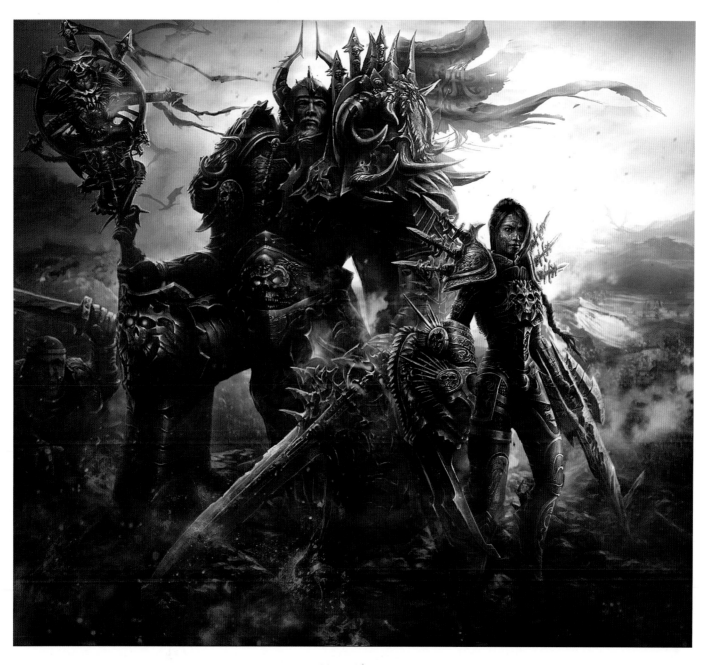

Yang Liang
Title: Old Marshal *Medium:* Digital

Chuan Zhong
Title: Concentration Camp *Medium:* Digital

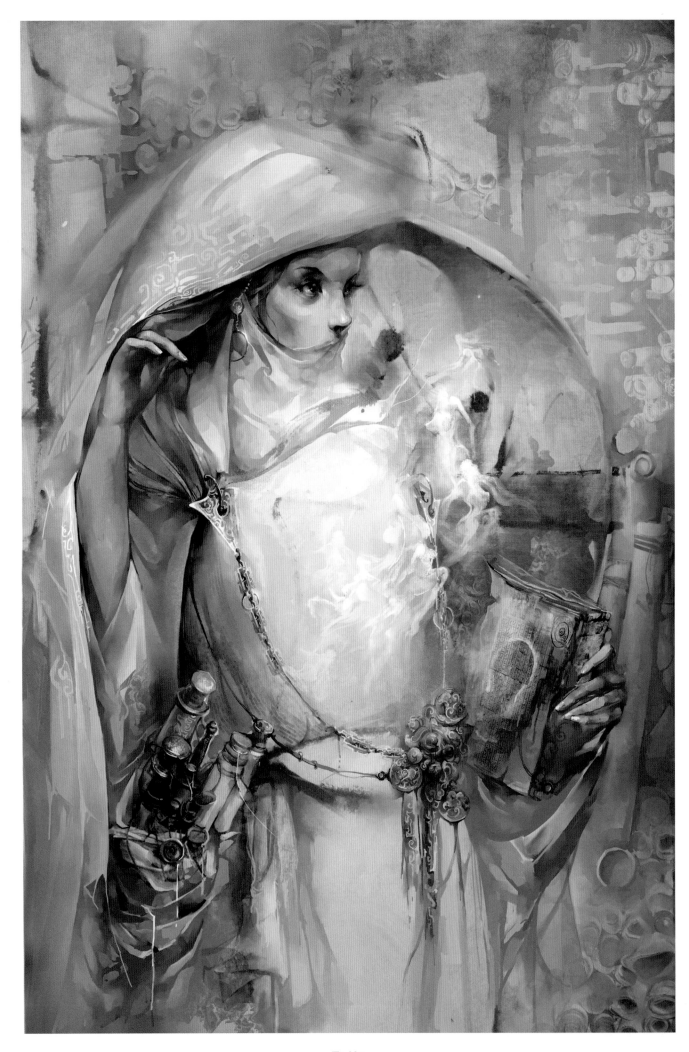

Te Hu
Title: Where Is My Soul? *Medium:* Digital

Brian Thompson
Client: Big Fish Games *Title:* Dark Ages—Fetch *Size:* 13"x19" *Medium:* Digital

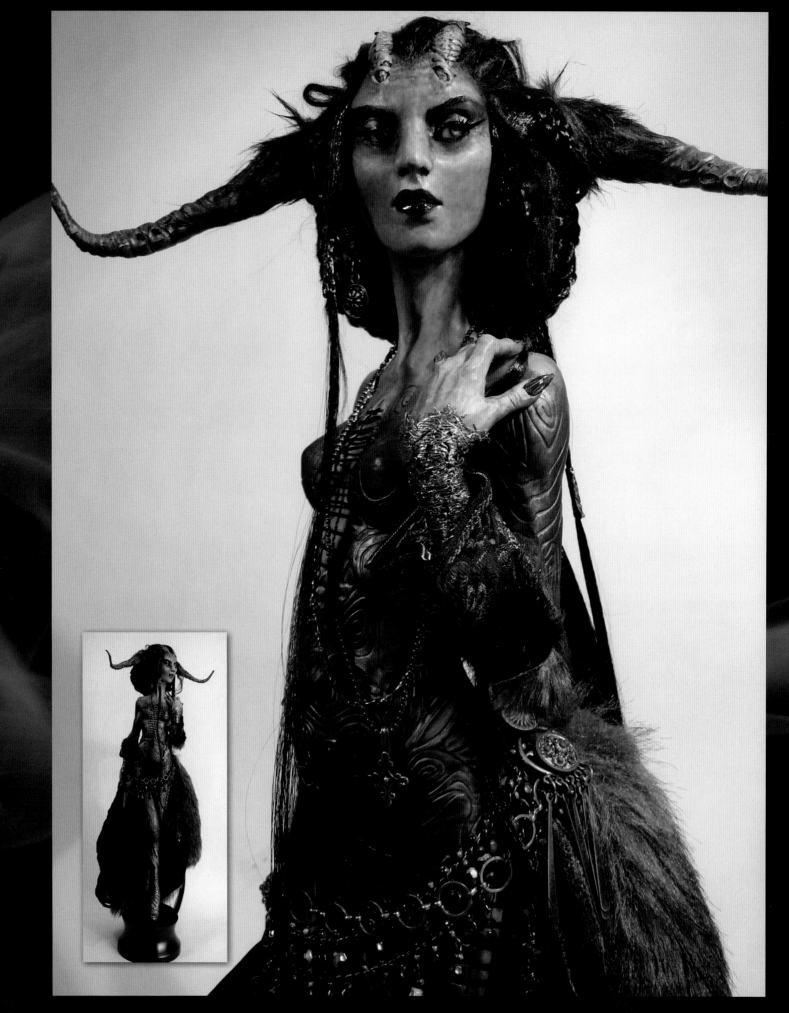

Virginie Ropars
Title: Acanthophis III *Size:* 62cm tall *Medium:* Mixed

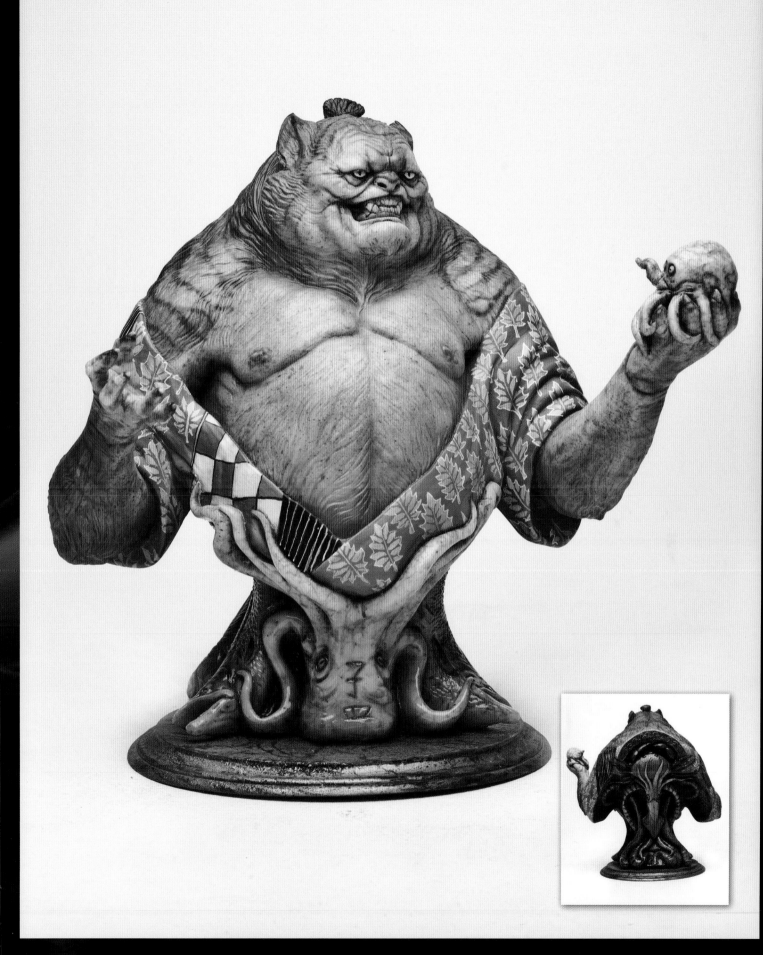

David Meng
Photographer: Tas Limur *Title:* Sashimi *Size:* 16"x17" *Medium:* Resin

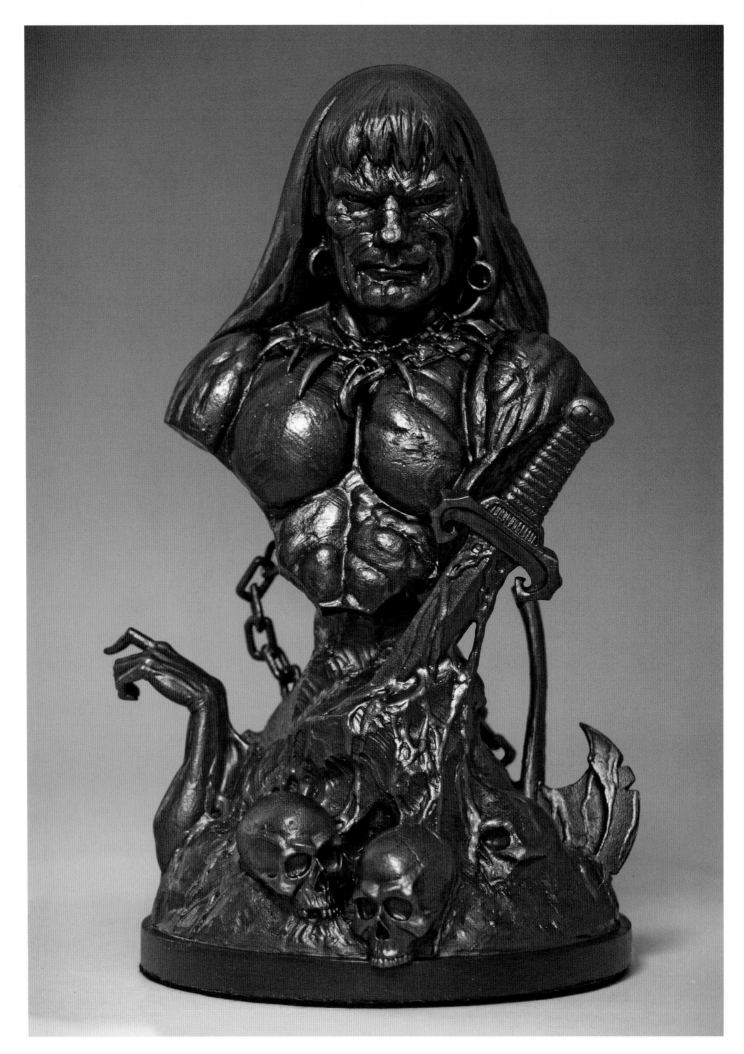

Tim Bruckner
Designer: Tim Bruckner and Frank Frazetta *Client:* Arnie & Cathy Fenner *Title:* The Barbarian *Size:* 9" tall *Medium:* Bronze finished resin

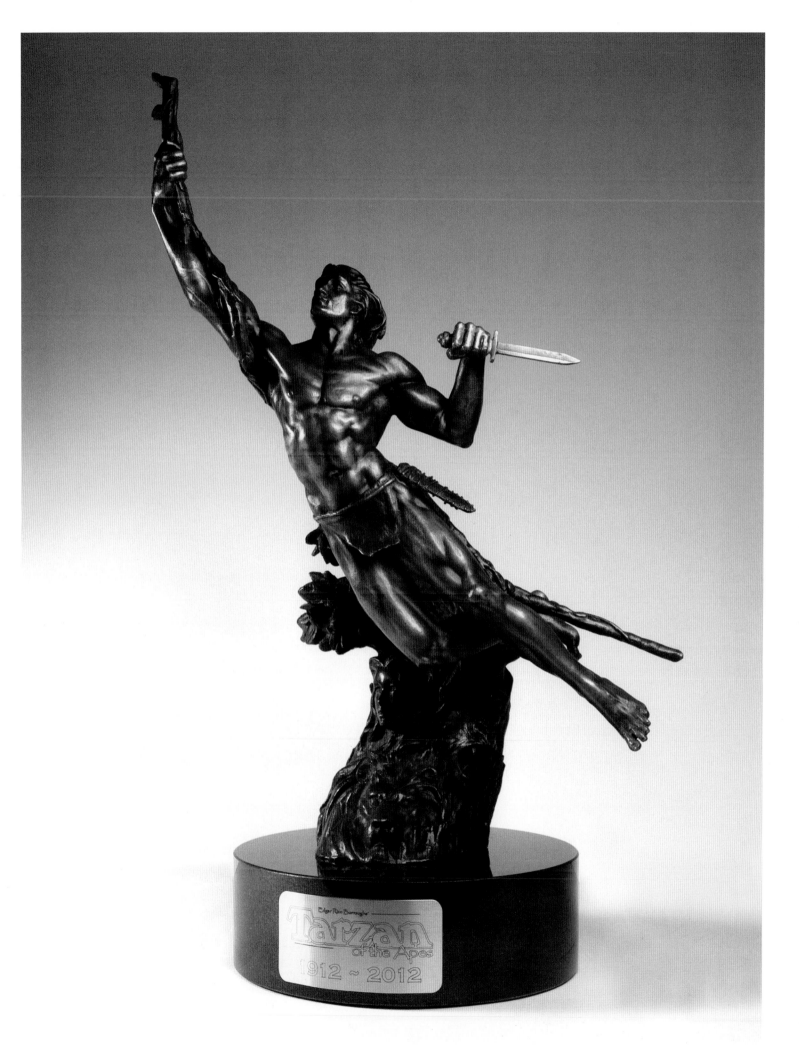

Joe DeVito

Art Director: Jim Sullos *Client:* Edgar Rice Burroughs, Inc. *Title:* Tarzan of the Apes Centennial Statue *Size:* 16" tall (w/base) *Medium:* Bronze

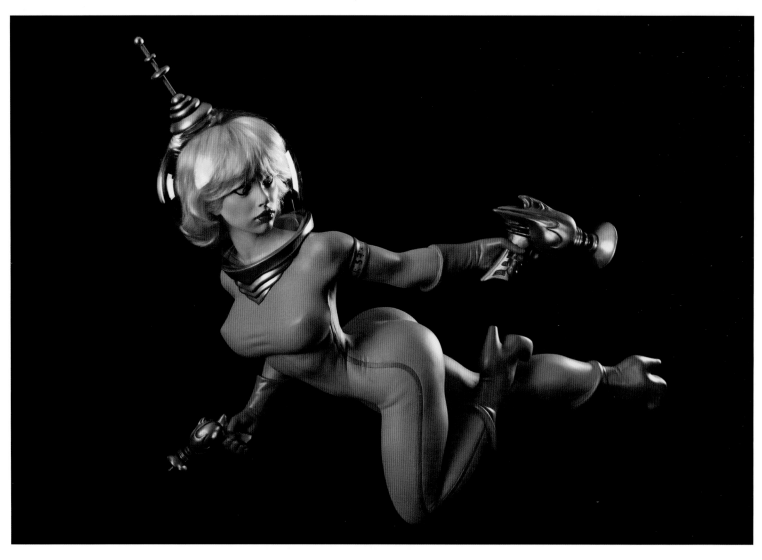

Mark Alfrey
Title: Rayla *Size:* 27" long *Medium:* Resin, acrylic, glass

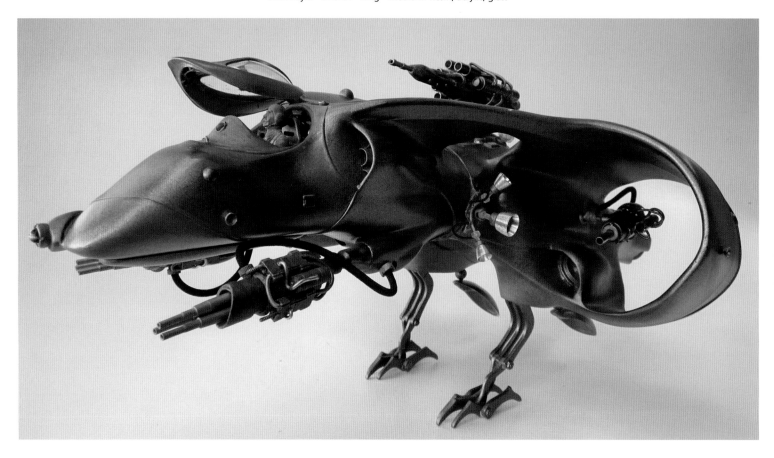

Steve Wheeler
Title: SKUA *Size:* 500mm long *Medium:* Fiberglass and plastic over foam fittings

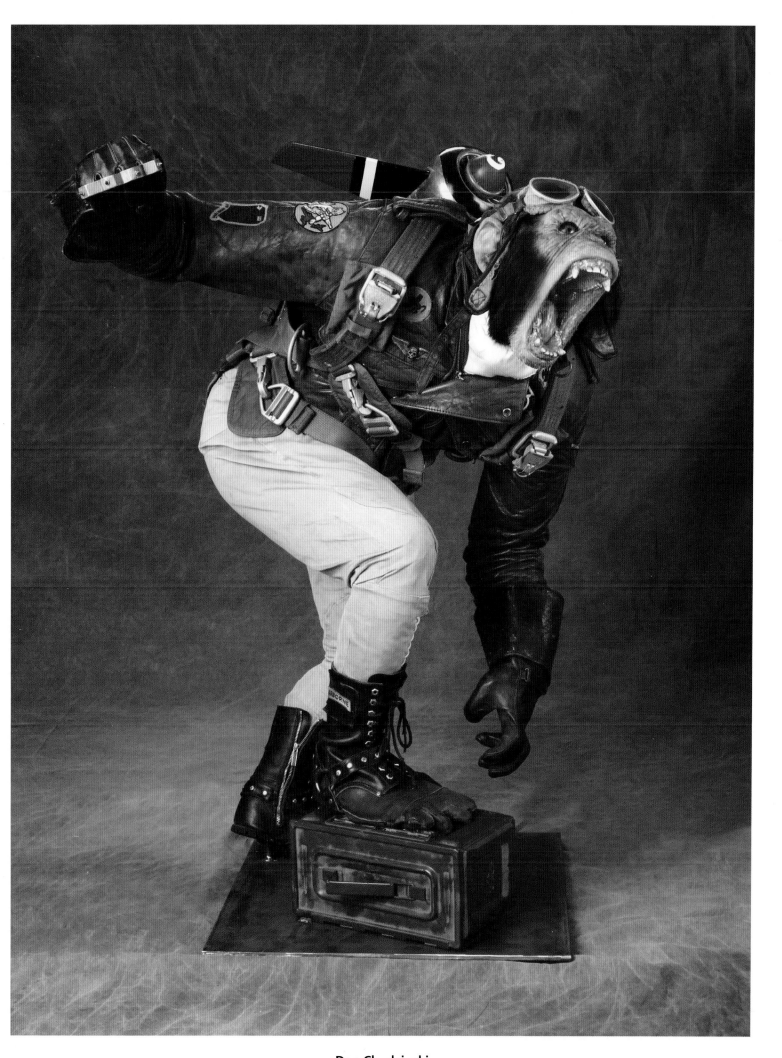

Dan Chudzinski

Photographer: Dave Casperson *Title:* Turbulence *Size:* 50"H x 44"W x 37"D *Medium:* Silicone, mixed

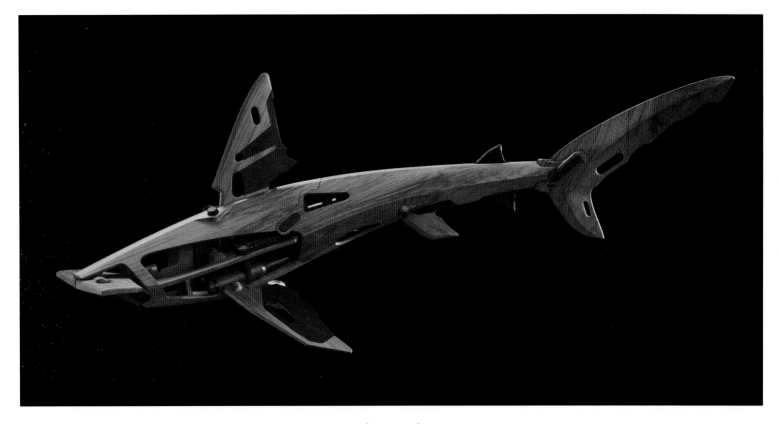

Stephen Lambert
Photographer: Steve Unwin *Title:* The Timber Beneath *Size:* 780x320x300cm *Medium:* Rimu, Jarrah

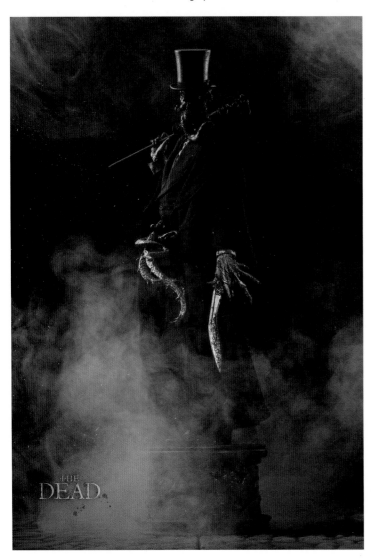

THE
DEAD

Martin Canale & The Gore Group
Paint: Anthony Mestas/Tom Gilliland *Designer:* Tom Gilliland/Paul Komoda
Photographer: Ginny Guzman/Jeanette Villarreal *Title:* The Dead: Jack the Ripper
Size: 25.5"H *Medium:* Polystone/resin

Virginie Ropars
Title: Mothra *Medium:* Polymer clay, mixed

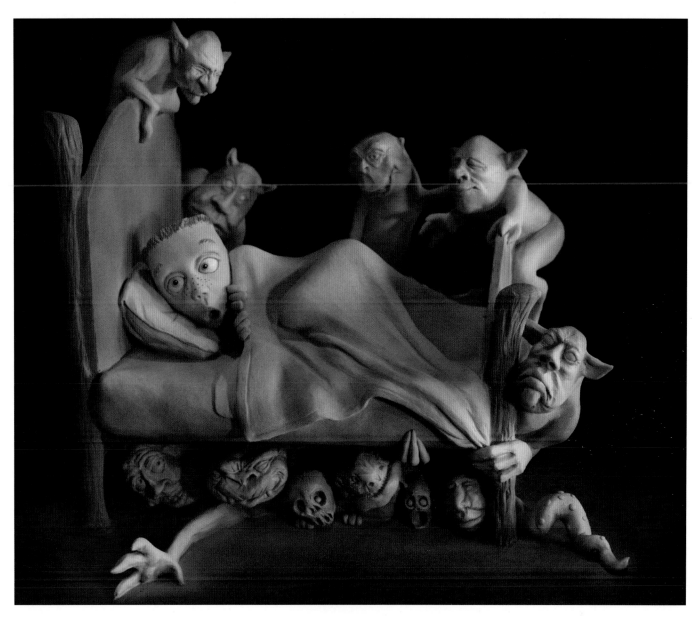

Randy Hand
Title: Nighty Night *Size:* 13"Wx13"Dx11"H *Medium:* Clay

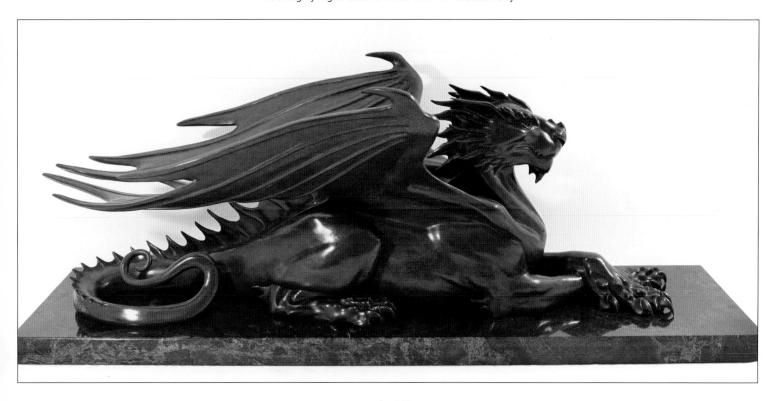

Paul Kidby
Title: Feldspar *Size:* 76x31x25cm *Medium:* Bronze

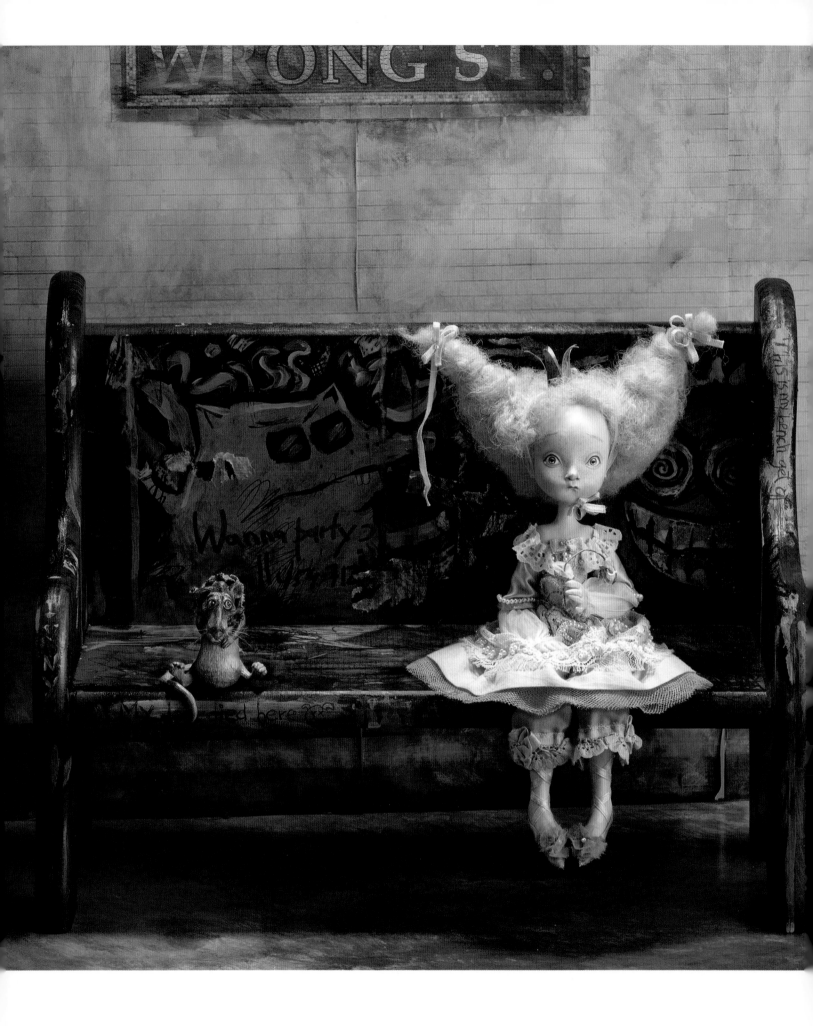

Katya Tal
Photographer: Brooks Ayola *Title:* Lost Princess *Size:* 13"Wx10"H *Medium:* Mixed

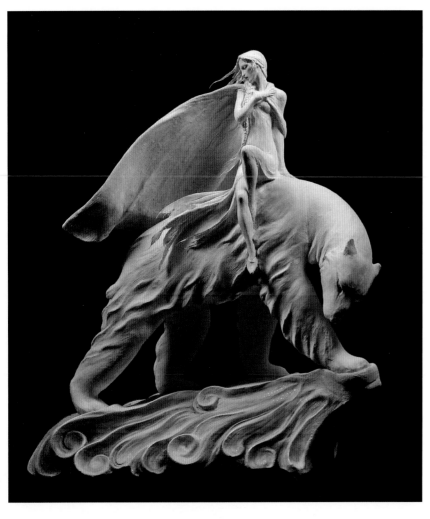

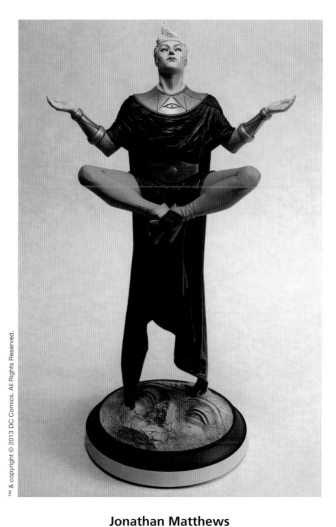

Jonathan Matthews
Art Director: Shawn Knapp *Designer:* Jae Lee *Client:* DC Collectibles
Title: Ozymandias *Size:* 12"H *Medium:* Painted resin

Forest Rogers
Title: East of the Sun *Size:* 12"x14" *Medium:* Premier Air-Dry Clay

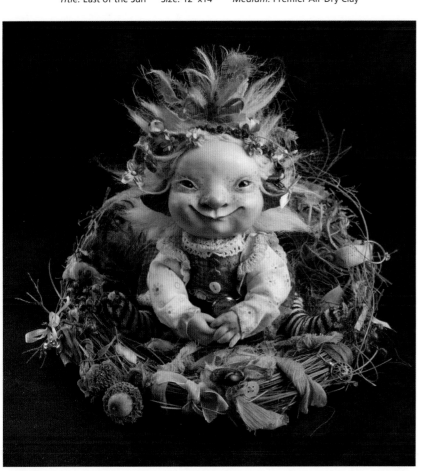

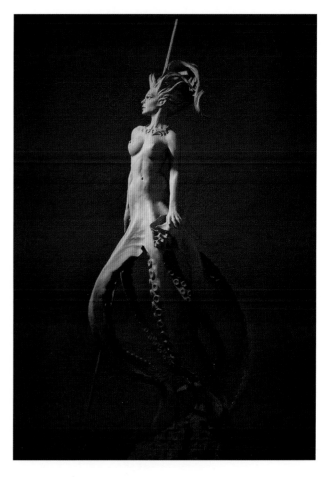

Katya Tal
Art Director: Bobby Shanes *Photographer:* Brooks Ayola *Title:* Blanket Fairy
Size: 7"H *Medium:* Mixed

Devon Dorrity
Photographer: Melissa Papaj *Title:* Queen of the Seas
Size: 24"x24"x72" *Medium:* Clay

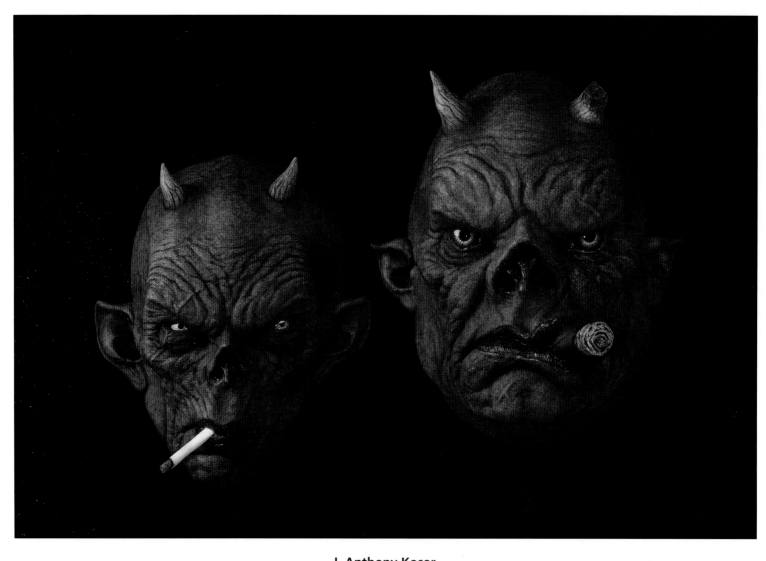

J. Anthony Kosar
Photographer: Bear McGivney *Title:* Smokey Joe & The Inferno *Size:* SJ: 11"Wx12"Hx6.5D / I: 12"Wx14"Hx8.5"D *Medium:* Rubber latex, acrylic, epoxy

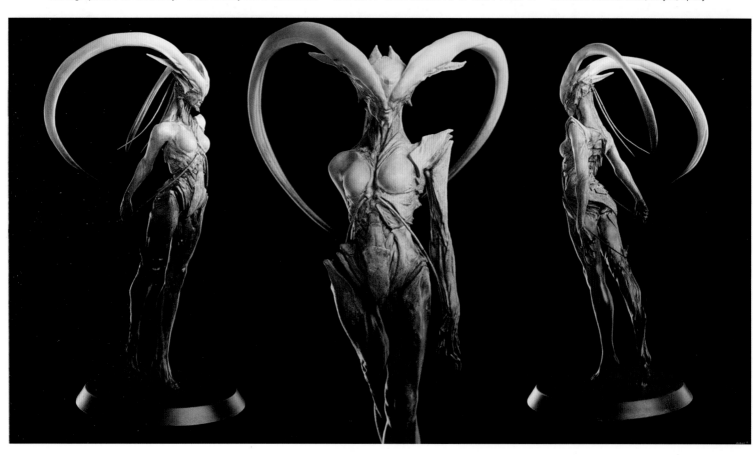

Andrew Baker
Photographer: Steve Unwin *Title:* Demon Girl *Size:* 10" *Medium:* 3D Printer

The Shiflett Bros.
Photographer: Chad Michael Ward *Title:* Lulu the Destroyer *Size:* 11"H *Medium:* Super Sculpey Firm

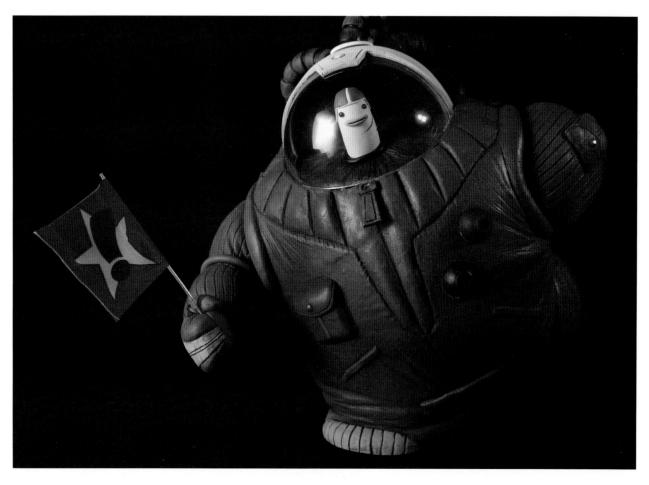

Dave Pressler
Title: Cosmonaut Monkey Explores New Worlds *Size:* 11"Hx10"W *Medium:* Super Sculpey

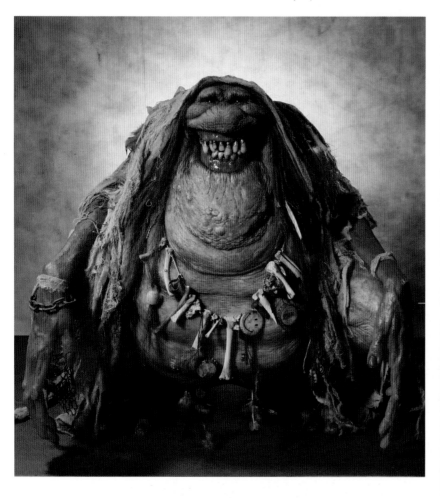

Thomas S. Kuebler
Title: Sewer Dweller *Size:* 19"H *Medium:* Resin/mixed

Lee Joyner
Title: Attitudinal Imp *Size:* 11"H *Medium:* Clay

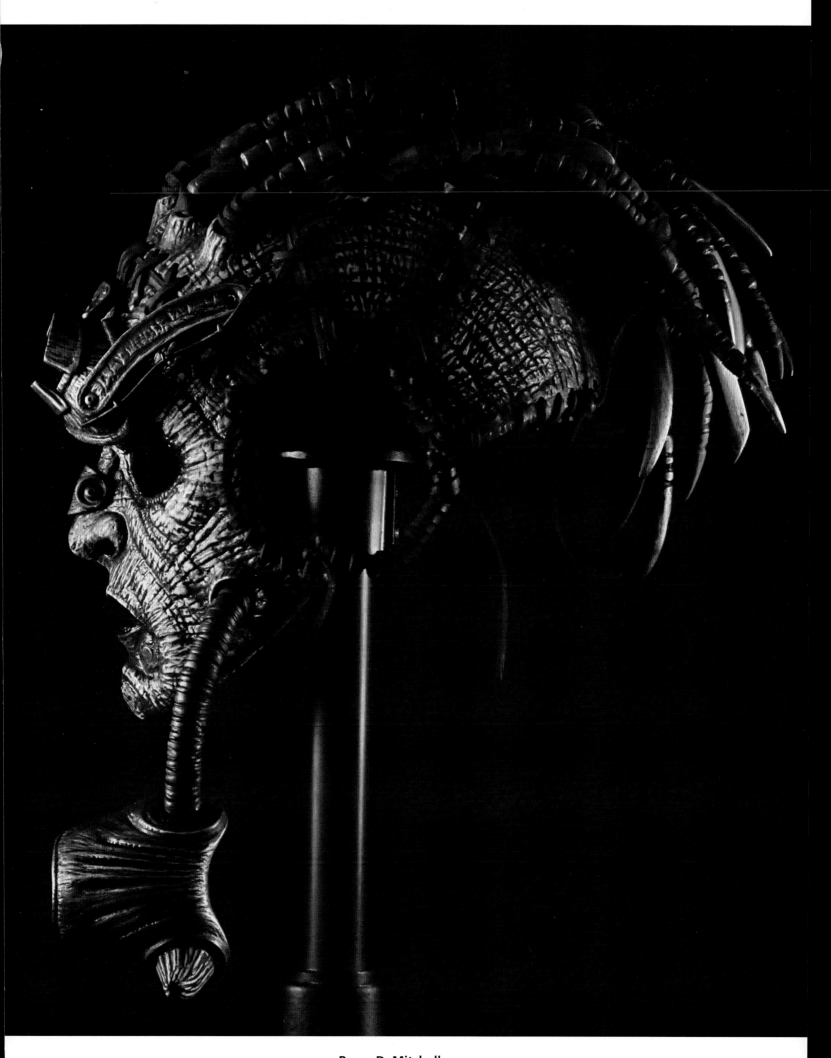

Bruce D. Mitchell

Photographer: Steven Munson *Title:* Dreadtennae *Size:* 9"Wx16"Lx12"H *Medium:* Mixed

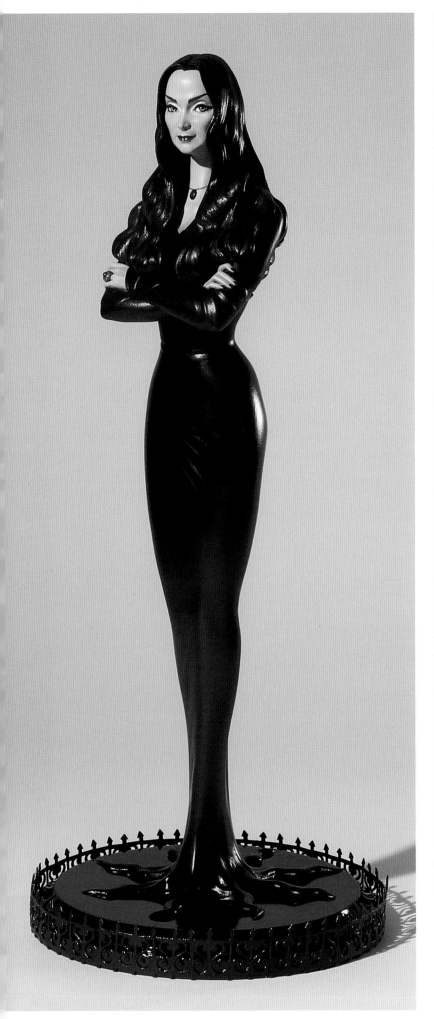

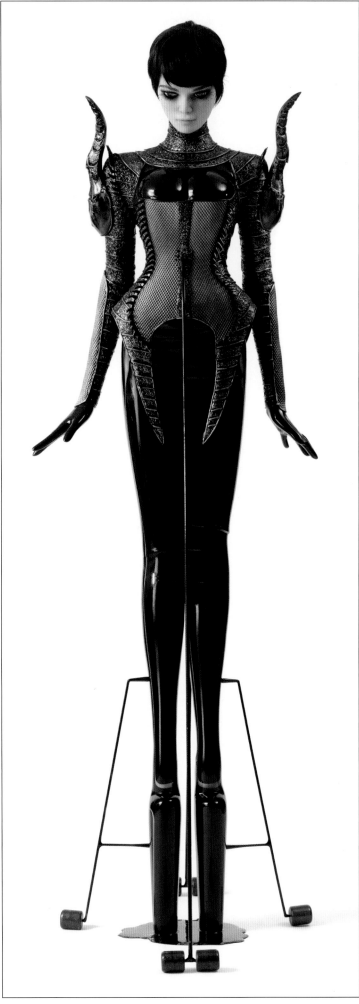

Michael Defeo
Designer: Serge Birault Client: MD 3D, Inc. *Title:* Morticia
Size: 15"Hx6"Wx6"D *Medium:* Resin, acrylic

Colin Christian
Title: Zoofy
Size: 7' *Medium:* Fiberglass, silicone, steel

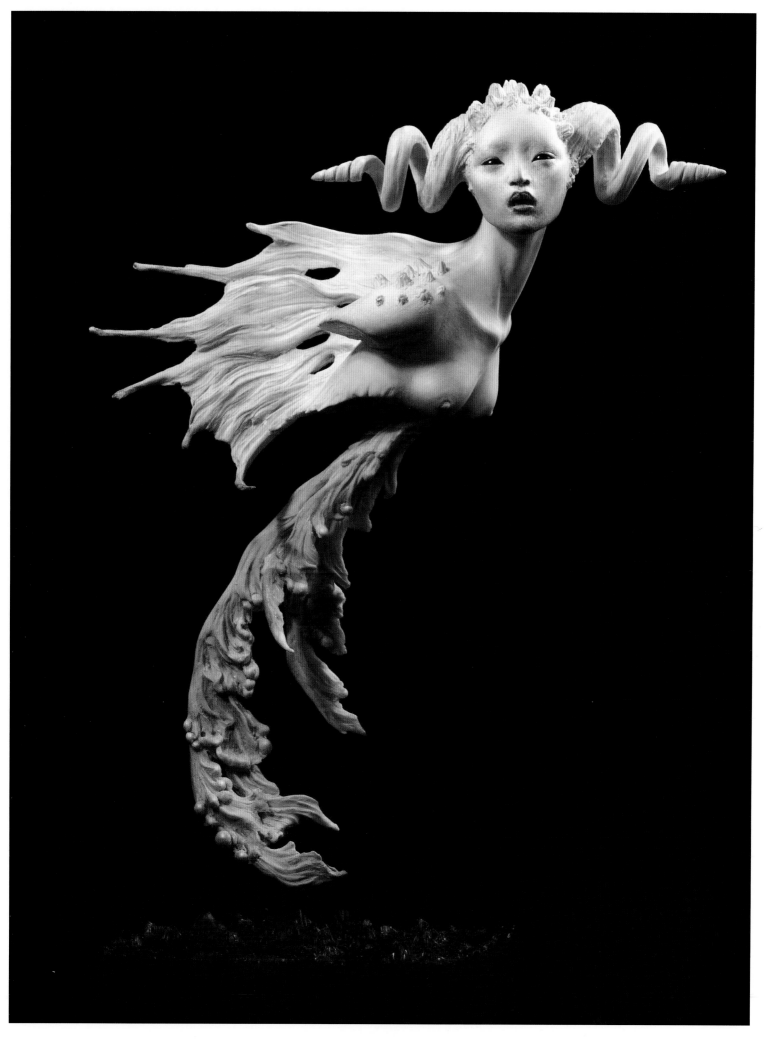

Forest Rogers

Title: Horned Fragment *Size:* 11"H *Medium:* Polymers

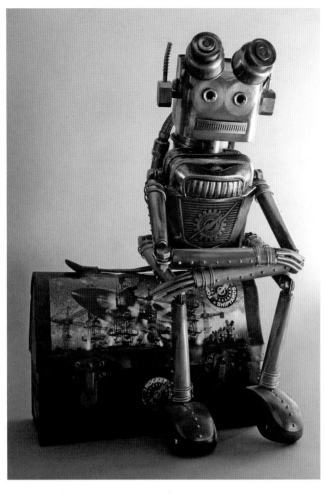

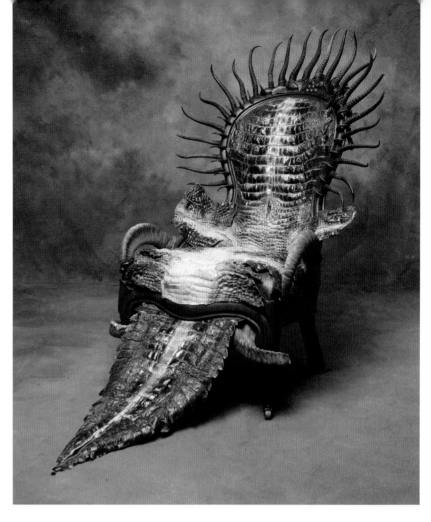

Dan Chudzinski
Photographer: Dave Casperson *Title:* The Reliquary of St. George *Size:* 45"Hx33"Wx52"D
Medium: Horns, alligator hide, wood

Steven Welter
Title: Lunch Break Bot *Size:* 11"x10"x17" *Medium:* Mixed

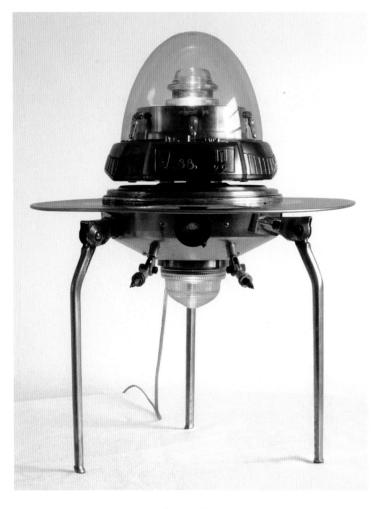

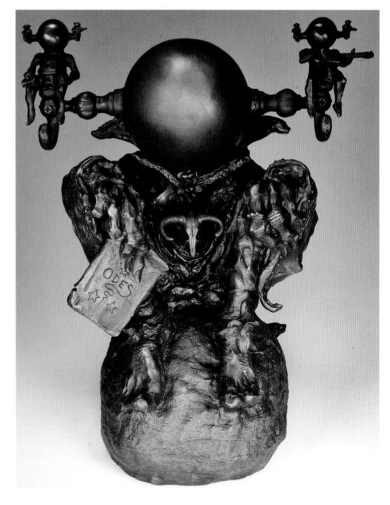

Jesse Gee
Title: Lunar Probe Scout *Size:* 25"x16"x16" *Medium:* Mixed [found objects]

Vincent Villafranca
Title: Spaceman On the Verge *Size:* 15"H *Medium:* Bronze

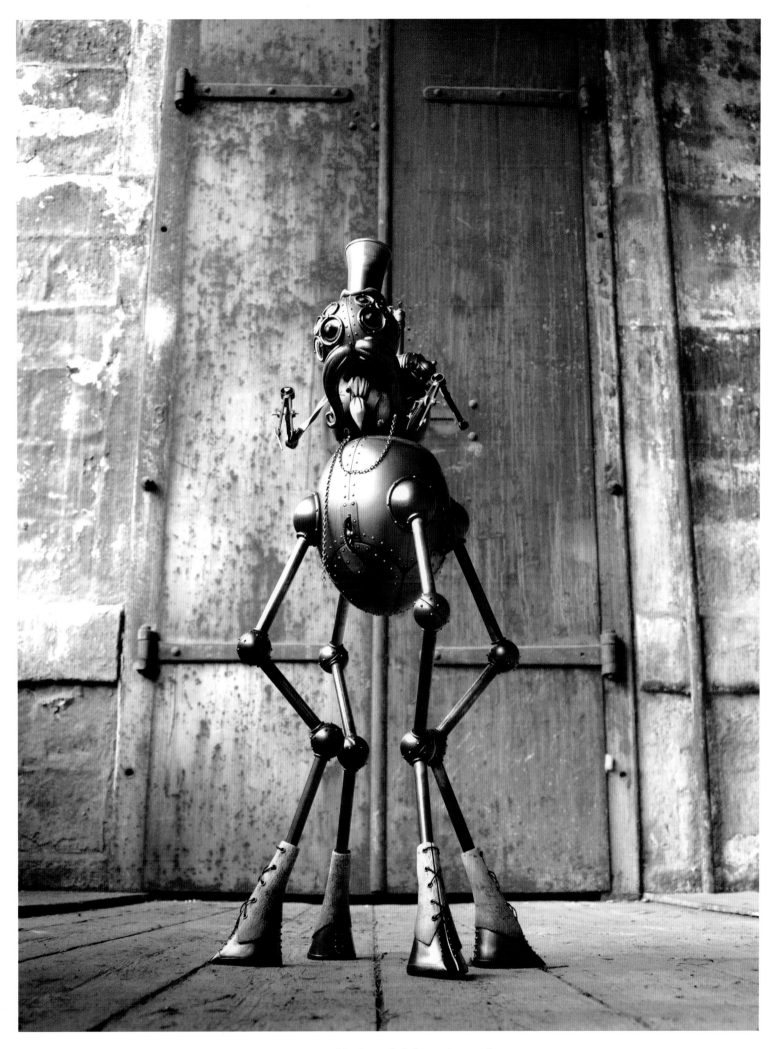

Bruce Whistlecraft (aka Doktor A.)
Title: Harry K Nidd *Size:* 28"H *Medium:* Mixed

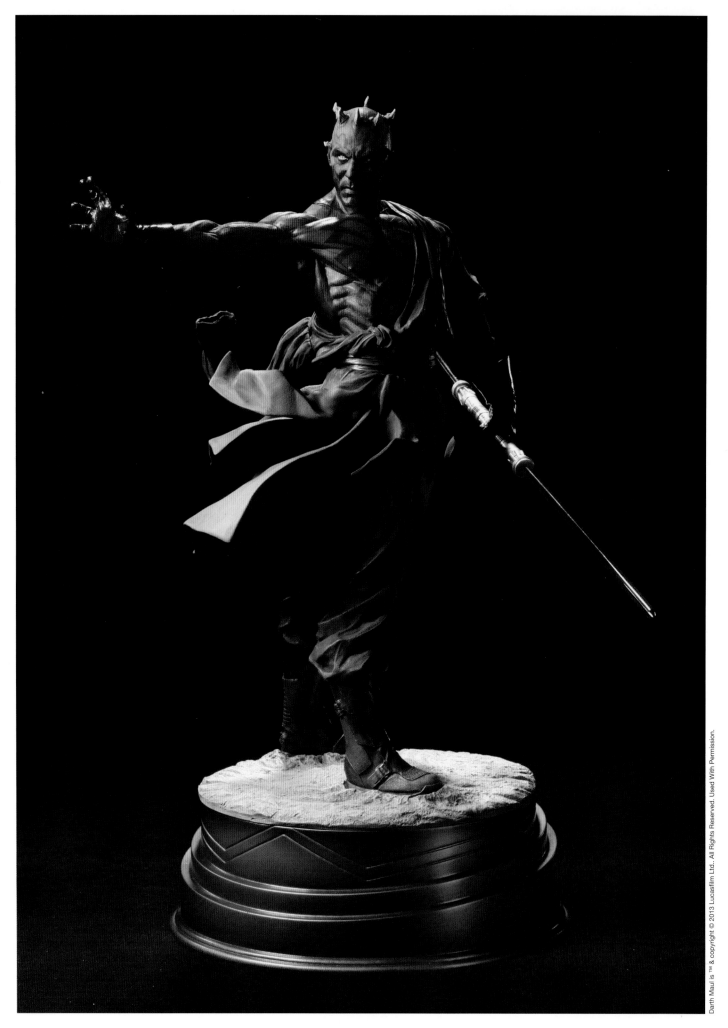

Walter O'Neal

Art Director: Tom Gilliland/David Ioo *Paint:* Sandy Shaffer *Photographer:* Ginny Guzman *Client:* Sideshow Collectibles
Title: Mythos - Darth Maul: Dark Disciple *Size:* 18"H *Medium:* Resin

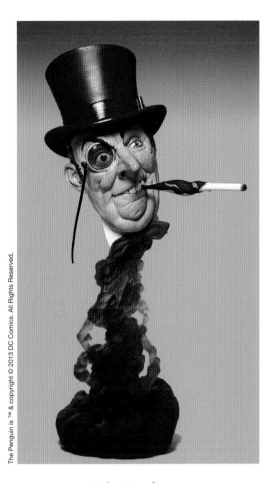

Tim Bruckner
Size: 13"H *Medium:* Painted resin

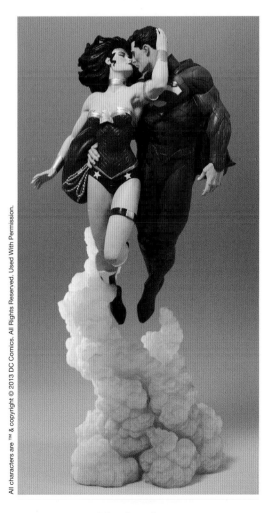

Tim Bruckner
Art Director: Shawn Knapp *Designer:* Jim Lee
Client: DC Collectibles *Title:* The Kiss
Size: 15.5"H *Medium:* Painted resin

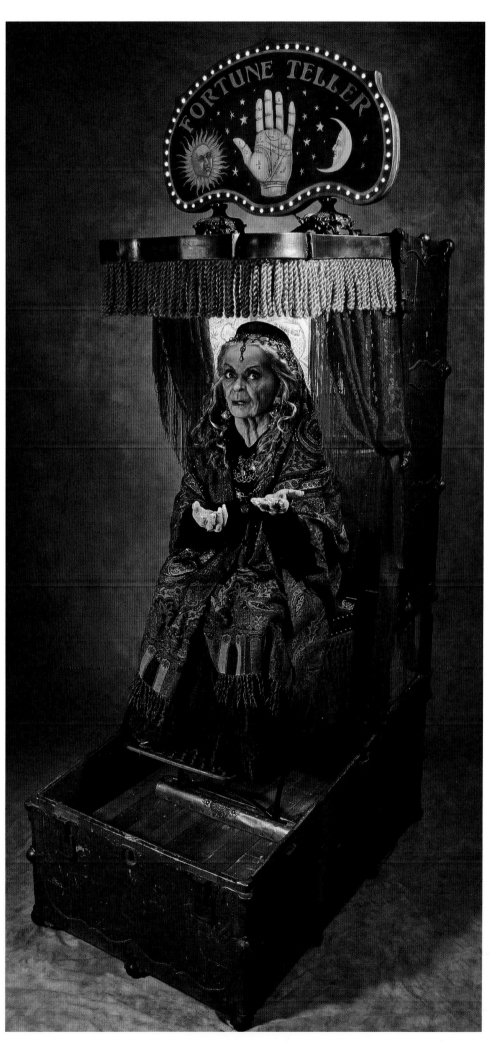

Thomas S. Kuebler
Title: Lady Luminitsa *Size:* Life size *Medium:* Silicone, mixed

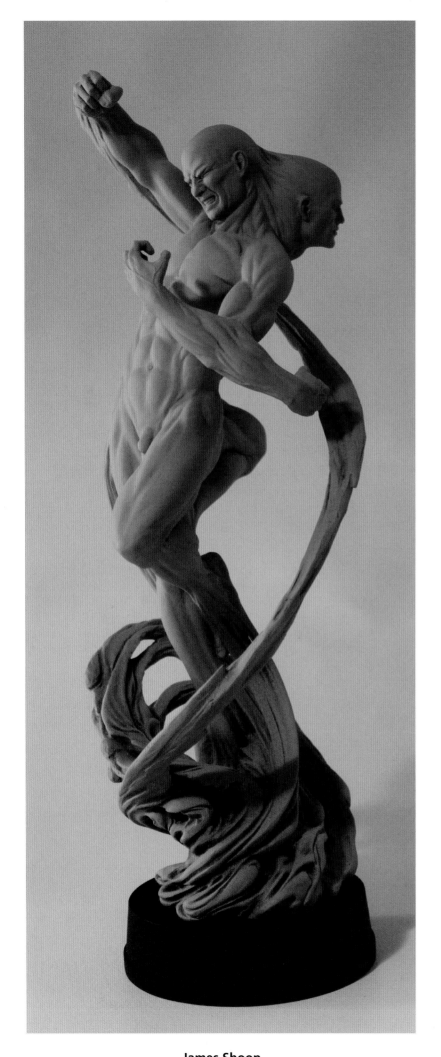

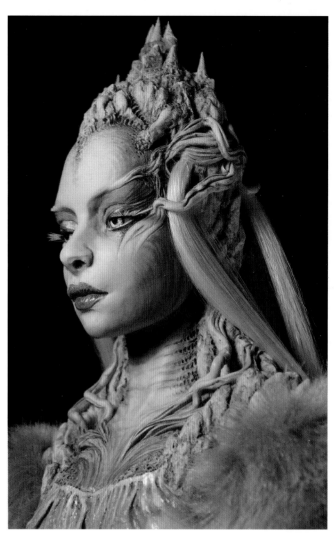

Virginie Ropars
Title: Leaterfalls *Size:* 88cm H *Medium:* Mixed

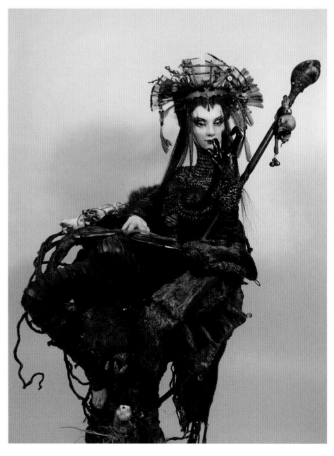

James Shoop
Title: The Struggle of Progress *Size:* 14.5"H x 6"D x 6"W *Medium:* Resin

Virginie Ropars
Title: Witchcraft *Size:* 50cm H *Medium:* Mixed

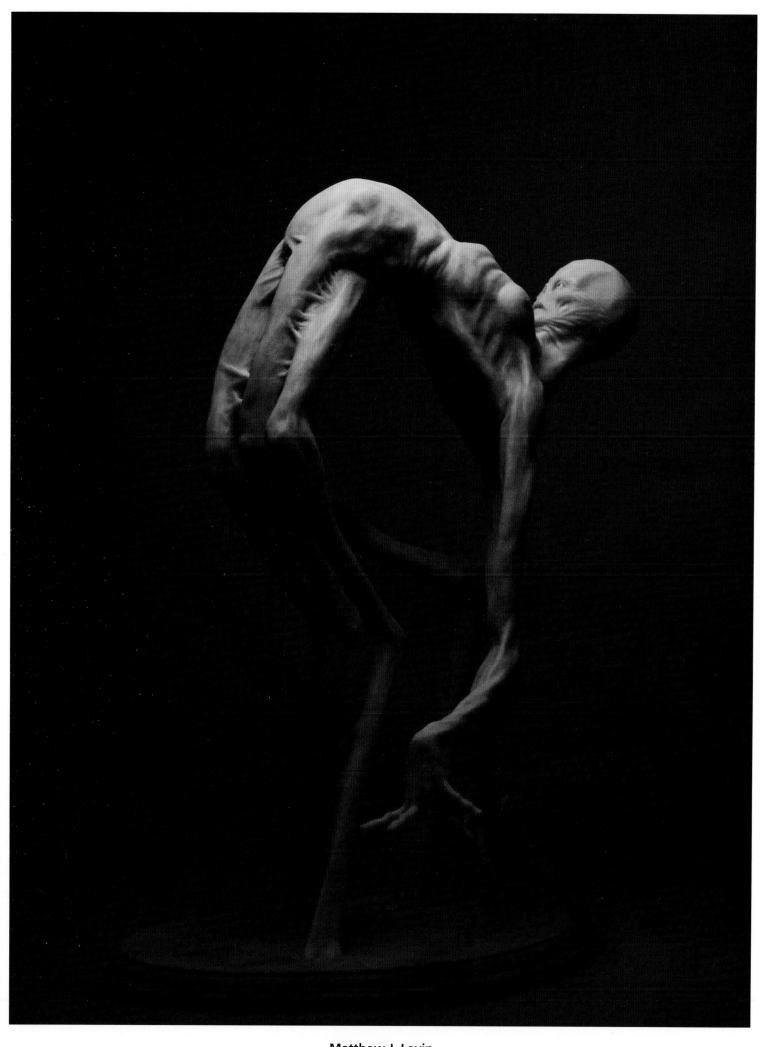

Matthew J. Levin

Title: Spellbound *Size:* 14"Hx7"Wx7"D *Medium:* Polymer clay

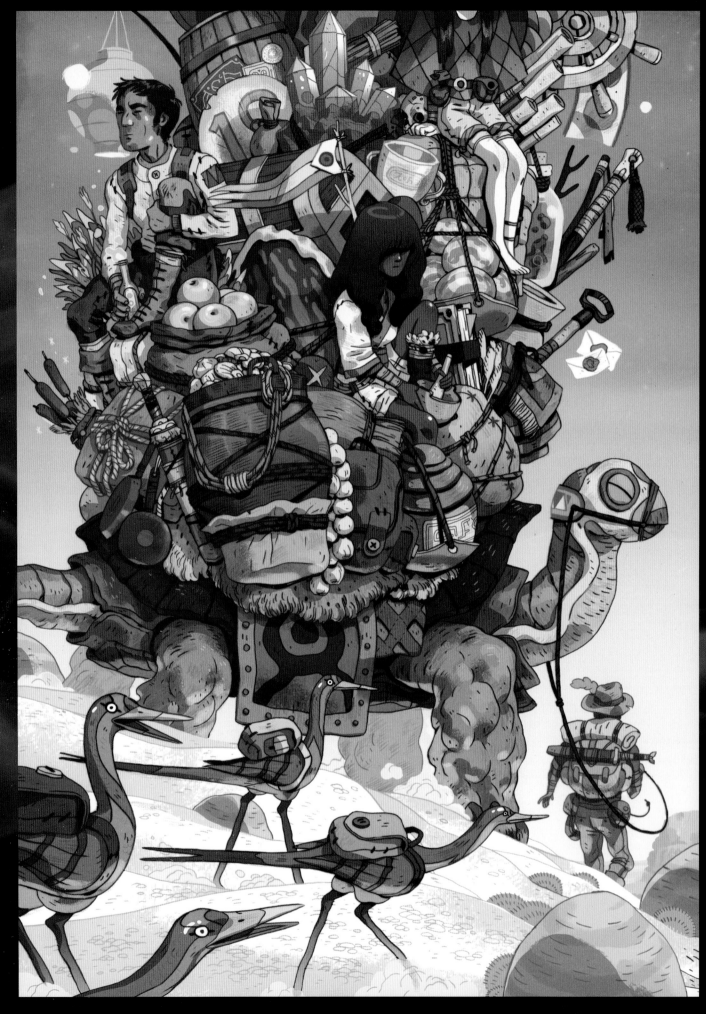

Sam Bosma
Art Director: SooJin Buzelli *Client:* Plansponsor *Title:* Stability *Size:* 5"x7" *Medium:* Digital

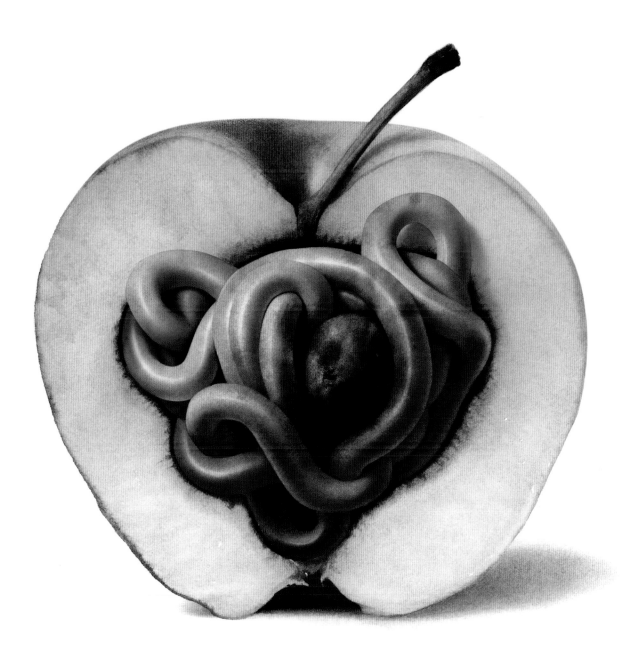

Sam Weber
Art Director: Alexandra Zsigmond *Client:* The New York Times *Title:* Cancer Monster *Size:* 5"x6" *Medium:* Watercolor, digital

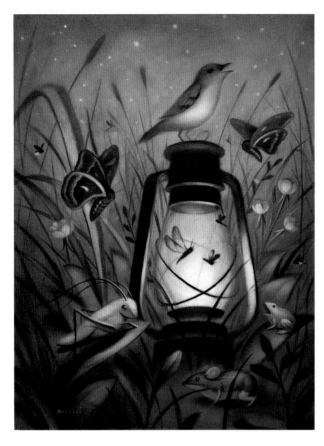

Chris Buzzelli
Art Director: Marti Golon *Client:* Reader's Digest
Title: Midsummer Night *Size:* 12"x16" *Medium:* Oil on board

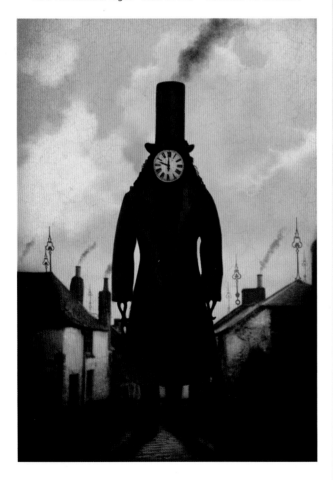

Bill Mayer
Art Director: Tia Powell *Client:* Oz Magazine
Title: The Clockmaker *Size:* 18"x24" *Medium:* Mixed

Scott Murphy
Art Director: Kate Irwin *Client:* Wizards of the Coast *Title:* Ghost Caravan of Doom
Size: 8"x18" *Medium:* Oil on panel

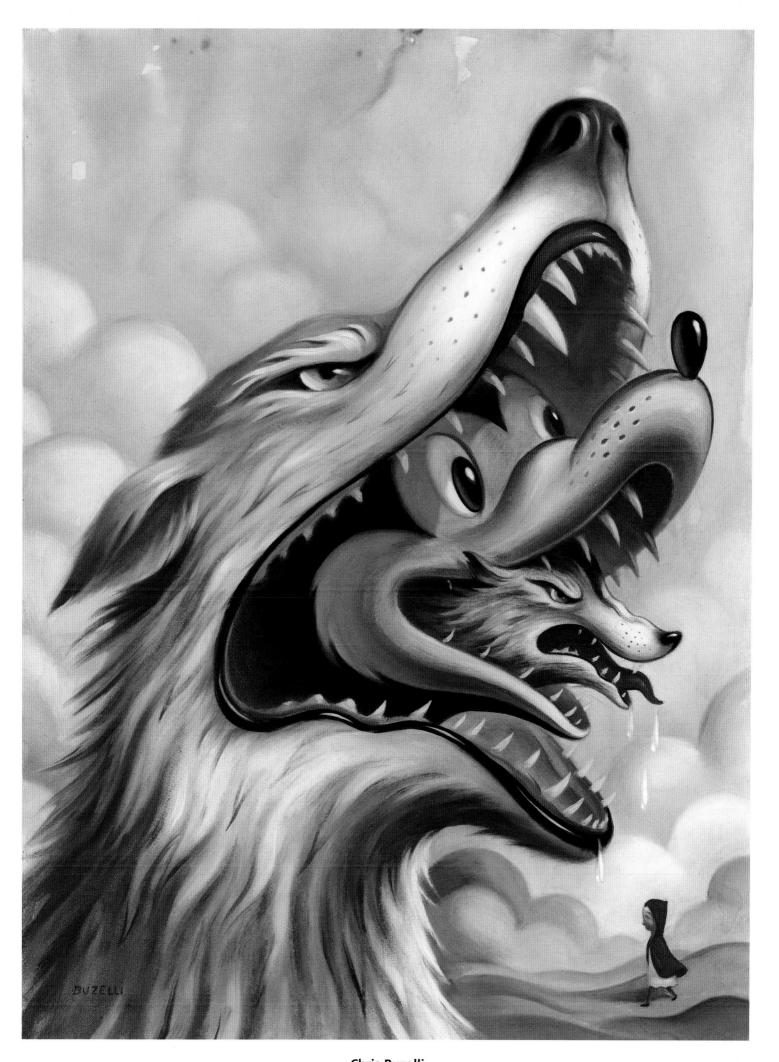

Chris Buzelli

Art Director: Guido Mendez *Client:* University of Chicago Magazine *Title:* Fairy Tale Evolution *Size:* 13"x19" *Medium:* Oil on board

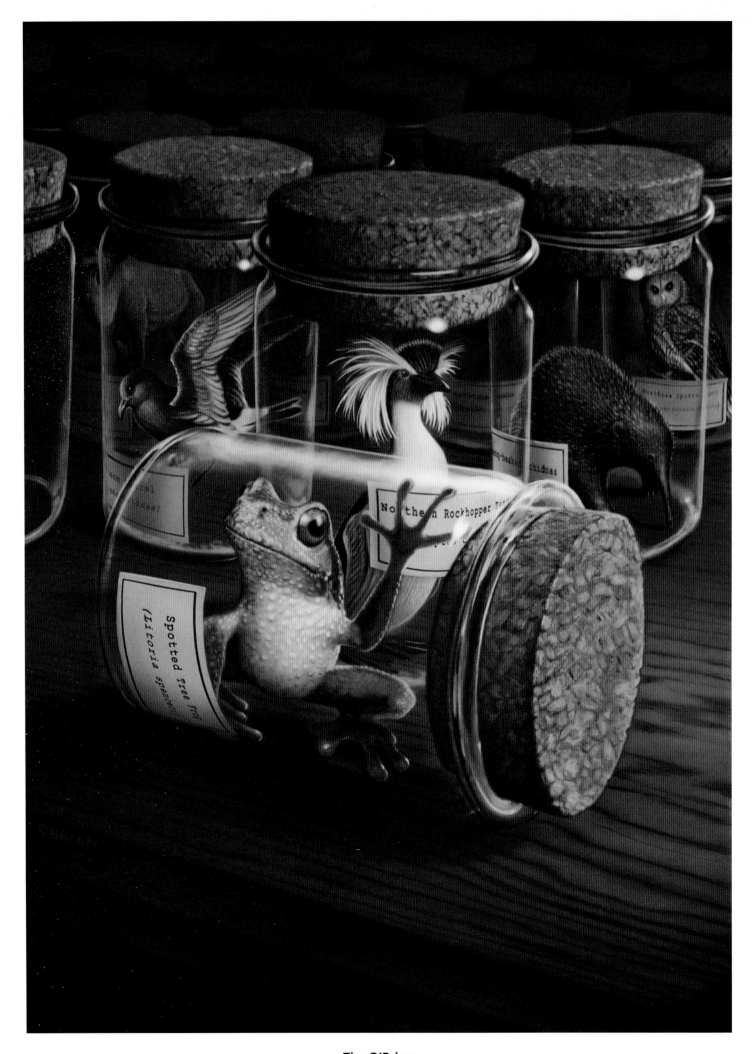

Tim O'Brien

Art Director: Mike Mrak *Client:* Scientific American *Title:* Extinction *Size:* 11"x14" *Medium:* Oil

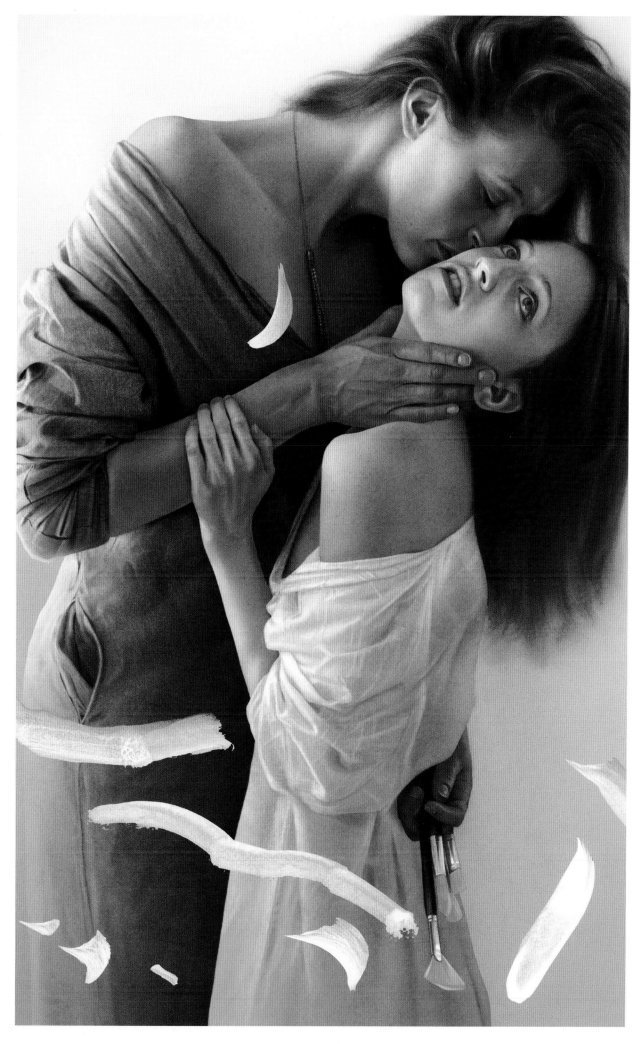

Sam Weber

Art Director: Irene Gallo *Client:* Tor.com *Title:* Portrait of Lisane da Patagnia *Medium:* Acrylic, watercolor, digital

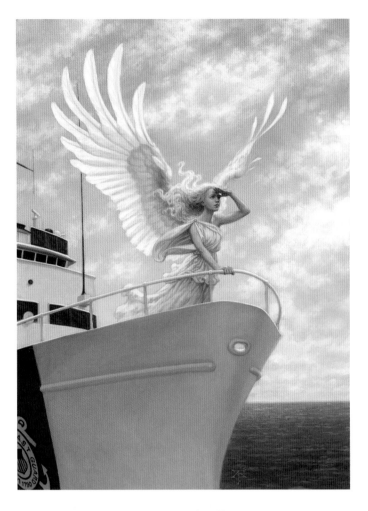

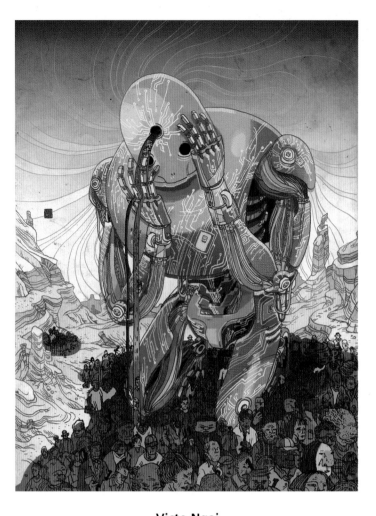

Tristan Elwell
Art Director: Olga Jakin *Client:* Angels on Earth
Title: Coast Guard Angel *Size:* 11"x15" *Medium:* Oil on board

Victo Ngai
Art Director: April Montgomery *Client:* Computer World
Title: Cobol Braindrain *Medium:* Mixed

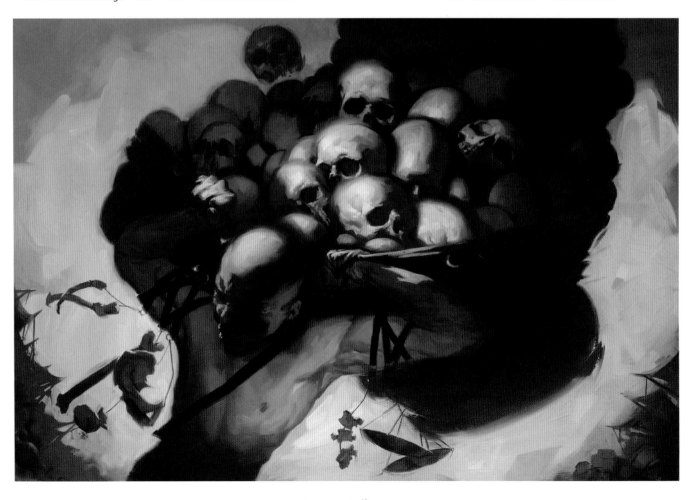

Jeremy Wilson
Art Director: Aaron J. Riley *Client:* 1000 Words Magazine *Title:* Skull Merchant *Size:* 23.5"x16" *Medium:* Oil on panel

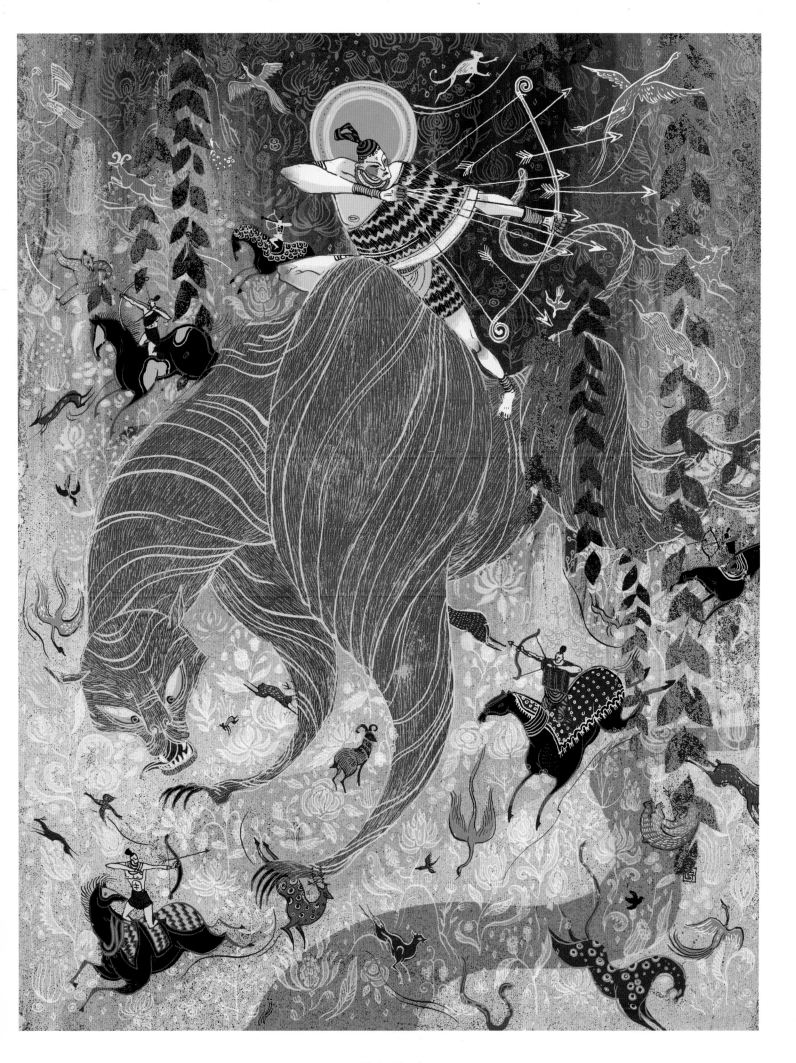

Victo Ngai

Art Director: SooJin Buzelli *Client:* Plansponsor *Title:* Best of the Best *Size:* 14"x18.5" *Medium:* Mixed

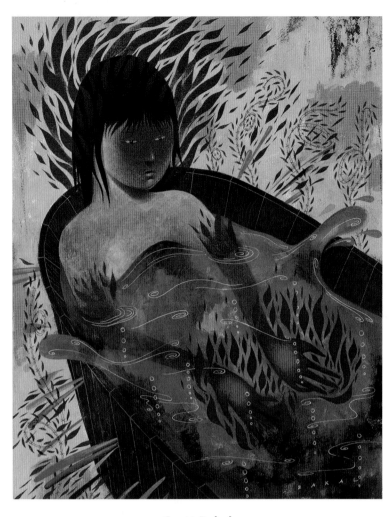

Scott Bakal
Art Director: Irene Gallo *Client:* Tor.com *Title:* Combustion
Size: 13"x16" *Medium:* Acrylic, ink

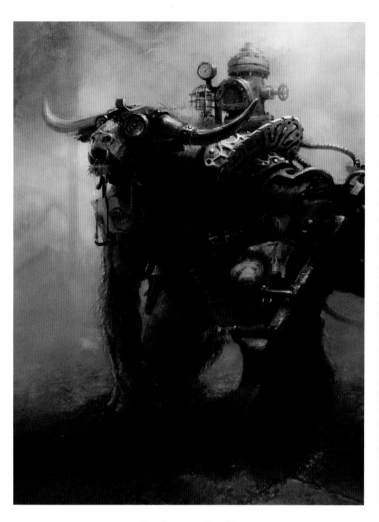

Stefan Kopinski
Art Director: Ian Dean *Client:* ImagineFX Magazine *Title:* Steampunk Minotaur
Size: 13x23cm *Medium:* Digital

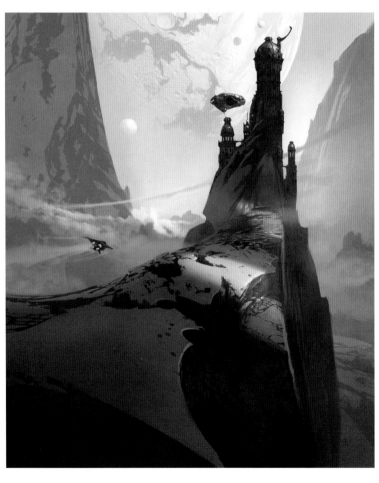

Thom Tenery
Client: ImagineFX Magazine *Title:* Gethen Rising *Medium:* Digital

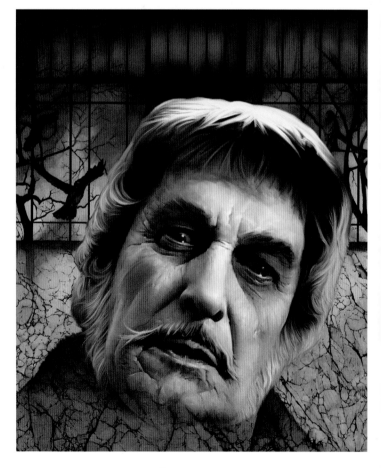

Jeff Preston
Client: Little Shoppe of Horrors Magazine
Title: The Definitive Dr. Phibes *Size:* 11.5"x 15" *Medium:* Mixed

Jonathan Bartlett

Art Director: Bonnie Becker *Client:* The Atlantic *Title:* Year of the Dragon *Size:* 20"x20" *Medium:* Digital

Kali Ciesemier

Art Director: Elizabeth Goodspeed *Client:* Domestic Etch *Title:* The Past *Size:* 8"x10.5" *Medium:* Digital

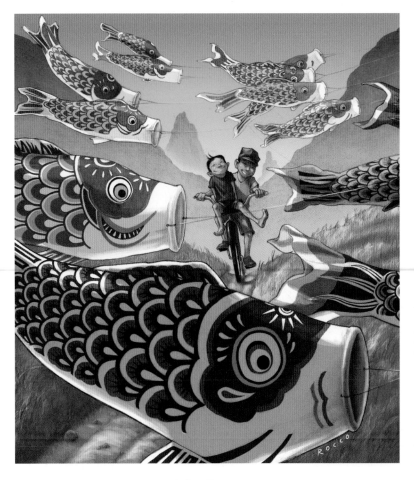

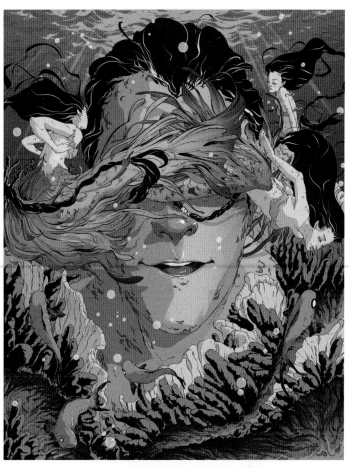

John Rocco
Client: Society of Childrens Book Writers & Illustrators
Title: Koinobori *Sice:* 9.5"x10.5" *Medium:* Digital

Goñi Montes
Art Director: Irene Gallo *Client:* Prehistoric Tor.com
Title: Legacy Lost *Sice:* 11"x14" *Medium:* Digital

Sam Wolfe Connelly
Art Director: Irene Gallo *Client:* Tor.com *Title:* Thirteen Steps In the Underworld *Medium:* Graphite

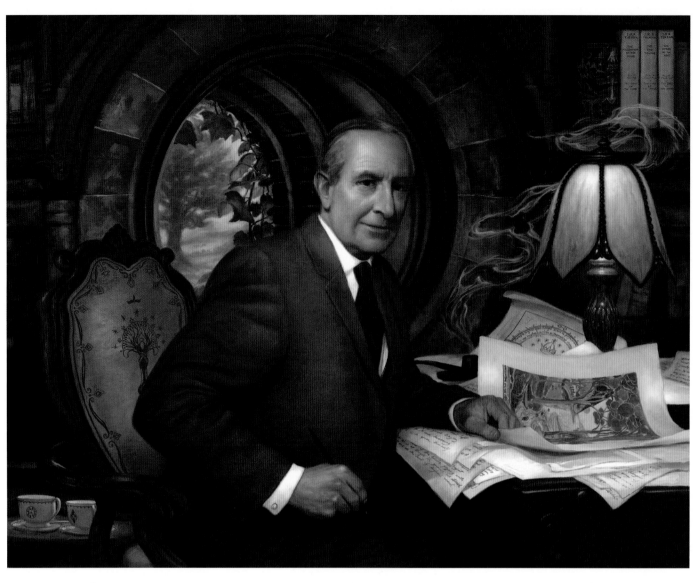

Donato Giancola
Art Director: Chris Redlich *Client:* TheOneRing.net *Title:* J.R.R. Tolkien Size: 42"x33" *Medium:* Oil on panel

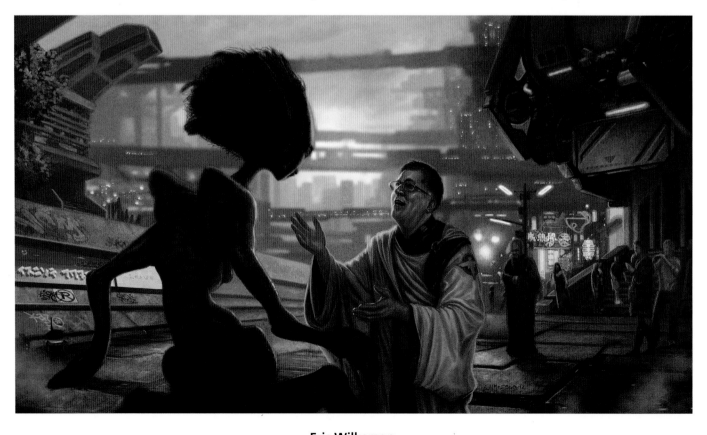

Eric Wilkerson
Art Director: Kathleen A. Bellamy *Client:* Intergalactic Medicine *Title:* Sojourn for Ephah *Medium:* Digital

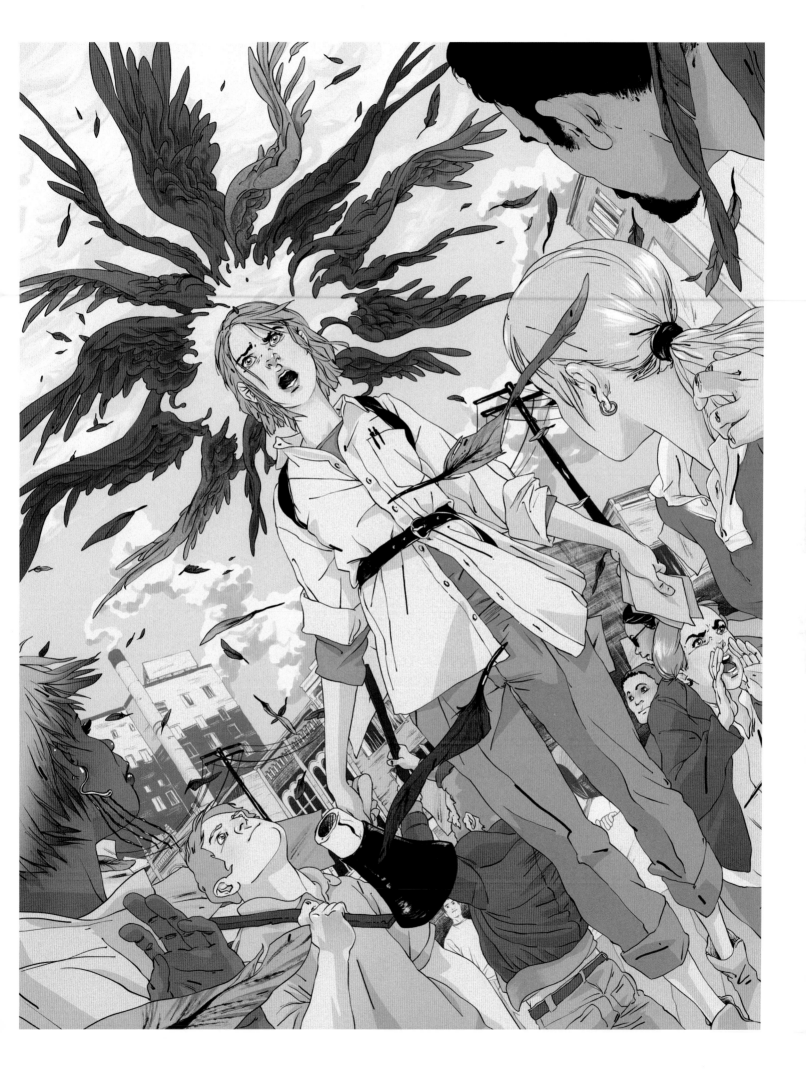

Goñi Montes

Art Director: Marta Scetta *Client:* The Work Style Magazine *Title:* The Activist *Size:* 12.5"x16" *Medium:* Digital

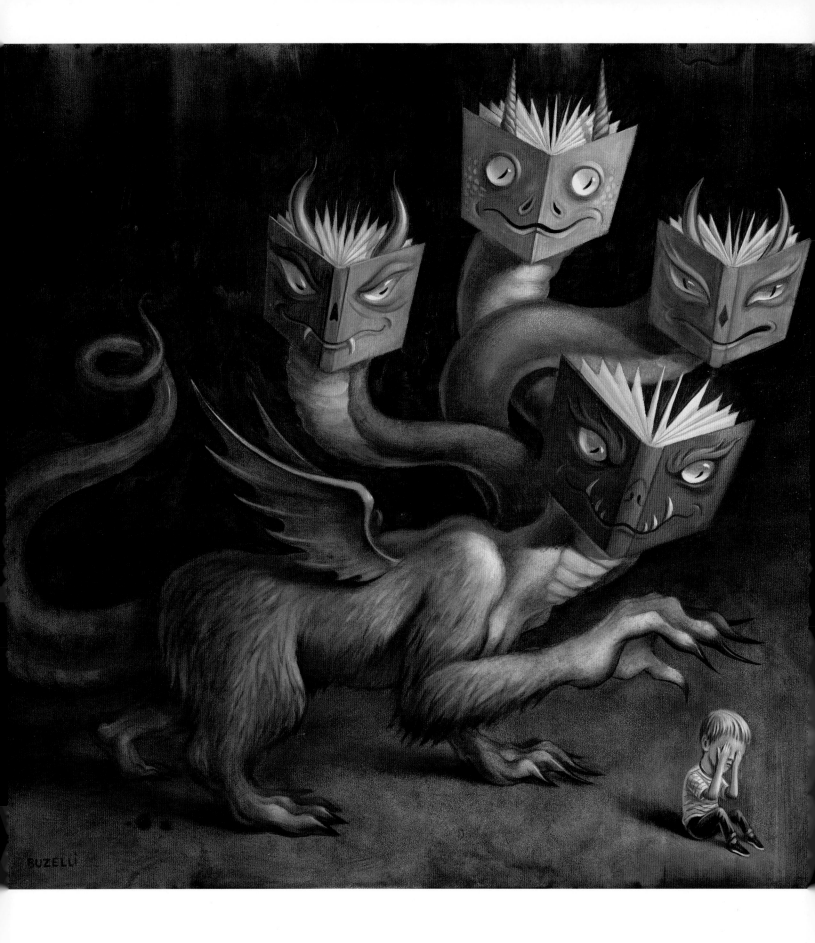

Chris Buzelli
Art Director: Judi Connelly *Client:* Educational Leadership Magazine *Title:* Book Monster *Size:* 20"x19" *Medium:* Oil on board

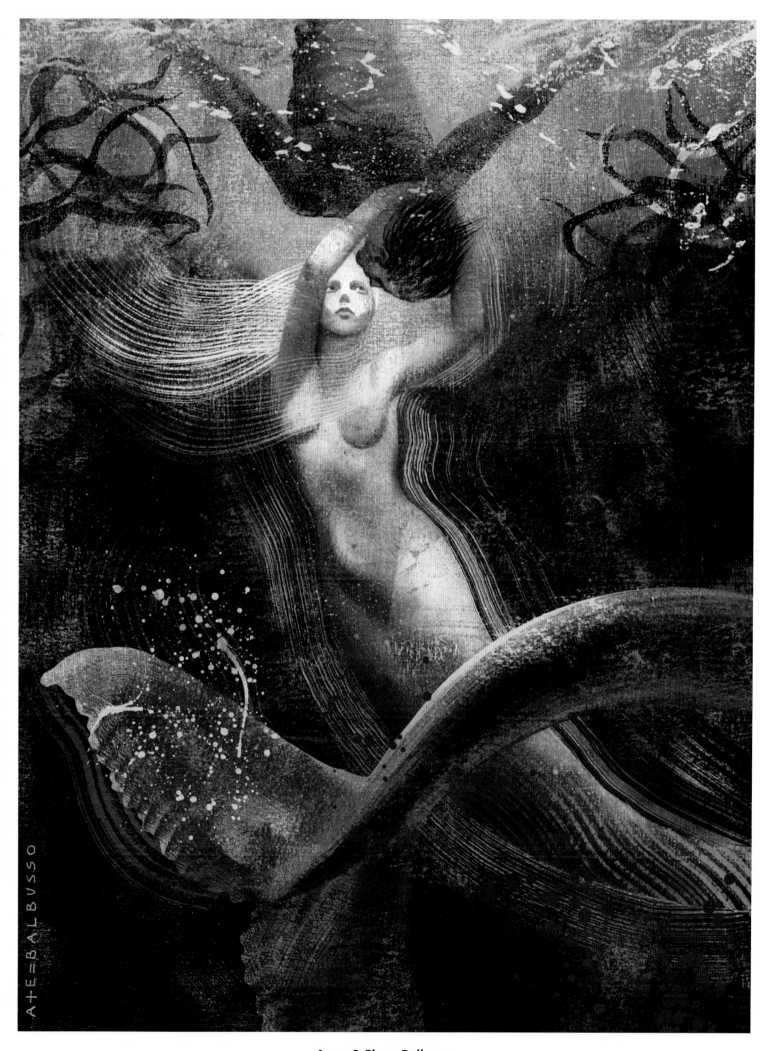

Anna & Elena Balbusso

Art Director: Irene Gallo *Client:* Tor.com *Title:* Men Who Wish to Drown *Medium:* Digital

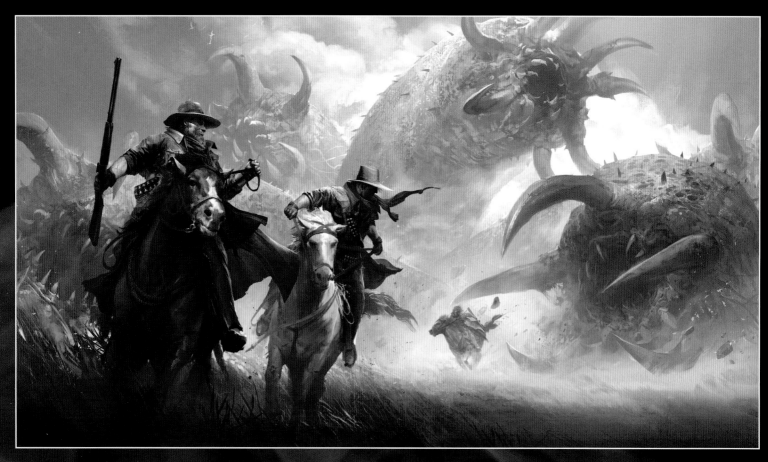

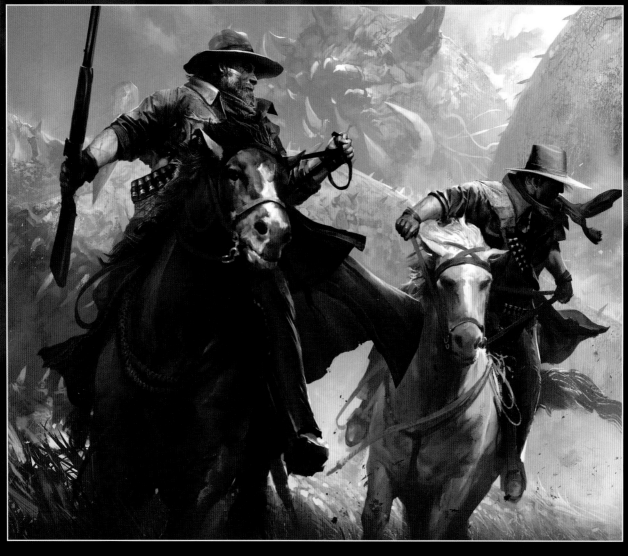

Kekai Kotaki
Title: Stampede *Size:* 22"x12" *Medium:* Digital

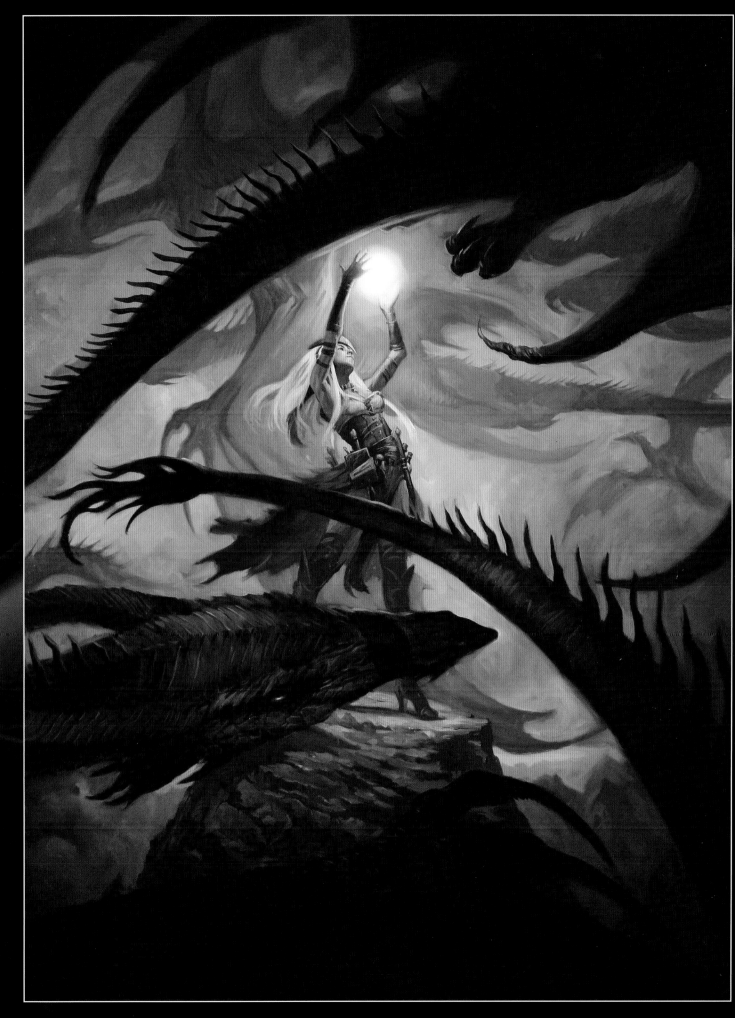

Lucas Graciano
Art Director: Sarah Robinson *Client:* Paizo *Title:* Dragon Swarm *Size:* 18"x24" *Medium:* Oil

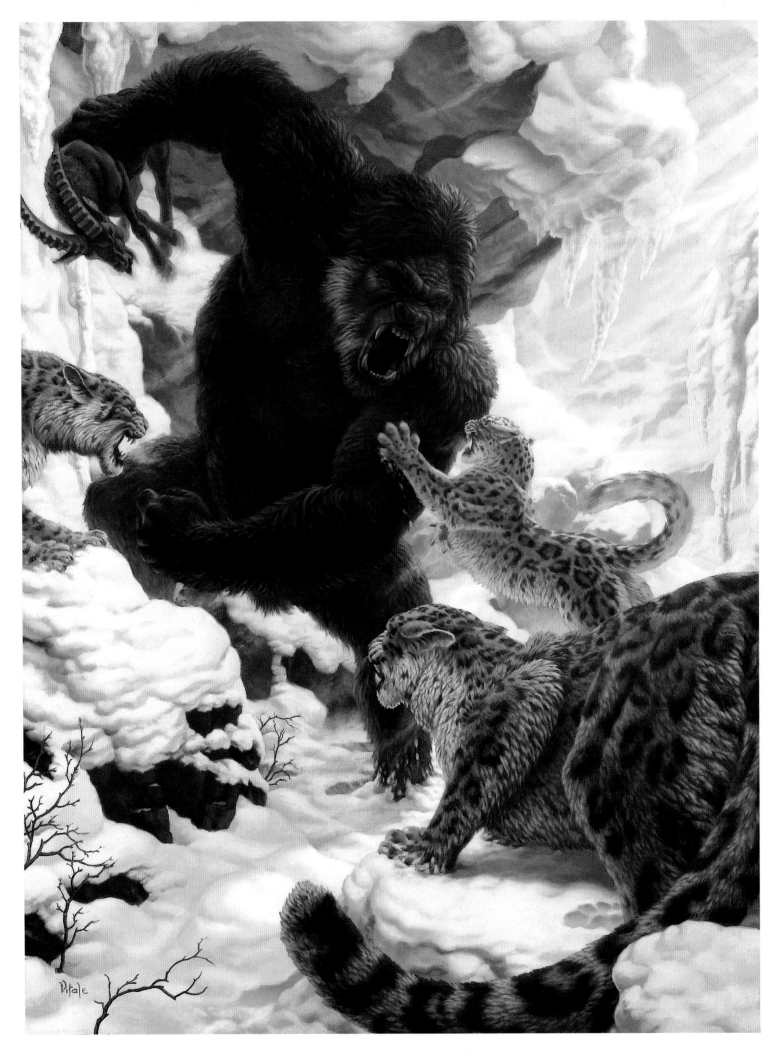

Raoul Vitale
Client: Greg Obaugh *Title:* Yeti *Size:* 18"x24" *Medium:* Oil

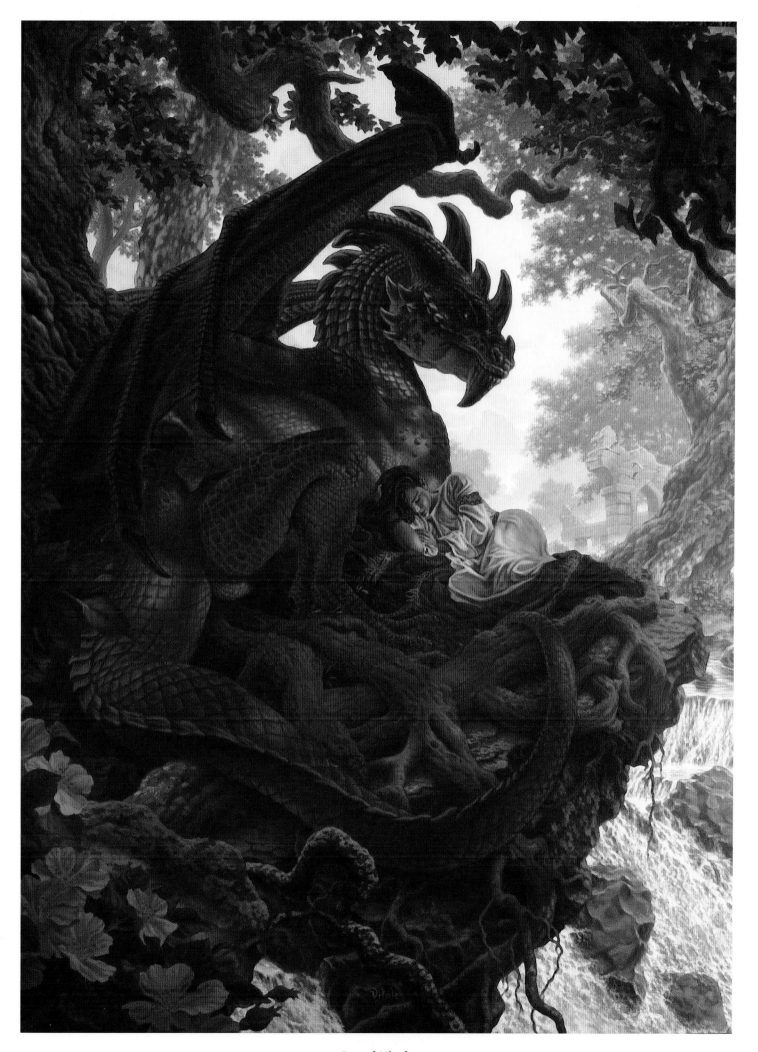

Raoul Vitale
Client: Dan Dos Santos *Title:* Safe *Medium:* Oil

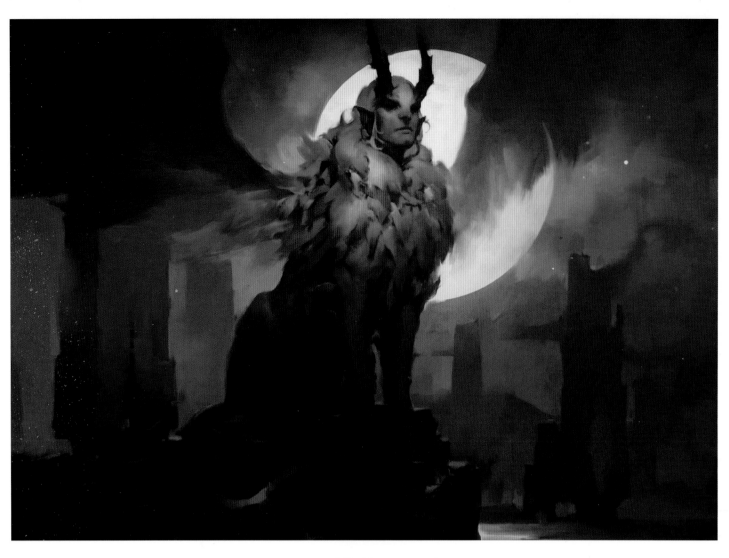

Min Yum
Art Director: Jeremy Jarvis *Client:* Wizards of the Coast *Title:* Windreader Sphinx *Medium:* Digital

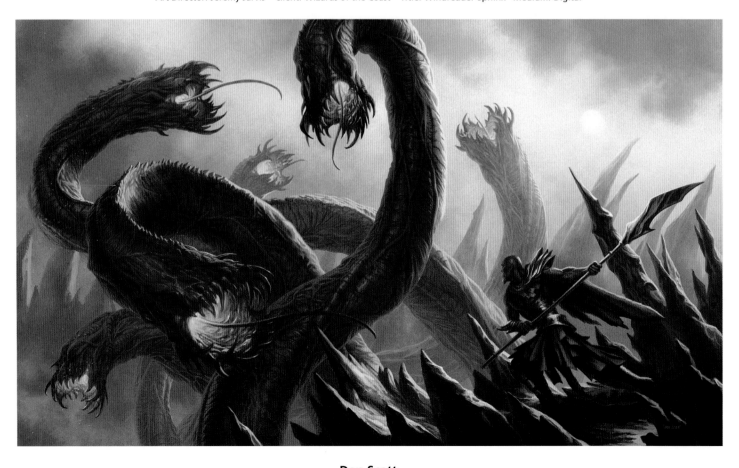

Dan Scott
Art Director: Jim Mears *Client:* Jim Mears *Title:* Against the Odds *Medium:* Digital

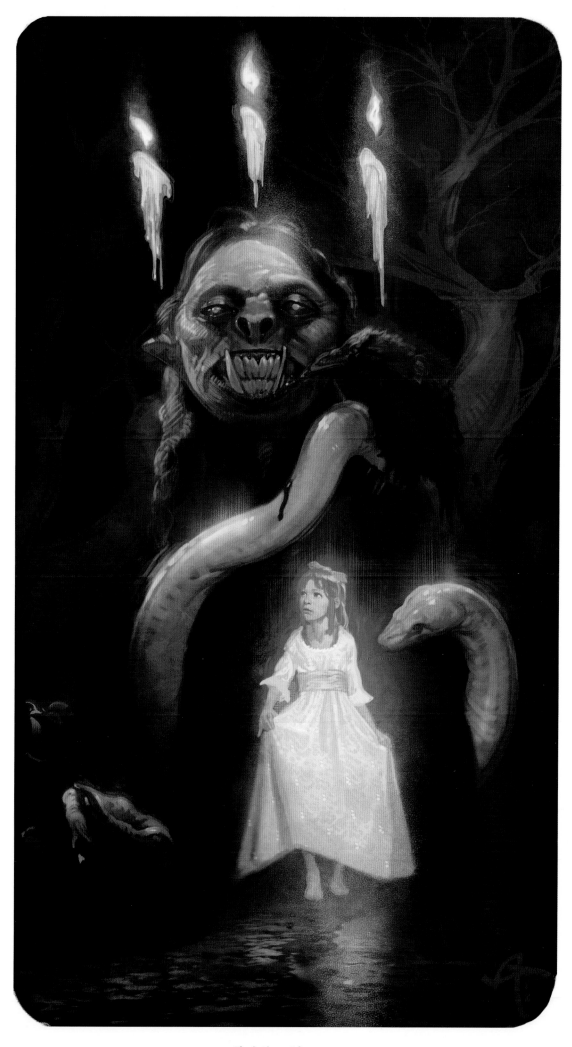

Christian Alzmann
Title: Beguiled *Size:* 9.5"x17" *Medium:* Digital

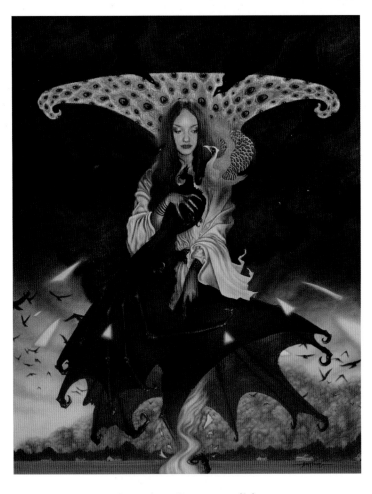

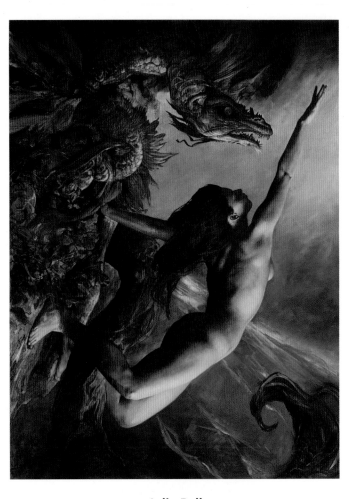

Soutchay Soungpradith
Title: Peacock Prophecy *Size:* 24"x30" *Medium:* Oil

Julie Bell
Title: Workman Publishing *Title:* Leap *Size:* 30"x40" *Medium:* Oil

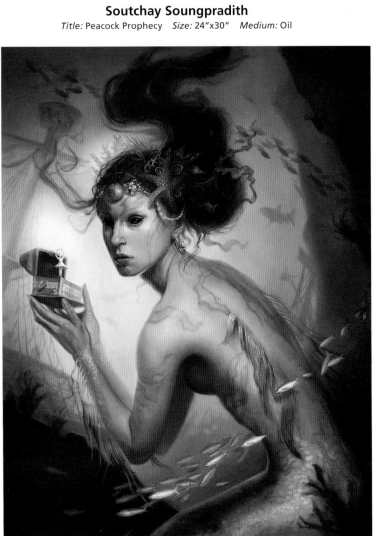

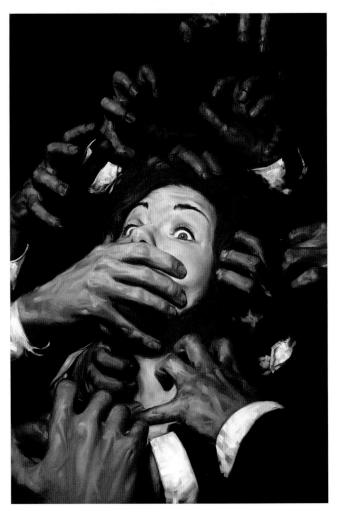

Lindsey Look
Title: Sirena *Size:* 12"x16" *Medium:* Oil on board

David Palumbo
Client: Science Fiction Book Club *Title:* Taken *Size:* 24"x 36" *Medium:* Oil

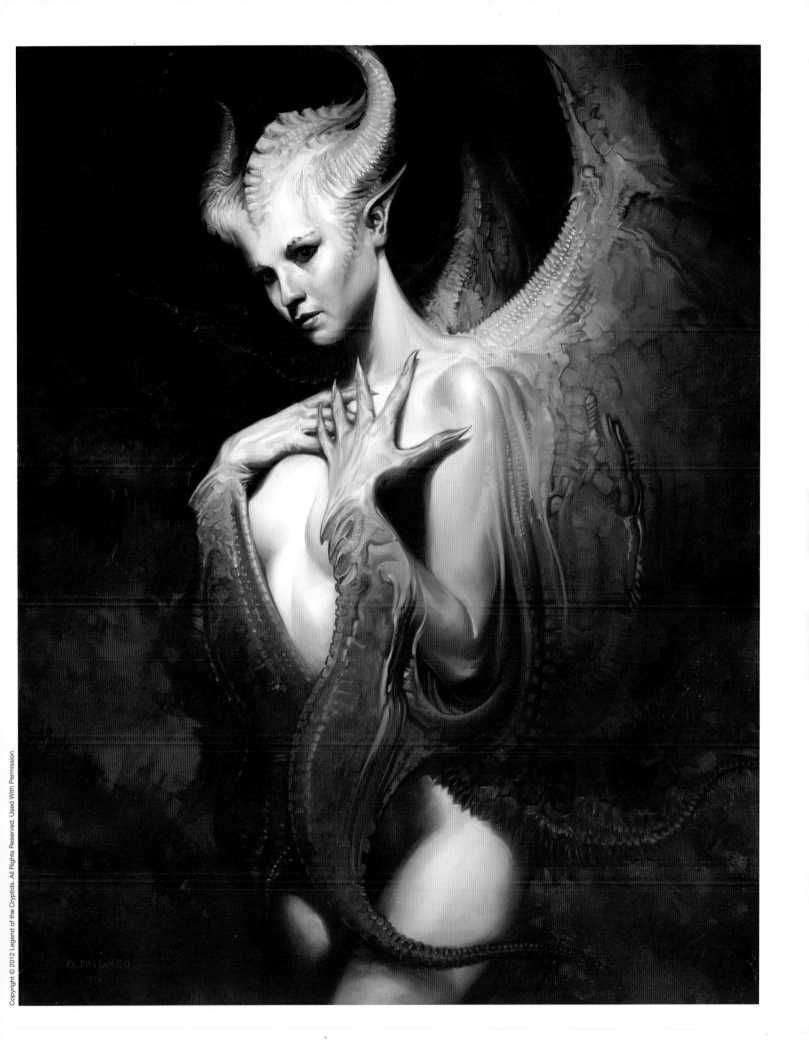

David Palumbo
Art Director: Haruna Tsuda *Client:* Applibot *Title:* Ivory Wings *Size:* 16"x20" *Medium:* Oil on panel

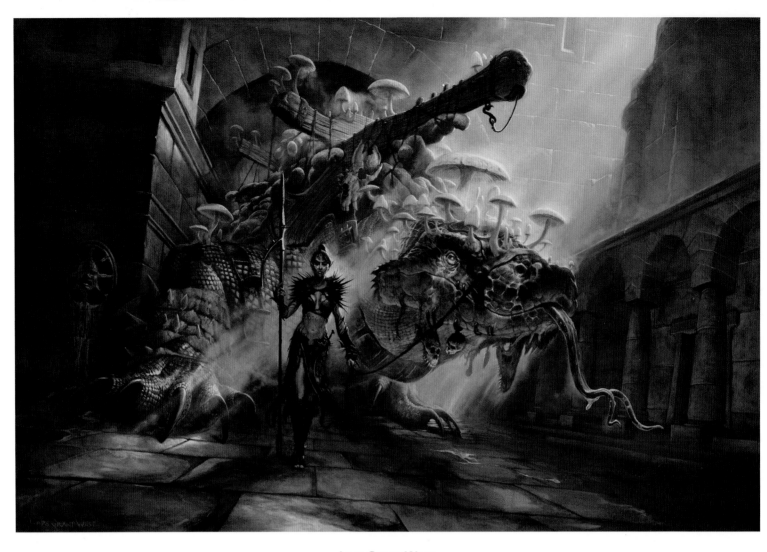

Lars Grant-West
Art Director: Jeremy Jarvis *Client:* Wizards of the Coast *Title:* Korozda Monitor *Size:* 36"x24" *Medium:* Oil

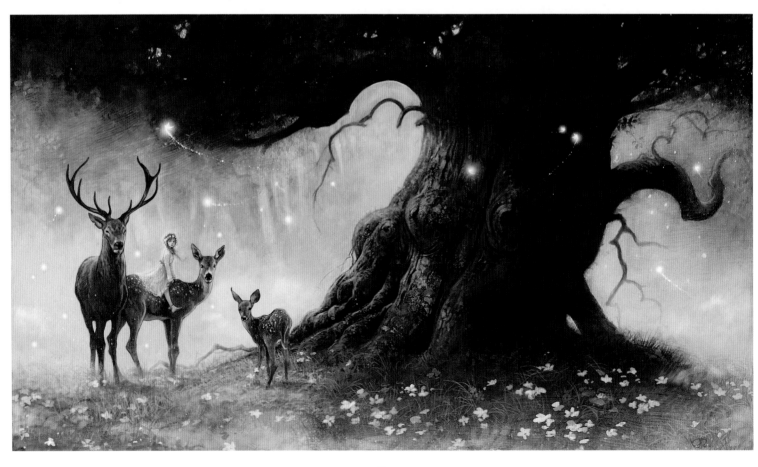

Jean-Baptiste Monge
Client: CTN Expo *Title:* At Fairies Dawn *Size:* 19.6"x13" *Medium:* Watercolor, digital

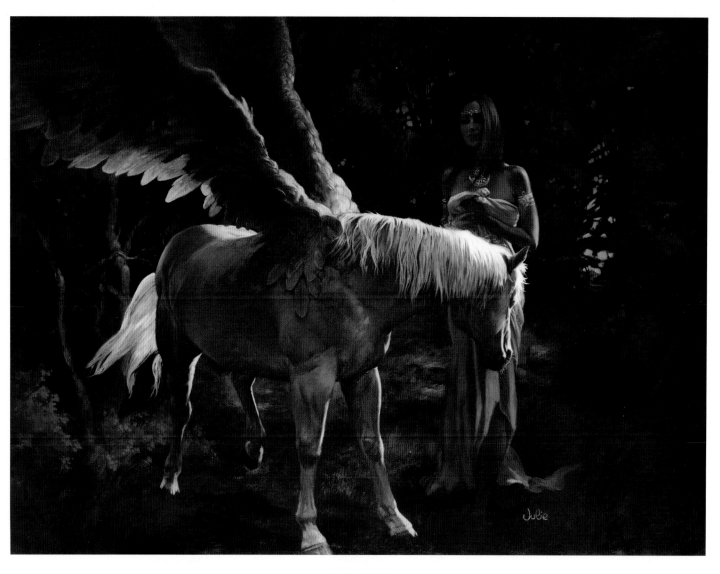

Julie Bell
Client: Workman Publishing *Title:* If Wishes Were Horses *Size:* 24"x18" *Medium:* Oil on mounted linen

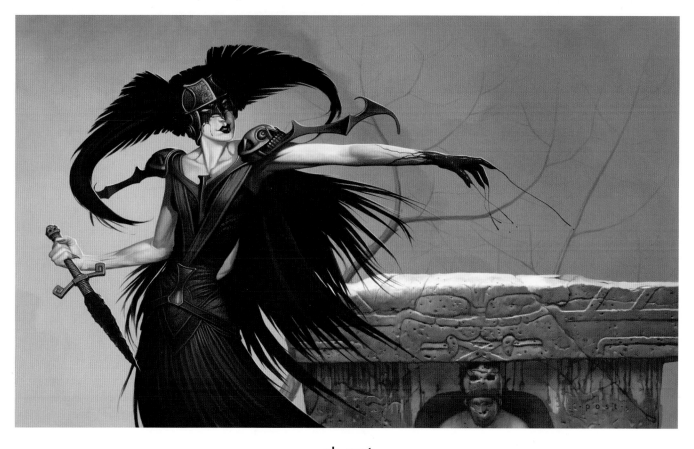

r.k. post
Client: Devir *Title:* Pre-Columbian Woes *Size:* 24"x14" *Medium:* Digital

Laurie Lee Brom
Title: Moonflower *Medium:* Oil

Ciruelo
Client: Ronnie Sellers Calendars *Title:* Urlindea *Size:* 20"x28" *Medium:* Oil on canvas

Derek Stenning
Client: Born in Concrete *Title:* The Jellyfish [Garbage]
Size: 12"x23" *Medium:* Digital

Thom Tenery
Title: Erreth Unfor *Medium:* Digital

Richard Wright
Art Director: Jeremy Jarvis *Client:* Wizards of the Coast *Title:* Ravnican Plains *Medium:* Digital

Tom Fleming
Title: Imagination [Mind] *Size:* 18"x30" *Medium:* Watercolor, mixed

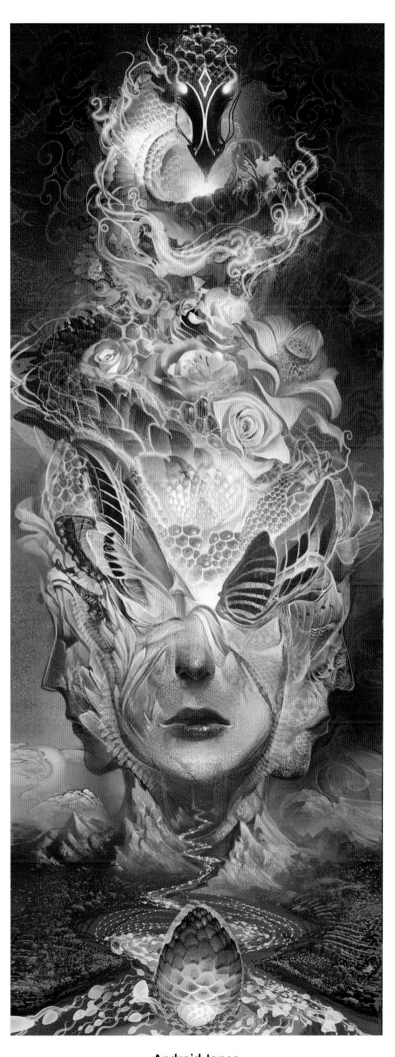

Android Jones
Art Director: Larry Harvey *Client:* Burningman 2012 *Title:* Fertility *Medium:* Digital

Ana Bagayan
Client: Distinction Gallery *Title:* Undersea Moon
Size: 18"x 24" *Medium:* Oil on wood

Bill Carman
Art Director: Jon Schindehette *Title:* Double Red Bird Durbo-Charger
Size: 3"x6" *Medium:* Acrylic on copper

Tom Fowler
Art Director: Graham Fowler *Title:* Gostritch *Size:* 14"x20" *Medium:* Gouache

Don Seegmiller
Title: No Swimming *Size:* 19"x13" *Medium:* Mixed

Francis Livingston
Client: Arcadia Gallery *Title:* Lightstream *Size:* 60"x40" *Medium:* Oil

Steve Argyle
Art Director: Jeremy Jarvis *Client:* Wizards of the Coast *Title:* Somber Wald Sage *Medium:* Dgital

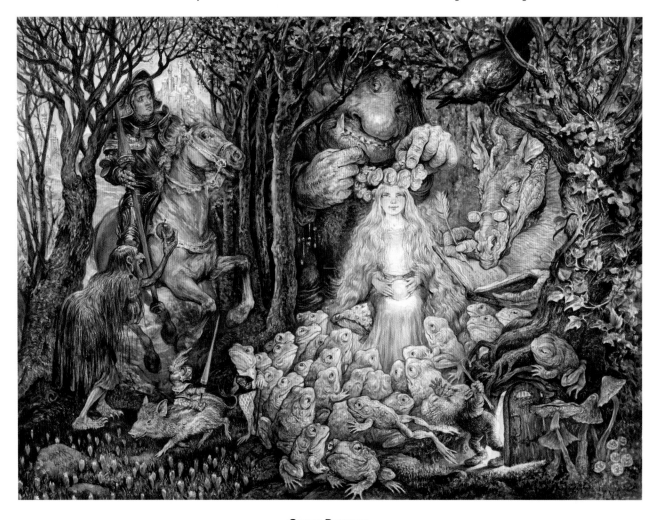

Omar Rayyan
Art Director: Michelle Nephew *Client:* Atlas Games *Title:* Once Upon A Time *Size:* 17"x13" *Medium:* Watercolor

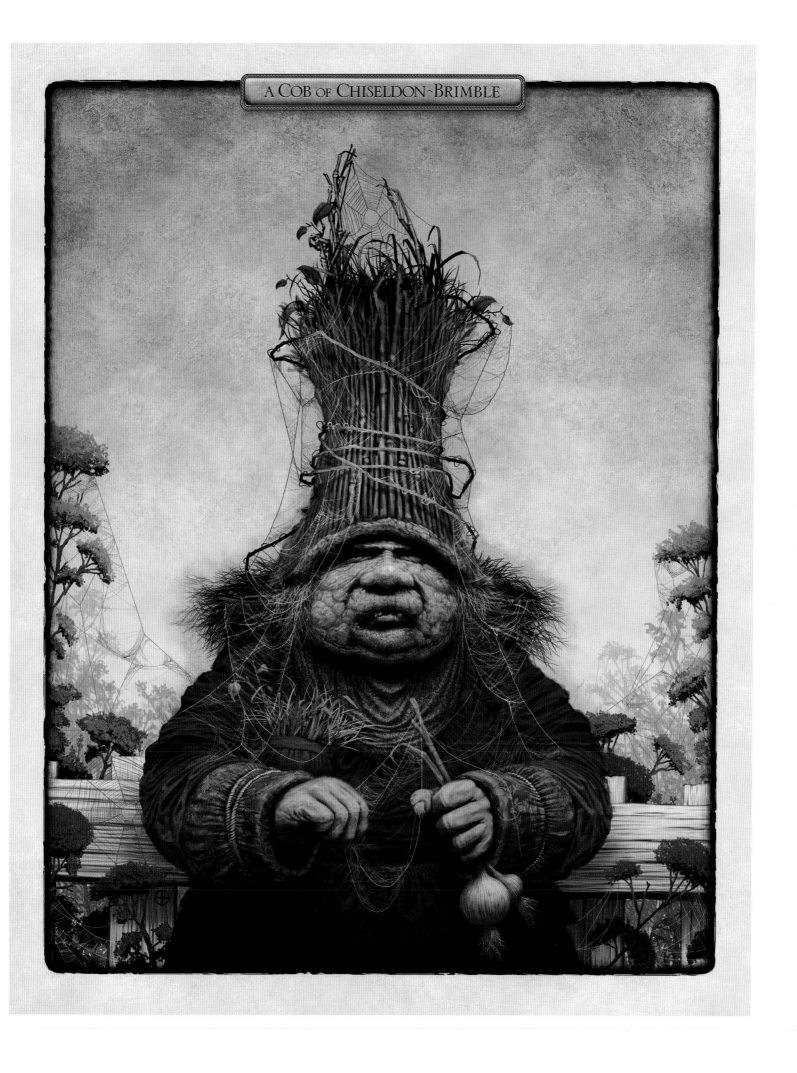

Ed Binkley
Title: A Cob of Chiseldon-Brimble *Size:* 15"x19" *Medium:* Digital

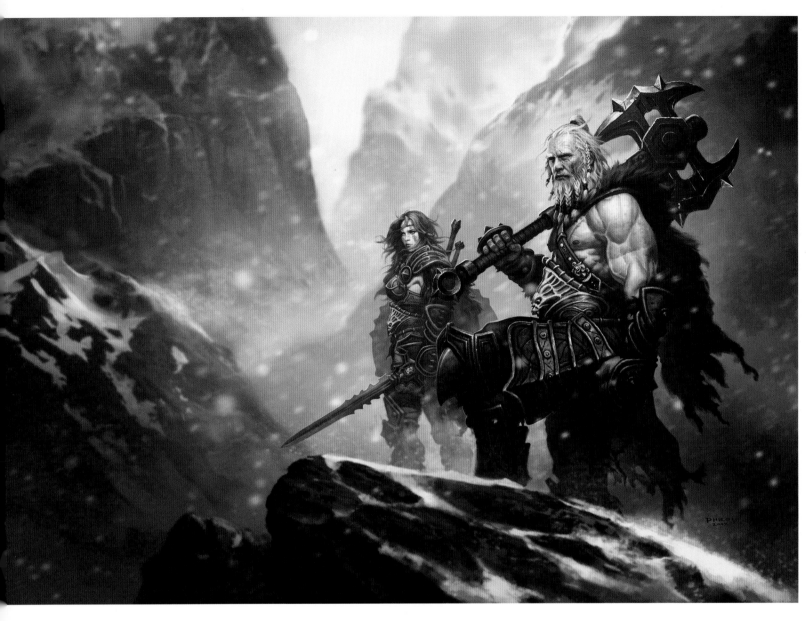

Phroilan Gardner
Client: Blizzard Entertainment *Title:* Vigil of Arreat *Size:* 20"x14" *Medium:* Digital

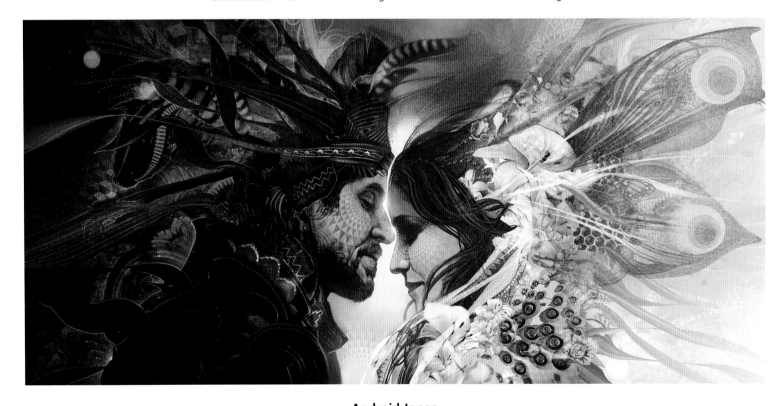

Android Jones
Client: Bryan Franklin & Jennifer Russell *Title:* Union *Medium:* Digital

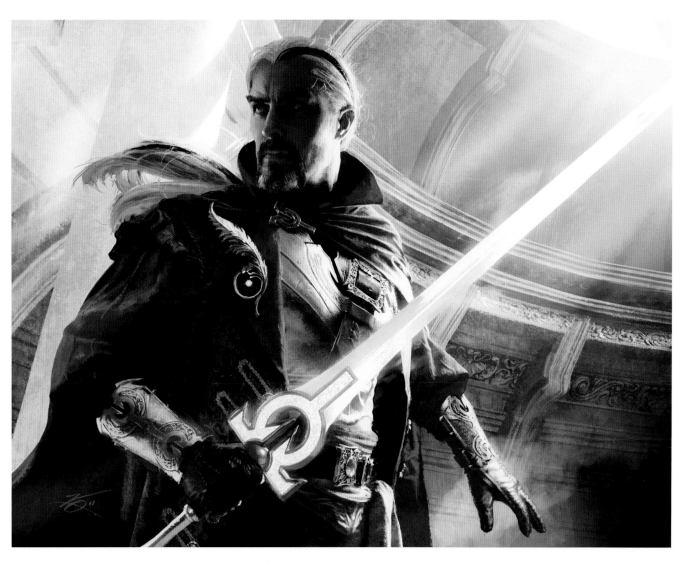

Michael Komark
Art Director: Jeremy Jarvis *Client:* Wizards of the Coast *Title:* Odric, Master Tactician *Medium:* Oil

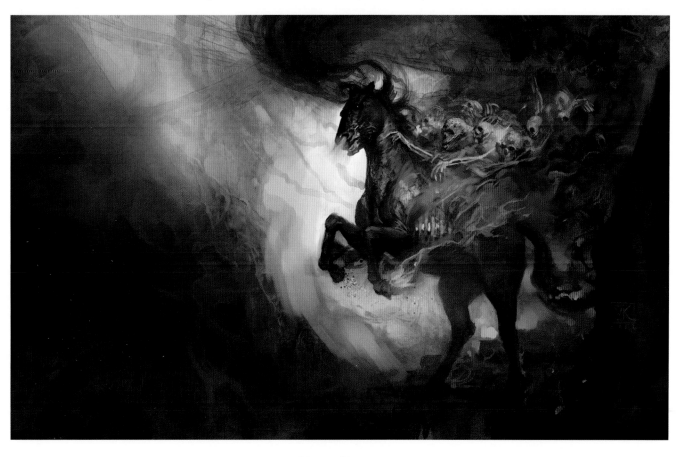

Vance Kovacs
Art Director: Jeremy Jarvis *Client:* Wizards of the Coast *Title:* Nightmare *Medium:* Digital

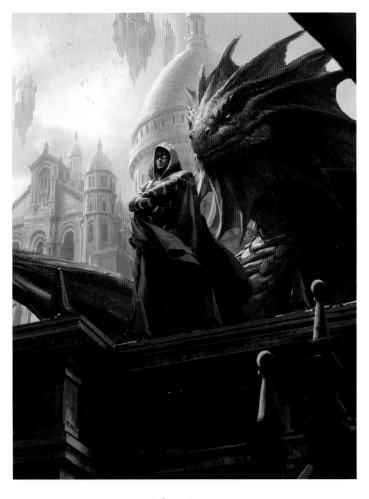

Jaime Jones
Art Director: Jeremy Jarvis *Client:* Wizards of the Coast
Title: Return to Ravnica *Medium:* Digital

Jaime Jones
Art Director: Jeremy Jarvis *Client:* Wizards of the Coast
Title: Jace, Architect of Thought *Medium:* Digital

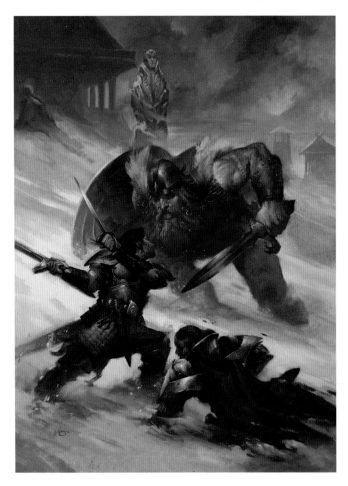

Lucas Graciano
Art Director: Sarah Robinson *Client:* Paizo *Title:* Snow Viking
Size: 18"x24" *Medium:* Oil

Johannes Holm
Title: Snowing Already *Size:* 8"x11" *Medium:* Digital

Lauren Saint-Onge

Title: The Descent *Size:* 12"x14" *Medium:* Digital

Inga Poslitur
Client: University of Hartford *Title:* Death of a Housedress *Size:* 16"x20" *Medium:* Oil on board

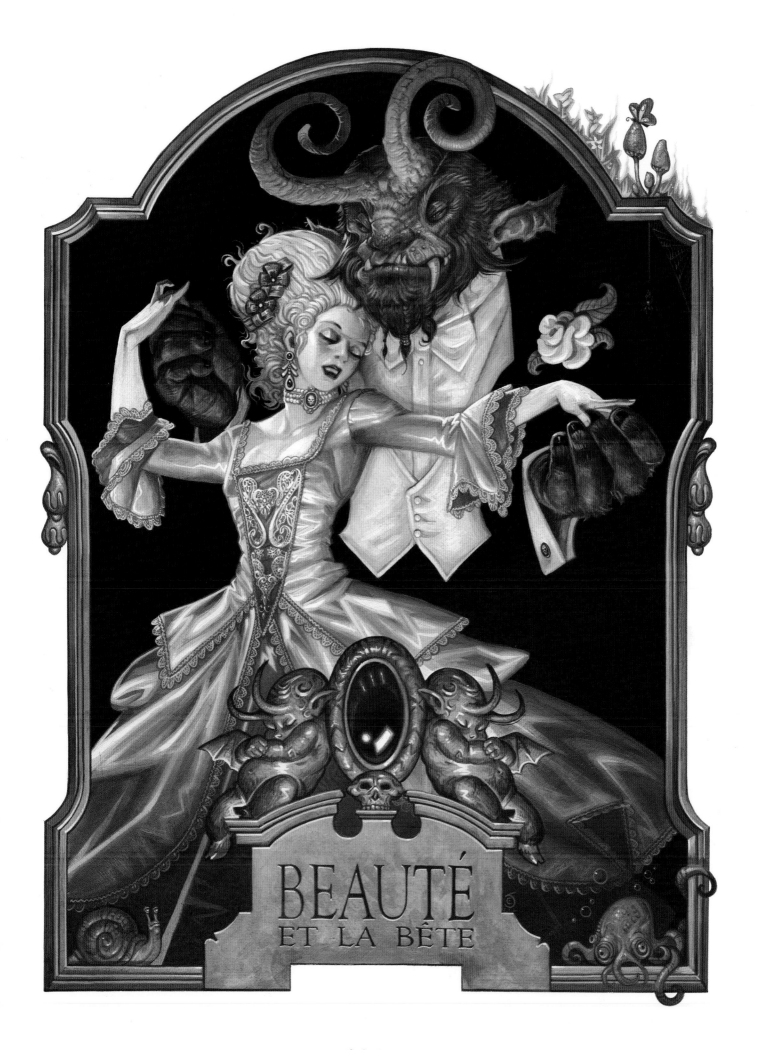

Chris Seaman
Title: Beauté et la Bête *Size:* 16"x21.5" *Medium:* Acrylic on board

Christopher Moeller
Art Director: Jeremy Jarvis *Client:* Wizards of the Coast *Title:* Banner Griffin Size: 11"x9" *Medium:* Acrylic, oil

Jesper Ejsing
Art Director: Kevin Smith *Client:* Wizards of the Coast *Title:* Kaijudo—Rise of the Monarchs, Infernus *Medium:* Oil

Cory Godbey
Title: Gryphon Portrait *Size:* 10"x8" *Medium:* Watercolor, digital

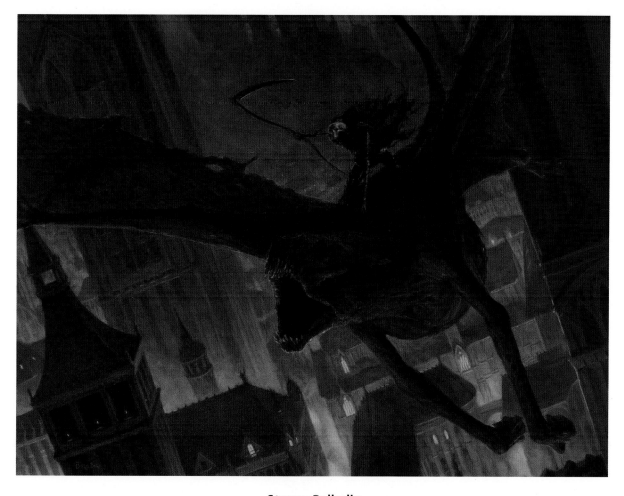

Steven Belledin
Art Director: Jeremy Jarvis *Client:* Wizards of the Coast *Title:* Nightveil Specter *Size:* 20"x16" *Medium:* Oil

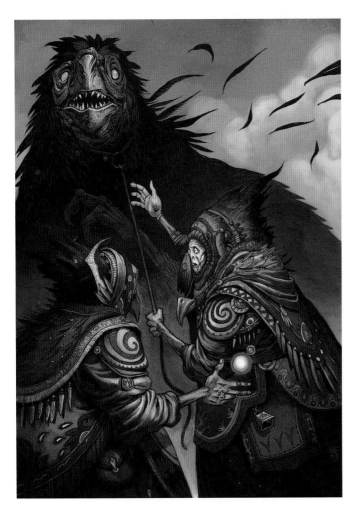

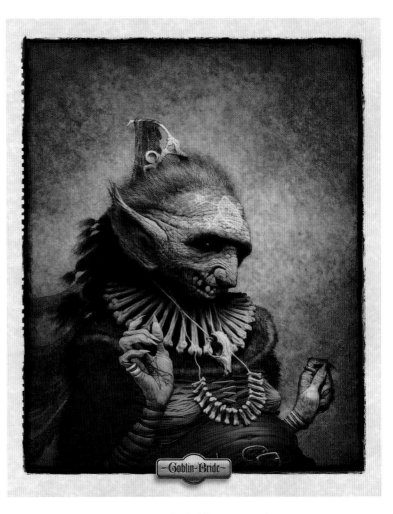

Sean Andrew Murray
Title: He's Gone Full Bird *Medium:* Digital

Ed Binkley
Title: Goblin-Bride *Size:* 11"x14" *Medium:* Digital

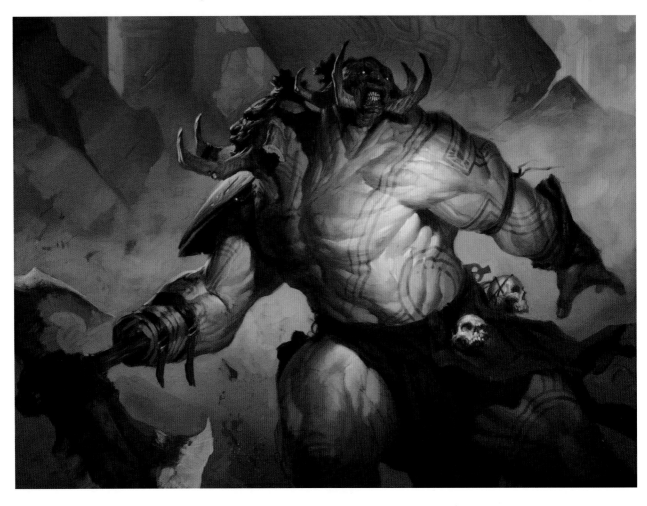

Tyler Jacobson
Art Director: Jeremy Jarvis *Client:* Wizards of the Coast *Title:* Ruric: Thar, the Unbowed *Medium:* Digital

Fabio Listrani

Title: Haiku *Medium:* Digital

Terese Nielsen
Art Director: Jeremy Jarvis *Client:* Wizards of the Coast *Title:* Hanna, Ship's Navigator *Medium:* Mixed

Cynthia Sheppard
Art Director: Jeremy Jarvis *Client:* Wizards of the Coast *Title:* Wake the Reflections

Raoul Vitale
Client: Greg Obaugh *Title:* Tovin's Quest *Medium:* Oil

Karla Ortiz
Art Director: Jeremy Jarvis *Client:* Wizards of the Coast *Title:* Teysa, Envoy of Ghosts *Medium:* Digital

Android Jones

Client: Boom Festival 2012 *Title:* Dharma Dragon *Medium:* Digital

Kekai Kotaki
Title: The Green Throne *Size:* 14"x22" *Medium:* Digital

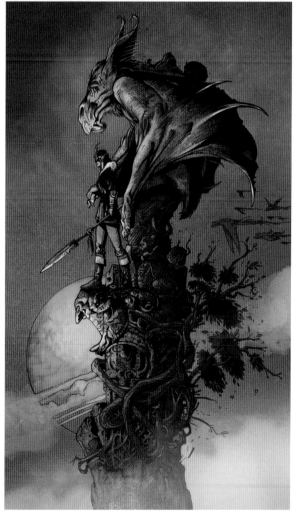

Zelda Devon
Client: Jay Tomio East *Title:* Pomegranite *Size:* 9"x16" *Medium:* Mixed, digital

Mark A. Nelson
Title: Eyes *Size:* 10.5"x15.5" *Medium:* Ink, digital

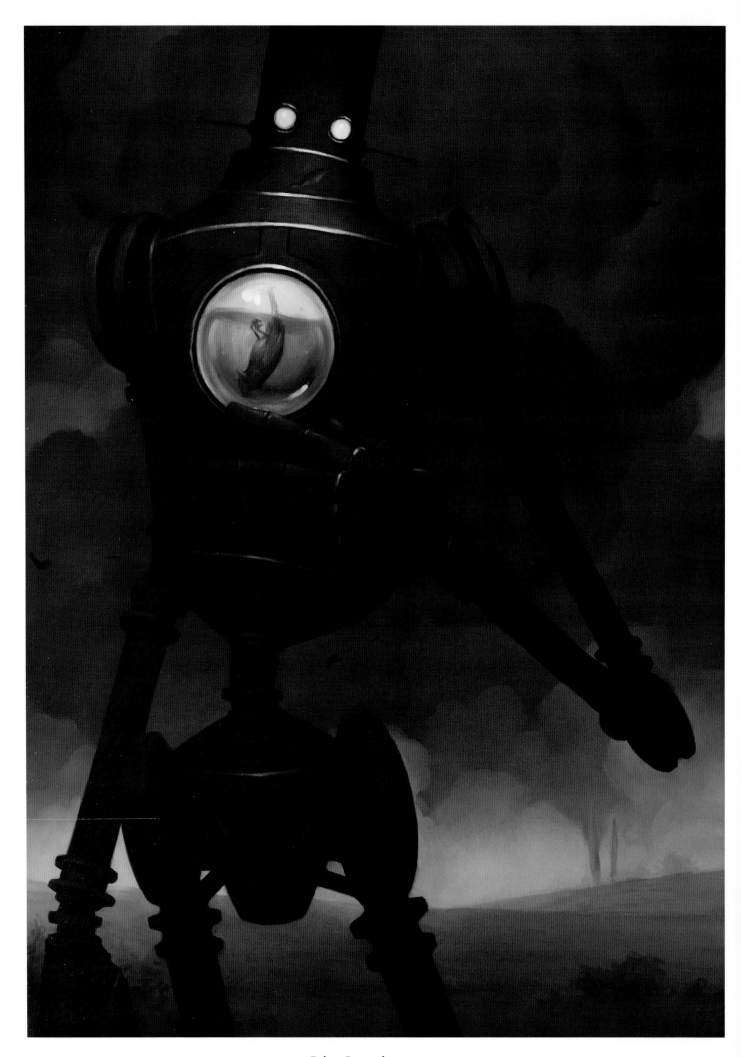

Brian Despain
Client: Kyle Hensley *Title:* Dear Companion *Size:* 5"x7" *Medium:* Oil on board

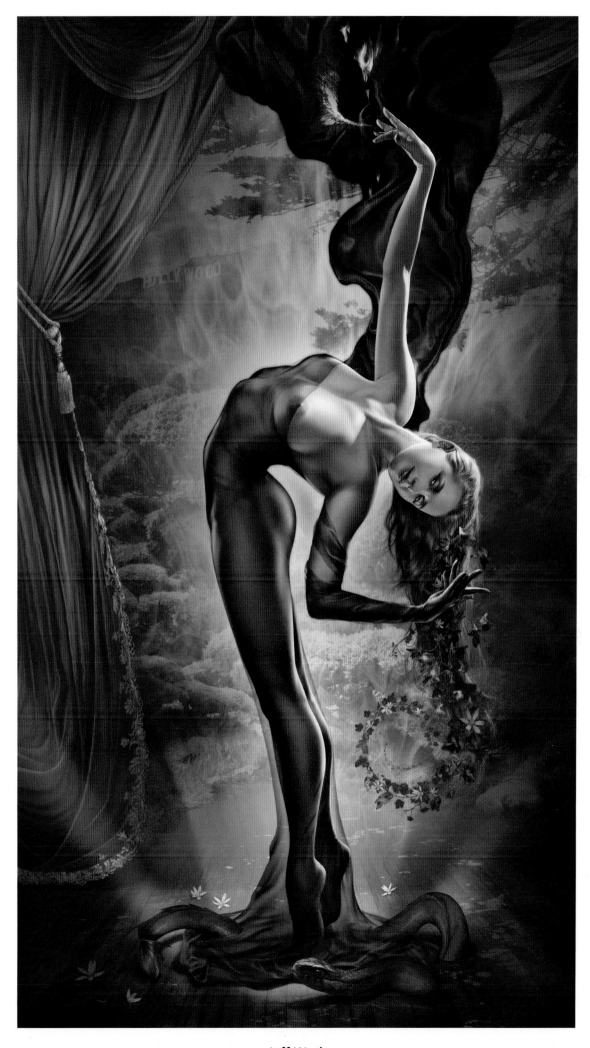

Jeff Wack

Client: Irina Kazakova *Title:* Irina *Size:* 32"x56" *Medium:* Digital

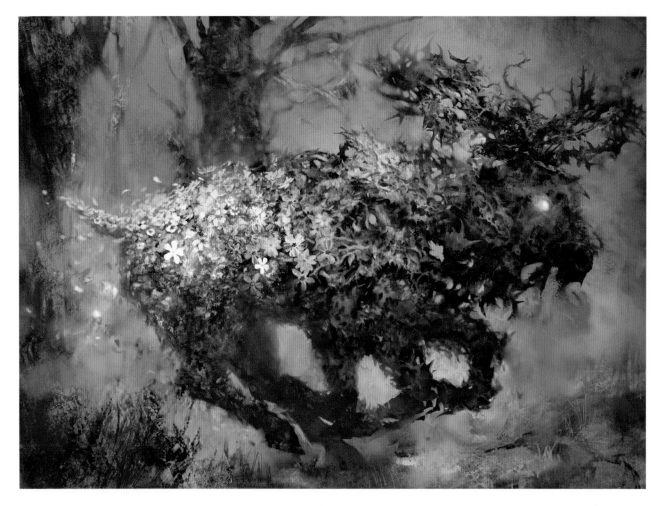

Karla Ortiz
Art Director: Dawn Murin *Client:* Wizards of the Coast *Title:* Elderwood Scion *Size:* 10"x7.25" *Medium:* Digital

Boris Dubrov
Art Director: Vladmir Bokser *Client:* www.kabrealism.com *Title:* Gevurah
Size: 45.8"x62.5" *Medium:* Oil on canvas

David Crust
Title: Angel *Size:* 13"x19" *Medium:* Mixed

Edward Kinsella III

Client: Richard Solomon Artists Representative *Title:* Hash–Inau–UK *Size:* 18"x18" *Medium:* Ink, gouache

Jerry Lofaro
Art Director: Michael McGloin *Client:* The Mountain
Title: Face Off *Size:* 20"x20" *Medium:* Digital

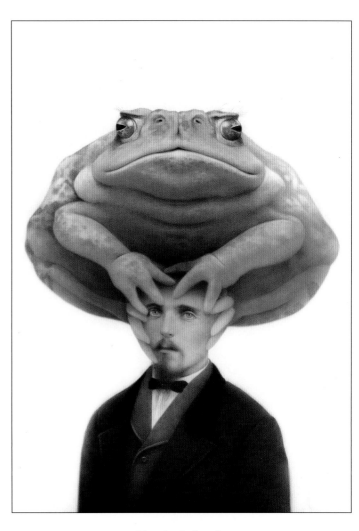

Travis A. Louie
Title: Karl & The Truth Toad *Size:* 16"x20" *Medium:* Acrylic on board

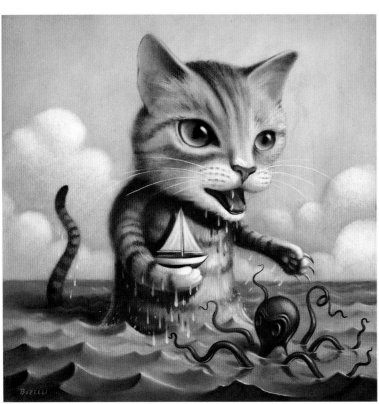

Chris Buzelli
Art Director: Jessica Hische *Client:* Jessica Hische & Russ Maschmeyer
Title: Kitty *Size:* 12"x12" *Medium:* Oil on board

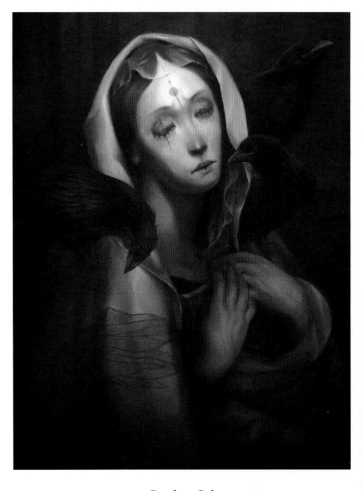

Rovina Cai
Title: Ravens *Size:* 7"x10" *Medium:* Digital

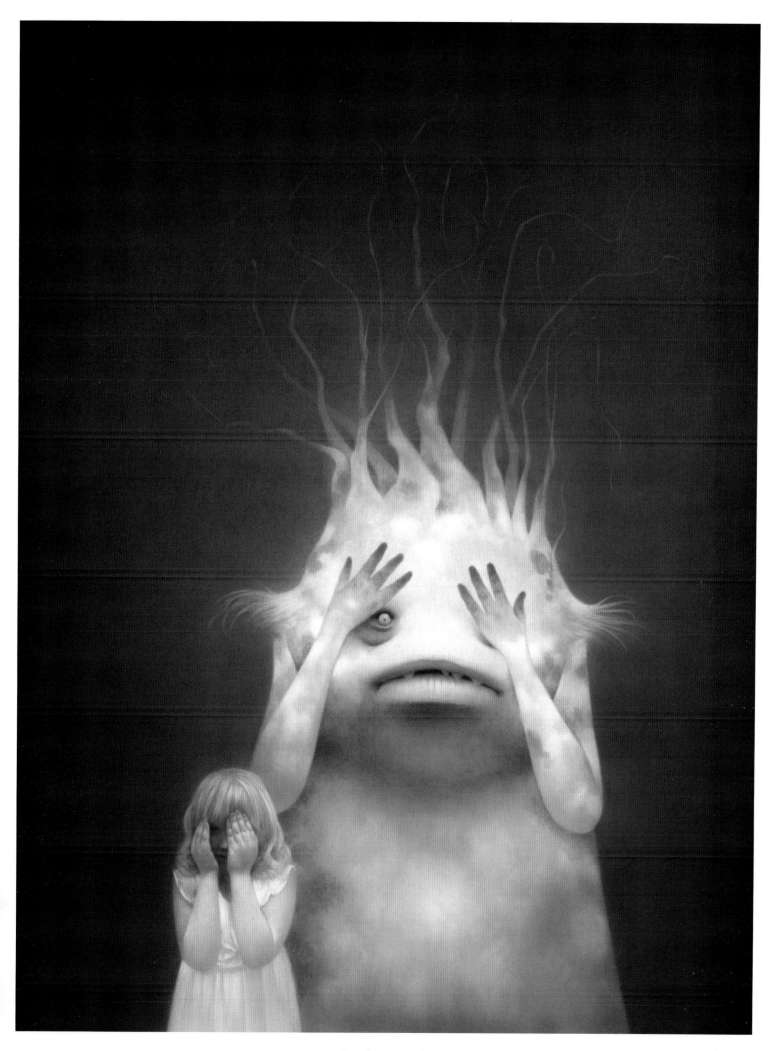

Travis A. Louie
Title: Julia & Her Swamp Friend *Size:* 16"x20" *Medium:* Acrylic on board

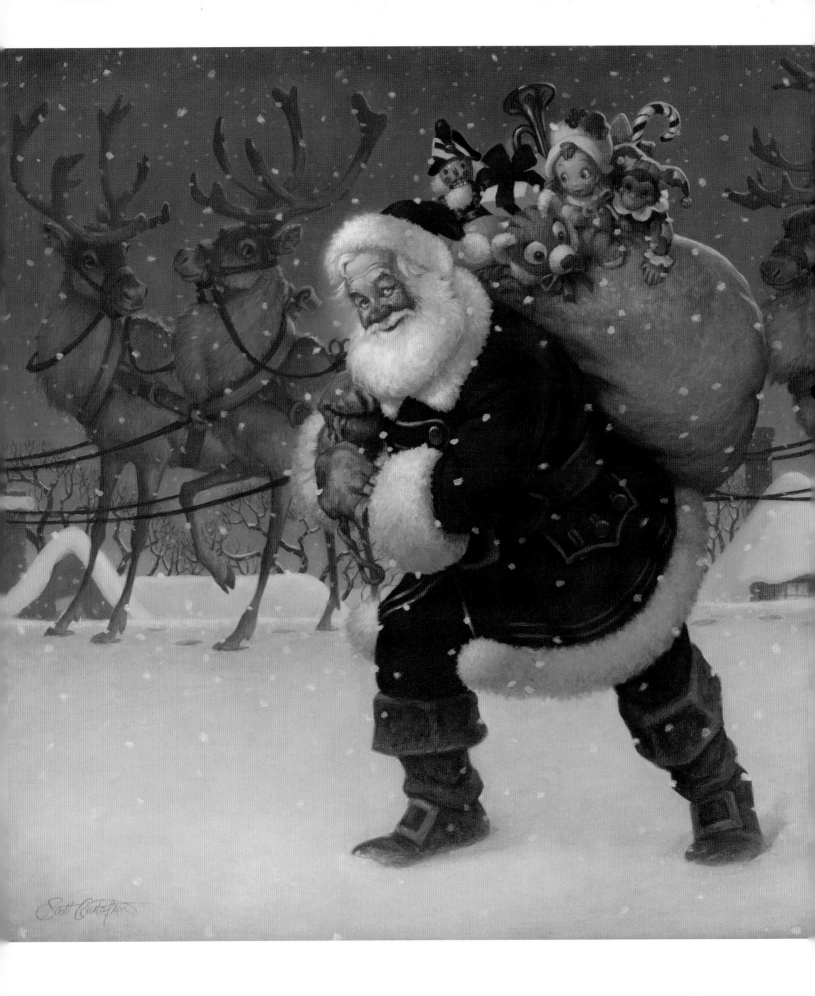

Scott Gustafson
Title: Santa with Reindeer *Size:* 27"x23" *Medium:* Oil

Steven Belledin
Art Director: Jeremy Jarvis *Client:* Wizards of the Coast *Title:* Searchlight Geist *Size:* 12"x9" *Medium:* Oil

John Stanko
Art Director: Jeremy Jarvis *Client:* Wizards of the Coast *Title:* Nightshade *Medium:* Digital

Kirk Reinert
Client: AFA NYC Gallery *Title:* Satin & Chinchilla *Size:* 21"x25" *Medium:* Acrylic

Jason A. Engle
Art Director: Jeremy Jarvis *Client:* Wizards of the Coast
Title: Beast Tracker *Size:* 10"x14" *Medium:* Digital

Jon Foster
Client: Richard Solomon *Title:* Change of Season *Medium:* Digital

Frank Cho
Colorist: Brandon Peterson *Client:* Monkey Boy Productions
Title: Wonder Brandy *Size:* 14"x21" *Medium:* Ink, digital color

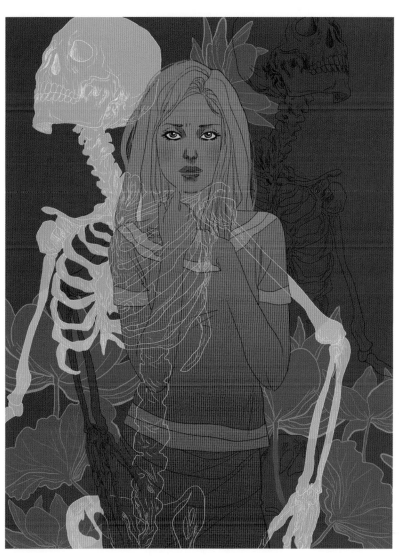

Marguerite Sauvage
Art Director: Mimi Leung *Client:* Designers Against Child Slavery
Title: Reclaim *Size:* 16"x20" *Medium:* Pencil, digital

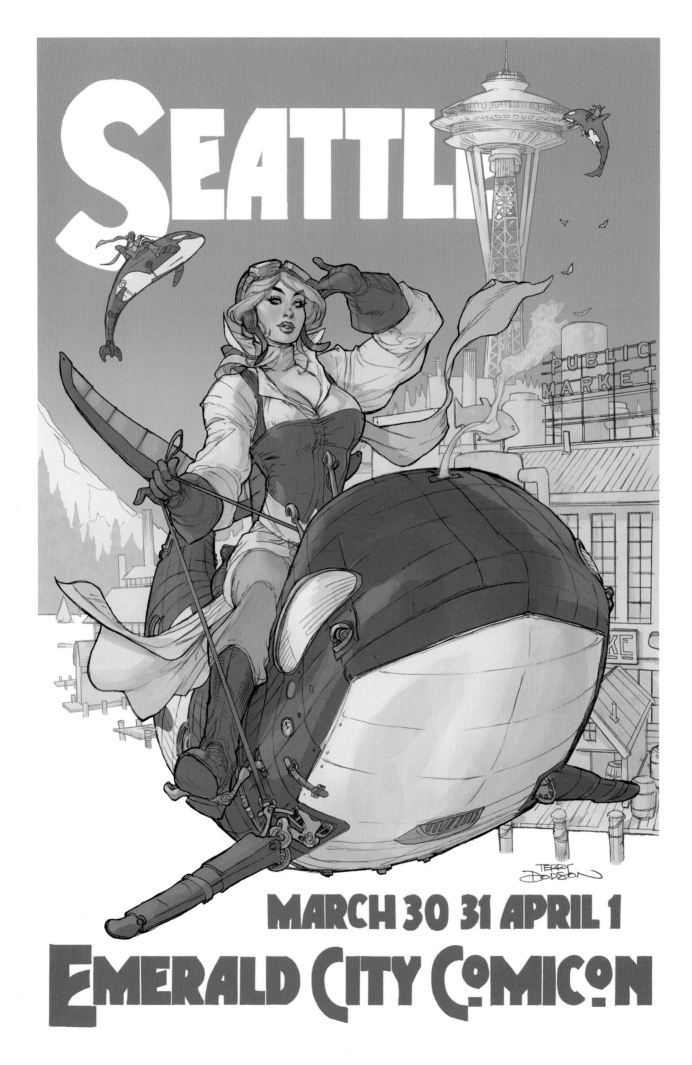

Terry Dodson
Title: Seattle *Size:* 13"x19" *Medium:* Pencil, digital

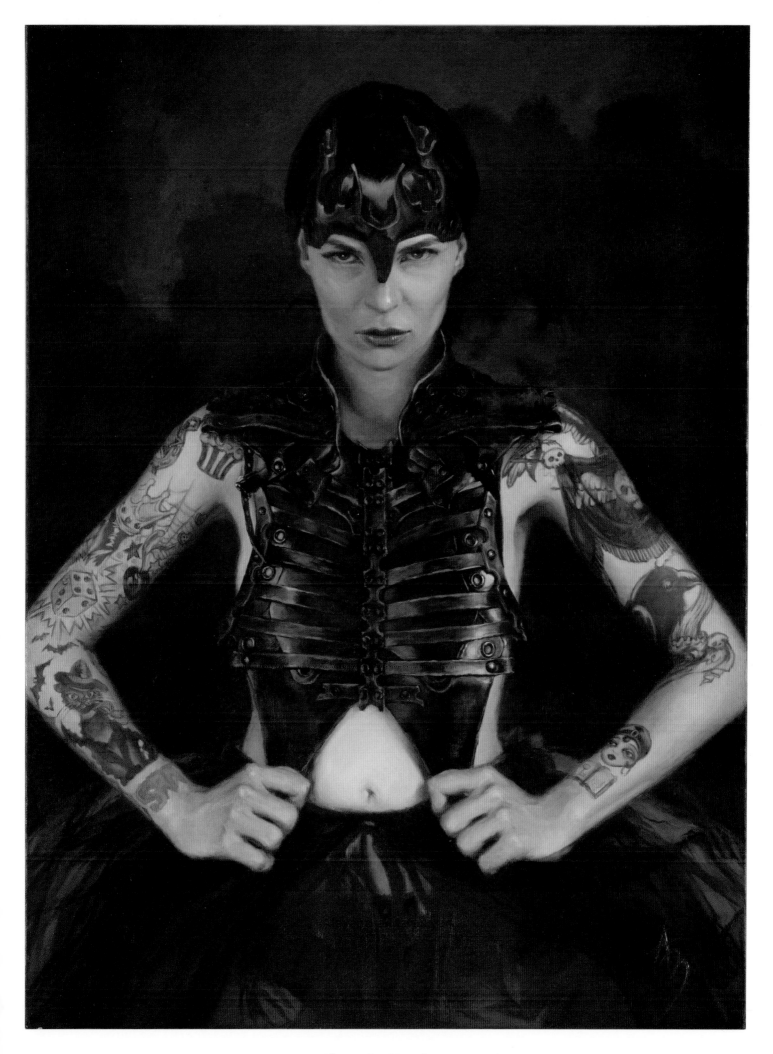

Alexandra Manukyan

Title: Animus *Size:* 18"x24" *Medium:* Oil on canvas

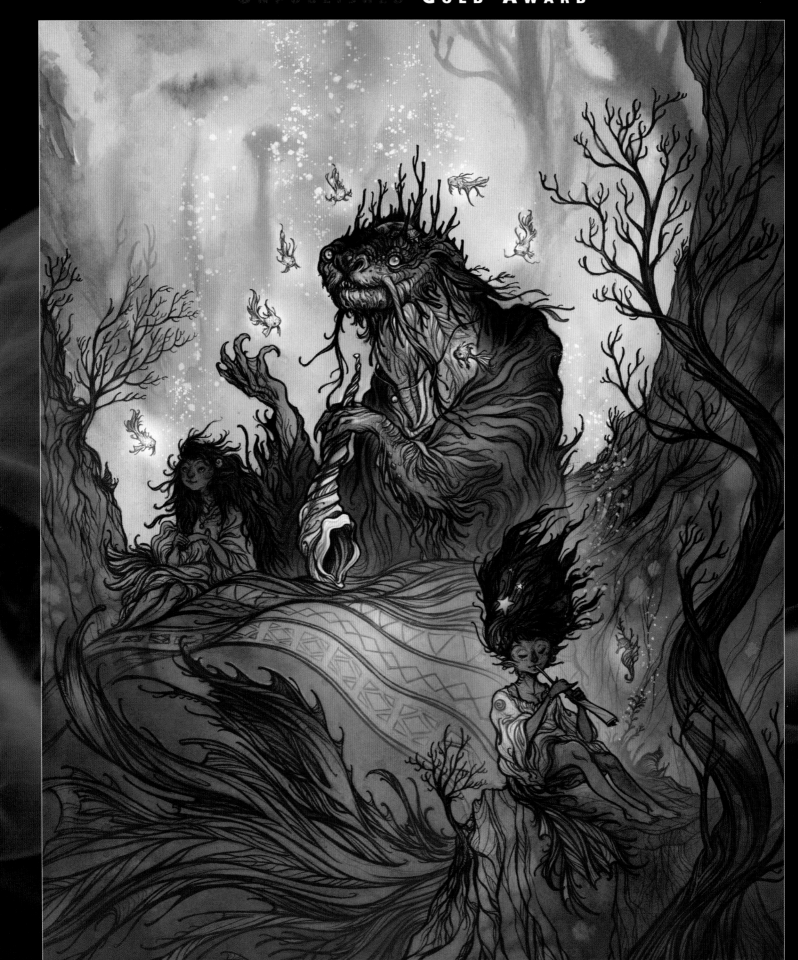

Andrew Mar
Title: Tell-Tale Heart *Medium:* Digital

Raphael Lacoste
Title: Mining on Gliese *Size:* 8.5"x11" *Medium:* Photoshop

Eduardo Peña

Title: Athena *Medium:* Photoshop

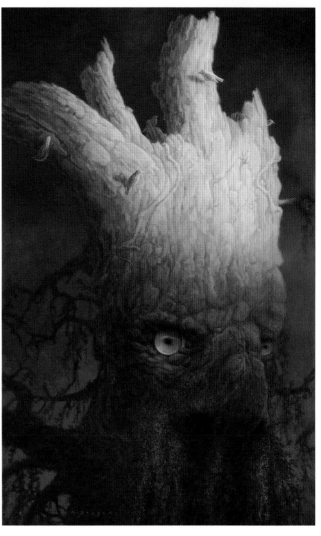

Allen Douglas
Title: Treebeard *Size:* 11"x18" *Medium:* Oil on panel

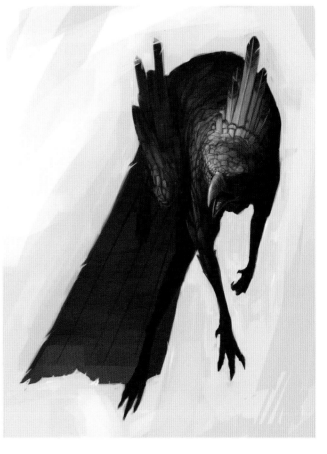

Tohru Patrick Awa
Client: Foehn Show/haleARTS *Title:* Sudden Shower *Size:* 10"x21.5" *Medium:* Watercolor

Henry Christian-Slane
Title: Spirit of Birds *Size:* 195mm x 264mm *Medium:* Photoshop

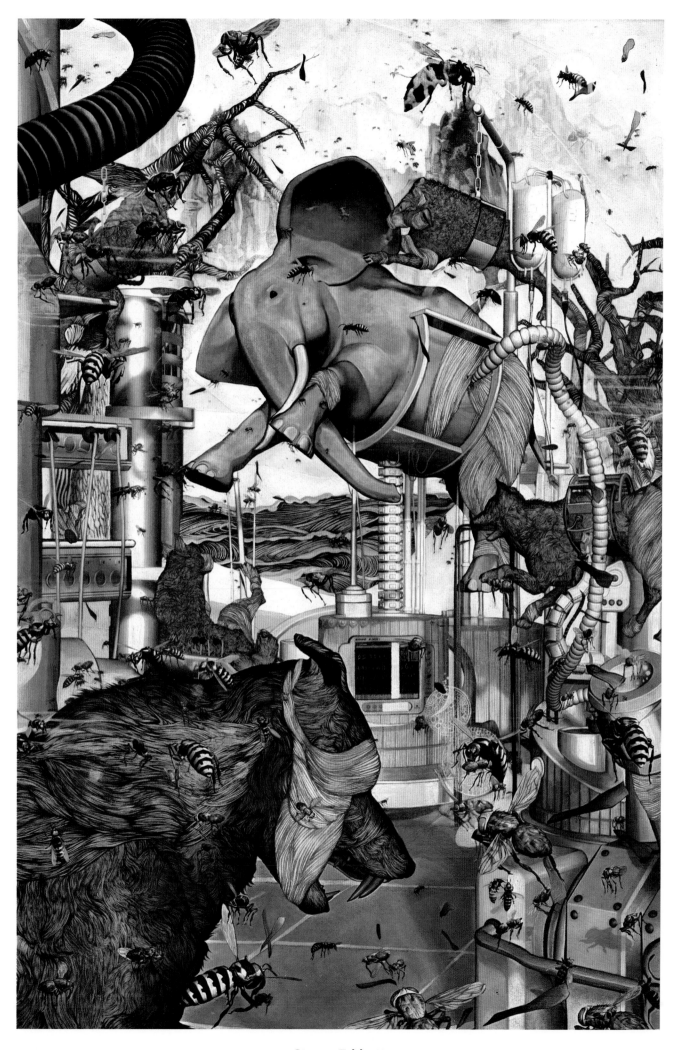

Steven Tabbutt

Title: Kingdom *Size:* 12.5"x19" *Medium:* Acrylic and pencil on paper

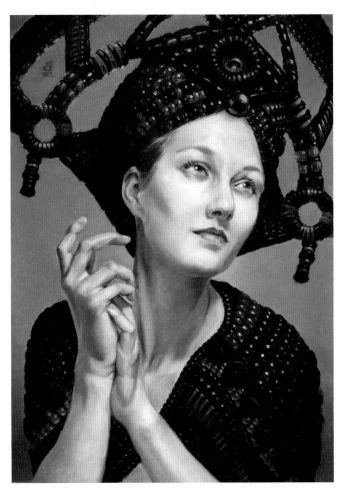

Randy Gallegos
Title: Bluebeads *Size:* 5"x7" *Medium:* Oil

Andrew Theophilopoulos
Title: Sick of Hiding *Size:* 18"x24" *Medium:* Photoshop

A.M. Sartor
Title: The Bloody Chamber *Medium:* Photoshop

Cynthia Sheppard
Title: Omens *Size:* 22"x30" *Medium:* Oil on board

Rebecca Guay
Title: Poppies *Size:* 4'x5' *Medium:* Oil on canvas

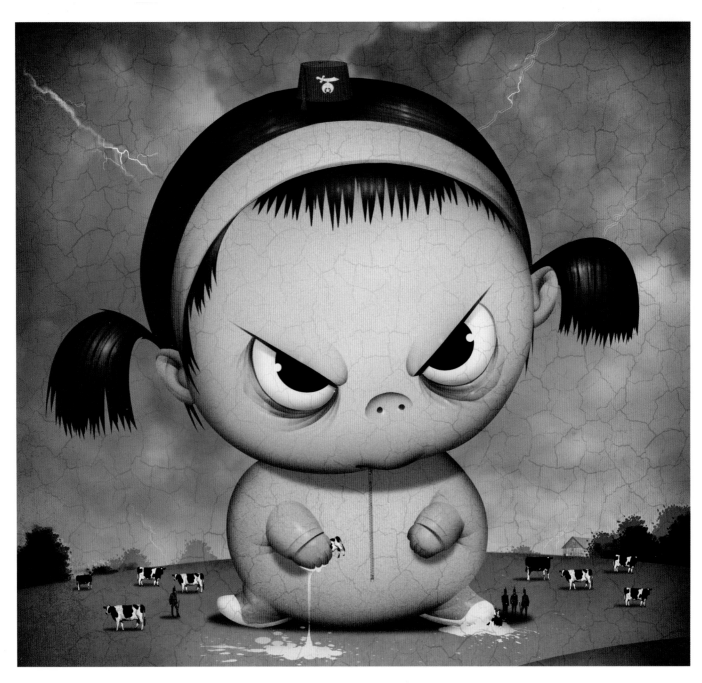

Bill Mayer
Title: Demented Little Beasties 05 *Size:* 14"x13" *Medium:* Mixed

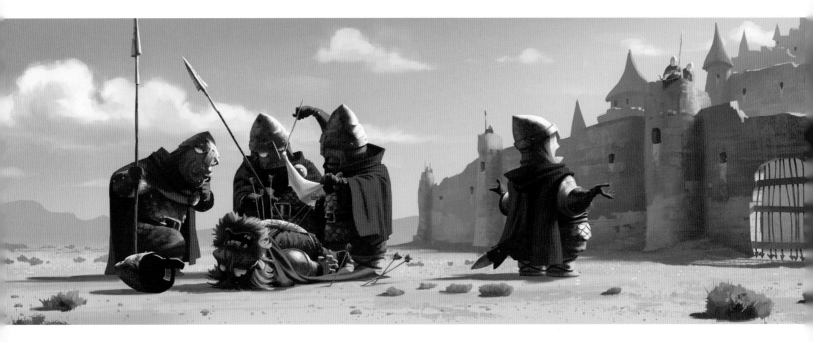

Tony Weinstock
Title: Don't Shoot the Messenger *Size:* 13.3"x4.7" *Medium:* Photoshop

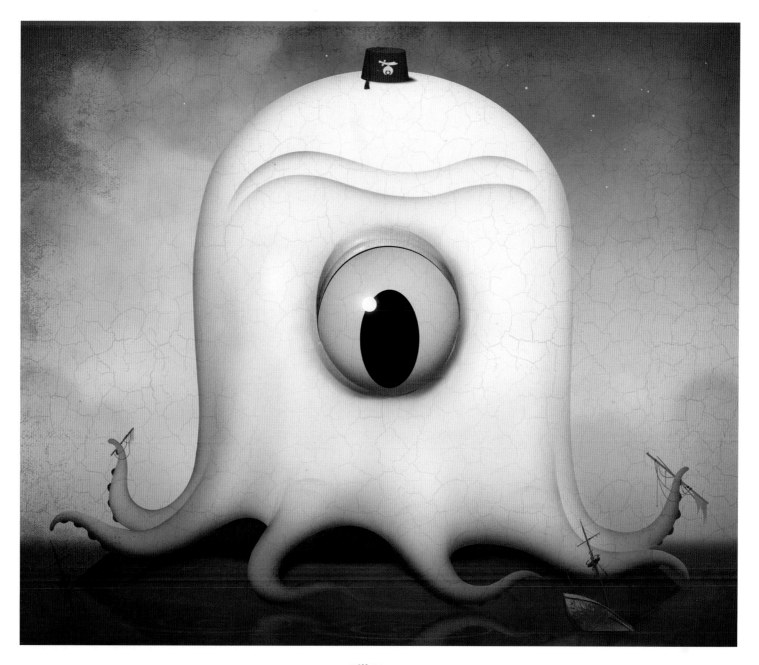

Bill Mayer
Title: Demented Little Beasties 04 *Size:* 14"x18" *Medium:* Mixed

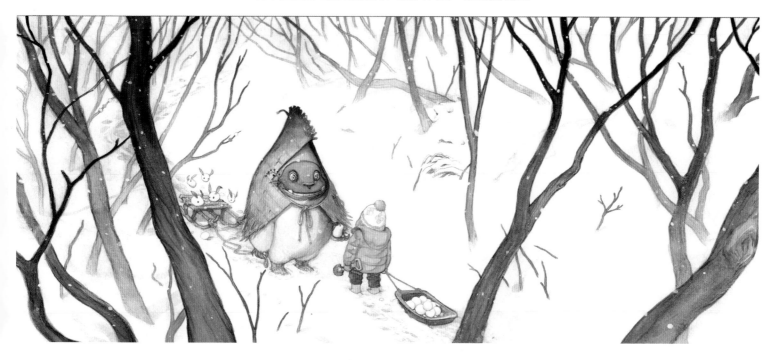

Tohru Patrick Awa
Client: Foehn Show/haleARTS *Title:* Snowlets *Size:* 17"x8" *Medium:* Watercolor

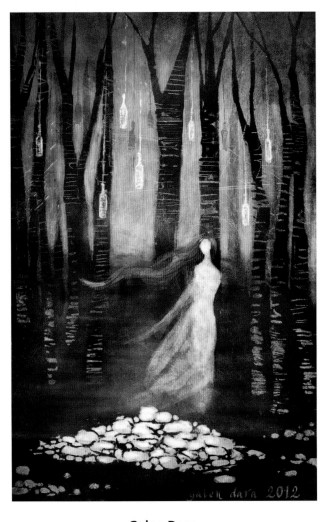

Galen Dara
Title: The Cairn in Slater Woods *Size:* 11"x17" *Medium:* Digital

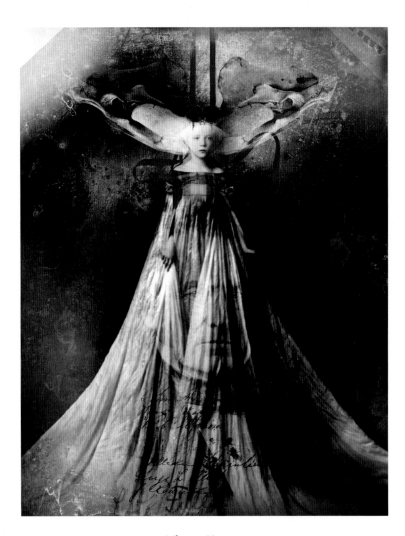

Victor Koen
Title: Erigone *Size:* 13"x19" *Medium:* Digital

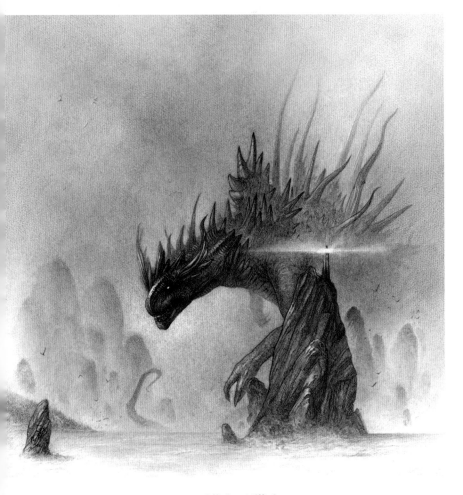

Olivier Villoingt
Title: From the Seas *Size:* 17.1"x18.3" *Medium:* Graphite on paper

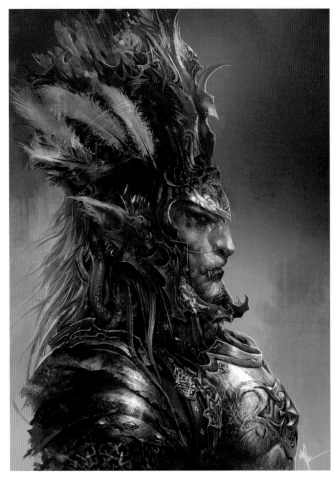

Feng Guo
Title: The Dragoon *Medium:* Digital

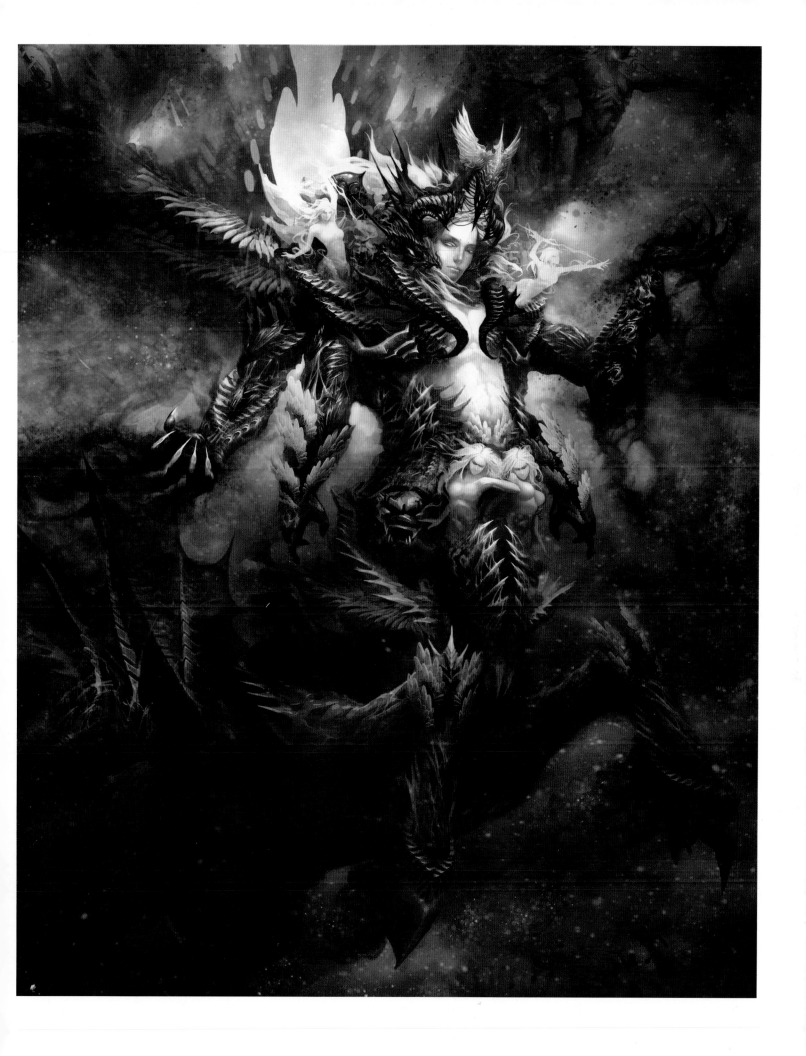

Zhao Huanhua
Title: Archangel *Medium:* Digital

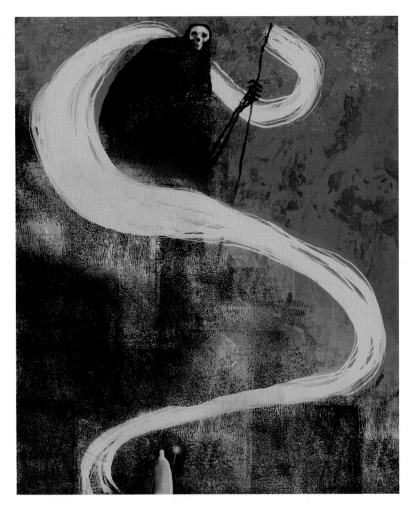

Jeffrey Alan Love
Title: Night Upon the Mountain *Size:* 10"x12" *Medium:* Mixed

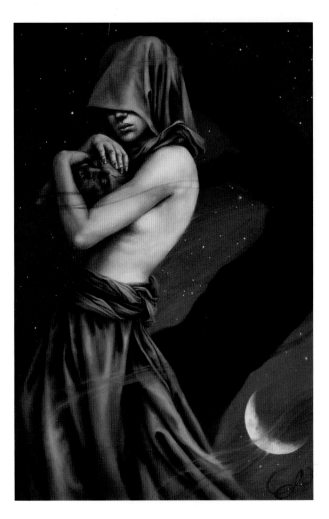

Lauren K. Cannon
Title: Salome *Medium:* Digital

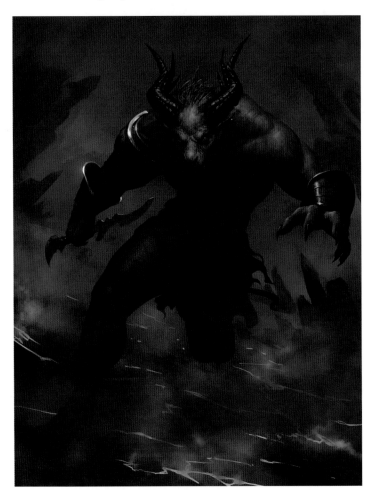

Ryan Wardlow
Title: Hunter *Size:* 8.5"x11" *Medium:* Digital

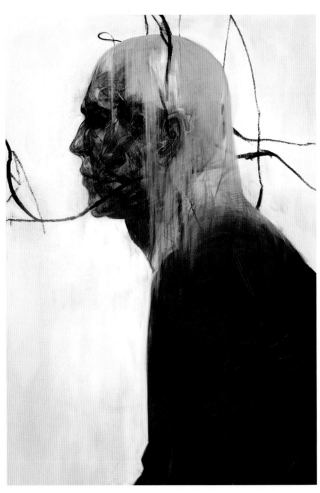

Jeff Simpson
Title: Listener *Size:* 10"x15" *Medium:* Pencil, digital

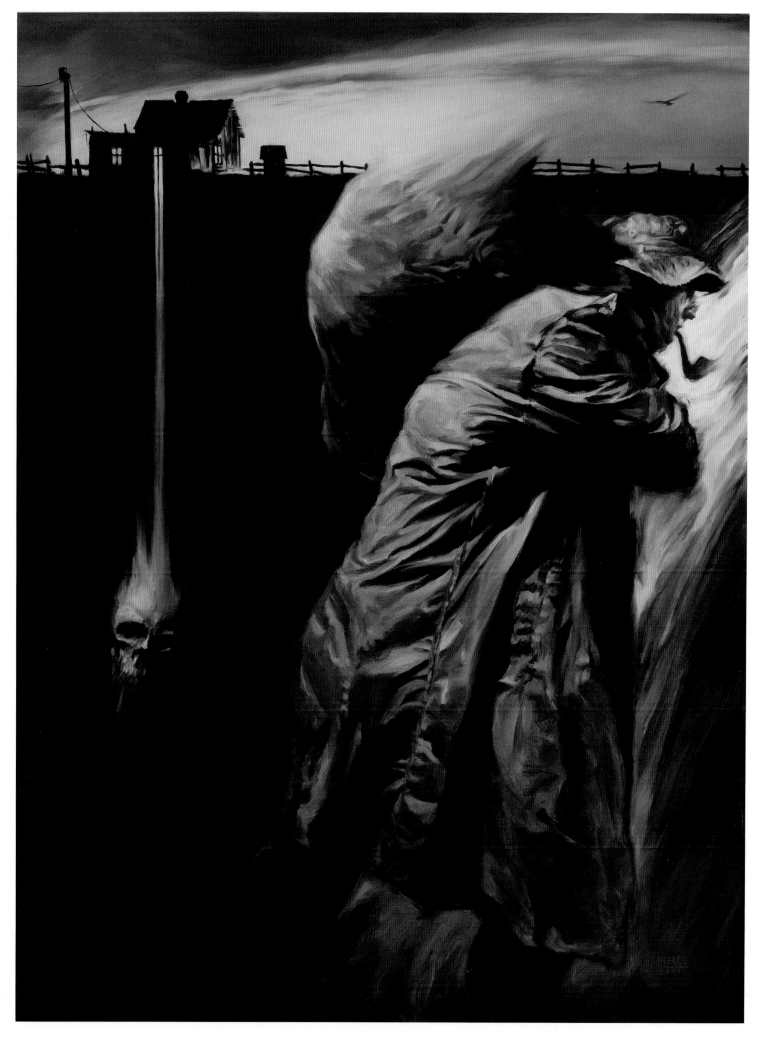

Shane Pierce

Title: Below the Surface *Size:* 18"x24" *Medium:* Oil

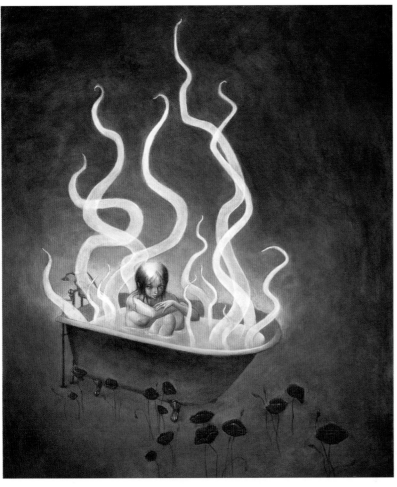

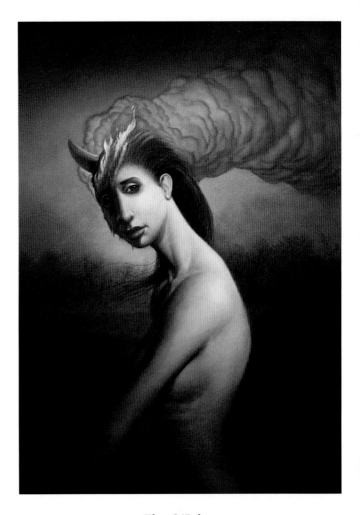

Erika Taguchi-Newton
Title: Soak *Size:* 16"x20" *Medium:* Acrylic

Tim O'Brien
Title: Krampus *Size:* 11"x14" *Medium:* Oil

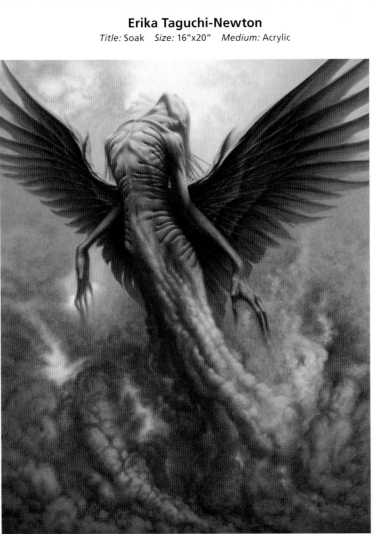

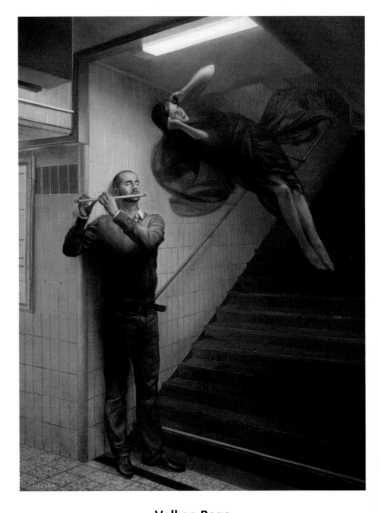

Cam de Leon
Client: Gallery Nucleus *Title:* Rise *Size:* 16"x20" *Medium:* Oil

Volkan Baga
Title: Incantation *Size:* 60cm x 80cm *Medium:* Oil

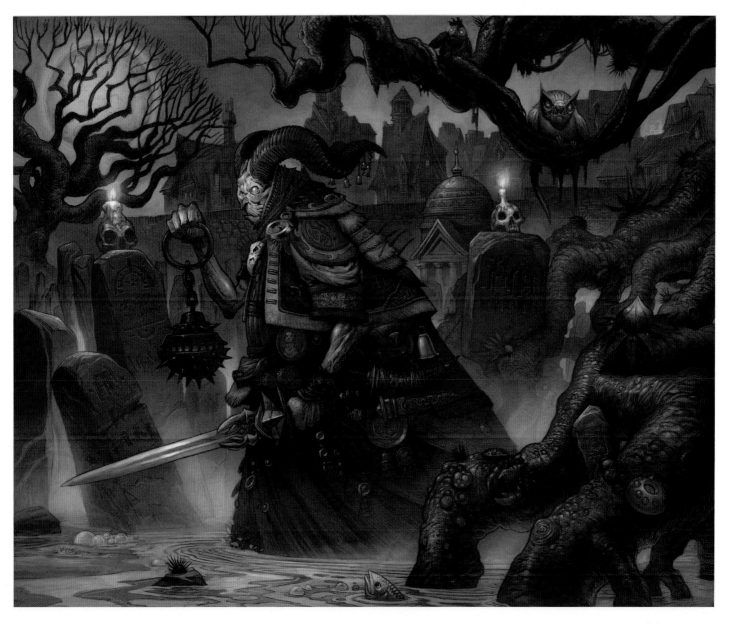

Sean Andrew Murray
Title: Gateway–The Book of Wizards: Gravemaster *Medium:* Digital

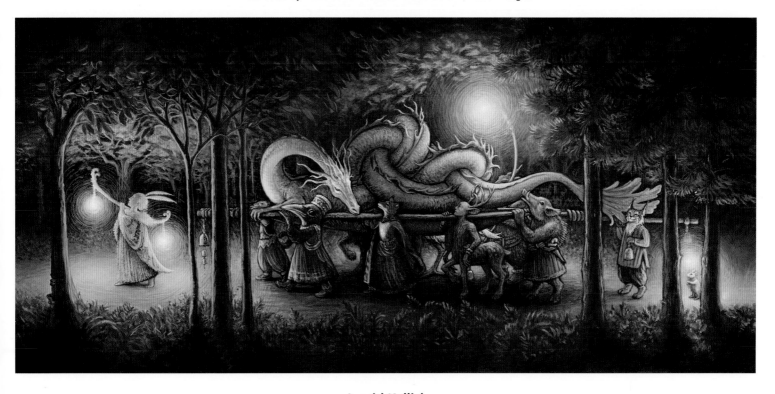

Ingrid Kallick
Title: Procession *Size:* 24"x12" *Medium:* Acrylic on board

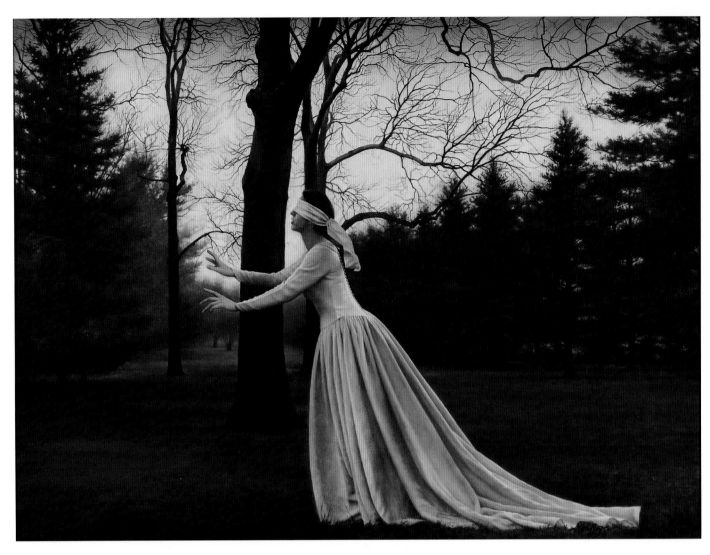

Michael J. Deas
Client: Ogden Museum of Southern Art *Title:* Blind Man's Bluff *Size:* 54"x40" *Medium:* Oil on panel

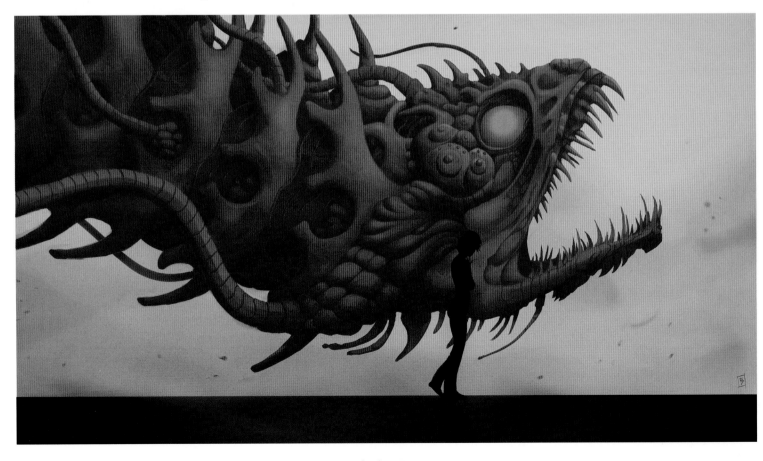

Florian Bo
Title: A Softer Goodbye *Size:* 26.7cm x 16.6cm *Medium:* Digital

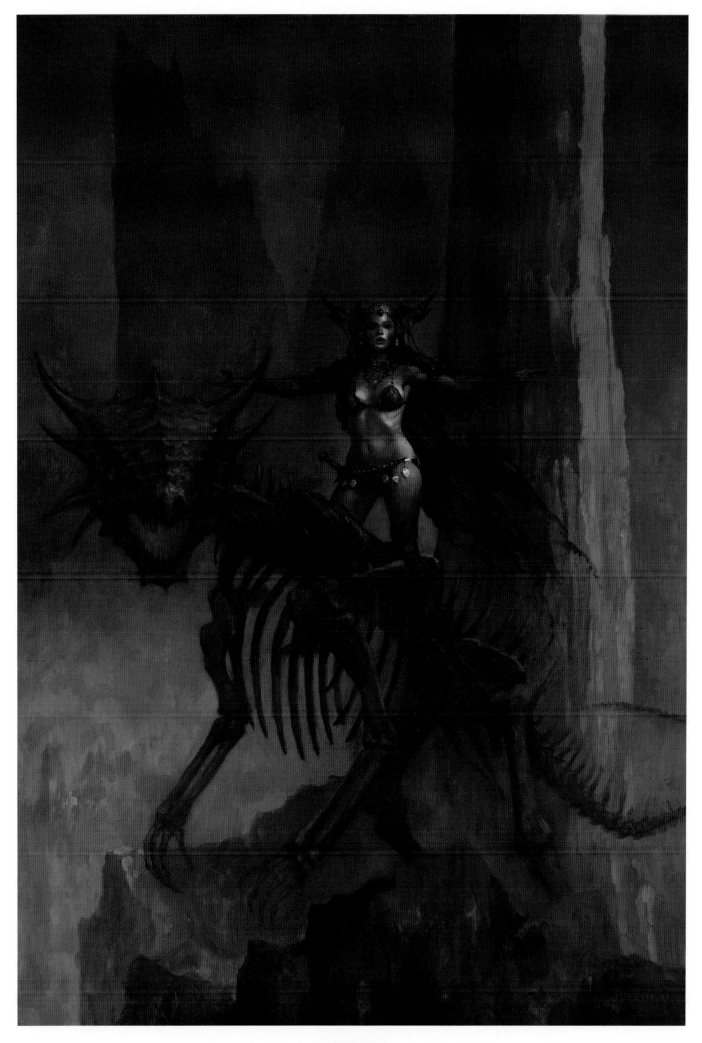

Justin Sweet

Title: Death Mark *Size:* 32"x45" *Medium:* Oil

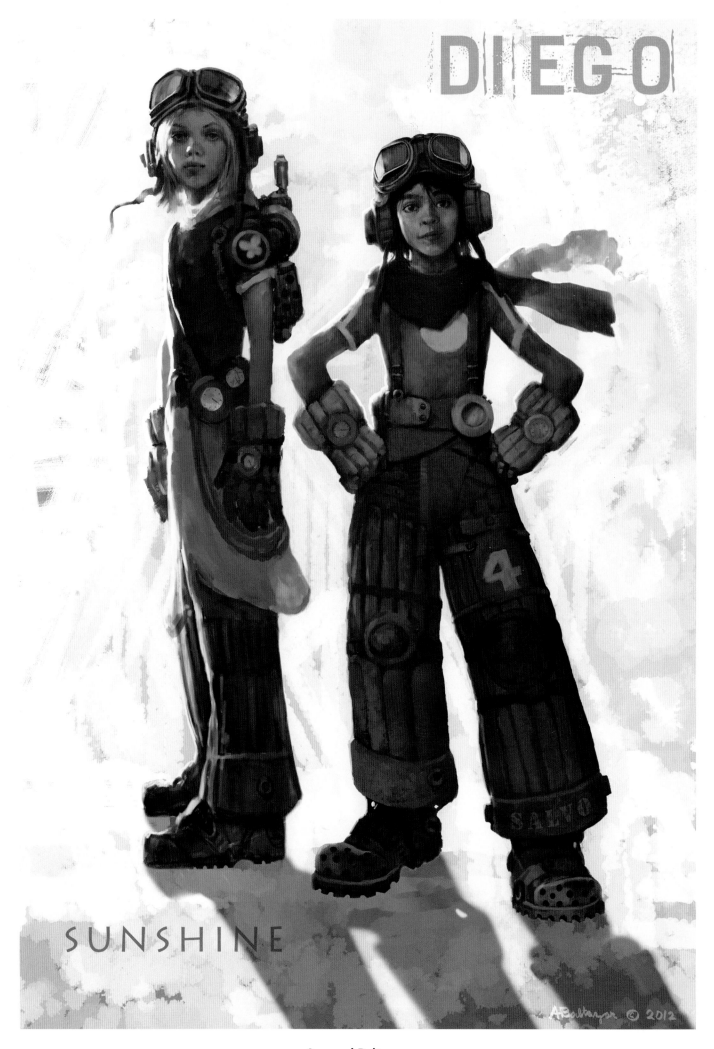

DIEGO

SUNSHINE

Armand Baltazar
Client: Diego and Sunshine *Size:* 13"x19" *Medium:* Mixed

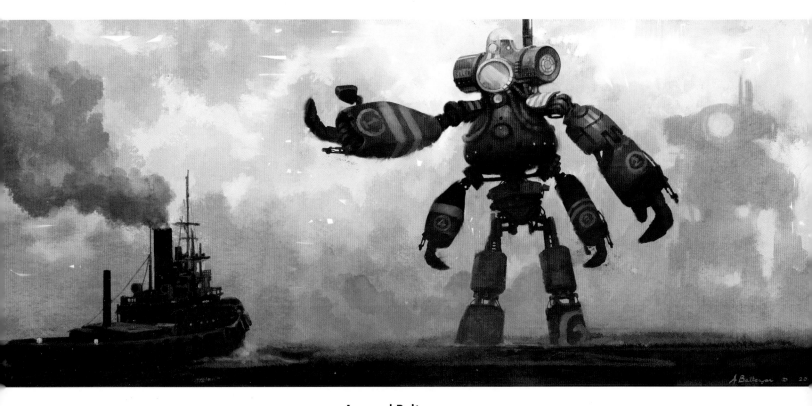

Armand Baltazar
Title: Wecoming the Submariners *Size:* 24"x10" *Medium:* Mixed

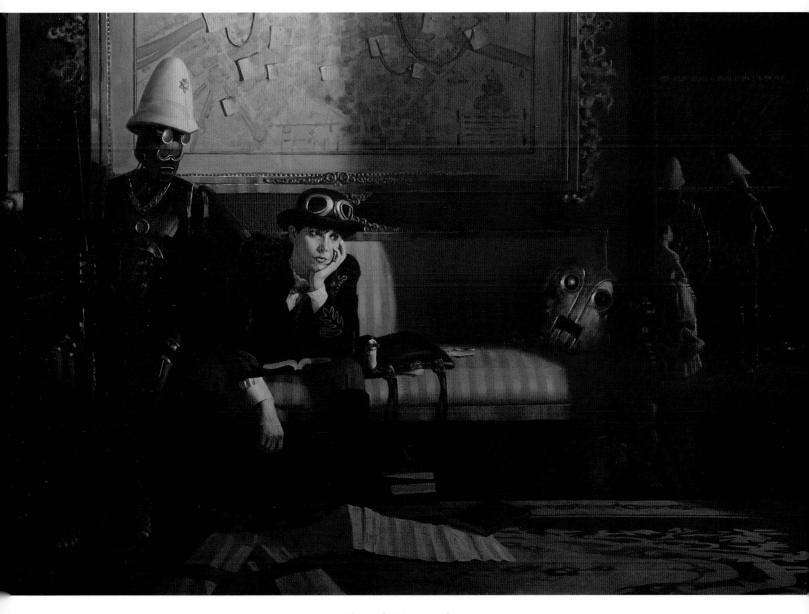

Edward F. Howard
Title: Loss *Size:* 36"x24" *Medium:* Oil on board

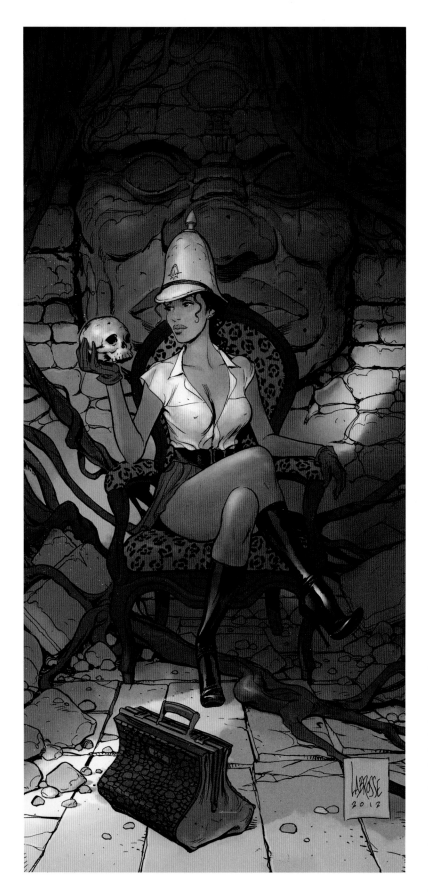

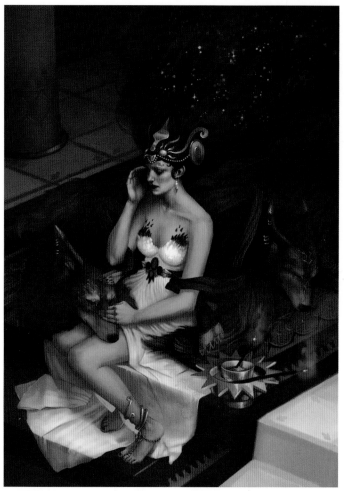

Sara K. Diesel
Title: The Lamentation of Gahl *Size:* 20"x28" *Medium:* Digital

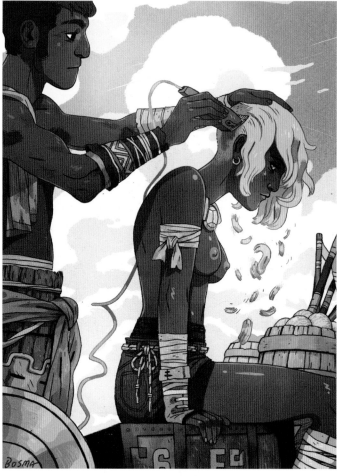

Thierry Labrosse
Title: To Be Or Not To Be *Size:* 10"x22" *Medium:* Ink, digital

Sam Bosma
Title: Haircut *Medium:* Digital

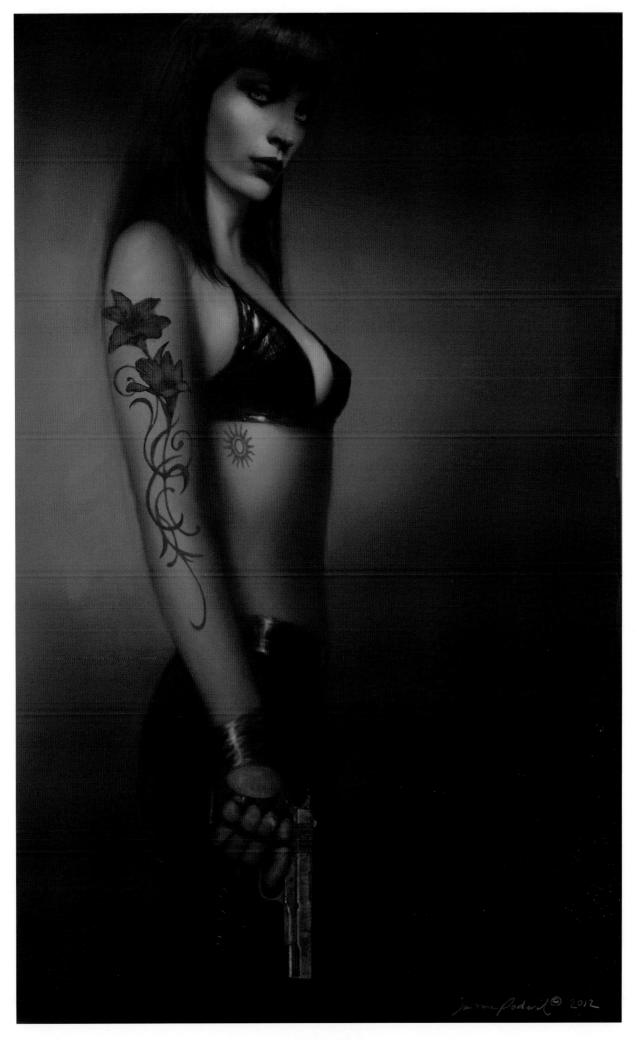

Jerome Podwil

Title: Girl With Lily Tattoo *Size:* 20"x30" *Medium:* Mixed

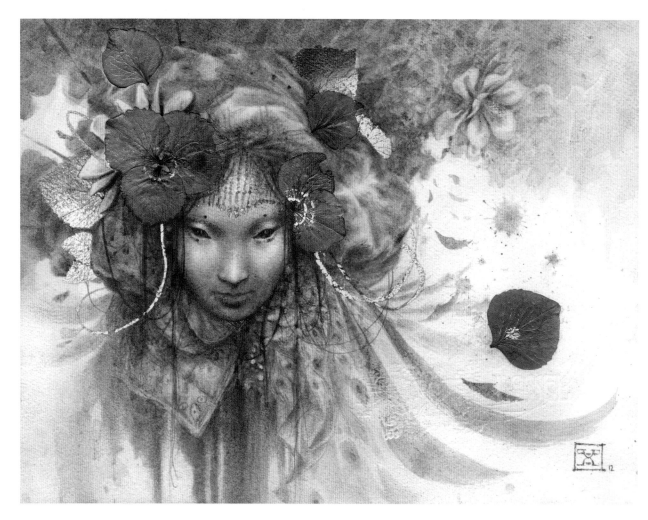

Yoann Lossel
Title: Sugar Plum Fairy *Size:* 12"x9" *Medium:* Graphite, gold leaf, hydrangea petals

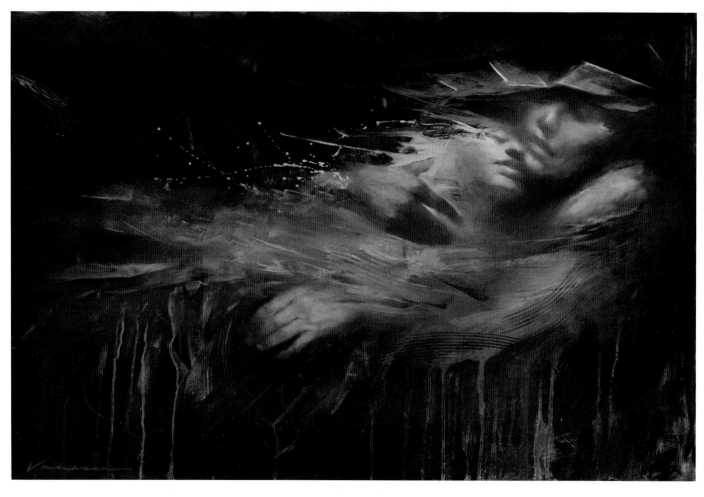

Vanessa Lemen
Title: Vortex *Size:* 30"x20" *Medium:* Oil on panel

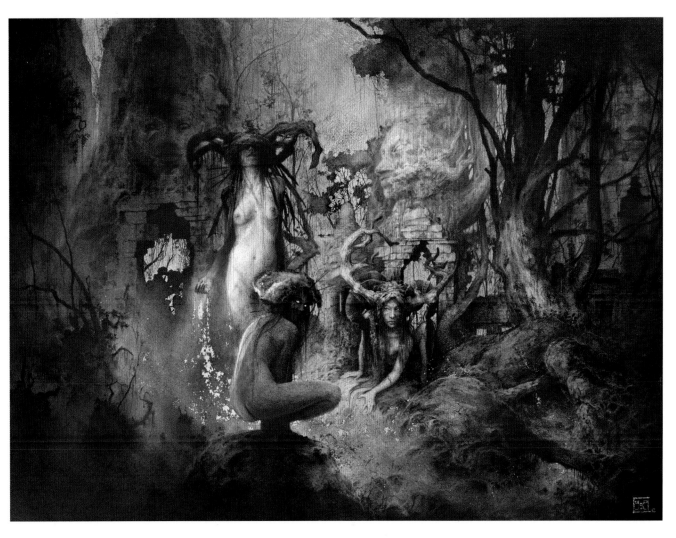

Yoann Lossel

Title: The Golden Age *Size:* 23.2"x17.3" *Medium:* Graphite, gold leaf

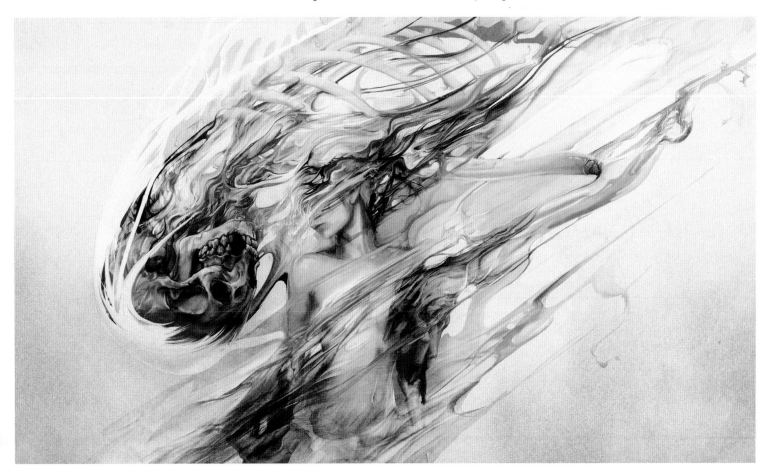

Ryohei Hase

Title: Suddenly appeared Out of Nowhere *Size:* 30"x17.5" *Medium:* Photoshop

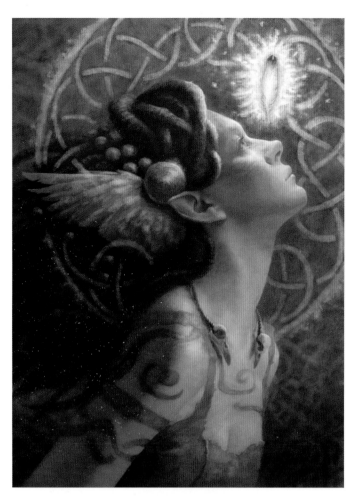

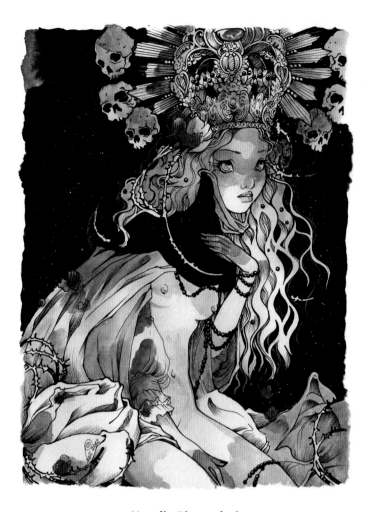

Christine Mitzyk
Art Director: Rebecca Guay *Title:* The Morrigu *Size:* 9"x12" *Medium:* Digital

Natalia Pierandrei
Client: Fine Grime Gallery *Title:* Black Pearls *Size:* 24cm x 33cm *Medium:* Mixed

Mark Poole
Title: Decisions *Size:* 44"x36" *Medium:* Oil

Ruth Sanderson

Title: Persephone *Size:* 12"x16" *Medium:* Scratchboard

Eric Joyner
Client: Corey Helford Gallery *Title:* The Lost and Found *Size:* 40"x30" *Medium:* Oil on wood

Julie Dillon
Title: Afternoon Walk *Medium:* Digital

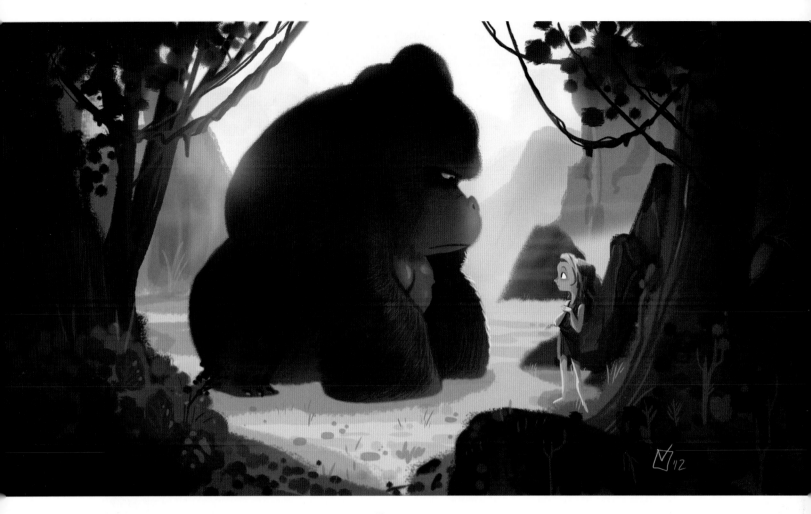

Jeff Victor
Title: Welcome to Skull Island *Medium:* Digital

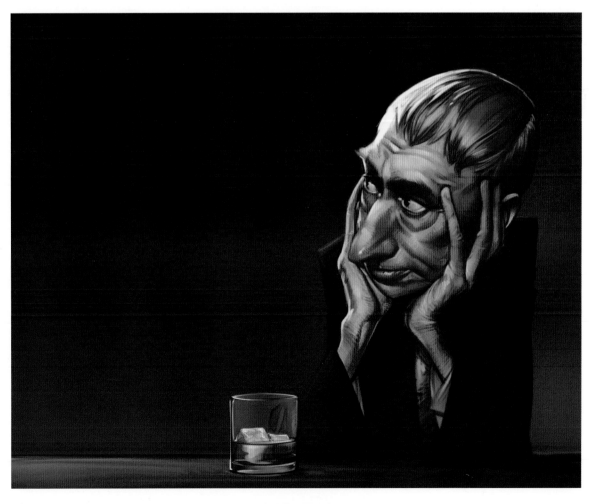

David Malan
Title: Norm Waiting *Medium:* Digital

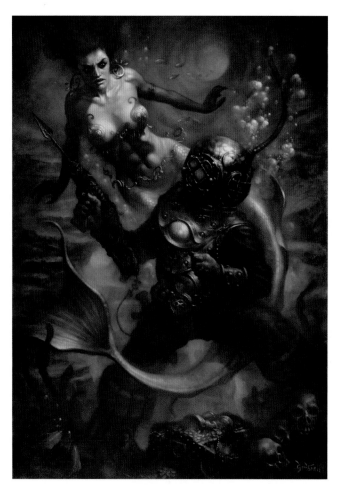

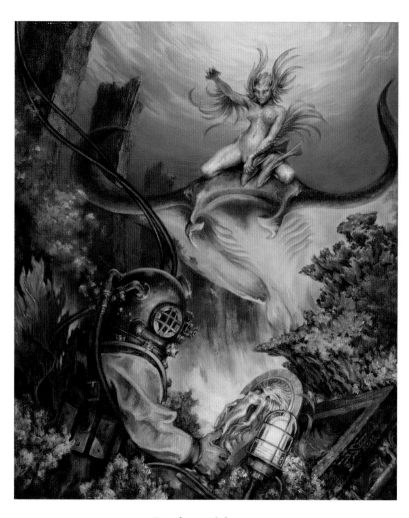

Patrick J. Jones
Art Director: Neil & Leigh Mechem *Client:* Girasol Collectibles, Inc.
Title: The Lost Treasure *Size:* 24"x36" *Medium:* Oil on canvas

Stephen Hickman
Title: Treasure of Dagon *Size:* 16"x19" *Medium:* Oil

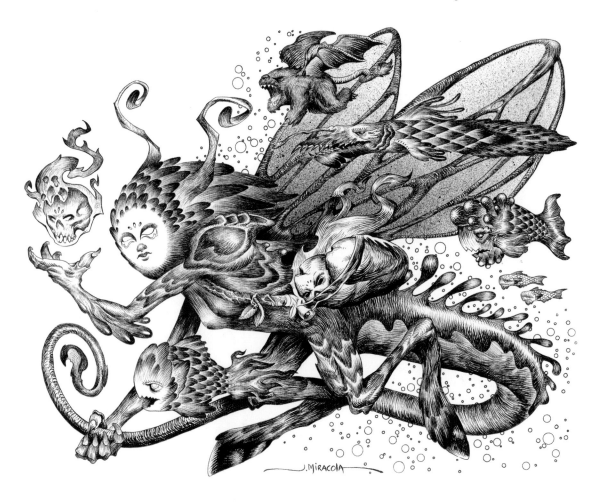

Jeff Miracola
Title: Skullshaker Sprite *Size:* 20"x16" *Medium:* Ink

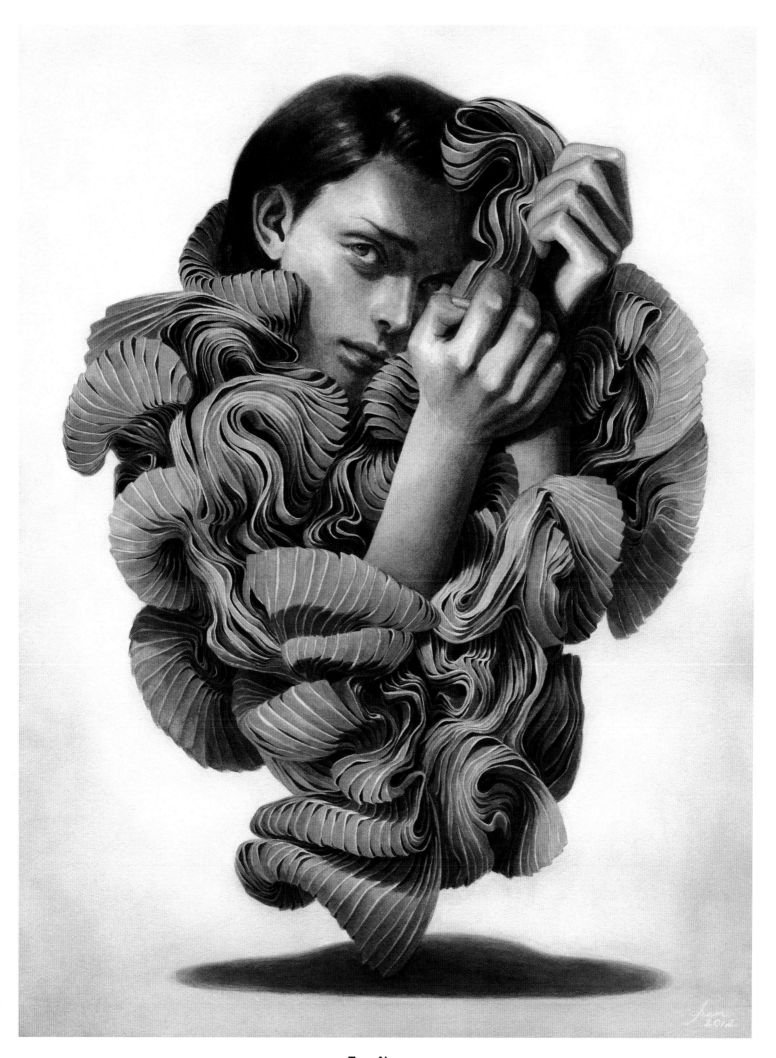

Tran Nguyen
Title: Enveloped Between a Pleated Thought *Size:* 12"x16" *Medium:* Acrylic

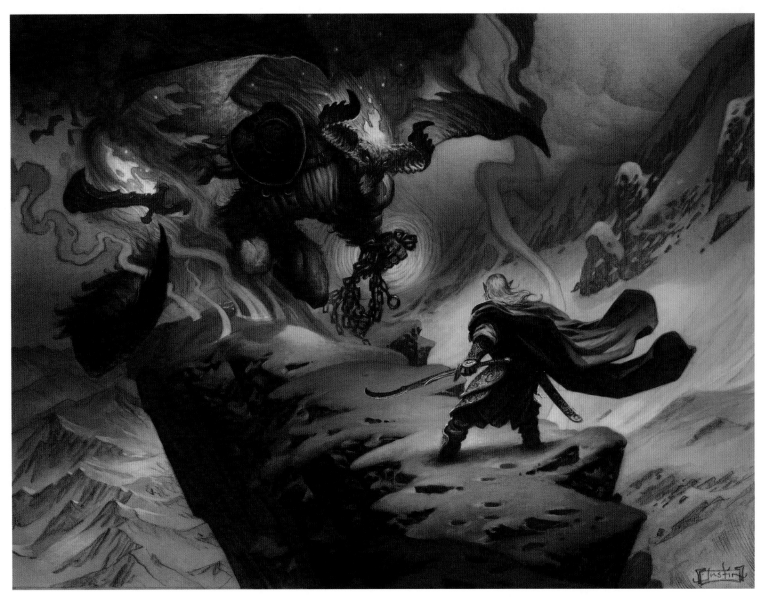

Justin Gerard
Title: Glorfindel & The Balrog *Size:* 22"x16.5" *Medium:* Watercolor, digital

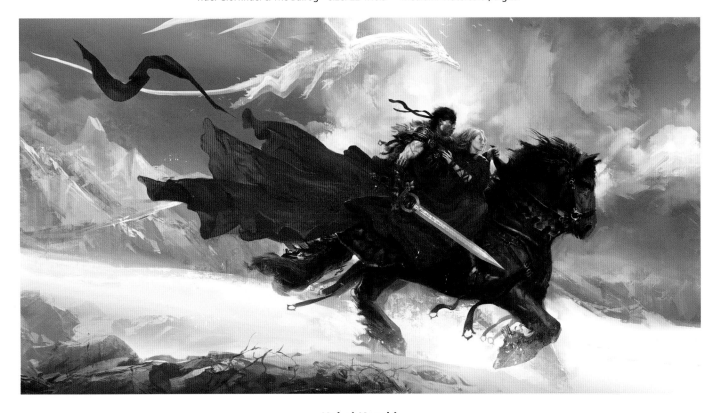

Kekai Kotaki
Title: Ride *Size:* 25"x14" *Medium:* Digital

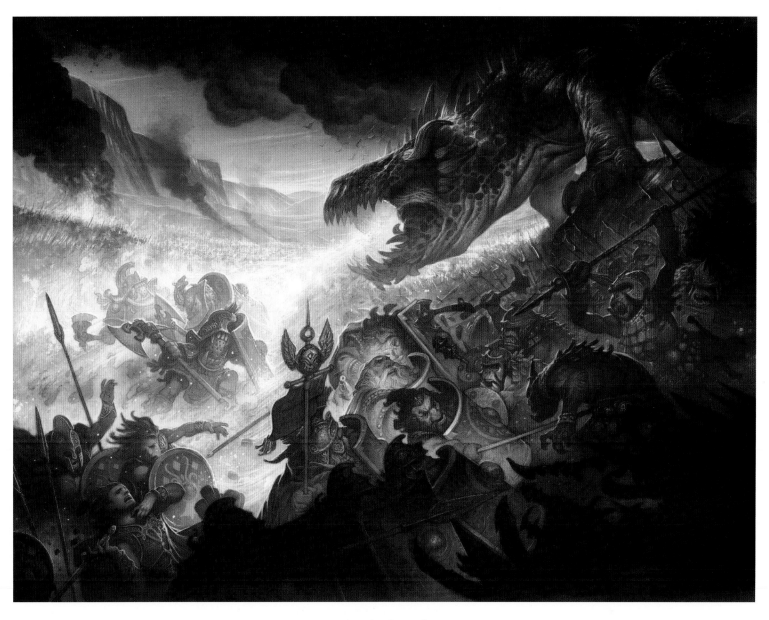

Justin Gerard
Title: Glaurung *Size:* 22"x17" *Medium:* Watercolor, digital

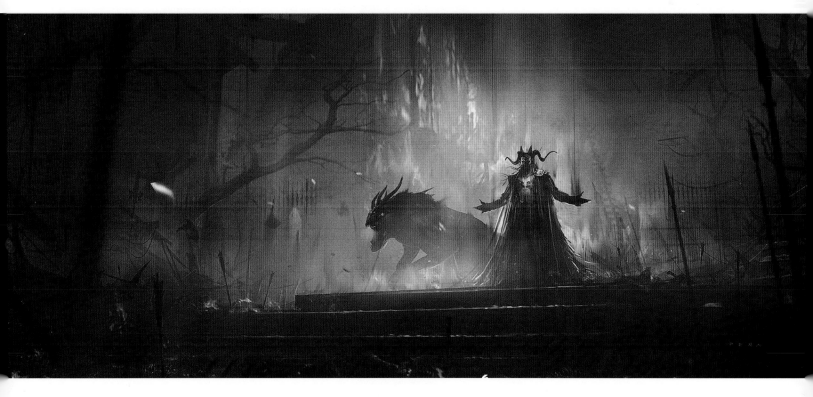

Eduardo Peña
Title: Purgatoria *Medium:* Digital

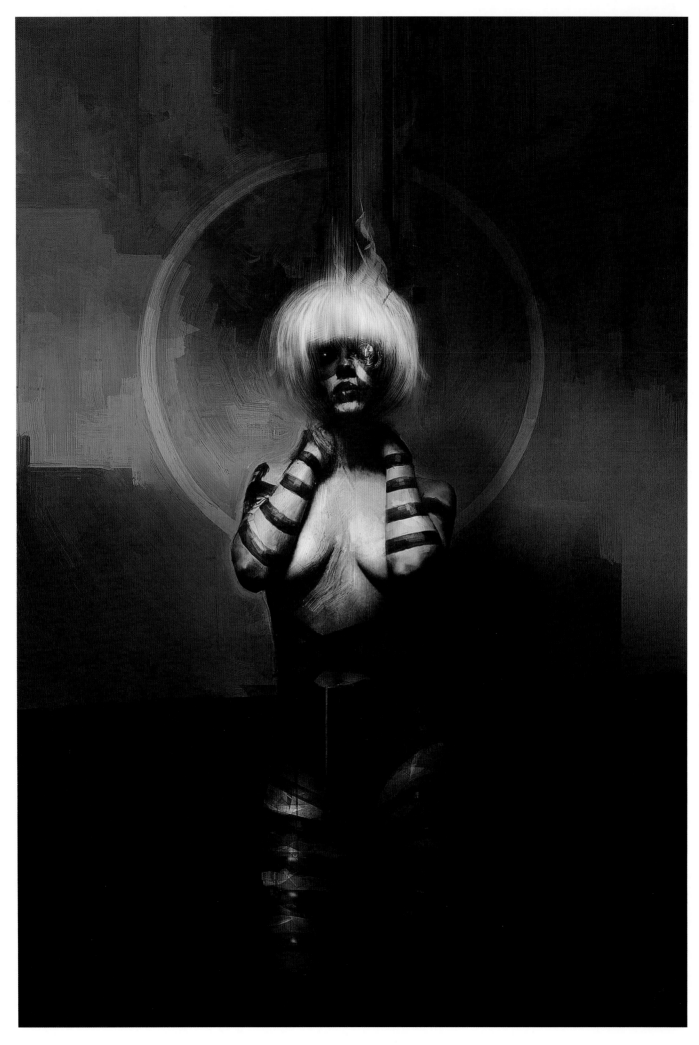

Bastien Lecouffe Deharme
Title: Pris *Medium:* Digital

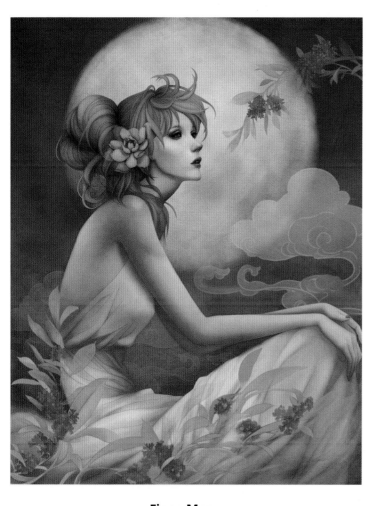

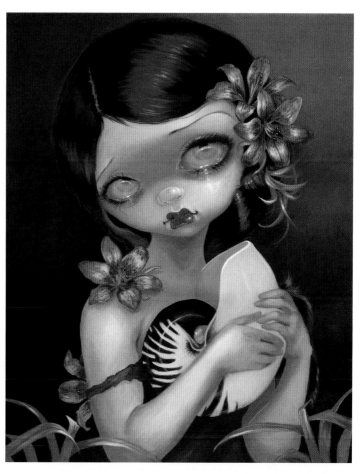

Jasmine Becket-Griffith
Title: Tiger Lily, Tiger Nautilus *Size:* 16"x20" *Medium:* Acrylic on wood

Fiona Meng
Title: Mid Autumn *Size:* 11"x14" *Medium:* Digital

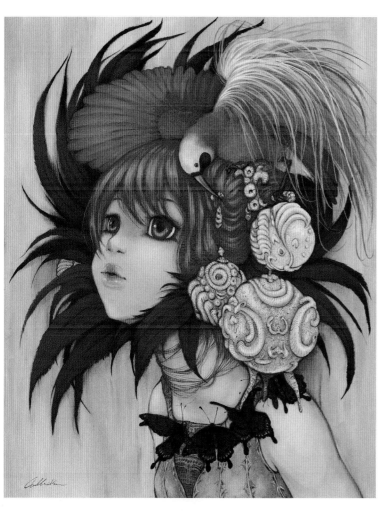

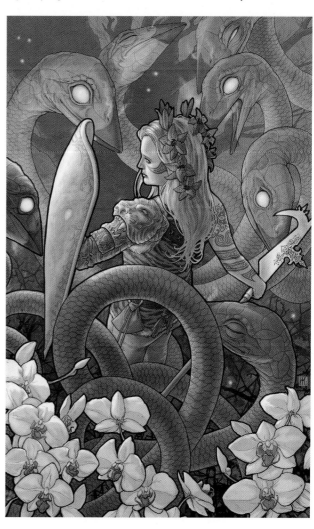

Camilla d'Errico
Title: Peaks of Paradise *Size:* 16"x20" *Medium:* Oil on wood panel

Herman Lau
Title: Tiger Lily *Medium:* Digital

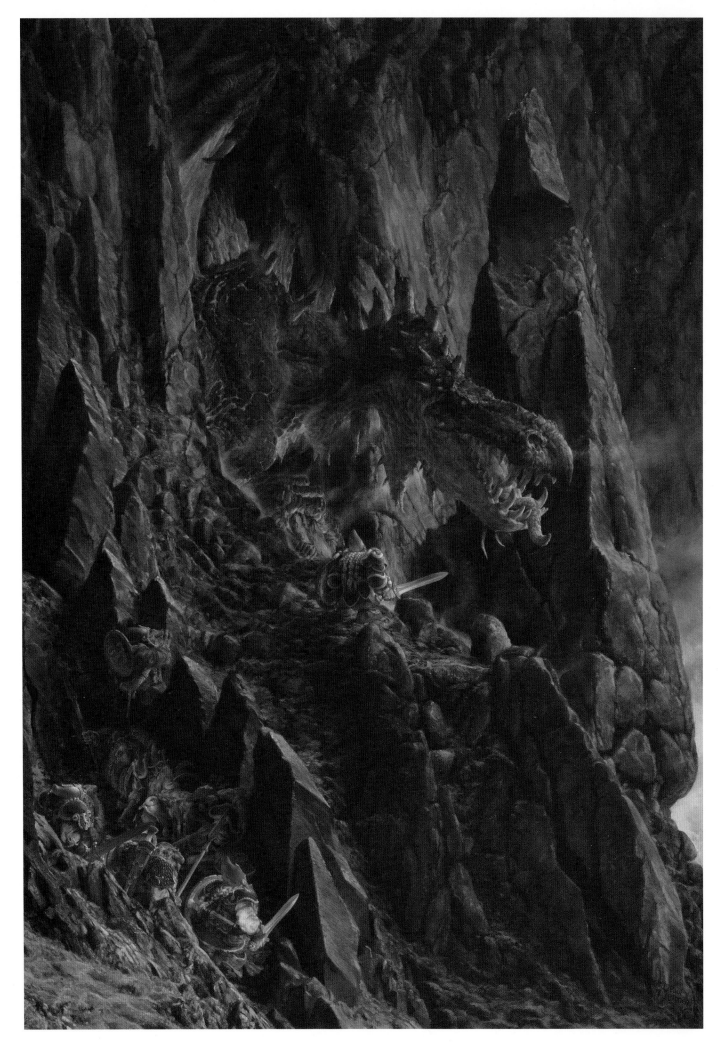

Paul Bonner
Title: Beowulf *Size:* 48cm x 67cm *Medium:* Watercolor

Paul Bonner
Title: Beowulf *Size:* 68cm x 47cm *Medium:* Watercolor

Kekai Kotaki
Title: Clash *Size:* 23"x14" *Medium:* Digital

Loudan
Title: Xungtian *Size:* 19.4cm x 29.9cm *Medium:* Digital

Bill Carman
Title: But I Don't Like Bird *Size:* 9"x12" *Medium:* Acrylic on panel

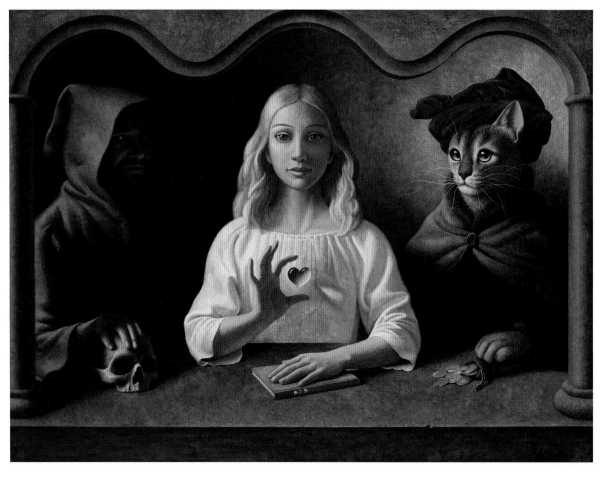

Chris Miles
Title: Trinity *Size:* 40"x30" *Medium:* Acrylic on panel

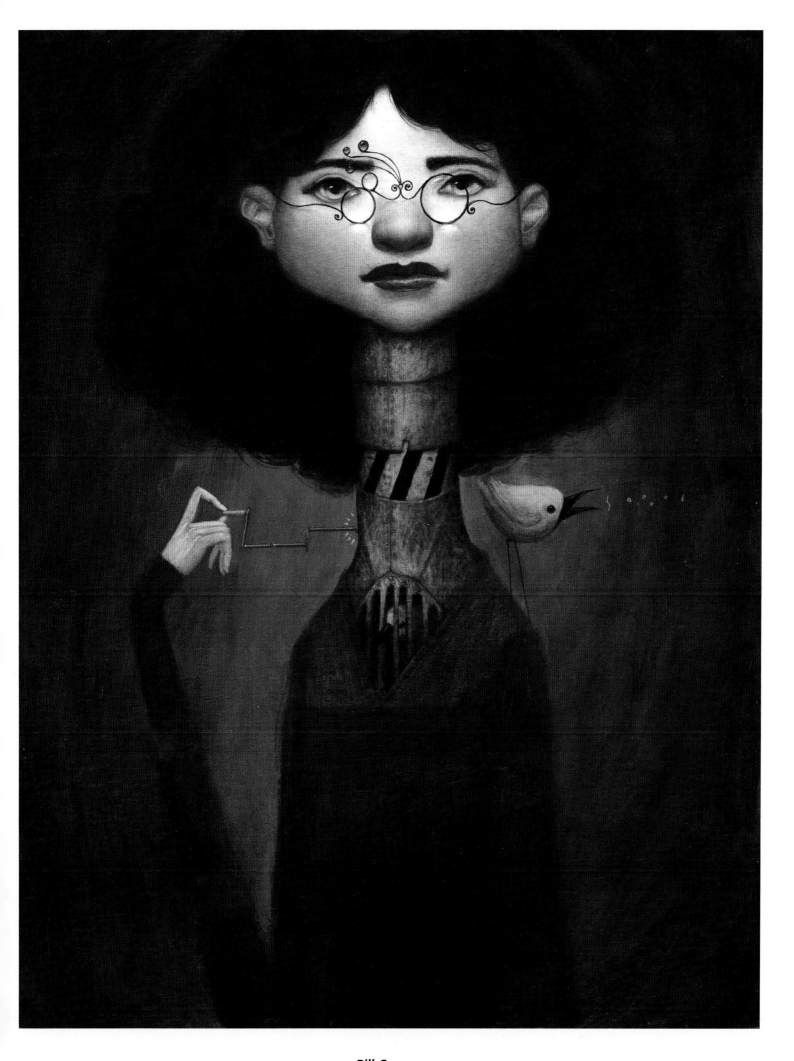

Bill Carman
Title: Maybe a Little Oil *Size:* 11"x14" *Medium:* Acrylic

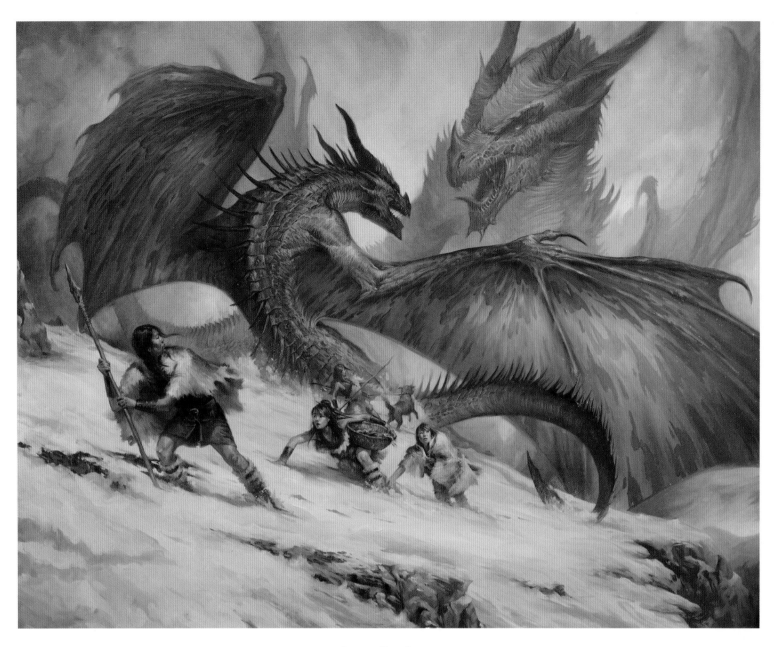

Lucas Graciano
Title: Guardianship *Size:* 40"x30" *Medium:* Oil

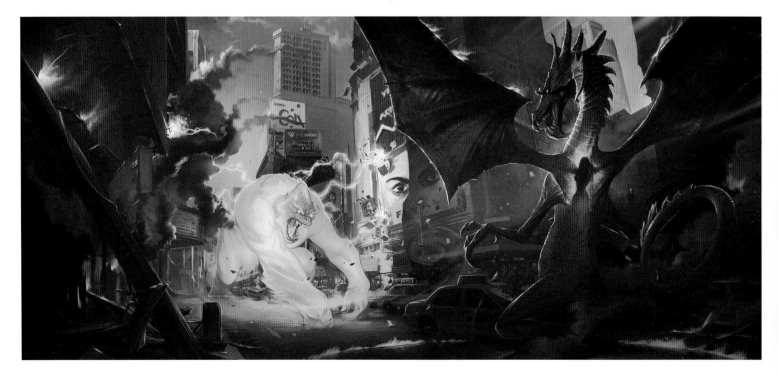

Brian Hagan
Title: Street Fight *Size:* 27"x17" *Medium:* Digital

Matt Stawicki
Title: Rip Van Winkle *Size:* 16"x20" *Medium:* Oil

Omar Rayyan

Title: The Card Sharp *Size:* 13"x16" *Medium:* Watercolor

Patricia Raubo
Title: Fleet-Footed *Size:* 14"x20" *Medium:* Photoshop

Omar Rayyan
Title: The White Knight *Size:* 14"x18" *Medium:* Watercolor

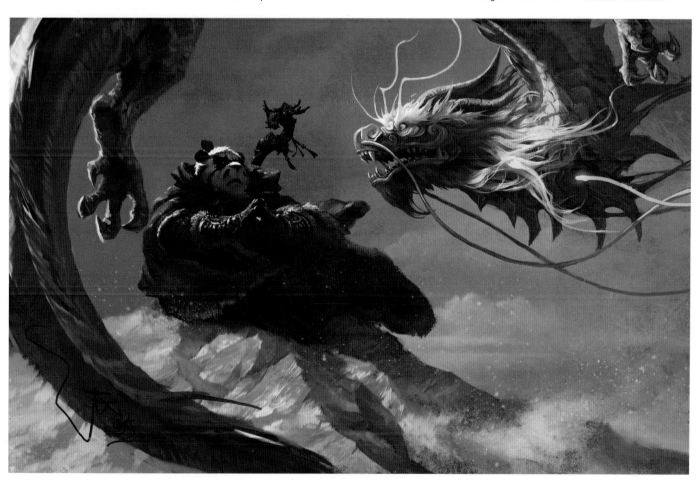

Bayard Wu
Title: Mountain Everest *Size:* 39.34cm x 25.4cm *Medium:* Digital

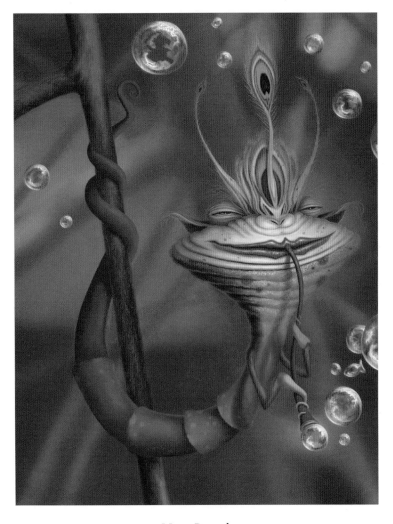

Matt Dangler
Client: Drawing Dreams Foundation *Title:* The Spellbinding Bubble Baron
Size: 16"x20" *Medium:* Oil

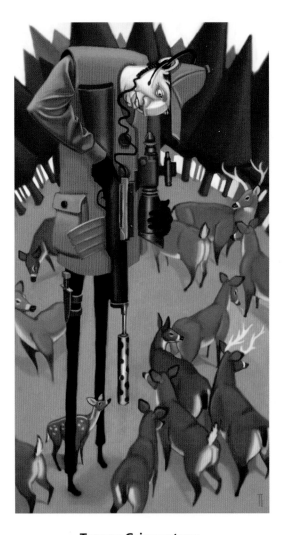

Tanner Griepentrog
Title: The Hunter *Size:* 8.5"x16.04" *Medium:* Digital

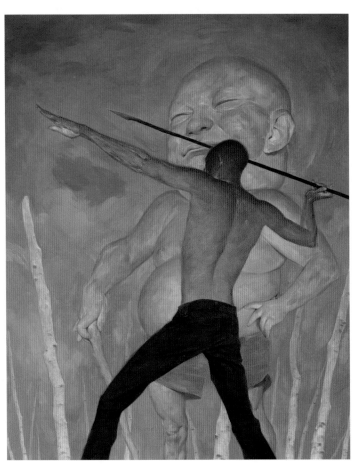

Jeremy Enecio
Title: The Teacher *Size:* 19"x24" *Medium:* Acrylic, oil on panel

Brian Despain
Title: The Prophets *Size:* 5"x7" *Medium:* Oil on board

Dave Dorman

Title: Ahab's Wife *Size:* 24"x36" *Medium:* Oil, acrylic

Donato Giancola
Title: I Threw Down My Enemy *Size:* 33"x45" *Medium:* Oil on panel

Donato Giancola
Title: Lover's Quarrel *Size:* 24"x30" *Medium:* Oil on panel

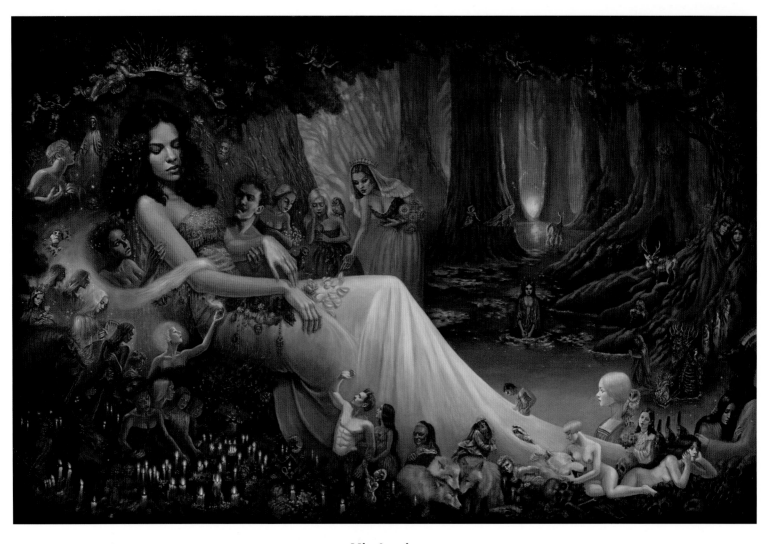

Mia Araujo
Client: Corey Helford Gallery *Title:* Death of a Forest *Size:* 60"x40" *Medium:* Acrylic on wood

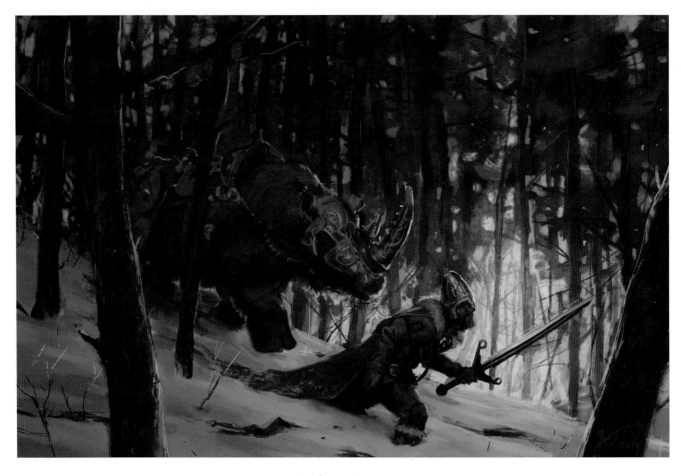

Andrew Sonea
Title: Broadsword and Beast *Medium:* Digital

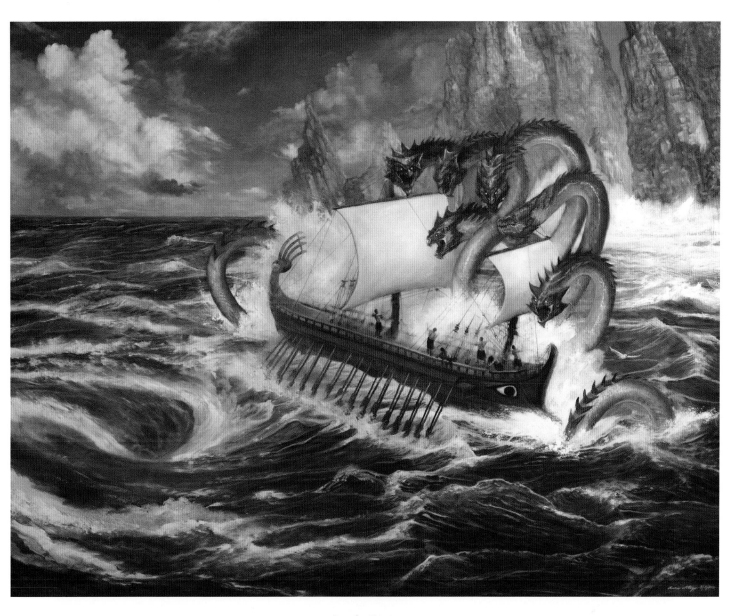

Annie Stegg
Title: Odysseus and Scylla *Size:* 40"x30" *Medium:* Oil on wood

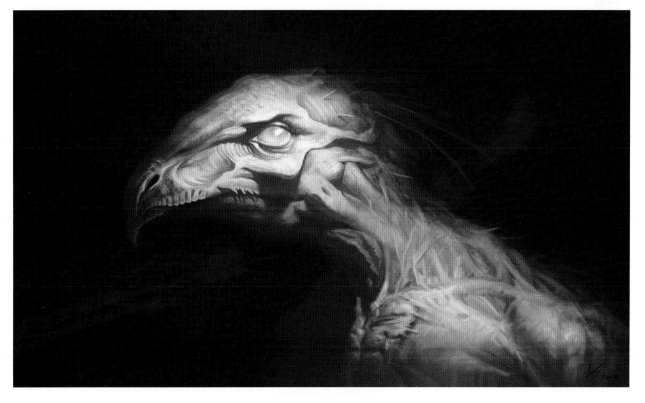

Andrew Sonea
Title: Birdman *Medium:* Digital

Donato Giancola
Title: The Fall of Gondolin *Size:* 16"x20" *Medium:* Pencil on paper

Michael Manomivibul
Title: Halloween Knight *Size:* 12"x16" *Medium:* Sumi ink

William O'Connor
Title: Dragon Lord *Size:* 17"x11" *Medium:* Digital

Tom Babbey
Title: King of Wyrms *Size:* 24"x18" *Medium:* Oil on board

Daren Bader
Title: The Hunt *Size:* 20"x12" *Medium:* Acrylic

Chris Dunn
Title: Autumn Scribe *Size:* 24cm x 31cm *Medium:* Watercolor

Kelley Hensing
Title: Paradox *Size:* 29"x32" *Medium:* Oil on masonite

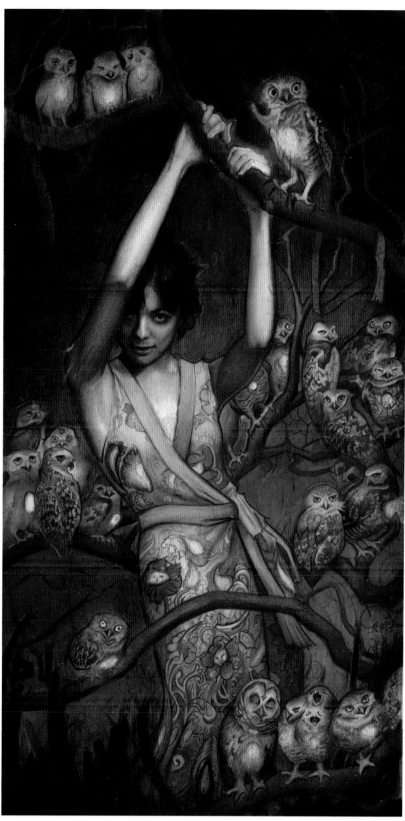

Ed Ko
Title: Poison Chalice *Size:* 6"x10" *Medium:* Digital

Rodrigo Luff
Title: Nocturne *Size:* 9.7"x18.8" *Medium:* Pencil, pastel, acrylic, mixed

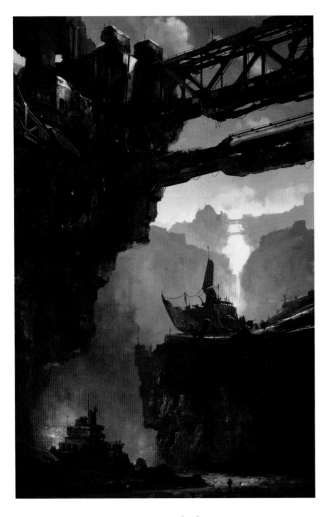

Jan Urschel
Title: Cavelands #2 *Medium:* Digital

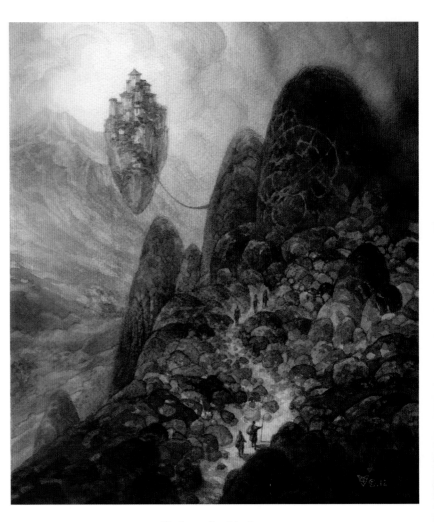

Christophe Vacher
Title: Pilgrimage to Khoon Lam *Size:* 8.25"x9.425" *Medium:* Watercolor

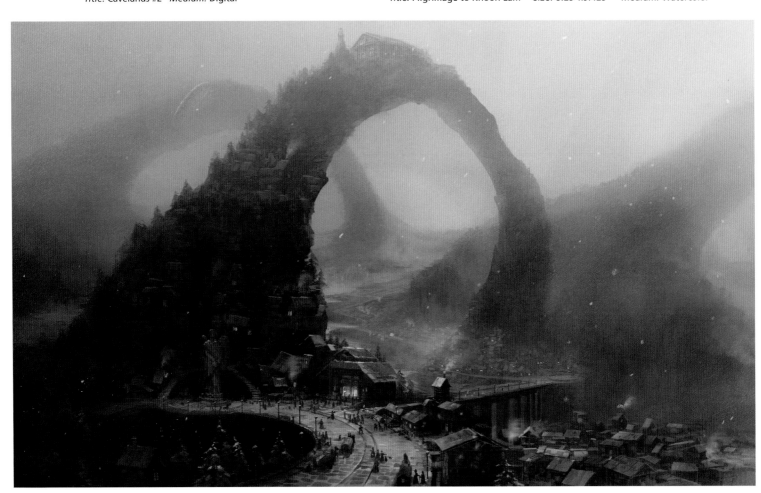

Jason
Title: City of Angels *Size:* 94.54cm x 57.43cm *Medium:* Digital

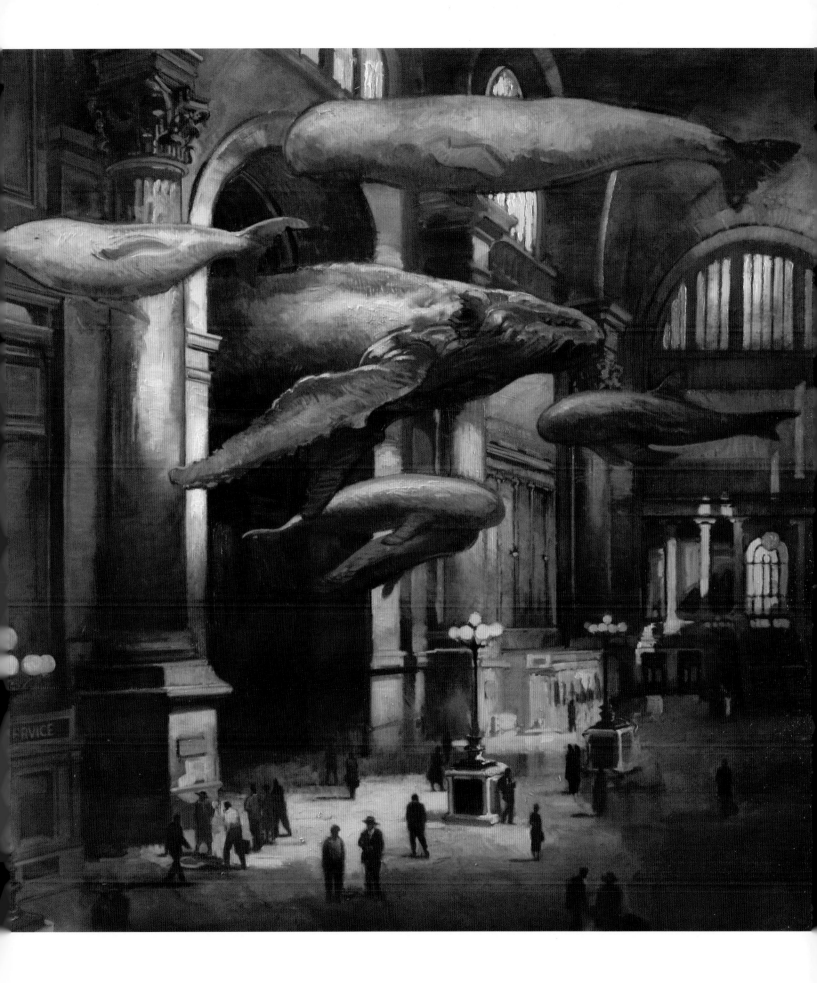

Francis Livingston
Client: Arcadia Gallery *Title:* Rush Hour *Size:* 60"x60" *Medium:* Oil

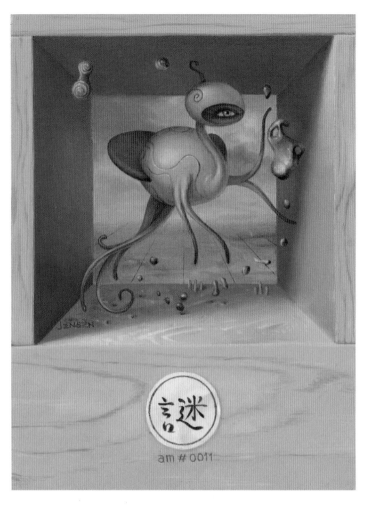

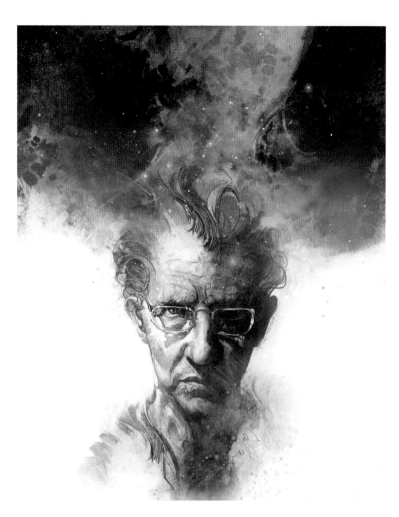

Bruce Jensen
Title: Enigma Alien *Size:* 6"x8" *Medium:* Oil on panel

Lauffray
Title: Tribute to Moebius *Medium:* Digital

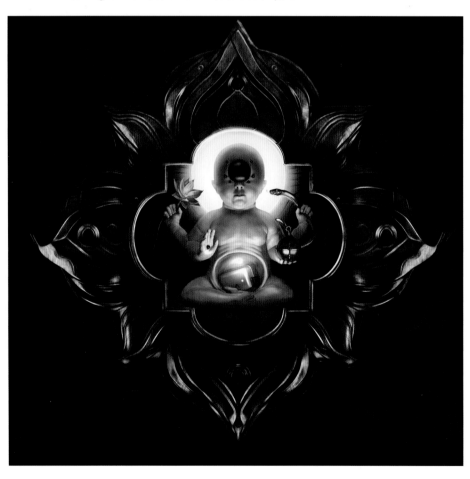

Lee Dotson
Title: Fatal Toaster *Size:* 16"x16" *Medium:* Digital

Dan Maynard
Title: Golem's Love *Size:* 11"x19" *Medium:* Digital

Jean-Baptiste Monge

Title: Flying Pumpkin *Size:* 18.3"x26.2" *Medium:* Oil on canvas paper

Edward F. Howard
Title: Young Dragoness *Size:* 24"x24" *Medium:* Oil on board

Aly Fell
Title: Ligeia *Size:* 10"x22" *Medium:* Digital

Kate Adams
Title: Vasilisa the Brave *Size:* 10"x15" *Medium:* Scratchboard

Eric Fortune
Title: Awaiting *Size:* 15"x20" *Medium:* Acrylic

Nick Southam
Title: Gulp! *Medium:* Digital

Eric Fortune

Title: The One *Size:* 15"x21.5" *Medium:* Acrylic

David Ho
Client: Pop Gallery *Title:* Milk Temptation 2 *Size:* 8"x10" *Medium:* Mixed. digital

Sean McMurchy
Title: Hidden Treasure *Size:* 8.5"x11" *Medium:* Graphite, digital

Pally Zhang
Art Director: Leonard Long *Title:* Flight *Size:* 10"x8" *Medium:* Gouache

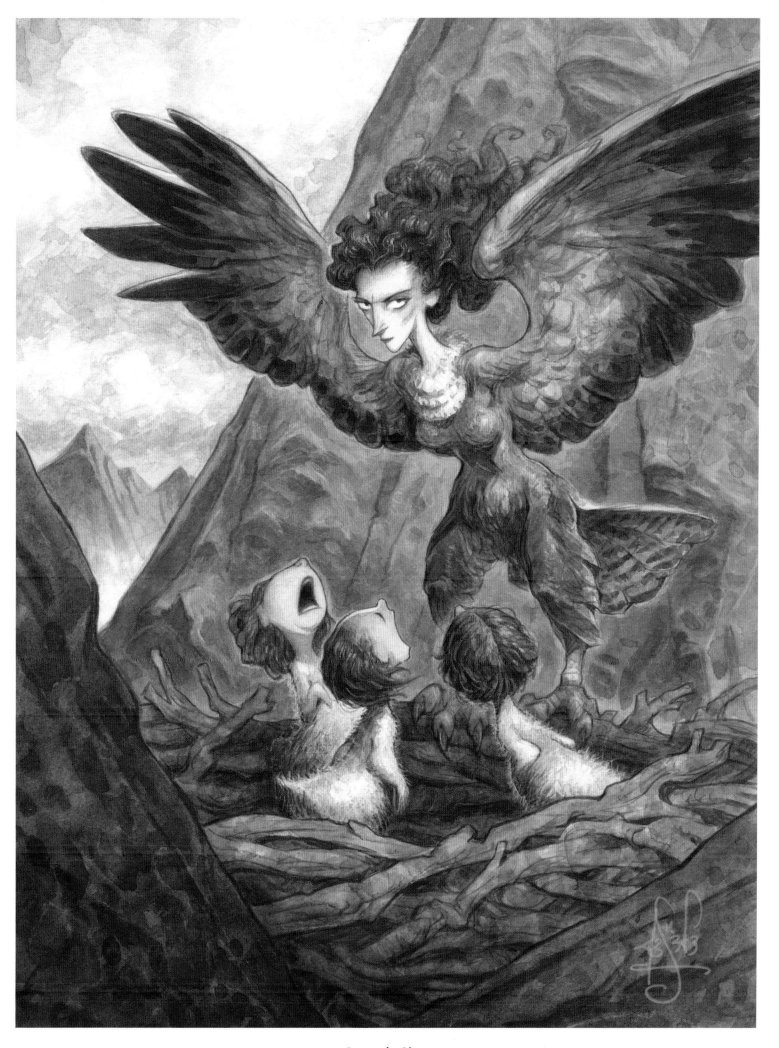

Peter de Sève

Title: The Harpy's Daughters *Medium:* Gouache

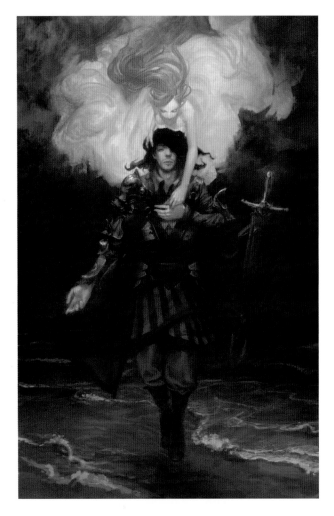

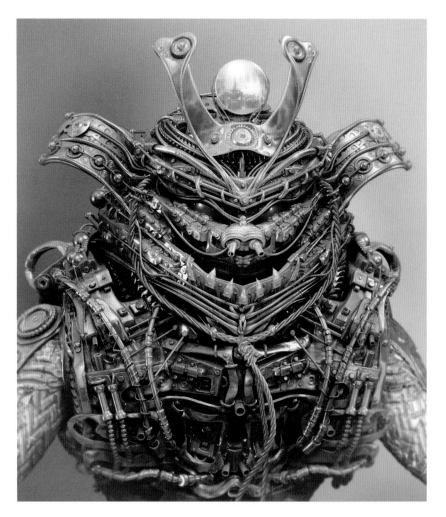

Peter Mohrbacher
Title: Tristan and Isolde *Medium:* Oil. Photoshop

Meats Meir
Title: Samurai *Medium:* Digital

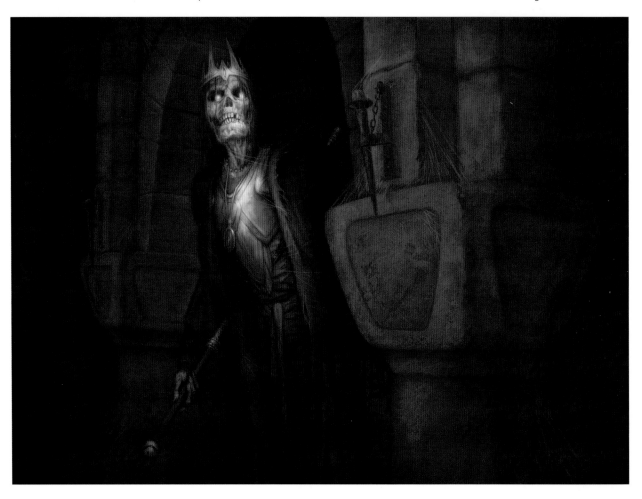

Allen Douglas
Title: Baron Voth, The Unliving *Medium:* Digital

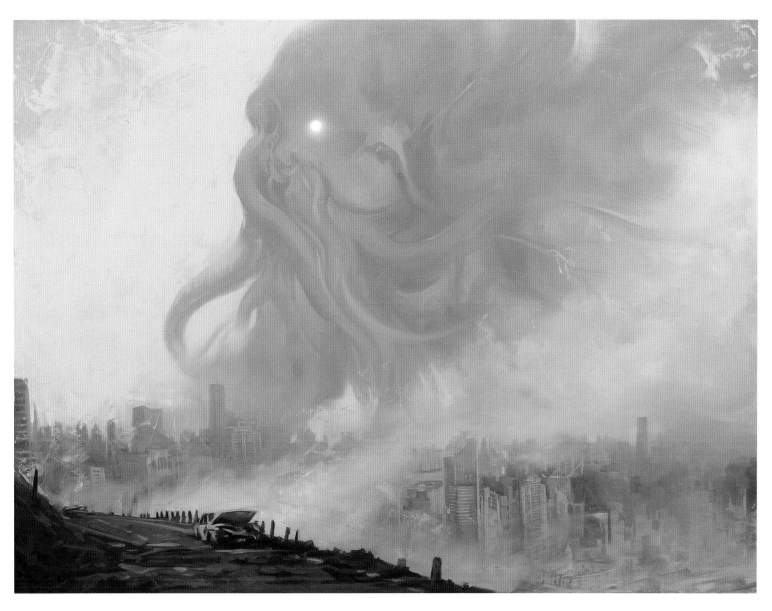

David Palumbo
Title: The Old Ones Return *Size:* 24"x18" *Medium:* Oil on panel

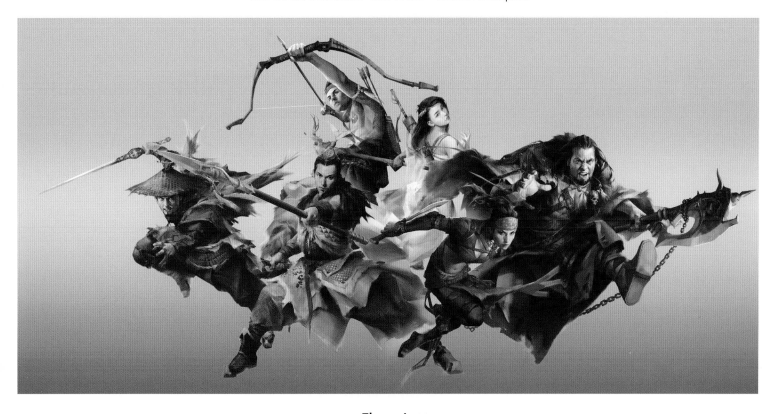

Zhang Lu
Title: Swordsmen *Medium:* Digital

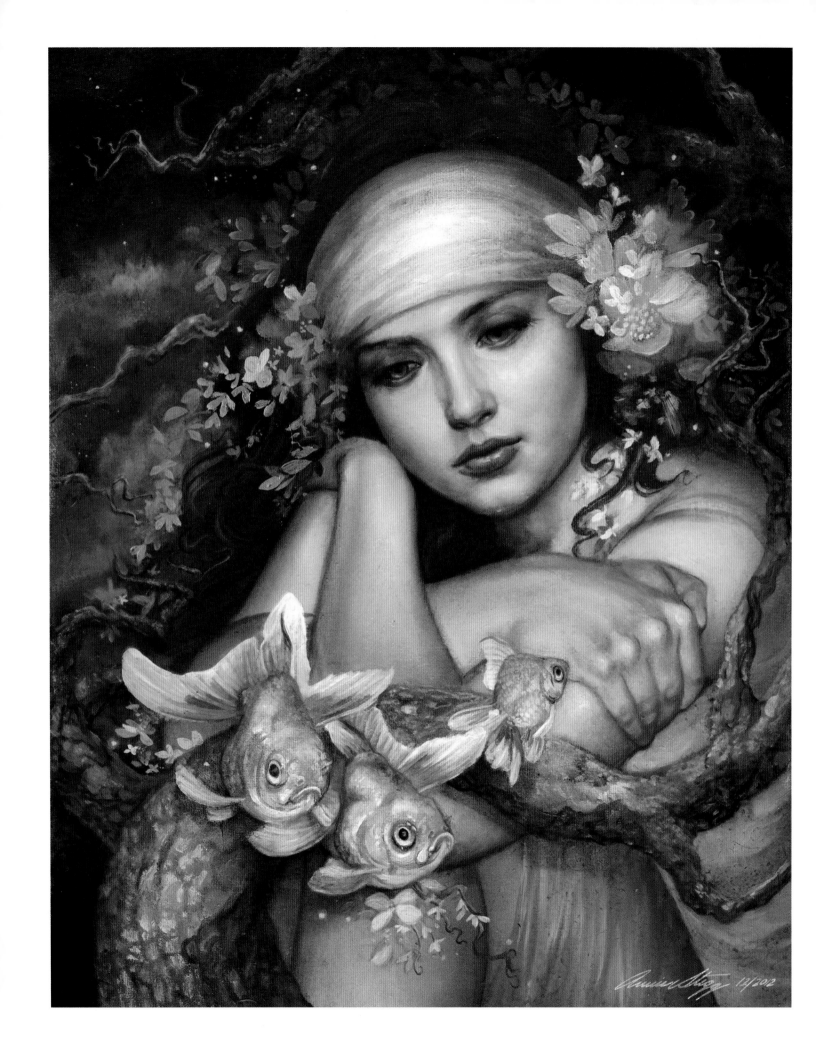

Annie Stegg
Title: Antiquated Thoughts *Size:* 8"x10" *Medium:* Oil on canvas

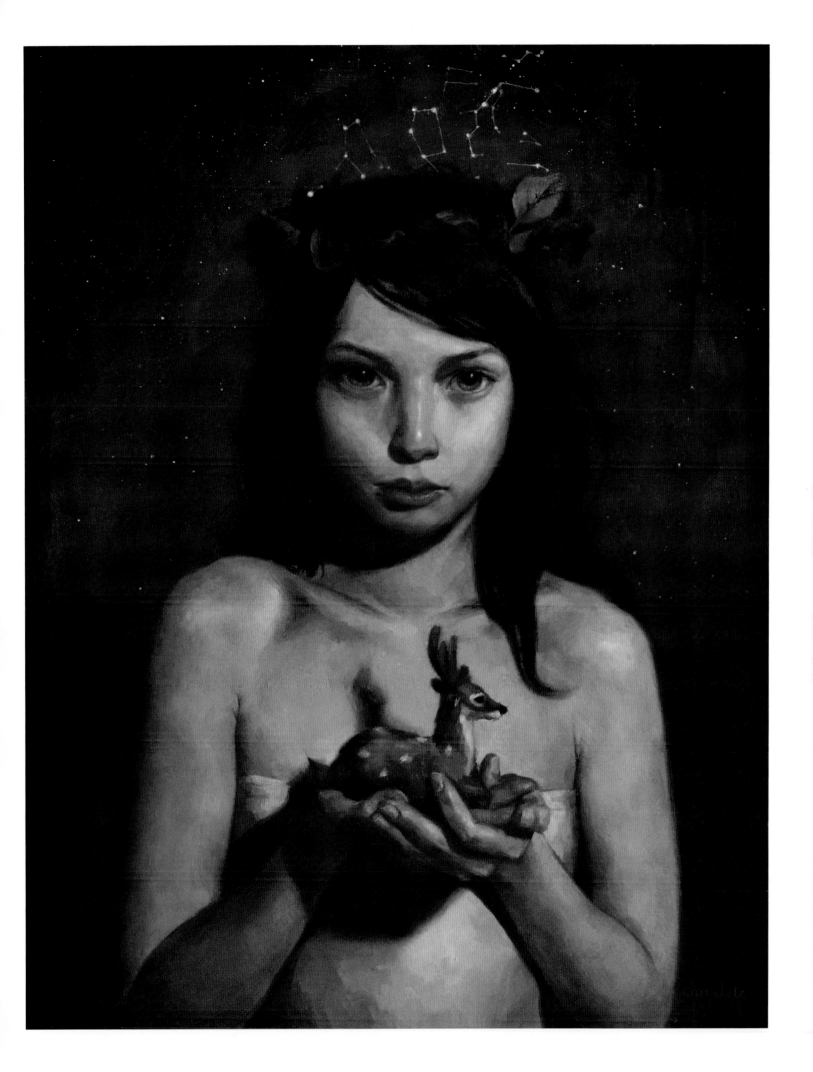

Chrystal Chan
Title: Fated Innocent *Size:* 11"x14" *Medium:* Oil on board

Raphael Lacoste
Title: Asgard's Journey *Size:* 8.5"x11" *Medium:* Photoshop

Serena Malyon
Title: Runs Amok *Size:* 8"x10" *Medium:* Digital

Thom Tenery
Title: The Keys to December *Medium:* Digital

Theo Prins
Title: Cityscape *Medium:* Photoshop

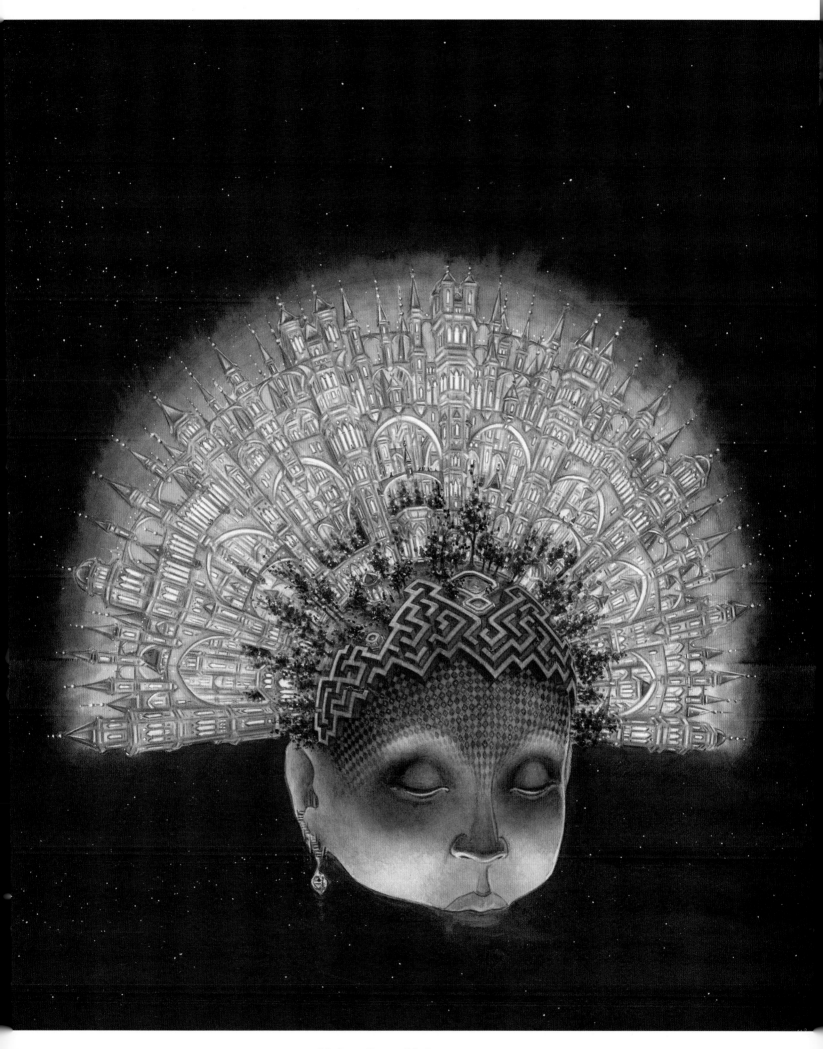

Malene Reynolds Laugesen
Title: The Queen's City *Size:* 23"x20" *Medium:* Watercolor, pencil, gouache, Photoshop

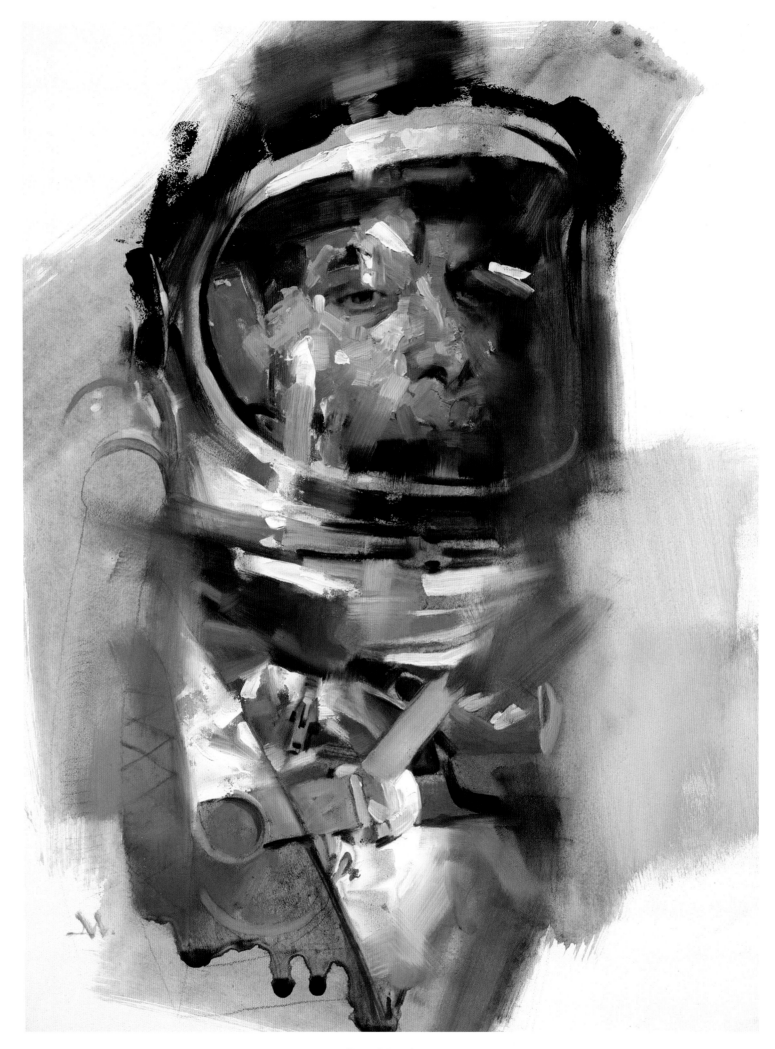

Greg Manchess

Title: Astronaut 5 *Size:* 12"x16" *Medium:* Oil on board

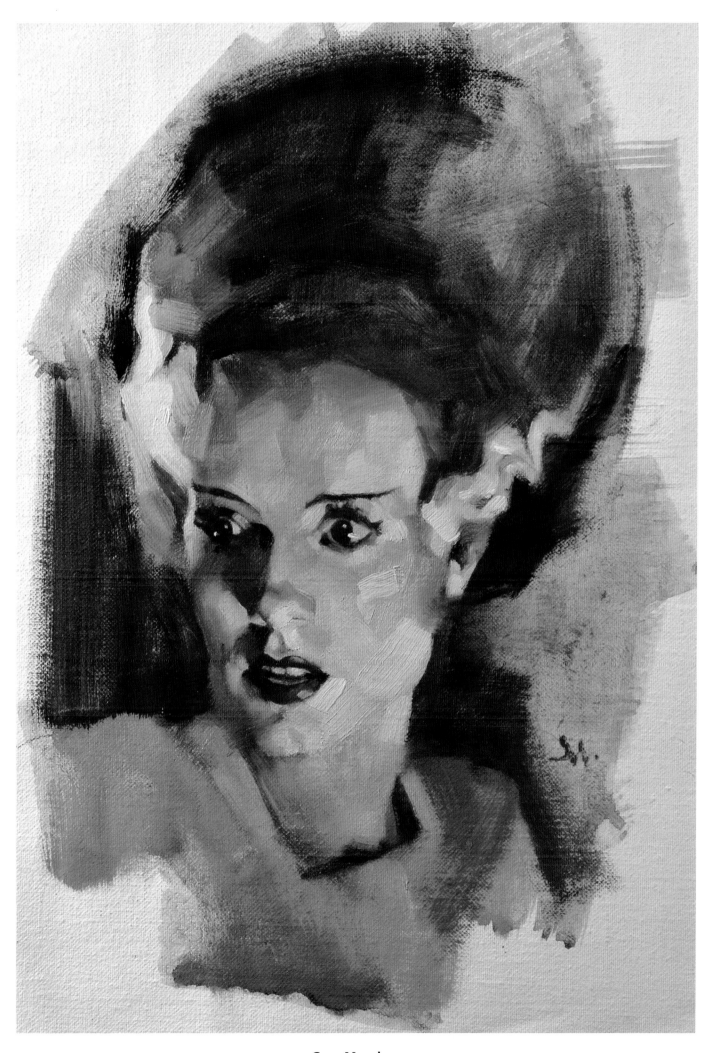

Greg Manchess
Title: Bride of Frankenstein *Size:* 10"x13" *Medium:* Oil on linen

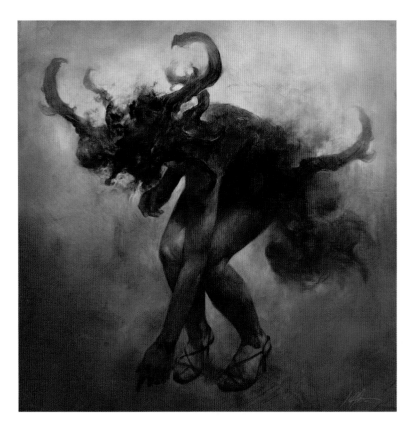

Jeff Simpson
Title: Cordyceps *Size:* 8"x8" *Medium:* Photoshop

Patrick Whelan
Title: The Secret Forest *Size:* 18"x25" *Medium:* Oil

Aldo Katayanagi
Title: Dog Walkers *Size:* 11"x17" *Medium:* Digital

Burton Gray
Title: Disco *Size:* 14"x18" *Medium:* Digital

Mark Garro
Client: Copro Gallery *Title:* Carpool *Size:* 9"x12" *Medium:* Acrylic, oil on panel

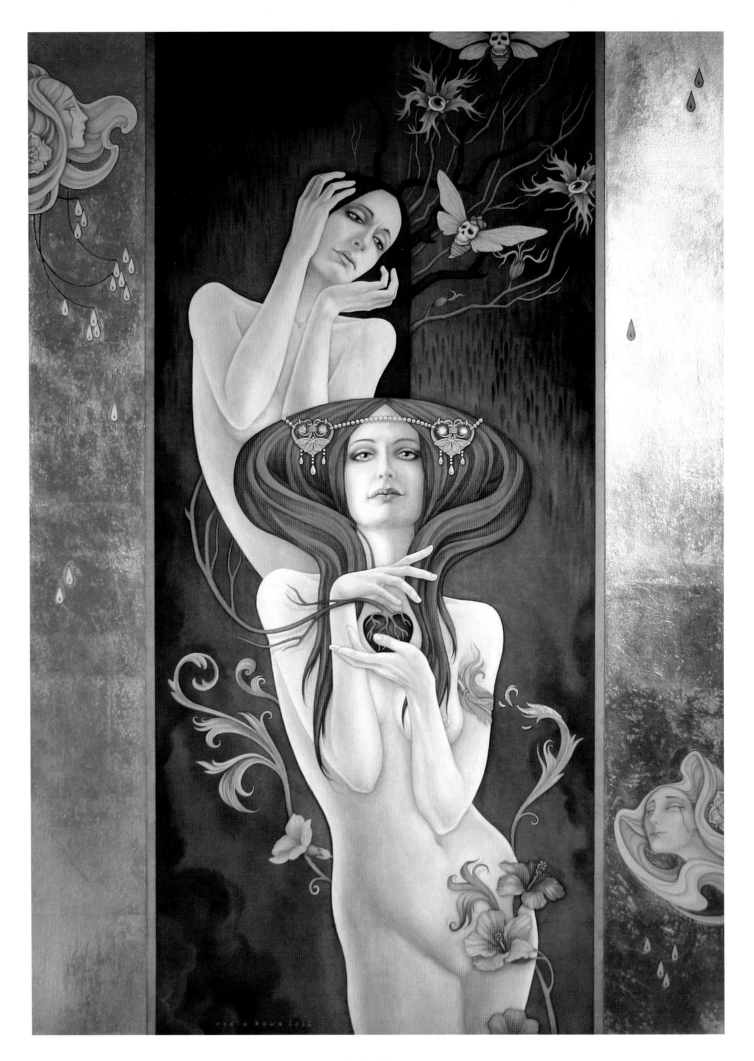

Agata Kawa
Title: Le Masque *Size:* 28"x40" *Medium:* Watercolor, gold leaf

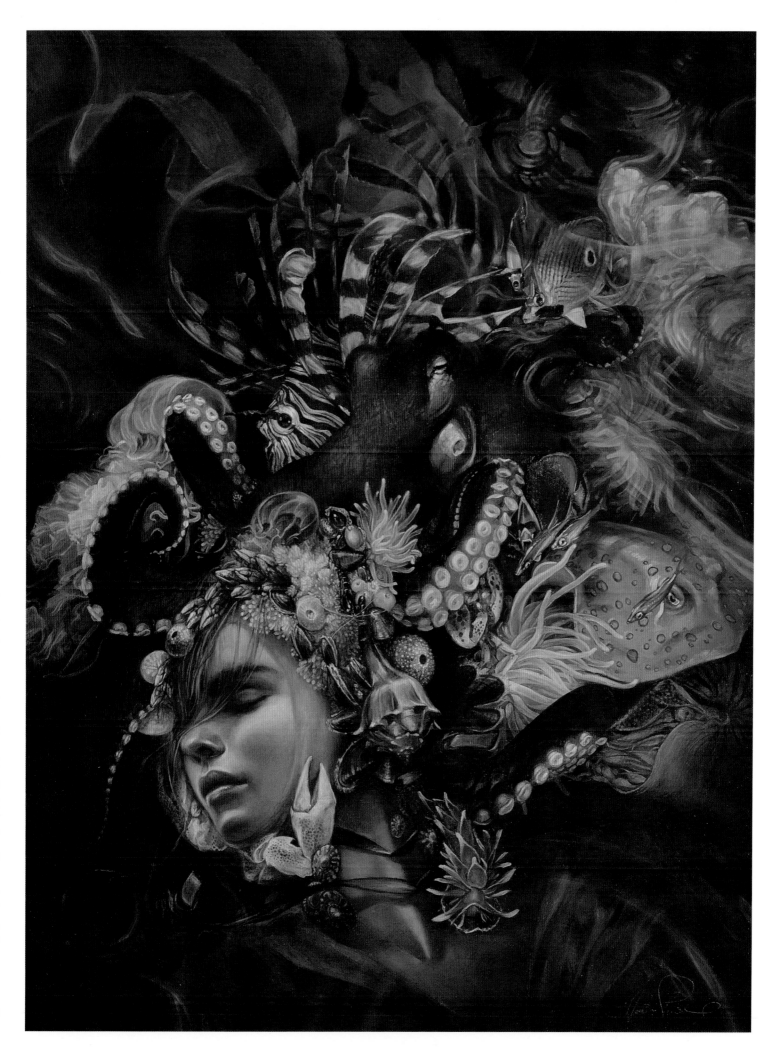

Heather Theurer
Title: Blue Ribbon *Size:* 18"x24" *Medium:* Oil on board

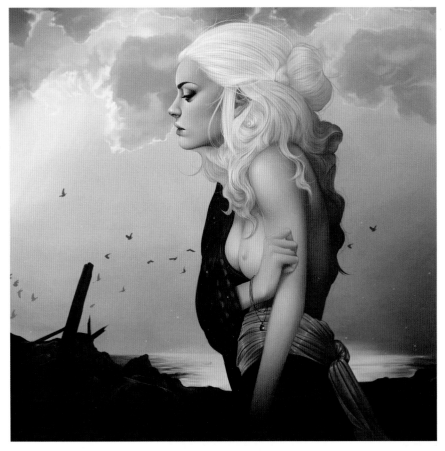

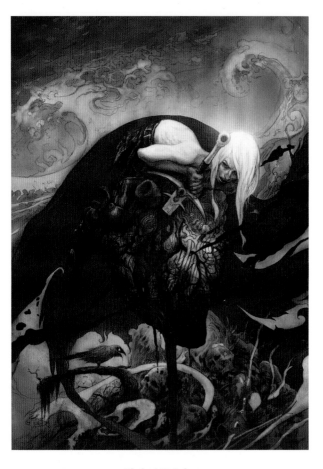

Kelsey Beckett
Title: Mother of Dragons *Size:* 15"x14" *Medium:* Digital

Aleksi Briclot
Client: Glénat *Title:* Elric *Size:* 29.8cm x 42cm *Medium:* Mixed

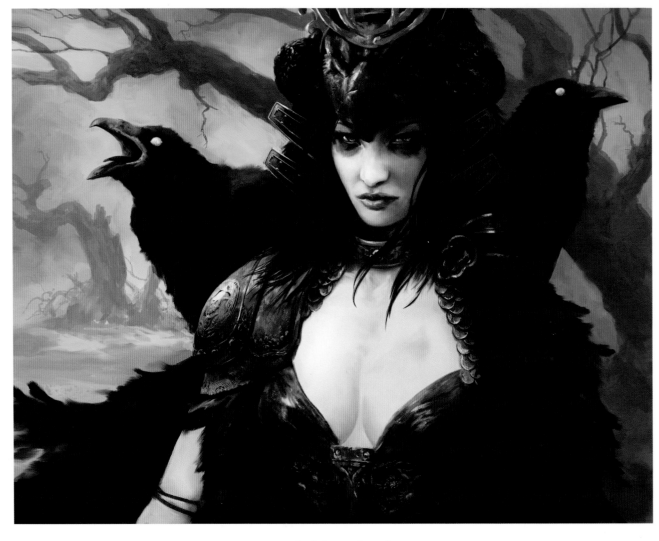

Frederick Rambaud
Title: Crow Witch *Medium:* Digital

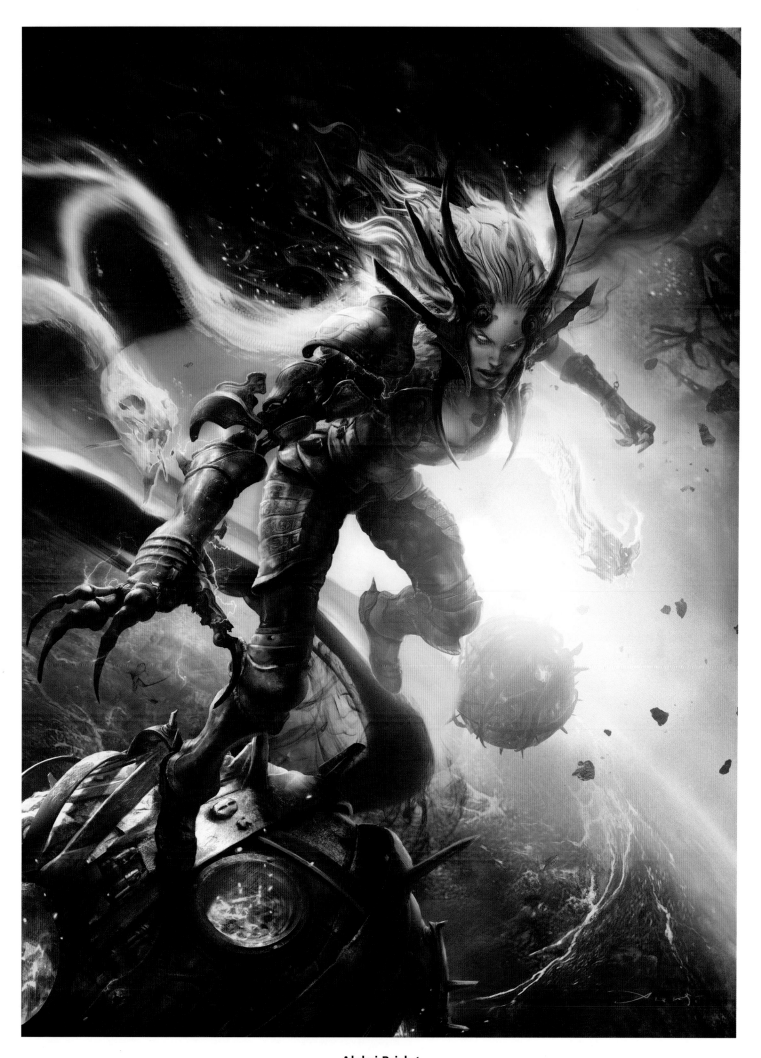

Aleksi Briclot
Title: Azzar'Hi *Size:* 29.3cm x 40cm *Medium:* Digital

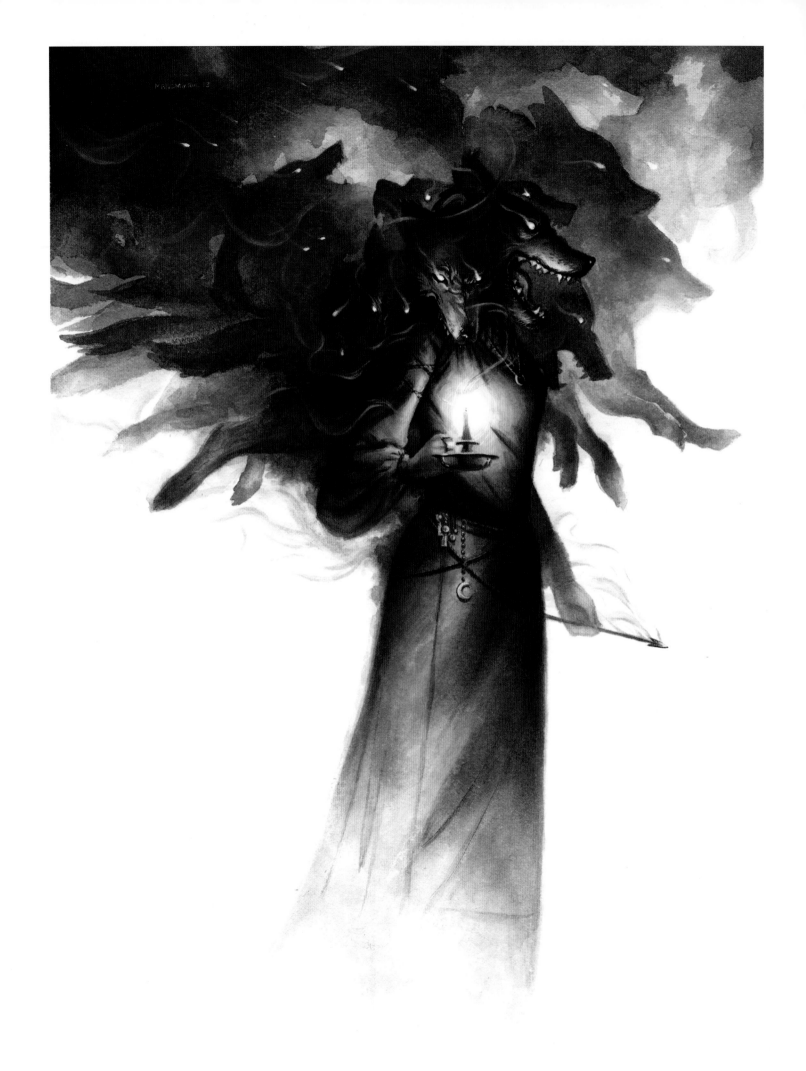

Michael Manomivibul

Title: The Hunter's Wife *Size:* 10"x14" *Medium:* Sumi ink, digital

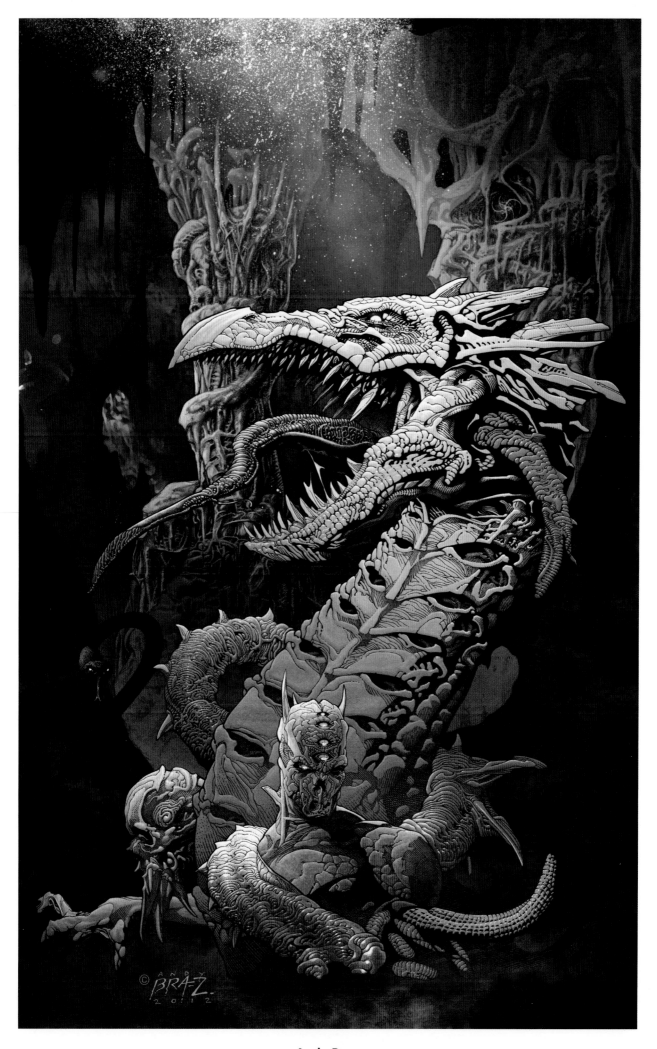

Andy Brase

Title: Dragonizor: Into the Amaurotic Abyss *Size:* 11"x17" *Medium:* Ink, pencil, digital color

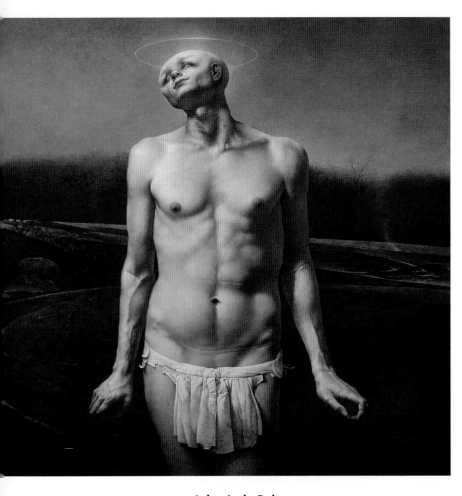

John Jude Palencar
Title: Extasis *Size:* 33"x32" *Medium:* Acrylic on birch panel

Andris Liepnieks
Title: The Paper Merchant *Size:* 8"x11" *Medium:* Digital

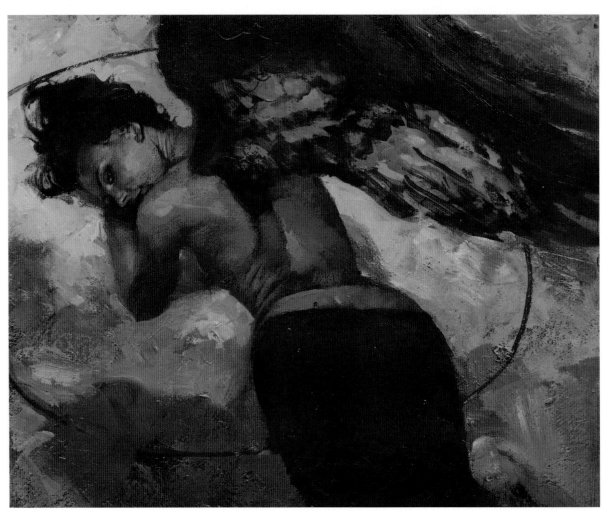

Christopher Moeller
Title: Angel in a Red Dress *Size:* 10"x8" *Medium:* Acrylic

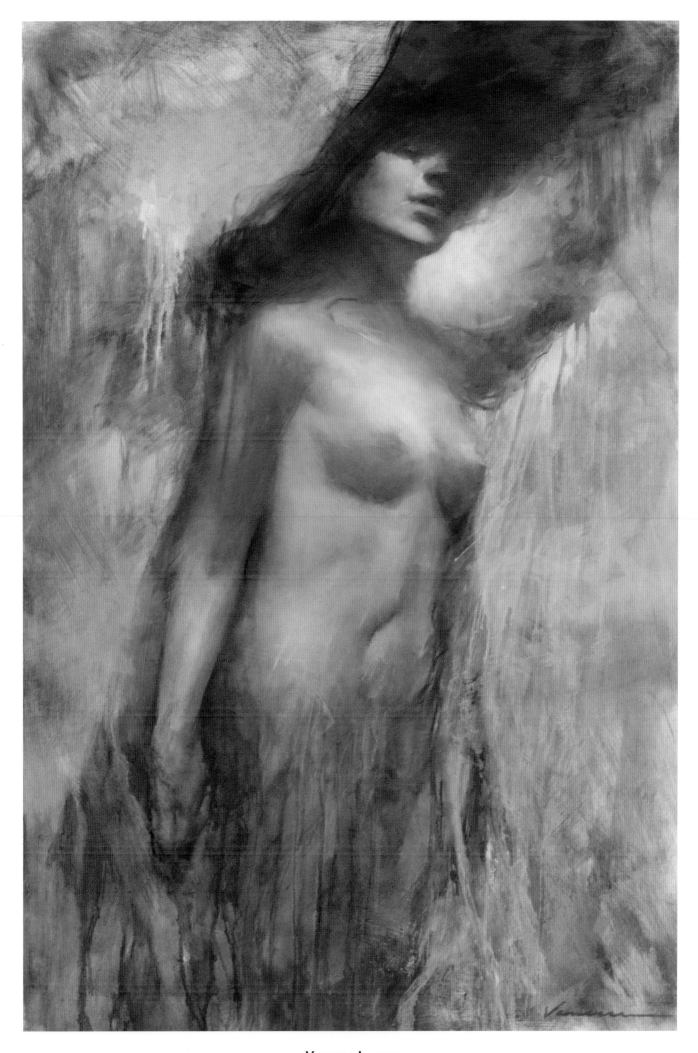

Vanessa Lemen
Title: Ishi *Size:* 27"x40" *Medium:* Oil on panel

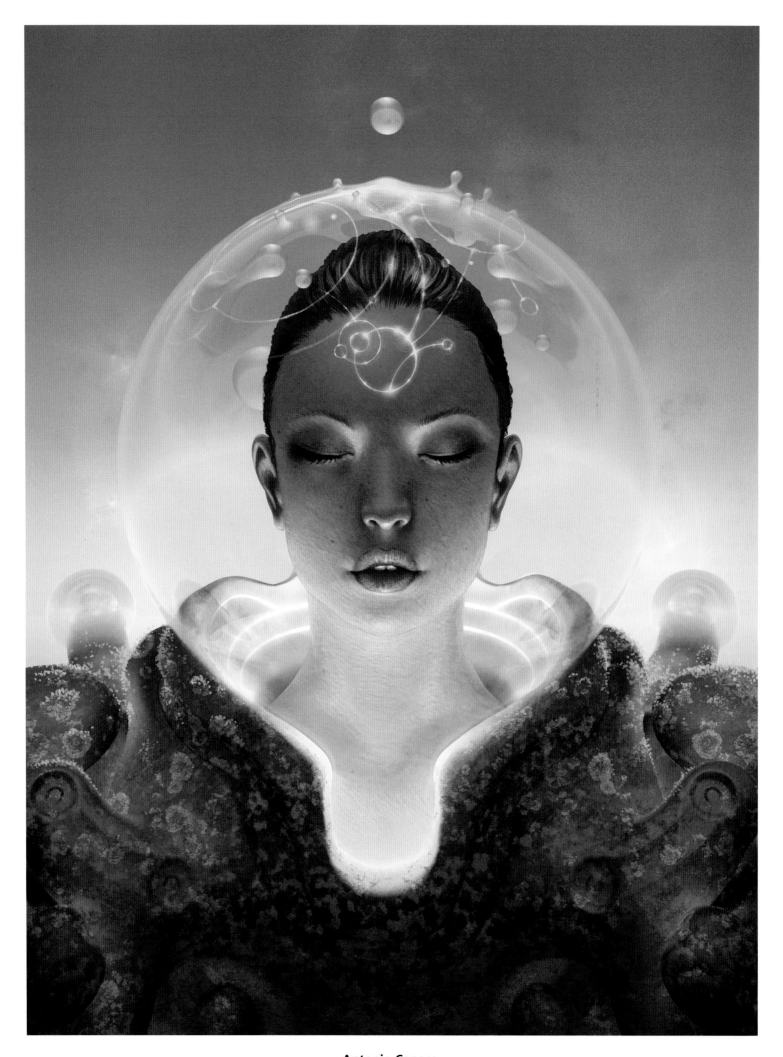

Antonio Caparo
Title: Telepathist *Size:* 13.5"x18" *Medium:* Digital

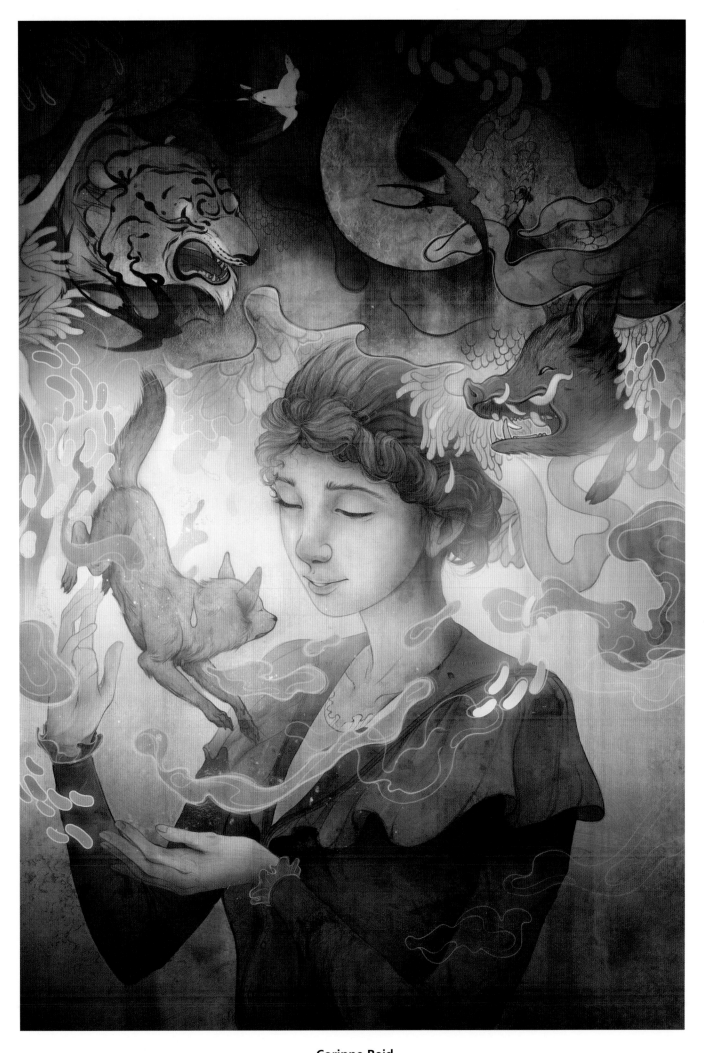

Corinne Reid
Client: Wonderland Gallery *Title:* Silent Visions *Size:* 15"x20" *Medium:* Digital

Rob Benevides
Title: Meren of Aranel *Size:* 24"x36" *Medium:* Digital metallic print

Gordon Crabb
Title: Silk *Medium:* Digital

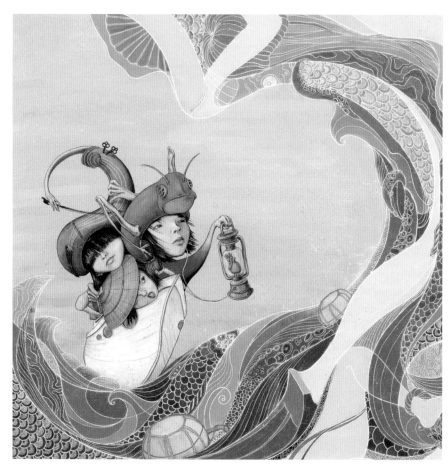

Marc Scheff
Art Director: Rebecca Guay *Title:* The Boy Lived *Medium:* Digital

Donna Choi
Title: Miracle Sea Road *Size:* 18"x20" *Medium:* Mixed

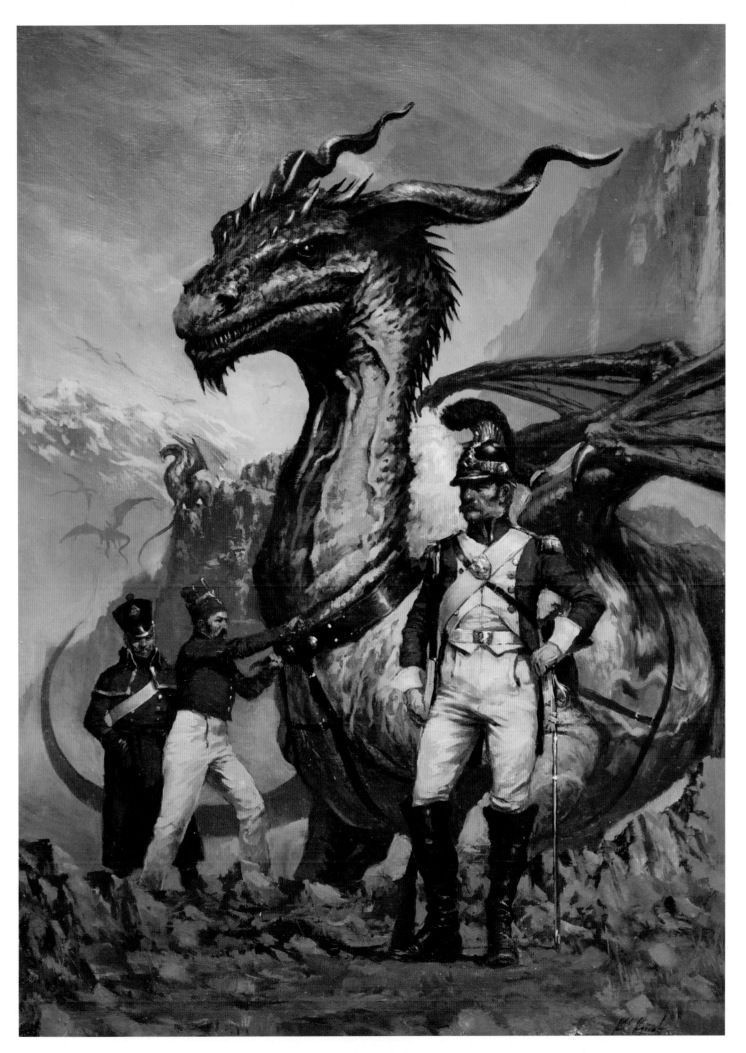

Karl Kopinski
Client: Gallery Daniel Maghen *Title:* Dragon's Guard *Size:* 42cm x 29cm *Medium:* Oil

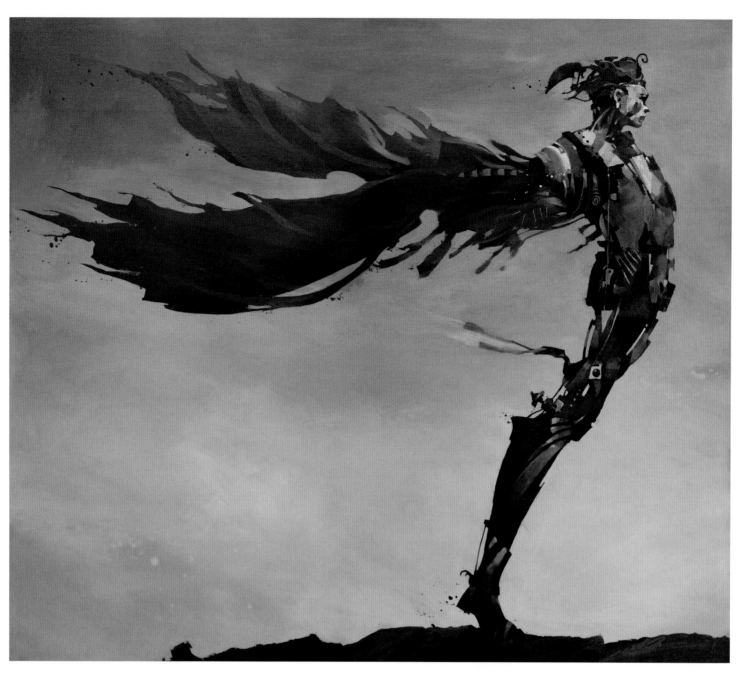

Bruce Holwerda
Title: Seeking Heroes *Size:* 42"x36" *Medium:* Acrylic painting

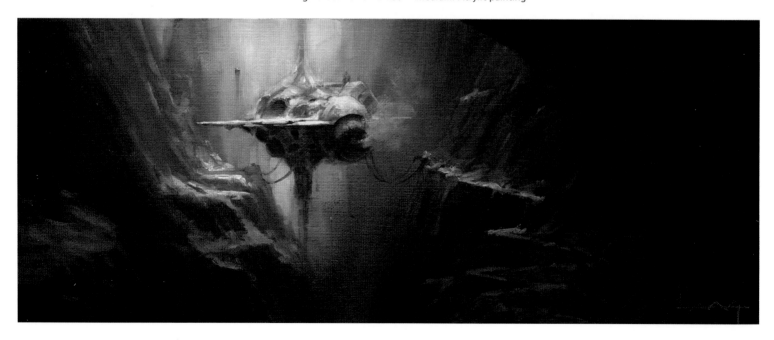

Wayne Haag
Title: Levitation *Size:* 48"x12" *Medium:* Oil on paper

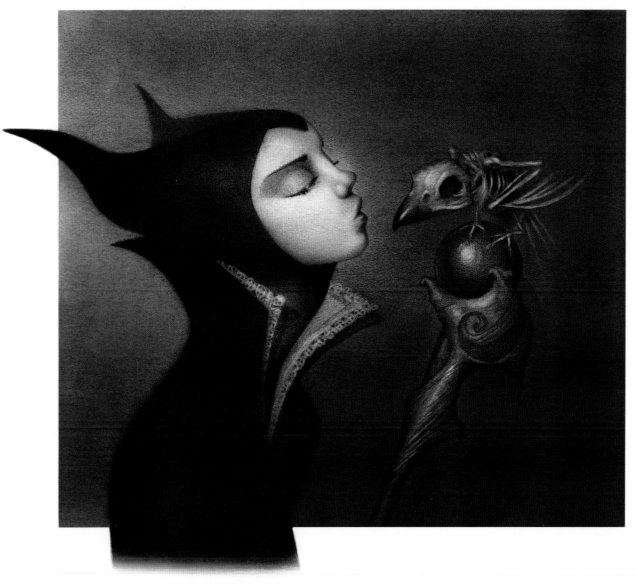

Travis Lewis
Title: Uninvited *Size:* 15"x12" *Medium:* Graphite

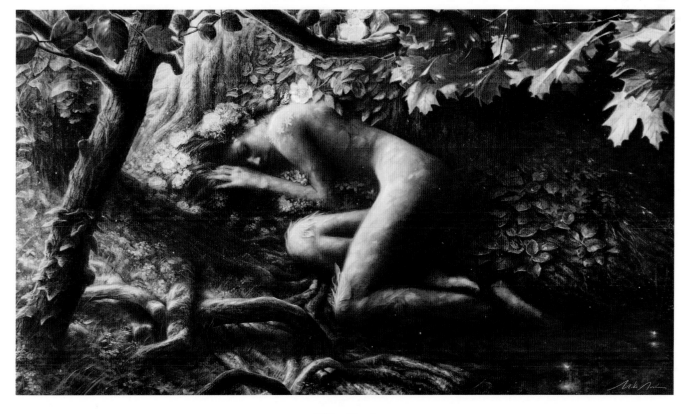

Mike Nash
Title: Dryad *Size:* 30"x18" *Medium:* Digital

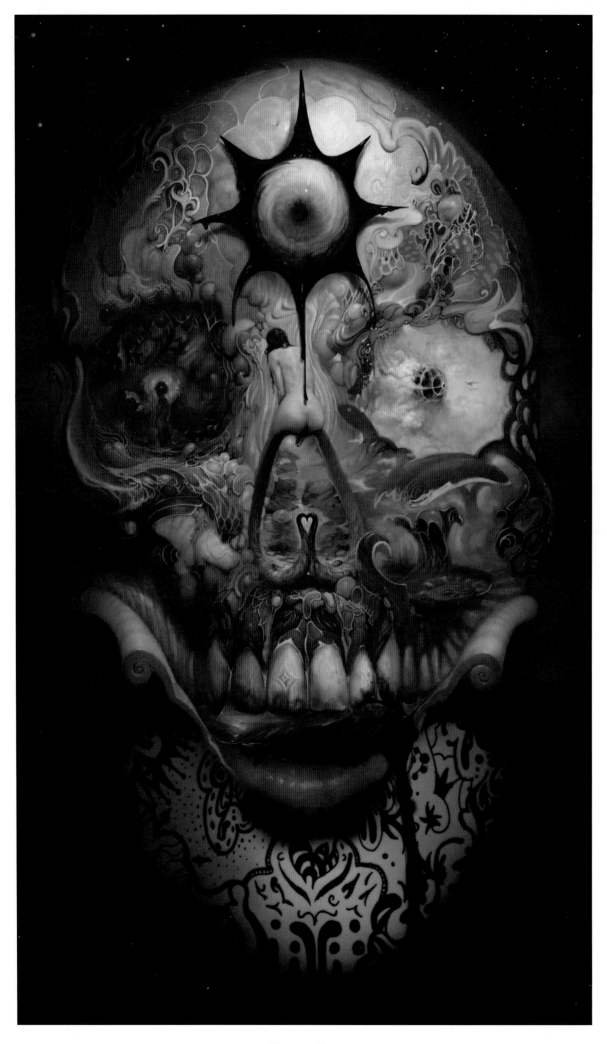

Burton Gray

Title: Skull *Size:* 24"x36" *Medium:* Digital

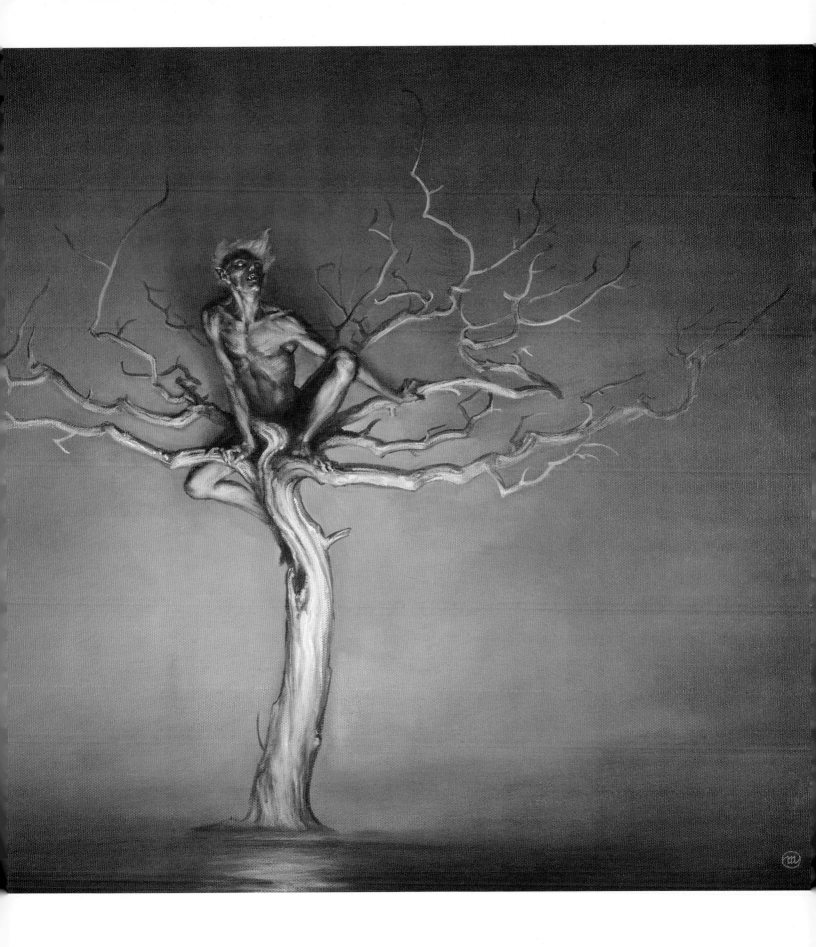

Michael Whelan

Title: Apparition *Size:* 20"x16" *Medium:* Oil on canvas

Spectrum INDEX

Become a part of the Spectrum Community!

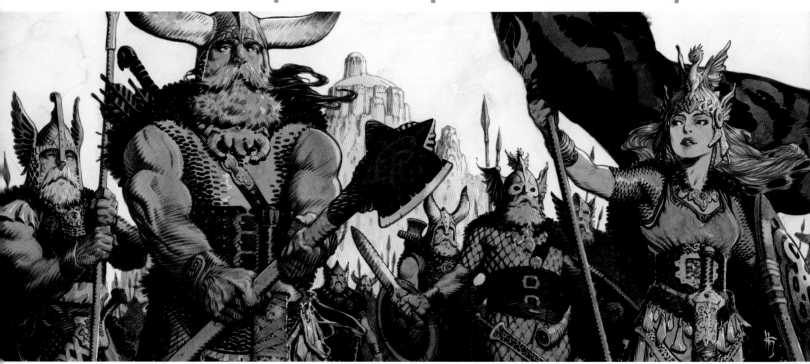

Art by Mark Schultz

Learn how to participate in **Spectrum 21** by visiting the official website:
www.spectrumfantasticart.com
Mail us your name and address to receive the Call For Entries poster in the Fall:
Spectrum/Flesk Publications, P.O. Box 54044, San Jose, CA 95154

And plan on joining us in Kansas City, May 9-11, 2014 for **Spectrum Fantastic Art Live 3**, the art fair with a sense of wonder. Featuring workshops, panels, portfolio reviews, lectures, and hundreds of exhibiting artists selling originals, prints, and books—all capped with the awards ceremony for Spectrum 21—SFAL is a celebration of fantastic art and the people who create it. To learn how to exhibit or attend go to **www.SFALKC.com** and please follow us on Facebook at **www.facebook.com/spectrumfantasticartlive**